Not Drowning But Waving

Not Drowning But Waving

Women, Feminism, and the Liberal Arts

EDITED BY

SUSAN BROWN

JEANNE PERREAULT

JO-ANN WALLACE

HEATHER ZWICKER

The University of Alberta Press

Published by
The University of Alberta Press
Ring House 2
Edmonton, Alberta, Canada T6G 2E1
www.uap.ualberta.ca

Library and Archives Canada Cataloguing in Publication

Not drowning but waving : women, feminism and
the liberal arts / edited by Susan Brown ... [et al.].

Includes bibliographical references and index.
Also issued in electronic formats.
ISBN 978-0-88864-550-0

1. Women in the humanities--Canada. 2. Women in
higher education--Canada. 3. Feminism and higher
education--Canada. I. Brown, Susan, 1964-

AZ515.N68 2011 001.3082'0971 C2011-903563-4

First edition, first printing, 2011.
Printed and bound in Canada by Houghton
Boston Printers, Saskatoon, Saskatchewan.
Copyediting by Brendan Wild.
Proofreading by Joanne Muzak.
Indexing by Judy Dunlop.

The University of Alberta Press has made
every effort to correctly identify and
credit the sources of all photographs,
illustrations, and information used in
this publication. We appreciate any further
information or corrections, and will provide
acknowledgement in subsequent editions.
The University of Alberta Press is committed
to protecting our natural environment.
As part of our efforts, this book is printed
on Enviro Paper: it contains 100% post-
consumer recycled fibres and is acid- and
chlorine-free.

The University of Alberta Press gratefully
acknowledges the support received for
its publishing program from The Canada
Council for the Arts. The University of
Alberta Press also gratefully acknowledges
the financial support of the Government
of Canada through the Canada Book Fund
(CBF) and the Government of Alberta through
the Alberta Multimedia Development Fund
(AMDF) for its publishing activities.

Canadä Canada Council Conseil des Arts Government
 for the Arts du Canada of Alberta ■

Contents

HISTORY / TEMPORALITY / GENERATIONS

ACTIVISM

Women, Feminism, and the Liberal Arts

Not Drowning But Waving

SUSAN BROWN, JEANNE PERREAULT,
JO-ANN WALLACE, AND HEATHER ZWICKER

YES, IT'S RECKLESSLY OPTIMISTIC to entitle a volume about women, feminism, and the liberal arts "Not Drowning But Waving." Pick up any newspaper in this still new twenty-first century and you'll be overwhelmed by the number of urgent women's issues at home and abroad. Sit through a university committee meeting—or, for that matter, the House of Commons debates—and listen for the number of times you hear the term *equity*: we'll bet it's zero. And when is the last time you heard about a big bequest designated for women's studies? As for the liberal arts: the humanities, social sciences, or fine arts are not necessarily at the centre of the corporatizing university. By most measures, we—that problematic, variably representative, contested, and vulnerable category that plagues and yet underwrites the project of feminism, and that shifts in this introduction and this collection between

specific, identifiable groups and more amorphous collectives—
are not waving, but drowning.

That's how Stevie Smith originally put it. Her short poem "Not
Waving but Drowning" reads,

Nobody heard him, the dead man,
But still he lay moaning:
I was much further out than you thought
And not waving but drowning.

Poor chap, he always loved larking
And now he's dead
It must have been too cold for him his heart gave way,
They said.
Oh, no no no, it was too cold always
(Still the dead one lay moaning)
I was much too far out all my life
And not waving but drowning.[1]

The questions suggested by this poem are legion, and unsettling.
Have we been "too far out"? as feminists, aren't we *supposed* to
swim farther out? but can we get in too deep? is the climate still
too chilly? is feminism "dead"? has our "heart" given way? are we
about to go under for good? is it true that "nobody" can hear the
moans? who is the subject here anyway, that shifts so unpredict-
ably and seems to lurk between pronouns?

Or perhaps, as Aritha van Herk's dive into the "task and temp-
tation" of "daring to be optimistic" brings home, we need to undo
the impulse to surrender, since waves can both pull under and
buoy us up, we can ride out waves of exhaustion or be carried on
waves of exhilaration. The possibilities of *jouissance* here—love
and larks—are in tension with isolation, difference, separation
from the group. Yet are there grounds for hope, nevertheless, in the

"moaning" of this apparently dead body, change that might emerge from the listening, empathetic moment that invokes both collectivity and the isolation of the subject? Might we be not drowning but waving?

The idea for this volume originated in a conference held in October 2006 to celebrate Patricia Clements's career and achievements as the first—and, to that point, only[2]—woman Dean of Arts at the University of Alberta, and at a time of massive institutional change. We invited conference participants to weigh in on questions like "feminism in/and the liberal arts disciplines; the relationship of the liberal arts to the larger university; Women's Studies programs and the 'new' interdisciplinarity; the challenges, costs, and rewards for women in administration; the corporatization of university campuses; intergenerational and transcultural tensions within feminist communities; the state and stakes of feminist pedagogy; the relationship of feminism to cultural studies; women, social justice, and the liberal arts." We asked, "Feminist work in these areas has changed the liberal arts, but how much? What remains to be done, intellectually, pedagogically, institutionally?"

We heard plenty. Women and a few men presented research on feminist theory, popular culture, and woman-centred history. But as is often the case at conferences, some of the most interesting material emerged in the discussions after presentations, over coffee, or during meals. At these times, many of us spoke feelingly about being overworked, isolated, and unsure how to balance our many and sometimes conflicting roles in the classroom, the household, the meeting, the office. We talked about the exhaustion of making do without sufficient time, or energy, or resources, or colleagues. There was frustration over the sense that efforts to achieve genuine equity across the four groups targeted by the 1986 Federal Contractors Program—women, Aboriginal peoples, persons with disabilities, and visible minorities—through legislative,

institutional, and activist efforts had been forestalled.[3] We held
the conference dinner at the Muttart Conservatory in downtown
Edmonton, a cluster of pyramid-shaped greenhouses tellingly
devoted to arid, temperate, and tropical climates, which Beau
Coleman—an Edmonton-based theatre director, installation artist,
and University of Alberta professor—populated with evocative per-
formance art specimens of feminists in the wild. The more we
talked, the more we found to say to each other.

Throughout these conversations the admittedly somewhat
clunky and well-worn phrase "not drowning but waving" stuck.
It gestures both at the difficulties faced by feminists in the human-
ities in Canada and at the possibilities of hope, of new "waves"
of feminism. There are several pieces here describing the obsta-
cles, conundrums, and emotional costs associated with being
feminists in the university, feminists in the twenty-first century.
However, taken as a whole, the essays collected here suggest that
there is considerable feminist ferment in a number of arenas:
within the academy, within research groups, within our com-
munities, in courtrooms and boardrooms and households and
journals. As exhausted as we are by endless streams of email, we
find possibilities for feminist connectedness through the Internet.
At the same time, we worry about the toll this lack of direct con-
nection and asynchronicity takes on our sense of community.
Meditating on the relation of feminism to the institution, Donna
Palmateer Pennee struck a chord in addressing the difficulty of
orienting one's feminist self in relation to competing demands,
while Len Findlay gave us a bracing diatribe against the corporatiz-
ing university, and Christine Overall offered sane survival tips for
feminist administrators. Throughout the conference, and in con-
tributions here by Aruna Srivastava and Heather Zwicker, we heard
about the fragility of the (academic, institutionalized) body, and
Christine Bold, Amber Dean, and Marjorie Stone described impor-
tant feminist activism in the name of vulnerable women outside

the academy. We sought for this book, as for the conference, deliberately varied pieces, ranging from short position papers that take personal experience as their starting point, through more formal, scholarly articles, to Aritha van Herk's probing riff on the metaphors that move us. Our collection juxtaposes uneven styles and voices to suggest the strength of diverse approaches to the challenge of feminism's place in the liberal arts today.

For while we may be moaning, feminism is not dead yet. Enrolments in women's studies programs are on the increase in a surprising number of universities, even as the demise and renaming of some programs continue to provoke controversy. Young women are coming to feminism from unexpected directions: by reading Betty Friedan's now classic *The Feminine Mystique* or through activist work in antiracism or environmentalism.[4] Or, as in the case of Erin Wunker, from our own classrooms. We should emphasize that while our focus here is on the liberal arts, feminists are active in every area of universities and colleges.

Feminism may be reviving, but is it recognizable? Do our conventional designations of first wave, second wave, third wave work? Can a "generation" describe a particular kind of feminism? What is a feminist "generation," anyway, and how do you slot yourself into one, given the idiosyncrasies of individual experiences? Even casual conversation among we four co-editors made it clear we each have different answers to these questions. One of us put the end of second-wave feminism in the late 1970s, with the advent of "academic feminism" and feminist respectability. Others argued that second-wave feminism ended in the late 1980s, when personal computing changed both our work and our activist practices (more time alone at the terminal, less time spent organizing locally). Or with the insistence of women of colour (in the 1970s, '80s, '90s,...) that racism be recognized as an issue central to feminist practice. Or perhaps second-wave feminism hit its heyday with its exhilarating poststructuralist insistence on the capacity of academic,

cultural, and intellectual work to effect radical political change. In our own field of literary studies, this exuberance expressed itself in the publication of "big books"—*Sexual Politics* (1969), *The Madwoman in the Attic* (1979), *The Norton Anthology of Literature by Women* (1985), *This Sex Which Is Not One* (translated into English in 1985)—and then just petered out. While we love Rebecca Walker's bold pronouncement that she is not postfeminist but third-wave, we marvel at how ambitious third-wave feminism is, taking up not only "women's issues" per se, but also globalization, environmentalism, religion, trans issues (see Lise Gotell), and commercialism, to name just a few. Ann Wilson says knitting symbolizes an admirable do-it-yourself third-wave determination. Meanwhile, still-urgent issues such as violence (see Christine Bold, Amber Dean), sex trafficking (Marjorie Stone), and mothering (Susan Brown, Cecily Devereux)—first-wave issues, you could say, polemically—continue to demand our urgent attention.

Perhaps it's time to put our own "wave theory" to rest, or at least augment it with more supple ways of thinking through our histories and futures as women, as feminists. Certainly Phil Okeke-Ihejirika and Julie Rak point to the limitations of second-wave feminism for women coming to consciousness both outside North America and inside it, while Isobel Grundy's meditations on mentoring remind us that relationships that develop over time cannot be neatly broken down into periods. Katherine Binhammer and Ann B. Shteir, originally student and teacher, co-author across generational lines without overly problematizing their different locations. Their essay enacts the collaborative scholarship (see also Christine Bold and Susan Brown) that has helped carve out an institutional space for feminism in Canada. Binhammer and Shteir make a strong case for Wollstonecraft, while Susan Brown contends that "first-wave feminism has a lot to answer for." Perhaps we need new ways to think feminist time/time in feminism. Elizabeth Groeneveld suggests a rhizomatic approach, while Tessa Elizabeth

Jordan and Jo-Ann Wallace resuscitate three rich metaphorical approaches to temporality. Three *fertile* metaphorical approaches, we should say, to use a "retro" term. For, intriguingly, we came across several "retro" terms in the written contributions to this volume. *Patriarchy*, for one, occurs in no fewer than eight of these essays. *Experience*, *identity*, *oppression*, and *community*, to name four more, occur in about half a dozen, and several even talk about *sisterhood*. These terms were not used nostalgically, but with a sense that they name phenomena—power dynamics, communal relations, and personal orientation—that need expression or definition, that articulate possibilities.

The last of these, *community*, names a desire that runs throughout many of these essays. But it also points to significant absences. In addition to the ongoing under-representation of women as a whole in the senior professoriate (see the annual equity postcard issued by the Canadian Federation for the Humanities and Social Sciences) and among Canada Research Chairs (as Louise Forsyth documents), universities have largely abandoned efforts to ensure equitable treatment of racialized women, disabled women, and Aboriginal women (see Donna Palmateer Pennee and Aruna Srivastava). Ironically, while more women than ever occupy senior administrative positions (though not in numbers proportional to their representation in the professoriate, never mind in graduate and undergraduate programs), these increases have not produced more attention to equity or to the position of part-time and contractual academics. The neo-liberal political and economic environment in which universities currently operate ensures that administrative energy is consumed by the constant dance demanded by systemic public underfunding, and the resulting emphasis on fundraising, performance measures, and accountability reports. This activity is justified, by university boards of governors and by governments, in the name of "stakeholders"— a misleadingly comprehensive term that blurs the degree to which

some communities have a vastly greater "stake" in our universities than others. And the logic of accountability filters down, producing the "autonomous, self-sufficient" academic worker, the lone cowgirl whose career unfolds in the context of a market-based institutional logic.

The story so far goes like this: Our communities are global and professional—we access them at our terminals—but our local conditions are atomized and alienating, contributing to our sense of exhaustion and burnout. Self-reflection seems to bring that weariness to the fore, as though we suddenly realize how tired we are, or how little we are undertaking "feminist" work—if by "feminist work" we understand targeted, collectively based, principally motivated action designed to enable change for women. Our opponents once had names and faces; their tactics were brutal but overt (see Patricia Clements). Few of our colleagues today would argue against diversity in hiring or in our programs and curricula—diversity, after all, is measurable and publicly representable—and yet we make surprisingly little headway. The outsourcing of numerous jobs and services, everything from cleaning to printing, means that our academic work environment is increasingly monocultural and blind to class difference. Increased expectations for research productivity and the bottom line of the annual report have emptied our feminist meeting rooms. The loss of collegial governance makes it more difficult to know how to effect change in our practices and policies. It is more difficult now to name the enemy, but we have also found it more difficult to articulate demands. Is this because we do not know what we want? Or is the "we" hard to find because talking with each other across generations seems more difficult? One of the aims of this collection is to inspire conversation across multiple lines of identity and difference within a feminist frame, rather like Stevie Smith's ranging across unanchored pronouns in her poem. The questions "who are we?" and "what do we want?" are central to that conversation.

Cecily and Jo Devereux assert in their introduction to the 2005 ESC Reader's Forum on feminism's agenda, "feminism doesn't actually have a first-person plural subject," nor did it ever, but feminism has always been produced "in relation to the immediate and proximate, the ideological, social, cultural exigencies that underpin the experience of ordinary living in any place."[5] That said, Jeanne Perreault reminds us of what is to be gained from holding on to the utopian promises of "sisterhood." Striving for it means facing some of the most deeply psychologically embedded and embodied ways that our individual and collective imaginaries (including, but not only, "whiteness") constitute major points of blockage in feminism, obscuring the possibility of sustained action:

> To distinguish between "identity" and "identification" is essential. To some permeable extent, aspects of identity can be fixed— for example, place and date of birth, which inflect identity profoundly; interpretation of that significance, however, varies. "Identification," in contrast, can be quite fluid, changing with one's mood, information, maturation, and how one is accepted or rejected by the people around one.[6]

It is telling and perhaps promising that while many pieces in this volume explore that tension between identities and the diverse and changing impacts of locations, temporalities, and materialities on living subjects, category work gives way here to other priorities, whether taking stock of the histories that have produced current formations, reflecting on those formations, or calling for intervention or action in specific contexts.

Another part of what circulates in and beyond this collection is the question of what happens when a political movement gets institutionalized and legitimated. Does it lose its *oomph*? And how is it that we (and this "we" runs the gamut from senior tenured professors to young women), having arrived in the institution, find

ourselves so fractured, so distanced from a sense of institutional community? We think that feminism's substantial success in the academy and arrival at an improved, though not yet equitable, proportion of women faculty, coupled with a popular press that depicts feminism as having won the day for better or for worse, produces an "it goes without saying" mentality. "It goes without saying" generally means that the "it"—the actions that produce changes in equity with respect to all groups—does not "go" at all.

The chapters in our volume suggest that it may be time to tell another story and to demand other forms of accounting. What do we want? What do we need? At a minimum, we need to own our own history (as Heather Murray, Patricia Clements, and Tessa Elizabeth Jordan and Jo-Ann Wallace suggest). Feminism may be (imperfectly) institutionalized, but so long as its institutional memory is embedded in individuals' file cabinets or binders gathering dust on shelves, we risk losing through sheer ignorance the benefits of policies others fought hard to institute. In the longer term, we need to ensure that these essays find their ways into archives so that future histories can be written. Less obviously but equally importantly, we need those histories to vex easy oppositions and the stifling metaphors that trouble feminist subjectivities and impede collectivities.

One thing that is clear from the reflections on equity and institutional intervention in this volume (see especially Patricia Clements, Donna Palmateer Pennee, and Marjorie Stone) is that while feminism is at home in many programs and departments in the liberal arts, and while equity policies have been formally institutionalized, we still need to pay careful attention to the ways oppression and inequity persist and the extent to which we are complicit with their persistence. We need to imagine for ourselves, and to demand from our senior administrators and boards and governments, the kind of university we desire for ourselves and our students.[7] At the same time, we need to reflect seriously on the

high cost of administration for feminists, measured, for a start, in broken friendships, strained collegiality, shunning and isolation, fragile health and exhausted brains, institutional alienation. Think of the high proportion of senior feminist administrators in Canada who have not been renewed, who have been fired, and who have not stood for reappointment or further administrative positions because it was clear that they would not be renewed. Patricia Clements's two consecutive terms as Dean of Arts at a major Canadian research university, in the midst of unrelenting backlash, are a rare exception to this pattern. How many of us, witnessing the costs of staying the course, have simply not been willing to go down that path?

The future of feminism in the academy may mean figuring out different ways of interacting with and supporting women with power in the institution, in figuring out ways to remain true to feminist debate and feminist difference while also recognizing the *realpolitik* of working in university administrations at the present time. For instance, in the current political climate, attempting to promote equity by appealing to principles of justice arguably goes nowhere in certain quarters, whereas there is some traction in the contention that it matters because it creates harmonious workplaces, promotes a larger social good, and meets the demands of the Federal Contractors Program. While there will be very different views on how far strategy should go, it is clear that we need to empathize with the choices that feminist administrators have to make in the face of local conditions and at times sheer exhaustion. We need to get beyond tokenism ourselves, perhaps, and make space for the "good enough" administrator and, indeed, the "good enough" academic. Let's affirm that for each other, countering the surely-by-now exhausted and suspect rhetoric of excellence. Let us also be clear with ourselves that while some of the language of assessment and valorization may be imposed, part of the problem is what we do to ourselves as professionals. As Barbara Ehrenreich

has argued about middle-class guilt generally, we create hoops for ourselves to jump through that justify our privilege.[8] Surely we know enough about interpellation to try to dismantle those hoops and say *Enough!* to feelings of guilt, whatever their source, if they're impeding effective political action and collective organizing.

At the very least, as many of the essays in this volume suggest, we need to create for ourselves expanses of time and energy and imagination. These are the spaces that will enable the unfolding, the swell of thought and outrage and hope and need that will bring new groups of women into creative feminist activity. We know that genuine change is not achieved by top down "vision statements" or administrative fiats, but by a series of recognitions that draw people together in common cause. We have employed as a touchstone throughout this introduction Stevie Smith's enigmatic poem "Not Waving but Drowning," a poem that belongs to a long sisterhood or tradition of women poets writing from beyond death. One need only think of Emily Dickinson's "Because I Could Not Stop for Death" or, more pointedly, Christina Rossetti's "After Death," whose penultimate couplet—"He did not love me living; but once dead / he pitied me"—might stand as an ironic commentary on feminism in the academy, and on its continuity despite reports of its demise. But instead, let's take as our closing text Adrienne Rich's 1972 essay "When We Dead Awaken," whose subtitle, "Writing as Re-Vision," now reads like an oddly prescient critique of "vision statements." The swimmer sputters, coughs up a little saltwater, and staggers to her feet. She hears a roar, waves to the others bobbing up around her, and reaches out her hand to them.

NOTES

1. Ştevie Smith, "Not Waving but Drowning," in *The Norton Anthology of Literature by Women*, ed. Sandra M. Gilbert and Susan Gubar (New York: Norton, 1985), 1684.

2. Dr Lesley Cormack, whose term began in the summer of 2010, is the second.

3. The Federal Contractors Program, implemented by a Cabinet decision in 1986, was intended to improve workplace representation of the following groups: women, Aboriginal peoples, persons with disabilities, and visible minorities. See http://www.rhdcc-hrsdc.gc.ca/eng/labour/equality/fcp/index.shtml.

4. "[Jess] Chapman [now 18] began identifying as a feminist at 16, around the time she read Betty Friedan's *The Feminine Mystique*." Misty Harris, "Defining the New Feminism," *Edmonton Journal*, August 8, 2008, B11.

5. Cecily Devereux and Jo Devereux, "Feminism: What Are We Supposed to Do Now?" *ESC* 31, no. 2–3 (2005): 9.

6. Jeanne Perreault, "Imagining Sisterhood, Again," *Prose Studies* 26, no. 1–2 (2003): 308.

7. Re-reading Adrienne Rich's "Toward a Woman-Centered University" (1973–1974) reassures us that we have had a real impact and makes us know how little things have changed. *On Lies, Secrets, and Silence: Selected Prose, 1966–1978* (New York: Norton, 1979): 125–56.

8. Barbara Ehrenreich, *Fear of Falling: The Inner Life of the Middle Class* (New York: Perennial Library, 1990).

Not Drowning

"My World as in My Time"[1]
Living in the History
of Equity and Backlash

PATRICIA CLEMENTS

MY TEACHING CAREER AT THE University of Alberta began in 1970, the year of publication of the Royal Commission report on *The Status of Women in Canada*. A mandatory retirement rule ended it officially in 2005, the year the University's first woman president took office on the recommendation of a selection committee of which I had been a member. Between those dates, our universities and the lives and careers of women were reshaped by major social developments: the powerful acceleration of women's presence in post-secondary education; the evolving character of the twentieth-century university, with its foundation in the arts and sciences; the growth of feminist scholarship and the creation of women's studies; and women's demand for full and equal participation in the professoriate. Decidedly not what are famously thought of as the "small politics" of the academy, these developments were creating a history of social transformation.

Though the first degree in the British Empire to be given to a woman—a BSC to Grace Annie Lockhart—was awarded in 1875 by Mount Allison College, in most jurisdictions women's official participation was long delayed, and the call for inclusion rings through early twentieth-century women's writing. The exclusion that prompts Virginia Woolf's 1929 meditation on women in *A Room of One's Own* is an enduring cultural memory: "he was a Beadle; I was a woman....the gravel is the place for me." But the 1906 Act establishing the University of Alberta specifically provided that "no woman shall by reason of her sex be deprived of any advantage or privilege accorded to male students of the university." That was twelve years before Canadian women had the vote, and twenty years before Alberta's "Famous Five" fought and won the Persons Case. Rod Macleod, who has written a history of the University for its centenary, attributes this provision to the "determination" of our first President and the province's first Premier "to create a thoroughly modern university in line with the spirit of the new century."[2] University President Indira Samarasekera has made a point of quoting the promise of our first president, Henry Marshall Tory, that the goal of this university would be "the uplifting of the *whole* people."[3]

Though many, even very recently, have thought the issue marginal to the main business of the university, the expanding participation of women, first as students, then as professors, researchers, administrators, is the most shaping force in the history of the modern university. It has permanently changed our universities and hugely magnified their intellectual and socially productive impact. A commitment to diversity and inclusiveness, together with policy and accountability for that, is now a part of the definition of the modern public university.

It is important, as we consider our histories and our present, to understand to what extent these changes have depended on Faculties of Arts. They have been a key instrument of democratization over the century in which the modern university has become a

major support of our society, economy, and culture. When I was Dean I heard from the Editor-in-Chief of one of Canada's largest daily newspapers that as a boy he was told that university was "not for the likes of you, my son." He couldn't, he said, have gone into a professional faculty. But he could, and he did, take courses in Arts, finally acquiring the degree that gave him access to a wide range of careers. His story exemplifies the personally liberating and socially equalizing impacts of Faculties of Arts in the modern university. They have opened doors for thousands upon thousands and changed not only the quality of lives, but also the behaviour of the labour market. In the twentieth century, and especially after World War II, they have often led the effort to take down barriers of gender and class and race in universities, and often, as in the University of Alberta in the 1990s, they have been a site of conflict over issues of equity and diversity.

In the last half of the last century, women entered universities in rapidly rising numbers. When, in 1967, Florence Bird was appointed Chair of the Royal Commission on the Status of Women in Canada, she said that Canada needed urgently to update its sense of what women are now and what they do, that postwar urbanization and employment patterns had drastically changed Canadian society, and that education was at the top of the list of things needing attention. The Commission's report put it at the forefront: "Equal opportunity for education is fundamental," it said. "Wherever women are denied equal access to education they cannot be said to have equality." The Commission predicted that "Changes in education could bring dramatic improvements in the social and economic position of women in an astonishingly short time."[4] In 1921, women accounted for only 16.3 per cent of university enrolment in Canada.[5] By 1967–1968, that had risen to 34.2 per cent. But since 1970, "women have driven enrolment growth" in Canadian universities, and since 1981, women have accounted for 75 per cent of enrolment growth.[6]

Looking back, you can see how clearly your life is imbricated with the larger developments of your time. I began with a year of teacher training, then, after teaching elementary school for a year, did a BA Honours in English at the University of Alberta, 1960–1964, spent a year in graduate school at the University of Toronto, 1964–1965, taught English in France for a year, then for four years was a graduate student in St Anne's College, Oxford. I came back to the U of A as an Assistant Professor of English in 1970 and was Dean of Arts here for two terms, 1989–1999.

Those milestones in my career reflect almost exactly some points of departure in the larger picture. I became a student when the rapid increase in numbers of female students was getting underway, an assistant professor when enrolment of women began to mushroom and attention was turning to the need for more women in academic staff positions, and a dean when women were beginning to take leadership roles in administration and more or less exactly when our University's work on equity policy came to a crisis of resolution, and, both inside and outside the University, we faced a bitter, ugly, destructive backlash. Decisive moments in my life intersected with the developing history of women in post-secondary education in the second half of the twentieth century. This essay is a personal account—"my world in my time"—and I am working from a personal archive.[7]

I go backwards, as a literary historian does, and start with my mother, as a feminist must.

My playful, musical mother, Marjorie Anderson, grew up on a farm a mile or so from the village of Scott, Saskatchewan. As a girl, she rode her pony across the prairie to town for classes in her one-room rural school and for piano lessons. She became a teacher, like her mother and both of her older sisters. University was out of the question for her. In her generation, it was teacher-training that most drew women into post-secondary education, and her father sent her to Saskatoon for a year at Normal School. She took a job in

an ungraded rural school, teaching grades one to eight in a single classroom. She read hungrily and with delight, and she loved the music of the French language. She also played piano in a busy little dance band, performing on weekends in community halls around the region. She met my clarinet-playing father at one of these country dances, and on 16 November 1938, when a blizzard had closed the roads, he drove five or six miles across the stubble fields from the neighbouring town of Wilkie to her parents' farm to marry her in their living room. Telling this story, he would remember that the preacher's toes were coming through his shoes, and that after driving his bride back to Wilkie, he traded his car and his clarinet for a houseful of furniture. She would remember that in these "dirty thirties," when the rule was one family, one job, the day of her marriage ended her career.

My first taste of post-secondary education was that same Normal School, though by then it was called the Saskatchewan Teachers' College. Here, the Principal told us, young women would learn to grow out of bobby socks and into nylon stockings. I had career options, I had been told at school: become a secretary, a nurse, or a teacher. The graduation present I asked for was an anthology of English poetry—the names of Chaucer, Shakespeare, Milton, and Tennyson are gilded on its cover—and teaching seemed the way to stay in touch with these. Though my own teachers advised me to go to university, it was, for me, as for my teacher mother and hers, out of the question. My father offered to fund a year in Teachers' College. Earlier, before I so rapturously encountered Shakespeare and company, I had told him that I intended to be a doctor. "No daughter of mine will be a doctor," he said. "You'll just get married." At sixteen or so, I was outraged; now I am able to remember that for my father, too, university had been out of the question. Growing up in the thirties, when the topsoil was drifting across the highways, he left school to work.

Teachers' College it was, then, for the likes of me, and I moved to Saskatoon to undergo the bobby socks-to-nylons makeover. Much more exciting was my first experience of what we later learned to call institutional struggle on the issue of women's rights. The larger part of the student body of about four hundred was female, since the business of the College was the production of elementary school teachers, and at the end of the 1950s a small fraction of these were men. When it came time for elections, I was persuaded to run for student president by a woman who offered to be my campaign manager. She had come back to school after some years of work, and she was well in advance of most of us in the matter of raised consciousness. She crafted a campaign excitingly based on an idea of women's rights, the posters declaring that the hand that rocked the cradle ruled the word, the follow-up little feet marching across the floors and walls proclaiming the inevitability of a new history for women. This was heady stuff, and, oddly paired with the nylons makeover, it was the beginning of an understanding that sex roles were imposed and that they could be opposed politically. Then, in the next summer, I was given a copy of Simone de Beauvoir's *The Second Sex*. I decided that I *must* go to university. My mother and my aunt agreed, and they developed a plan to get me there. My aunt and uncle, Meryle and Alder Clark, who lived in Edmonton, next door to the University of Alberta, opened their home to me and so, with my mother, gave me a university education, as they did later to my sister and my brother. Bless them! My aunt, a nurse, had, like my mother, given up her job when she married. My uncle, who, I think, had hardly a grain of sexism in him, never for a moment thought that girls should not have access to advanced education. When my younger sister and brother graduated from high school, it was out of the question that they should *not* go to university.

The University of Alberta was wondrously, fabulously exciting in the early 1960s. Small, with an enrolment less than a third of

what it is now, and undergoing profound generational change, it was rapidly filling up its academic staff with brilliant young scholars, poets, and administrators in a time when the massive modern expansion of universities was getting underway. The English Department had twenty full-time staff in 1960, and it taught thirteen senior full year courses.[8] The appointment of modernist scholar and novelist Henry Kreisel as Chair of the Department of English, together with the launch of the department's PHD Program, was a watershed. Wilfred Watson was writing very modern plays and scandalizing Edmontonians, some of whom walked out of performances, leaving headlines in their wake. Rowland McMaster and Ian Sowton were giving informal evening seminars on avant-garde films. John Orrell, still working on his University of Toronto PHD dissertation, had just driven across the country, with his family and his trumpet, to teach Shakespeare. Women professors, however, were thin on the ground. In my first year, Alison White was the only woman on the full-time continuing academic staff of the English Department. The next year she was joined by Sheila Watson, who had previously been kept out by the University's nepotism rules, and the year after that by Diane Lane (later Bessai). Alison was doing pioneering work on children's literature; Sheila had recently published her landmark novel, *The Double Hook* (1959), and was working with Marshall McLuhan on her University of Toronto PHD on Wyndham Lewis; and Diane was teaching an honours seminar on myth, later the subject of her University of London PHD. It was a young place, all energy, excitement, and creation; and for me the Honours Program in English was heaven.

Freud was acquiring a majority share in literary criticism while I was an undergraduate, but political gender talk was not significantly part of the classroom agenda. The by-and-large absence from the curriculum of women's writing drew little attention, and "feminism" was an outmoded word of the twenties and thirties.

Sexual politics were nevertheless an unspoken feature of institutional behaviour. My colleague Juliet McMaster, who was the Department's first PHD student, remembers that when Dr White taught, the Department Head, Miltonist Mr Jones, would stand at the door of her classroom to listen; and I remember that before escorting me to the Head's office to recommend my admission to the Honours Program in English, Wilfred Watson warned me that Mr Jones didn't like women in his classes and might therefore be cool to me. When, two years later, Henry Kreisel encouraged me to apply for scholarships for graduate work, I learned that the Rhodes Scholarship was open only to men and that the Woodrow Wilson Foundation limited to 15 per cent the number of fellowships awarded to women.

But de Beauvoir was in the air; Doris Lessing's *The Golden Notebook* appeared in 1962; my mother read Betty Friedan in 1963, the year *The Feminine Mystique* was published, and passed the book to me. In universities, the enrolment of women began to snowball. Very shortly, the University of Alberta would be obliged to consider whether the spirit of the brave and equitable mandate of its first president was being observed.

Oxford in the second half of the 1960s was a different story. In its very name, my College invoked a tradition of women's education. It was St Anne who taught the Virgin to read—and the College named after her was keenly aware of the history of women in post-secondary education, of how hard-won access had been, and of its own role in the struggle. In 1879, long before the University of Oxford admitted women to degrees (in 1920), radical dons who supported the admission of women created the Society for Home Students. The Society's establishment as St Anne's College waited until 1952. Until 1979, when it became co-educational, it admitted only women students, and until 1976, it appointed only women as Fellows, so ensuring some Oxford jobs for female scholars.[9] The Senior Common Rooms of the women's colleges—St Anne's,

Somerville, St Hilda's, St Hugh's, Lady Margaret Hall—included powerfully distinguished women, icons of female achievement. Iris Murdoch had recently been a Fellow at St Anne's, for instance, and her portrait hung outside the Senior Common Room. My DPHIL thesis was examined by Dame Helen Gardner, who, in 1966, was appointed Merton Professor of English Literature, the first woman to hold this Chair. Dorothy Bednarowska, my supervisor, was an acute and aggressive reader, alert to the gender politics of texts and the evolving history of women. She was delighted to tell me, after introducing me to Dame Janet Vaughan, the distinguished hematologist and radiologist and former Principal of Somerville College, that she had been a partner in the medical experiment Virginia Woolf describes in *A Room of One's Own*. St Anne's gave a view of possibilities for women that was unrestricted by gender—that is, unrestricted in practice as well as in policy. Its student humanists, scientists, artists, lawyers, doctors, were all female; so were its Principal, Governing Body, Fellows, and staff. The Oxford women's colleges are now co-educational (as are the men's), a consequence of the accelerated intake of women across the whole system of universities, but in the 1960s, they kept current the issues and the ideal of women's full participation.

I came back to Canada in summer 1970 to take a position in the Department of English at the University of Alberta. It was the year of Kate Millett's *Sexual Politics*, Germaine Greer's *The Female Eunuch*,[10] and the Report of the Royal Commission on the Status of Women in Canada. In the English Department, the number of full-time staff was now triple what it had been when I became a student here in 1960, and the number of women on staff had quadrupled since I graduated.[11]

Irresistible pressure for change in the conduct of business in Canadian universities was building not only because of the escalation in the number of female students but also because of rising numbers of women in the professoriate (228 women and 1,305

men in 1974 at the U of A)[12], developing feminism in American and Canadian universities, and, most critically, new legislation in Canada on women's rights. The federal government established the Advisory Council on the Status of Women in 1973, giving it a mandate to "make policy recommendations to the federal government on anything pertaining to the status of women which falls within the federal jurisdiction."[13] Zoology professor Jean K. Lauber, who had great impact on women's issues at the University of Alberta, recruited me to an eye-opening local sub-committee she was chairing for the Association of Universities and Colleges of Canada. It was gathering information on the status of women in Canadian universities, and she produced a full slate of statistics describing the condition of women at the University of Alberta. I was appalled. So were many others. In 1973, the University Women's Club of Edmonton "in a written submission to the Senate charged discrimination against women at the University of Alberta and made strong representations to this body to undertake a study of the subject."[14] That year, the Senate (which at the U of A is not the senior academic legislative council, but a multi-constituent body including public members) established its Task Force on the Status of Women at the University of Alberta. The Task Force was chaired by June Sheppard, a columnist for the *Edmonton Journal*.

The Task Force published its *Report on Academic Women* in 1975. It was International Women's Year, and issues relating to women's participation in post-secondary education were everywhere much discussed. That fall, for instance, the Canadian Association of University Teachers' *Bulletin* published a "Special Report" on "Women in Higher Education."[15] Oriented to change, it provided a list of major organizations dealing with the status of women, focussed a review section on publications on women (including the University of Alberta Task Force Report), and printed substantial sections from the U.S. "Affirmative Action" Guidelines, and a

number of feminist articles. Carolyn Masleck reported the passing by Parliament of Bills C-16 and C-72. The first, "the so-called omnibus bill on the status of women," amended a whole range of Acts: the *Criminal Code*, *Public Service Employment and Unemployment Acts*, and the *Immigration Act*. The passage of the bill, Masleck said, "signals the end of certain blatant discriminatory practices by the federal government against women."[16] The second, Bill C-72, was the *Canadian Human Rights Act*. The tone of the whole was decidedly activist. A bolded block inset in an article on Women's Studies reads, "**woman in western cultural history...evil temptress, virgin, earth mother, passive object, genius, political activist.**" One headline identified universities as "Bastions of Orthodoxy."

The University of Alberta Senate's *Report on Academic Women* was boldly to the point: "Women academics at this University are discriminated against on the basis of sex both individually and as a group." It also said that "Hiring practice is a substantial factor in discrimination against women academics."[17] Documenting a range of discriminatory and disabling conditions across the system— in salary, promotion, membership on influential committees, appointment to senior administrative positions—it addressed each of its recommendations to a specific office, so making accountability clear. To the Board of Governors it recommended that a policy statement against sex discrimination be adopted and printed in all contractual and administrative manuals, to the President that a position be created at a high level for a Dean or Director of Women's Affairs whose function would include a responsibility "to monitor, collate, and publish data and to lobby for improvement in the status of women," and to the Vice-President (Academic) that his office keep records on issues relating to the employment of women.

In particular, the Task Force recommended that "when academic staff vacancies occur the Vice-President (Academic) place the onus on Deans and Directors to justify when a woman is not hired,

why this is the case."[18] That recommendation was the beginning of serious conversation about gender equality at the University of Alberta.

The University began a major house-cleaning at every level, from the President's Office to departments. So did the Association of Academic Staff, whose Council approved a proposal for a study of women's salaries.[19] The Academic Women's Association constituted itself formally in 1975 to encourage implementation of the recommendations of the Senate Task Force, and "to foster collegiality among academic women, to promote and encourage equal opportunities for women in university affairs, and to provide a forum and a mechanism for affirmative action for women at the university."[20] It is hard to over-emphasize the influence, over those years, of the Academic Women's Association, both as a support and as a collective voice for academic women.

At home, in the English Department, we passed a series of motions calling for specific revision of the manual of department practices, each motion co-signed by a female and a male member of the Department. These removed sexist language, incorporated anti-discrimination statements, disclosed unwritten "rules of thumb," and deleted rules preventing the spouse of a staff member from receiving support for graduate work. Here, as in the Senate Report, hiring and the absence of women in administration were central. The Department resolved "to give preference to woman applicants when their academic qualifications are equal to those of male applicants" and to urge the Dean to increase female representation on committees, "especially where these are central decision-making bodies."

These documents still excite me: they are fresh with the energy of change, even though some of them, mimeographed, are literally disappearing. What is most remarkable about this chapter of English Department history is that we moved so immediately to change our practices and that we were, on the whole, so unified

about it. Though the decisions were taken by majority, not consensus (the Department's ongoing strain of misogyny therefore defeated rather than deleted), the majorities were substantial. From a very early stage, English was committed to removing discrimination against women in the University. Bastion of Orthodoxy we were not.

Particularly because of subsequent events in relation to the hiring of women, it is important to note that in taking this position the Department was not isolating itself from, but aligning itself with, University policy. Throughout the system, changes were underway to make the institution more open to academic women. On 29 September 1975, the General Faculties Council had adopted "measures to prevent discrimination against women," and a year later, in his Convocation Address, the President, Dr Gunning, said that discrimination against women was "a cultural malignancy," that progress toward eliminating it had been "unjustifiably slow," and that "our universities have not shown leadership." He expressed "our great indebtedness to this outstanding Task Force for pointing out to the administration of our University inequities concerning the role-status of academic women on this campus." He announced the appointment of Jean Lauber, "one of the major leaders in women's affairs in this country, as our Associate Vice-President (Academic)" (the first woman to hold this position), and the plan for a study of the salaries of academic women. He spoke of the need for flexible work patterns and maternity leave, and he raised the matter of affirmative action. He said that at the University of Alberta "we hope to develop a community...wherein such pernicious sex-linked discrimination will be progressively eliminated and thereby provide a model for the larger society that we serve."[21]

In the Faculty of Arts and across the University, we worked to get women onto key committees and into administration. "I have a feeling," Linda Woodbridge wrote to the English Department

before its discussion of the Senate Task Force Report, "that twenty television documentaries on the improving lot of women or forty pep talks on new opportunities for women cannot do as much for the confidence of a female student as can the one simple experience of going for an interview with an 'official' person and finding that the person sitting behind that desk is a woman."[22] We organized ourselves for quick response to calls for nomination. Aiming to elect a woman to every significant committee, we could gather the required signatures within a few hours of the call. The Academic Women's Association compiled a "Register of A.W.A. Members Interested in Serving on University Committees."[23] In 1983, I was appointed Assistant Dean of Arts, following Margaret Jendyk, Professor of Drama. In 1986, Linda Woodbridge was appointed Chair of the Department of English, then the University's largest department. It was a major milestone. Jubilation all round.

While hundreds of us were working to open universities, feminist scholars around the world were redrawing the disciplines and providing newly gendered social and cultural analysis. English Departments, with their very large enrolments, had a major role in this, especially as they opened a new consideration of canon and explored the implications of a new understanding that from the beginning women wrote, too, and that traditional literary histories had systematically occluded this writing. I doubt that literary studies have ever had wider impact.

As President of the Academic Women's Association, Jean Lauber organized, in 1976, "A Women's Studies Sampler," a series of public lectures in several disciplines. The lectures drew large student audiences, and Jean made their popularity into an argument for establishing a program in Women's Studies. "What more can be said to department chairmen and deans?" she asked in her report on the series. "The ball is in your court."[24] The challenge met with a very long silence, but in fall 1984 leadership came from

Vice-President (Academic) Peter Meekison, who struck an advisory committee on Women's Studies, and Dean of Arts Terry White, who proposed that the program should be in Arts. The committee, which was chaired by sociologist Ann Hall, Professor of Physical Education and Leisure Studies, and in her absence on sabbatical by Dallas Cullen, Professor of Business, brought together feminist scholars from across the University.

Expecting that "very shortly" the Faculty would be offering courses for a multidisciplinary BA in Women's Studies, women in English drafted descriptions for both undergraduate and graduate courses in women's writing. (Shirley Neuman and I taught one of these together as the first of the English Department's courses in women's writing.) The memo proposing these courses was signed by ten of us.[25]

The proposal to establish a degree in Women's Studies came before Arts Faculty Council on 23 May 1986, and because the Committee Chair, Ann Hall, was not a member of the Council, I had the honour of presenting the motion to approve. There was some heated opposition—unsurprisingly, the program was said to be "trendy" and unserious—but in this decision, as in every other major policy decision about women's participation, the Faculty of Arts made a strong affirmative statement. Henry Kreisel, by now retired from his work as Vice-President Academic, rarely came to Arts Faculty meetings, but he came to this one—to support the motion. The Women's Studies program launched in 1988, with Shirley Neuman as its first Chair.

In 1975, no one could have mistaken the will of the Senate, the General Faculties Council, the President, the Association of Academic Staff, the Academic Women's Association—or the Department of English. Each of these duly constituted bodies had made abundantly clear its view that the University must improve conditions for academic women, and all of them had by due process adopted new practices for that purpose. Vigorous excision of

"cultural malignancy" was, by broad agreement, at the top of the agenda. But when, ten years later, a Senate committee reviewed progress on the recommendations of the Task Force Report, things had changed. The Committee concluded disappointingly that while "blatant" discrimination against women had almost disappeared, "a more systemic type of discrimination continues to exist."[26]

Hiring and employment issues remained the centre of contention in 1985. Then, in 1987, the University of Alberta became a signatory to the Federal Contractors Program, undertaking to "achieve and maintain a workforce that is representative of the Canadian workforce population." General Faculties Council again updated hiring policy, to conform to the requirements of the program. Now the GFC Policy Manual outlined its principles of employment equity. It declared that "employment decisions shall be made on the basis of merit"; that the University was committed to "the principle of equity in employment"; that "every individual is entitled to be considered without discrimination"; and that "the University is committed to the amelioration of conditions of disadvantaged individuals or groups within the system." In a section on "Measures to Prevent Sex Discrimination in Appointments," the policy manual stated that "Because women comprise the largest group of disadvantaged, the rules and regulations which follow will from time to time make specific requirements with respect to the employment of women."[27] Those policy statements were approved thirteen years after the Senate Task Force Report on Academic Women had declared hiring and employment conditions critical for women at the University of Alberta.

President Myer Horowitz and Vice-President (Academic) Peter Meekison had taken strong positions on equity. On their watch, the University gained an equity advisor to the President (Doris Badir, Professor and former Dean of the Faculty of Home Economics), an advisory committee (chaired by Susan Jackel, whose correspondence with the President is a treasure of information about the

development of consciousness and policy at this University), and a sexual harassment committee, and, following the successful matched peer study of salaries for academic women, a pay-equity study for non-academic staff. But as President Horowitz's time in office was running out, the pay-equity plan provoked increasingly vociferous opposition, and the whole equity issue festered. In March 1989 the Vice-President (Academic) and the President of the Academic Staff Association together circulated a booklet on non-discriminatory hiring practices, *Seeing and Evaluating People*. The worsening financial situation made already sensitive equity issues explosive.

I WAS APPOINTED DEAN OF ARTS in spring 1988, to begin my term on 1 January 1989, after a six-month research leave (to finish my part of *The Feminist Companion to Literature in English*).[28] Martha Piper, then Dean of Rehabilitation Medicine at the U of A, told an *Edmonton Journal* reporter that a female becoming Dean of Arts was a more important event than her own appointment to a smaller faculty three years earlier. Her faculty, she said, "like nursing, home economics and library science" traditionally appointed women, but Arts was "more significant."[29] Martha told me that she thought my appointment had "broken the logjam," and that doors to senior administrative appointments would now open for women in our University. In fact, the logjam was breaking up all across the country. In 1990, Patricia Marchak became Dean of Arts at the University of British Columbia, and, shortly after, Marsha Chandler became Dean of Arts and Science at the University of Toronto. The three of us met in Toronto, probably in 1991, to celebrate the extraordinary fact that each of our major faculties had for the first time in its history selected a woman to be dean, and to discuss our faculties, their critically worsening budgets, and our approaches. Martha herself became Vice-President (Research) at the University

of Alberta in 1993 and the first woman President of the University of British Columbia in 1997.

The *Edmonton Journal* story about my appointment provided a sketch of the Faculty of Arts in 1989: it was the oldest and the largest in the University of Alberta, with student enrolment of 6,110 students and 568 academic staff (full-time continuing and sessional). In an accompanying story, the *Journal* said that outgoing President Myer Horowitz awaited "the day when appointing women deans is as common as the teaching degrees many start out with. But he admits it's a long way off." In 1988, the article reported, women comprised 16 per cent of the 1,552-member staff, "one per cent lower than the national average among Canadian universities." And in the previous two years, the number of full-time continuing female staff had increased by only 1 per cent "despite the administration's aggressive approach to address sexual discrimination." Moreover, the number of women beginning new academic jobs was declining: it was 38 per cent in 1986, 33 per cent in 1987, and 25 per cent in 1988. "The bottom line is simple, brutally so," the *Journal* said: "Women still face inequity at the U of A despite an offensive launched to improve the situation."[30] And despite the fact that the number of women students was climbing rapidly.

In the late eighties the Faculty of Arts had exceptional strengths across the whole range of social sciences, humanities, and fine arts, and many of its finest scholars were entering their most productive years. It was full of promise. Though unremitting budget cuts were every year further restricting what we could do, I began my term as dean in January 1989 with a high heart and with two key priorities: to develop the Faculty's work in research and graduate studies and to address the situation of women academics.

My first year, 1989, was a difficult and troubled year. I remember it beginning with the sudden, bitter, sexist, polarizing, and utterly unprecedented attack on the Chair of English, Linda Woodbridge, because a committee chaired by her had, in the term before I

began my work, selected five women for five new assistant professorships in English.[31] And I remember the year as ending on December 6 when I adjourned the Faculty Evaluation Committee meeting so that members could join an assembly of students and professors and administrators on the steps of the Administration Building, in the falling snow, to express sympathy and horror and solidarity with teachers, and families and friends of the fourteen young women murdered at the École Polytechnique in Montreal.

To further agitate a destabilizing situation, in November 1989, the Engineering student newspaper, *The Bridge*, published an "obscene and sexist" issue, against which two female students filed a complaint under the Code of Student Behaviour. Then, horribly, in January 1990—that is, about a month after the Montreal massacre—"when she appeared on stage in the Engineering students' annual skit night, [a] woman student who had been embarrassed in *The Bridge* and who had criticized the Faculty of Engineering for its unresponsiveness to women's issues, was greeted by chants of 'Shoot the bitch!'"[32] In an increasingly toxic environment, Vice-President Academic Peter Meekison suggested to new President Paul Davenport the creation of a Commission for Equality and Respect on Campus, "to provide a forum for members of the University of Alberta community to discuss means of combating sexism and other forms of discrimination." Later, this mandate was broadened "to encompass the investigation of circumstances which contribute to the erosion of equality and respect on campus."[33] Associate Vice-President Dianne Kieren chaired the Commission. Commissioners included Law professor Anne McLellan (later Deputy Prime Minister of Canada), Engineering professor Peter Smy, Rehabilitation Medicine professor Jim Vargo, and graduate student Aruna D'Souza. They held extensive hearings on campus, opening the issues for public input and wide discussion.

On 23 May 1989, "a group of some 25 faculty members" opposed to measures intended to increase the number of academic women

met to form what they called the "Merit Only Group." Their purpose was to whip up opposition to the University's equity policies and practices, and their main targets were the central administration and the Faculty of Arts, attacking first the English Department, then the Faculty (both now led by a woman).[34] Four of the group's founding members were from Arts.[35] The senior member was economist Tom Powrie, who, as Acting Dean in the year before I began my term, had approved the five appointments in English he later criticized as discriminatory. He urged colleagues to join the group because, he said, selection committees were being asked "to discriminate against male applicants for academic appointments."[36] The agenda for its meeting of 28 September outlines a possible program of opposition to University hiring policy, including publications in *Folio*, the University's in-house newspaper, and a "Writing Campaign." In this, members of "M.O." would write "as individuals to University Officers, Staff Association, etc."[37]

The Merit Only Group sought to exploit the instability at the end of one presidency and the beginning of another. Its members used the press to undermine colleagues in administration and to attempt to reverse policy approved by vote in the University's councils. They had the new President in their sights before he got here, and Paul Davenport's early statements on equity, which seemed to accept that merit and equity were opposed to one another, gave them some comfort.[38] They lunched with Olive Elliott, the *Edmonton Journal* education columnist, who subsequently published four articles they thought "pretty accurate and sympathetic,"[39] in which she said that statistics showing the very small numbers of women were meaningless out of context, that there was a "strong element of coercion in the U of A's gender-balance policies," and that fear of retaliation was preventing staff members from speaking out openly against "preferential" hiring of women.[40]

In 1991 the group changed its name to the Association of Concerned Academics[41] and began to circulate to academic staff in

all faculties a newsletter entitled *Academic Concerns*. It also made alliances outside of the University, seeking to expand its powers by linking internal U of A policy discussions to American right-wing anti-feminism.[42] It participated, for instance, in a one-day conference sponsored by the like-minded Society for Academic Freedom and Scholarship (located at the University of Western Ontario) and the Fraser Institute and supported by the National Association of Scholars, an American organization dedicated to opposing "political correctness." The conference—"University in Jeopardy"—took place on 12 March 1993, at the Royal York Hotel in Toronto. Dinesh D'Souza, of the American Enterprise Institute, was its star speaker. Powrie chaired the morning session, on "Constraints on Academic Freedom from Non-Academic Policies."[43]

Writing "as individuals," members of the Merit Only Group seized the opportunity of a report in *Folio* to launch a program of public opposition. On 19 October 1989, under the headline, "AWA wants University to be more aggressive in hiring women," *Folio* reported a talk given by Linda Woodbridge to the Academic Women's Association. The report suggested, misleadingly, that Dr Woodbridge indicated she had intended from the outset to fill the five vacancies in English with women. In fact, she had spoken about special recruitment efforts to ensure that women were in the pool. On 2 November, *Folio* printed a letter from Professors Christensen and Rochet from Arts, and three others (Hunter from Oral Biology, Faulkner from Mechanical Engineering, and Anne Putnam Rochet, from Speech Pathology and Audiology): it accused Dr Woodbridge of ignoring merit and filling the five new positions on the basis of gender. The letter unleashed a bitter exchange and an abusive personal attack on employment equity.

I find myself barely less angry now than I was twenty years ago when I think of the waste and pain caused by a few colleagues who aimed to overturn a broad University agreement about improving the representation of women in the academic staff of the

University of Alberta. Giving the University yet *another* opportunity to "define its values,"[44] as new President Paul Davenport put it, they defended a status quo that would keep their female colleagues (not to mention their daughters, sisters, wives) from participating equally with them. They did not hesitate to damage the academic reputations of the five new female Assistant Professors of English and the professional integrity of the woman who had chaired the committee that selected them. Moreover, in what became their repeated theme, that of "free speech," they congratulated themselves for their courage. It was very dangerous, they said, to speak openly against equity. Of course, they *were* speaking openly—wide openly—in the University, in the press, at conferences, in lobbying lunches with reporters, in documents circulated to every member of the academic staff at the University (to list only those places I know of). And *of course* there were no professional repercussions for them: they were senior members of the academic staff who had long enjoyed the protection of tenure. From this secure position, they targeted the professional reputations of junior and senior colleagues. The five newly appointed professors suffered damage from this recklessness, and so did the Chair of English. In my files are two heart-rending documents. One is a note to me from one of the newly appointed professors: she tells me that a student had asked whether she was "one of those recently hired women whose qualifications were being questioned."[45] The other is a letter from Linda Woodbridge to the President's Commission on Equality and Respect. "Can you think of any other case in the history of this University when one Department's hiring was called into question by members of a number of other Departments, on no evidence whatsoever?" she wrote. "If the English Department had been chaired by a male, would such attacks have been made?"[46]

The "Merit Only" attacks on hiring in the University of Alberta in the late nineties focussed on the Department of English and the Faculty of Arts. Their silence on hiring in other

faculties—Engineering, for instance, where male predomi-
nance continued unexamined and unjustified, or Science, which
in the year the five were hired in English appointed one woman
and twelve men[47]—was eloquent. "We were viciously attacked by
a group of people pretending to be interested in 'merit,'" Linda
Woodbridge said in a letter to the President's Commission for
Equality and Respect, "but (I believe) really interested in keeping
women professors out of the university."[48] Not to mention out of
senior positions in university administration.

The President's Commission on Equality and Respect, estab-
lished after the events involving Engineering students, tabled its
report in July 1990. One of its sixty-eight recommendations was
that hiring policy "should reflect the principle that qualified dis-
advantaged group members should be hired unless there is a
candidate who is *demonstrably better* qualified for the position."[49]
On 7 January 1991, I sent to departments a policy letter on hiring
in Arts. My letter said that some departments had already adopted
this principle, that the Faculty would initiate with departments dis-
cussion of appropriate equity goals and recruitment practices, and
that we would now require that selection committees include rep-
resentation of both women and men.

Three months later, on 3 April, the President's Office received
a letter from an "Ad Hoc Association of Concerned Faculty Mem-
bers." Though the Merit Only Group was not mentioned, the letter
was signed by several members of its Steering Committee, and
it attached "A Petition to Uphold University Hiring Regulations."
This had been circulated to all faculties across campus, and it bore
139 signatures, a majority from outside the Faculty of Arts. It said
that the Dean of Arts had presented "as an acceptable option" the
policy of hiring members of under-represented groups "unless
there is a candidate who is demonstrably better qualified." It told
the President that it was his duty to enforce the regulations gov-
erning the University: "We call on him to direct the Dean of Arts

to advise all of her departments in writing that preferential hiring plans are in violation of GFC regulations." And it charged that I had gone beyond my authority as dean in instructing selection committees on procedures.

Moreover, the letter said, "a majority of the twenty-some faculty members involved in circulating the petition reported encountering colleagues who claimed to be in favor of it, but who confessed they feared that signing would be prejudicial to their careers. Such anxiety was especially common amongst members of Arts Faculty. This is but one of several indications that the intellectual climate here is seriously deteriorating as a consequence of illiberal political pressures."[50] The petition was reported in newspapers across the province and the country, mostly under headlines about a threat (mine) to free speech (theirs). It was the same suggestion of a reign of terror that we had seen in the attack on Dr Woodbridge.

Vice-President Meekison's reply, on 6 May, gave a strong interpretation of Section 48 of the General Faculties Council Policy Manual and concluded that I had not violated either the letter or the spirit of university policy and that I had not exceeded my authority as dean. I could not have realized at the time quite how fortunate it was that this petition came to the central administration while Peter Meekison was Vice-President (Academic) and Dianne Kieren Associate Vice-President (Academic). As Vice-President, Dr Meekison was the steady voice on equity policy. He understood what was at stake, and he gave firm, rational support when a change in presidents made the equity file increasingly difficult to deal with. In his last address to Convocation, he spoke about equity. Merit will always be the primary criterion, he told the *Edmonton Journal* reporter who covered his speech, "but other factors such as gender balance and recognition of the under-represented may need to be taken into consideration."[51]

When Peter Meekison left office, the central administration wavered. His successor, former Dean of Science John McDonald,

soon sent a letter to deans, signed by himself and the President, reversing a decision to forward to General Faculties Council the "demonstrably better" recommendation of the President's Commission on Equality and Respect. Their "commitment to the University's overall employment equity goals," they assured us, "as described, for example, in the President's Annual Report, is in no way diminished."[52] But of course there is a great difference between an optional report and a presidentially supported General Faculties Council policy.

In spite of the Vice-President's ruling on the petition whose aim was to tether or unseat me, the Merit Only Group/Association of Concerned Academics continued to attack and the President to seem uncertain. On 17 June 1991, some of the authors of "The Petition to Uphold" sent to all members of the academic staff a letter aiming to open wide the split between the President and pro-equity members of the administration, condemning Arts and the Vice-President Academic, and quoting the President in support. At almost the same time, the *Edmonton Journal* devoted the larger part of an "Insight" section to "Education and the white male bias." It commented on employment: the President, it said, was "cautiously treading the middle ground." It argued that what was at stake was the curriculum: "A growing number of young schol-ars believe that 'dead white males' are not solely responsible for the establishment of Western civilization and want the curricu-lum changed to reflect that a multitude of groups—women, blacks, native Indians—also played significant roles." The story noted that Peter Meekison was the only senior administrator to have com-mented on this.[53] Then, on 3 September, the paper printed a letter from eleven male professors in Arts, Education, the Library, and Mathematics. "We urge the university to exercise strong leadership on employment equity," they said.

The development of feminist and other new forms of critical scholarship at this institution is fostering an intellectual environment that is more hospitable to potential candidates and promising students from historically under-represented groups, especially women. Some of our colleagues oppose these changes and hope for a return to obsolete policies. Reversion to these old practices would mean that many of the best young scholars and the most exciting new ideas would pass by the university.[54]

In October, Tom Powrie wrote to new Vice-President (Academic) John McDonald that there appeared to be evidence "of systemic discrimination against males in the Faculty of Arts."[55] He did not copy his letter to me.

In Arts, we thought it urgent to establish unambiguously and without further delay the position of the Faculty as a whole. In the absence of clarity from the top, and with continuing attempts of "the vocal few" to undermine both University hiring policy and our administration of it, we decided to submit the issue to the authority of Arts Faculty Council. In spring 1991, I established a Dean's Advisory Task Force on Employment Equity. Its mandate was to examine and advise on the sixty-eight recommendations of the President's Committee on Equality and Respect, including the "demonstrably better" recommendation, and to develop workable plans for the implementation of employment equity in the Faculty of Arts. It was instructed to consult widely within the Faculty, to operate in an open and public manner, and to deliver its report by the end of December.

Members of the Task Force, which was chaired by sociologist Graham Lowe, represented various groups in the Faculty.[56] Their report was the result of painstaking consultation with department chairs, faculty members, non-academic staff, graduate students, other universities, and the Director of the Federal Contractors Program. It considered employment equity in the

light of educational equity and the diversity of the student popula-
tion and argued that "A successful [Educational Equity] policy is a
constructive way to make the 'climate' of the faculty, and the uni-
versity, more accepting of diversity." It proposed unambiguously to
commit the Faculty to employment equity and scholarly excellence
together and to pledge the Faculty to "strive to remove any barriers
in our employment systems which may inhibit the hiring, reten-
tion, and career advancement of women, visible minorities, native
Canadians and persons with disabilities." The report made the
Arts position on hiring abundantly clear: "Scholarly ability will be
the basis for recruitment and advancement; nobody will be denied
employment opportunities or benefits for reasons other than her
or his ability."[57] It recommended the development of Department
Employment Equity Plans in each department and establish-
ment of a Faculty Equity Resource Committee. It included detailed
guidelines on recruitment practices, hiring and retention, and cli-
mate issues. Though it focussed on all four designated groups, the
Task Force indicated that it expected that "the greatest immedi-
ate equity gains will be seen in the recruitment and retention of
women in academic positions" and that "achieving equity goals
for visible minorities, the disabled and native persons...will be a
greater challenge for the faculty."

The report was a landmark statement, and its creation led to
critical moments of clarification for the University. During the
preparation of its report, the Task Force Chair, Graham Lowe,
together with eight members of the Faculty of Arts, all male, met
with the President to discuss equity and the political situation in
the University. Following the meeting, on 7 January 1992, Lowe
wrote to the President with a summary of the discussion. The main
issues had been the need for strong leadership from the President,
concern about inadequate support for successful completion of the
Federal Contractors Program review, and the President's "Annual
Report," which was, Lowe wrote, "confusing." "You seem to tacitly

accept the 'merit only' group's arguments, which conflate employment equity, preferential hiring and U.S.-style affirmative action," he said. "Your position needs to be clarified." [58] On 6 February, the President copied to Graham Lowe a letter he had sent that day to the *Globe and Mail*. In it, he declared the University's commitment to its equity goals. A month later, and in time for circulation to Arts Faculty Council, he sent me a letter supporting the Task Force Report. [59]

I took the Task Force Report to Arts Faculty Council for its meeting on 29 April 1992. As expected, its recommendations were heatedly debated on campus before the meeting. "Feminizing a Faculty: an Agenda for Arts," said the headline of *Academic Concerns* on St Patrick's Day. The precedents set in Arts, it warned, "would have significant implications throughout our institution." [60]

Members of Arts Faculty Council came to this meeting in unprecedented numbers. They sat on the window ledges and the steps in the Council Chamber, and because the voters outnumbered the seats and voting machines, when the question was called they had to vote in shifts. They were aware that they were addressing the most pressing issue of the time, that they were doing it in a difficult and sometimes hostile environment, both in the University and in the general culture, and that their decision would have an impact on the whole University.

Feelings were high. The meeting began with a skirmish in the normally slow warm-up of the opening formalities. When that dust settled, Graham Lowe introduced the Task Force Report for discussion. Within minutes, Tom Powrie challenged a ruling I made as Chair of the meeting. The room became starkly silent, as the Council realized that his challenge to the Chair pitched the two sides of the argument against one another in a direct, personal confrontation. When the Council sustained my ruling by a large majority, it became clear beyond doubt that members of the Faculty of Arts intended to move forward on this issue. The report

of the Dean's Advisory Task Force on Employment Equity was passed by a vote of 125 to 52.

While I was gathering my papers at the end of the meeting, the Chair of the Department of Drama, David Barnett, came to my desk to tell me that the meeting had reminded him of *High Noon*. In fact, it was a marvellous and decisive moment, and remembering it makes me want to uncork a bottle of good champagne. The Task Force's careful work of consultation had resolved the issue of employment equity policy in the Faculty of Arts, and seventeen years after the Senate Task Force *Report on Academic Women*, members of Arts Faculty Council brought the wavering and the foot-dragging to an end. A year later, on 29 March 1993, the University's plan, *Opening Doors: A Plan for Employment Equity at the University of Alberta*, developed under the leadership of Lois Stanford, Vice-President for Student Services, was approved by General Faculties Council. In 1994, it was approved by the Board of Governors, and in 1995, then Vice-President (Academic) Doug Owram, who in 1992 had signed the "Petition to Uphold University Hiring Regulations," wrote to all deans requesting that each faculty develop an equity plan. That was twenty years after the Senate Task Force had called for strong action on hiring.

Over the course of my deanship, 1989–1999, the Faculty of Arts appointed 171 new professors. Ninety-one of these were women.[61] Women's participation in important administrative roles increased substantially. I appointed two women as Associate Deans immediately, and another in my second term, and during these years fourteen women were selected as Department Chairs.[62] As the Task Force expected, we were not so successful in meeting the challenge of recruiting and hiring members of the other designated groups. Two Associate Deans were members of a visible minority, and both of these were, at different stages, selected as a Department Chair.[63] A 1999 census reported that full-time continuing academic staff was 33.5% female, 0% Aboriginal people, 1.7%

persons with disabilities, and 10.9% visible minorities. In 2005, the year I retired from the University, women represented 43.1% of full-time academics in Arts, 48.4% in Education, 14.0% in Science, 9.6% in Engineering.[64] In Arts, on 1 July 2008, 56% of Contract Academic Staff Teaching, and 43% of faculty were women. They were also 58.9% of undergraduates.[65]

Thankfully, many other things were on the agenda of the Faculty of Arts in these years besides employment equity. Deep budget cuts notwithstanding, there were exciting developments in research and teaching. We established the Parkland Institute, a public policy think tank; the Centre for Austrian and Central European Studies,[66] a partnership with the Austrian government that engaged us in interdisciplinary exchanges of various kinds with a wide range of universities in Austria and Central Europe; a Centre for Public Economics; an Institute for Medieval and Early Modern Studies, and a Faculty of Arts School in Cortona, Italy. We conducted a successful fundraising campaign, and I focussed increasingly on speaking for the Arts, to government, community, and professional groups. By 1996, I had allowed myself to think that, the Faculty Council having so clearly declared its position, the attack on equity policy would end.

Fatal error, as my computer would put it. In summer 1996, when I was in Tuscany to discuss with officials in Cortona the establishment of our Faculty of Arts School in this beautiful, ancient hill-town, the issue of the employment of women and the Faculty of Arts was suddenly back—fatally attractive, it seems, to some core anti-equity academic staff members and to the right-wing press. I had a telephone call from Acting Dean Gurston Dacks. "I'm sorry to tell you this," he said, "but the *Alberta Report* is going to publish a nasty story on the appointment of the Chair of Political Science. They are going to say that you that rigged the committee to hire a woman."

The particular object of the attack was the selection of our new Chair of Political Science, Dr Janine Brodie, who came to us from York University. Currently a Canada Research Chair (and newly a Trudeau Fellow) at the U of A, she was then already an outstanding political scientist with distinguished publications on Canadian politics. A duly constituted Selection Committee, which I chaired, had conducted a painstaking national search and chosen her over several other candidates.

Alberta Report, a right-wing "newsmagazine" with a taste for scandal and personal attack, was published by United Western Communications, of which Ted Byfield was President. For several years, the magazine was widely distributed free-of-charge, so that members of the public would find it, for instance, in government offices or dentists' waiting rooms, looking as though it had a genuinely wide circulation. It maintained a corrosive attack on the University of Alberta. As time went on, its attack grew more vitriolic, then focussed on the Faculty of Arts and its faculty members, especially Dr Brodie, and on me, as dean of the faculty.

Of the appointments in English, Ted Byfield had written, that they show "our supposedly highest minds, eagerly flinging away all serious commitment to academic excellence." Of Myer Horowitz's appointment of Doris Badir as his advisor on equity issues, he said: "Her chief targets, it is...feared, will be the applied science and engineering faculties, which, with minor concessions, have remained largely bastions of male ascendancy, with skirts something to make you whistle, and feminism something to make you throw up."[67]

A cover story in January 1991, "Fembos in Academe," raised the alarm about women's studies, which, it said, were "proliferating in the West's universities." This "is not an academic discipline, say its few vocal critics, but an ideology. Therefore it is not taught; it is preached." Positioning feminism in opposition to the traditional

beliefs and ways of life of the Western world, it said that the feminist "revolution" "demands nothing less than the 'de-construction' of traditional knowledge."[68] Quoting philosophy professor Ferrel Christensen, it said that it was dangerous to disagree and that male students "are convinced dissent will damage their grade point averages."[69]

Two months later, *Alberta Report* published an editorial and a story about the U of A budget ("Defending the Ivory Tower: The U of A Whacks Mining to Protect Arts").[70] Mining Engineering was shut down, it said, and (wildly incorrectly) "Virtually nothing was cut from the more high-brow and politically sacrosanct arts, education, and pure science faculties." An editorial ("If Academe is a 'Dream World,' Here's How to Wake it Up") urged cuts to Arts and Education, the home of "easy courses" and "lazy people."[71]

The story, published in July 1996, was titled "Political Correctness in Political Science" and sub-titled "University of Alberta Profs Allege a Feminist Coup has Hijacked the Department." "Some faculty members," it said, "accuse Dean of Arts Patricia Clements of rigging the selection process to ensure the hiring of an academic who shares her feminist views and one who will impose them on the political science program." Quoting an unsigned letter "apparently" from an unnamed Political Science professor, it warned that "This department has, in effect, been taken over by a group of politically-correct academics led by Dean Clements." Quoting again an anonymous source, it said that the Department members of the Selection Committee had published nothing significant. "A lot of people," explained senior political scientist Larry Pratt, "are afraid to speak out."[72]

Ted Byfield followed up two weeks later: "the feminist dean of arts at the University of Alberta was discovered to have appointed a feminist selection committee that has named a feminist chairman for the political science department," he wrote. "So what if feminists are discovered to be telling lies, forging statistics, packing

staff selection committees, falsely accusing fellow workers, faking evidence, turning rape crisis centers into indoctrination schools." In addition to all that, he said, it is very dangerous for professors to speak out: "several have by public protest risked being badly mauled."

On 30 September, *Alberta Report* published its most abusive attack yet on the Faculty of Arts. Its cover depicted the first Premier of Alberta disfigured by a pink punk hairdo, and across the page was shouted: "Deconstructing the House that Rutherford Built: Feminist Post-modernists Purge the old Liberals and Consolidate their Control over the University Arts Faculty." The index page of this number of the magazine read: "The ivory tower besieged. 'Whatsoever things are true,' is the motto of the University of Alberta. But angry faculty and students are saying the quest for truth on the Edmonton campus has been supplanted by the will to power." The article, "Deconstructing the Arts Faculty: Doctrinaire Feminism Tightens its Grasp on the U of A's Biggest Department,"[73] reported that under my leadership "ambitious, power-driven feminists have secured tenure and helped hire like-minded academics. Collectively, the feminists adhere to a 'post-modern' ideology that rejects the intellectual and cultural heritage of Western civilization." Relying on the comments of a bitter former English professor and a political science professor who had been actively anti-equity since the early days of the Merit Only Group, it focussed an inflammatory attack on the Faculty and the Department of English. Citing as evidence specific courses in the area of postmodernism and theory—for instance, Jo-Ann Wallace's course on "Feminist Cultural Materialism"—they said that the intellectual life of the faculty was now "corrupt."

When *Alberta Report* published the allegation that I had "rigged" a committee by "appointing" its members, its reporter knew that the allegation was false. As Acting Dean, Gurston Dacks had explained to him that the dean chairs a Chair Selection

Committee, but that every other member is appointed or elected by someone other than the dean—by the Department, or the Vice-President Academic, or the Dean of Graduate Studies, or the graduate students, and so on. He also faxed them information about the composition of Chair Selection Committees (and the machine record of this transmission is in the file). Yet *Alberta Report* went ahead with the defamatory story.

I sought advice from the University's solicitors, and on 22 July I served notice to *Alberta Report* of my intention pursuant to the *Defamation Act* (Alberta). On 5 August the magazine published a long, clarifying letter from J. Paul Johnston, a Department representative on the Selection Committee, who wrote because "the record has to be set straight." The magazine also agreed to write a letter of apology to me, the text of which would be forwarded to them by the University solicitor, and to pay a sum of money to the University for costs. The letter, signed by Ted Byfield and dated 16 December 1996, apologized "for any anguish or embarrassment caused to you or others by statements in the above articles concerning the selection of the Political Science Chair." It also said that "We will use our best efforts to keep our facts straight and we sincerely regret any personal or professional harm which may have been caused to you or others by our failure to do so in this case."[74] *Alberta Report*'s attacks on the Faculty of Arts and the University ended with our notice of intent to file a complaint. Not very long after that, the magazine ceased publication altogether.

WHAT THE "MERIT ONLY" group, the "Concerned Academics," and the *Alberta Report* had so furiously resisted was a social consensus that had become a force of history. While they were fighting to hold the line against difference, the world was moving on.

WHY DID IT TAKE SO LONG for the University to act on issues of inclusion? I am struck by three features in this history. The first is

the repeated cycle of disconnect between policy and practice. Over and over again the University's councils approved hiring policies to create equality of opportunity for women and, later, for the other designated groups. And over and over again, policy momentum was defeated by inaction. The second is that the university was most able to make major progress on equity when there was a powerful policy push from the outside to do so. The Senate Task Force Report followed the Report of the Status of Women in Canada and the legislation flowing from that. The *Canadian Charter of Rights and Freedoms* came into effect in 1982, and it became a motivating context for the ten-year review of the Senate Report. Real progress in the hiring of women and members of the other designated groups followed the Federal Contractors Program, which bolted policy and practice together by requiring action plans.[75] Both of these elements in this history—long inaction and the policy push from the outside—underline the importance of the third, which is leadership. This is the necessary link between policy and practice. When strong presidents really did support change, it happened; when the president or the vice-president was half-hearted, or indifferent, or silent, or gave mixed signals, hard-won gains slipped back.

In its centennial year, my university has been more than usually retrospective, and its motto, translated by its official historian as *All True Things*, is much cited as a firm commitment to stand against limiting orthodoxy and for intellectual integrity. Looking back at the parts of this history that I know best, I see the true stories of many men and women who stood for equity and fairness. If there is guiding knowledge for the future in looking back, it is that change in this university, as in others, was the continuing work of a broad, intergenerational coalition. Responsibility for fairness and equity never ends, and it falls on all of us.

Having said at the outset that this would be a personal account, I wonder now whether for readers not themselves involved in these events it will seem dryly institutional. For me, returning to this

history has brought a range of feelings, including excitement, satisfaction, pain, and anger. Yet what I feel most, in this personal retrospective moment, is gratitude: for opportunities I wish had been open to my mother and my aunt; for joy of scholarship and teaching, and for work that was both a career and a life; for living in a time in which women's issues, then diversity more broadly, became central to the University; for my committed, generous colleagues in Arts and across the university and the country; and for the community we were, from the Senate Task Force Report to the Report of the Arts Task Force on Employment Equity, and beyond. Our world in our time. What a privilege to be part of it.

NOTES

1. Geoffrey Chaucer, "The Wife of Bath's Prologue" in *The Canterbury Tales*. I choose this title to remember my Chaucerian and feminist friend and colleague, Joan Crowther. The line is "Unto this daye it dooth myn herte boote/ That I have had my world as in my tyme." "Unto this day it warms my heart// That I have experienced my world in my time."

2. Rod Macleod, *All True Things: A History of the University of Alberta, 1908–2008* (Edmonton: University of Alberta Press, 2008), 7. See also Macleod's account of equity struggles at the U of A. Ellen Schoeck, *I Was There: A Century of Alumni Stories About the University of Alberta, 1906–2006* (University of Alberta Press, 2006), 19–21, reports that the *University Act* of 1906 was written in 1903 for Frederick Haultain, Premier of the Territories, and that it was later brought forward by Alberta's first Premier, A.C. Rutherford. The original vision of a non-denominational and co-educational university was Haultain's. I am grateful to both Rod and Ellen for discussion of events described in this essay.

3. Indira Samarasekera, "Centenary Address: Daring, Discovering, Delivering," University of Alberta, January 28, 2008. See Macleod, 15.

4. Report of the Royal Commission on the Status of Women in Canada (Ottawa: Information Canada, 1970), 167.

5. Ibid., 164.

6. Association of Universities and Colleges of Canada. *Trends in Higher Education* (2002): 2–3.

7. University of Alberta Archives, Patricia Clements Fonds. Hereafter referenced as UAA.

8. R.D. McMaster, "The Department of English, 1908–82," *Folio*, University of Alberta, Edmonton, September 30, 1982, 11.

9. A detailed outline of the College's history is online at http://www.st-annes.ox.
 ac.uk/.

10. To catch the tone of this time, see Larry Zolf's interview with Germaine
 Greer, October 28, 1971, at http://archives.cbc.ca/health/reproductive_issues/-
 clips/12448/.

11. The Department then included, in addition to the original three, Joan
 Crowther, Barbara De Luna, Jean MacIntyre, Juliet McMaster, Shirley Rose,
 Sara Stambaugh, Muriel Whitaker, and Dale Wilkie. Linda Woodbridge was
 hired the same year as I was.

12. The Senate Task Force Report on the Status of Women. Report on Academic
 Women. The University of Alberta Senate, March 1975, 12.

13. "Major Organizations Dealing with the Status of Women," CAUT Bulletin,
 September 1975, 24.1.26.

14. Senate Task Force Report, 2.

15. CAUT Bulletin, September 1975, 24.1.6–26.

16. Carolyn Maslek, "Bills C-16 and C-72: Steps Forward in the Struggle to End
 Discrimination," CAUT Bulletin, September 1975, 24.1.5.

17. Senate Task Force Report on Academic Women, 3.

18. Ibid., 3–4.

19. The Association of Academic Staff of the University of Alberta passed this
 motion on 18 November 1975. Six months earlier, in May 1975, the Canadian
 Association of University Teachers Council had passed a motion requesting
 "all universities to conduct, during the academic year 1975–76, matched pair
 studies of the remuneration, fringe benefits and career progress of women
 academics as compared to men academics; and that faculty associations
 play an active role in ensuring that the recommendations of such studies are
 implemented."

20. "Academic Women's Association: 1975–." n.d. http://www.ualberta.ca/
 ARCHIVES/guide/7ORGAN/153.htm (accessed July 29, 2010).

21. Harry E. Gunning, "President's Convocation Address," Folio, University of
 Alberta, Edmonton, November 25, 1976.

22. Linda Woodbridge to Chairman and Council, undated, but sent for the Council
 meeting of November 20, 1975. UAA.

23. Compiled by R. Mary Totman, October 1984; in my files as an attachment to a
 note from Margaret Ann Armour.

24. Jean K. Lauber, "Women's Studies—a Report on a Trial Course," attachment
 to a letter to Mrs M.M. Midgley, Secretary, General Faculties Council, April 28,
 1976. UAA. Lecturers in the "Sampler" were Doris Badir, Rosalind Sydie, Sheri
 Dalton, Carol Ladan, Pat Prestwich, Ann Hall, Tova Yedlin, Lorna Cammaert,
 Sheila Toshac, Linda Fitz (Woodbridge), Patricia Gallivan (Clements).

25. Professors Bessai, Bold, Demers, Gallivan (Clements), Juliet McMaster,
 Neuman, Stambaugh, Nora Stovel, Woodbridge, Wilkie.

26. Report: *1987 Progress Review. Task Force on the Status of Academic
 Women*, p. [1].

27. GFC Manual, 48.2.3, quoted here from the 1987 Progress Report, 7.

28. Virginia Blain, Patricia Clements, Isobel Grundy, eds., *The Feminist Companion to Literature in English: Women Writers from the Middle Ages to the Present.* (London: Batsford Academic; New Haven, CT: Yale University Press, 1990).

29. Sherri Aikenhead, "New Dean Lives for Learning," *Edmonton Journal*, February 5, 1989, B3.

30. Sherri Aikenhead, "U of A Women still Seek Equity," *Edmonton Journal*, February 5, 1989, B3.

31. See Jo-Ann Wallace, "'Fit and Qualified': The Equity Debate at the University of Alberta," in Stephen Richer and Lorna Weir, eds., *Beyond Political Correctness: Toward the Inclusive University* (Toronto: University of Toronto Press, 1995), 136–61. This is a full account and analysis of the reaction to the hiring of "the five" in English in the context of the culture wars.

32. Ibid., 137.

33. Report of the President's Commission for Equality and Respect on Campus. University of Alberta, Edmonton, Canada. July 1990. Commissioners: Dianne Kieren (Chair), Aruna D'Souza, Anne McLellan, Peter Smy, Jim Vargo. iii. UAA.

34. Linda Woodbridge, a brilliant Renaissance scholar, resigned as Chair of English, ending her term two years early, on 30 June 1989. Later, she left the University of Alberta.

35. Philosophers Ferrel Christensen and Cameron MacKenzie, linguist Bernard Rochet, and economist Tom Powrie.

36. Tom Powrie to Academic Staff in Economics, September 25, 1989. Attached to his letter is a memo from "Steering Committee" to "Members of 'Merit Only' Group," September 18, 1989 and the agenda for the meeting of 28 September. UAA.

37. Attachment to memo from "Steering Committee" to "Members of 'Merit Only' Group." September 18, 1989. UAA.

38. Davenport's response to the *Report of the Pay Equity Review Committee*, an oral report to General Faculties Council that was published in *Folio* on September 19, 1989, for instance, asserts that "Gender and other personal characteristics will have no role in decisions on hiring, promotion, or tenure." This is quoted in a letter signed by Christensen, et al., and sent, on June 17, 1991, that is, after the Vice-President's response to the Petition to Uphold, to "all members of the U. of A. faculty to solicit their support in upholding GFC hiring policies." UAA.

39. "Steering Committee" to Members of "Merit Only" Group, September 18, 1989. The agenda for the meeting of 28 September is attached to this. UAA.

40. Olive Elliott, "Preferential Hiring," four articles in the *Edmonton Journal*, June 1989.

41. Members of the Association of Concerned Academics executive committee were F. Christensen, L. Craig, T. Elrod, R. Gruhn, J.C. MacKenzie, T. Powrie, and A.P. Rochet.

42. Wallace, 138.

43. "University in Jeopardy. A One-Day Conference." Sponsored by The Society for Academic Freedom and Scholarship and The Fraser Institute. Friday, March 12, 1993. Royal York Hotel, Toronto. Poster and Program. UAA.

44. Paul Davenport, "Contentious Issues a Test of University's Ability to Define its Values," *Folio*, University of Alberta, December 7, 1989. President's statement to *General Faculties Council*, November 27, 1989.

45. Glennis Stephenson to Pat Clements, November 29, 1989. UAA. Later, Professor Stephenson left the University.

46. Linda Woodbridge to Dianne Kieren, Chair, President's Commission for Equality and Respect on Campus. March 27, 1990. UAA.

47. "Academic units with more than 4 vacancies," Office of Human Rights. Describes applicants and appointments for 1988–1989, 1989–1990. In 1988–1989, Engineering hired no women and eight men. UAA.

48. Linda Woodbridge to Dianne Kieren, Chair, President's Commission for Equality and Respect on Campus, March 27, 1990.

49. Report of the President's Commission for Equality and Respect on Campus. Recommendation 2.1.5, 26. University of Alberta, Edmonton.

50. Letter to Dr Paul Davenport from Ad Hoc Association of Concerned Faculty Members. April 3, 1991. Letter signed by Leon H. Craig, Ruth Gruhn, B.M. Patchett, Anne Putnam Rochet, Edit Gombay, Walter G. Arello, G.K. Hunter, J.C. MacKenzie, Ferrel Christensen. Petition, with 139 signatures attached. UAA.

51. Allen Panzeri, "University Urged to be at 'Forefront of Change' in Hiring," *Edmonton Journal*, June 8, 1991.

52. Dr W.J. McDonald, Dr P. Davenport, to Deans' Council. Employment Equity. March 4, 1992. UAA.

53. Allen Panzeri, "Education and the White Male Bias," *Edmonton Journal*, June 30, 1991, E1.

54. Don Carmichael, Jim Creechan, Claude Denis, Eric Higgs, John-Paul Himka, Jason Montgomery, Raj Pannu, Alan Rutkowski, Stephen Slemon, Gordon Swaters, Doug Wahlsten, "Employment Equity Critical for U of A," *Edmonton Journal*, September 3, 1991, A11.

55. T.L. Powrie, Department of Economics, to W.J. McDonald, Vice-President Academic, October 7, 1991. UAA.

56. They were Catherine Dechaine, a member of the non-academic staff, Michael Hymers, a graduate student in philosophy, Tom Keating, Professor of Political Science, Susan Purdy, a sessional lecturer in French, Jan Selman, Professor of Drama, Malinda Smith, then a graduate student in Political Science, and Jo-Ann Wallace, Professor of English.

57. G. Lowe (Chair), C. Dechaine, M. Hymers, T. Keating, S. Purdy, J. Selman, M. Smith, J. Wallace, Developing and Implementing Department Employment Equity Plans in the Faculty of Arts. Report and Recommendations of the Dean's Advisory Task Force on Employment Equity. Revised March 16, 1992. UAA.

58. Dr Graham Lowe, on behalf of Michael Asch, Gurston Dacks, Tom Keating, Harvey Krahn, Maurice Legris, Michael Percy, Desmond Rochfort, Allan Tupper, to Dr Paul Davenport. "Summary of our January 7th meeting on equity." January 16, 1992. UAA.

59. Dr Paul Davenport to Dr Graham S. Lowe and Dr Sandra Niessen, President of the Academic Women's Association, February 6, 1992. Dr Paul Davenport to Dean Patricia Clements, "Faculty of Arts Task Force Report," April 10, 1992. UAA.

60. Ruth Gruhn, "Feminizing a Faculty: An Agenda for Arts," *Academic Concerns*, 1.2.1. March 17, 1992. UAA.

61. Report prepared at my request June 1999 by Mary Delane, Executive Assistant to the Dean of Arts. UAA.

62. Lynn Penrod (Romance Languages), Margaret Van de Pitte (Philosophy), and Lesley Cormack (History) as Associate Deans. As Department Chairs: Nancy Lovell (Anthropology), Susan Jackel (Canadian Studies), Shirley Neuman (Women's Studies, then English), Patricia Prestwich, Ann Hall, Dallas Cullen (Women's Studies), Janine Brodie (Political Science), Patricia Demers (English) and Jo-Ann Wallace (English), Catherine Wilson (Philosophy), Eva Dargyay (Religious Studies), Rosemary Nielsen (Classics), Sonja Arntzen (East Asian Studies), and Jan Selman (Drama). I believe that before that time there had been four women over the history of the Faculty: Marjorie MacKenzie (Classics), Roberta McKown (Political Science), Jo-Ann Creore (Romance Languages), and Lois Stanford (Linguistics), later Vice-President (Student and Academic Services) under President Davenport.

63. Associate Deans Baha Abu-Laban, formerly Chair of Sociology and Associate Vice-President (Research), and Mohan Matthen, who was later appointed Chair of Philosophy, but he did not serve in this role, taking instead a position at UBC.

64. Figures reported by Malinda Smith, "Artful Dodging and the Conceits of Diversity Talk, Part I: The Pursuit of Equity and Diversity in the Faculty of Arts." Prepared for Arts in the 21st Century—Social Science Panel, 15 November 2007, 9. See Table I (Workforce by Faculty and Four Employment-Designated Groups Full-Time Teachers/Continuing Faculty [Respondents], 31 December 2005) and Table II (Faculty of Arts, 1993–2005, University Teachers—Full-Time (Respondents).

65. The 2008 numbers and the 1999 graduate student number, from the Office of the Dean of Arts, with thanks.

66. Now called the Wirth Institute.

67. Ted Byfield, "What's Academic Excellence when the Sacred is at Stake?" *Alberta Report*, April 10, 1989, 44.

68. Virginia Byfield, "Fembos in Academe," *Alberta Report*, January 7, 1991, 24. For analysis see Jo-Ann Wallace, "'Fit and Qualified': The Equity Debate at the University of Alberta," in Richer and Weir, eds., *Beyond Political Correctness*, 136–61.

69. *Alberta Report*, January 7, 1991, 29.

70. *Alberta Report*, March 4, 1991, 34–35.

71. *Alberta Report*, March 4, 1991, 4.

72. Chris Champion, "Political Correctness in Political Science," *Alberta Report*, July 8, 1996, 33.

73. Peter Verberg, "Deconstructing the Arts Faculty: Doctrinaire Feminism Tightens its Grasp on the U of A's Biggest Department," *Alberta Report*, September 30, 1996, 32–37.

74. UAA.

75. After writing this essay, I was reminded of Janina Marie Vanderpost's PHD dissertation, *Policy Implementation at the University of Alberta: A Case Study, 1992*.This is a detailed investigation of the University's response to the Federal Contractors Program.

"I forgot the attachment"
and Other Casualties of Academic Labour at the Present Time

DONNA PALMATEER PENNEE

THE CONFERENCE FROM WHICH this volume of work arose called
on participants "to evaluate the achievements of feminism," and
"to ask whether feminist work has had sufficient impact on aca-
demic culture generally and on the culture of the liberal arts in
particular." Answering such questions in the context of honour-
ing the achievements of Pat Clements provided an opportunity for
delegates to celebrate feminism's impact, to count the milestones,
and to hear from three generations of feminist arts scholars, teach-
ers, students, and activists. The call also asked participants to be
accountable for speaking to work still to be done, and through its
collage of images and miscellany of quotations, my presentation
demonstrated work still to be done. But the presentation I gave
was not the paper I had proposed. Ironically, the paper I imagined
giving was itself, in some ways, a casualty of the very working con-
ditions I had proposed to critique. More than that, however, the

form of the academic conference paper seemed inadequate to the kinds of issues I wanted to address.

As a lateral thinker in general, and as an administrator in particular, my first line of response to the call was to propose a consideration of the broader contexts in which feminists in the liberal arts conduct their academic labour. I would use the tools of close reading to analyze various reports and strategic plans, from national, provincial, and university sources, to demonstrate how university cultures were being reshaped under neo-liberalism, and the implications for the feminization of our labour in the liberal arts. I would demonstrate the modes by which universities were expected to compensate for reduced public funding for post-secondary education, and I would catalogue the increasing pressures on faculty, staff, and students to take on the work not only of doing more with less but also of providing the social services that were being similarly underfunded by the state.[1] My primary concerns were that (many) women and (some) men are often more apt to take on the extra work without acknowledgement, and that fiscal inequities across the disciplines would further feminize the arts, turning arts and humanities educators and students in the post-secondary sector into a "special interest" group, eroding quality and, through that erosion, undermining the lobby for increased levels of support. I would be addressing these concerns in a climate where feminism, equity issues, and the liberal, fine, and performing arts were fearful of cuts by the still-new Conservative government of Stephen Harper. That is the paper I had proposed to deliver at the conference. I was thinking in terms of what was being done *to* women, feminism, and the liberal arts, not so much in terms of what we hadn't yet accomplished ourselves.

As if to confirm the need for such analysis and action on these concerns, on 25 September 2006, mere weeks before the conference opened, Mr Harper's government cut $5 million from the $13 million budget of the Status of Women Canada; two days later

the government announced a new mandate for the women's program that shifted the terms from *equality* to *participation* and would refuse funding for research, advocacy, and lobbying.[2] The elimination of the Court Challenges Program (just before these announcements) made clear the linked strategies of this government: Dolly Williams, then-newly-elected president of the National Action Committee on the Status of Women, noted that "NAC has been able to use this [Court Challenges] program in the past to question the constitutionality of cuts to core funding for equality-seeking women's organizations."[3] Changing the language and closing off the routes through which funding could be sought by arts and equality-seeking groups, while also reducing that funding, made explicit the intention to undermine, if not entirely silence, these significant forces for critique of the social, political, and economic order of Canada.

These blatant displays of governmental power in the weeks and days leading up to the conference lent a certain poignancy to participants' accounts of the achievements of feminism as well as a certain receptivity by delegates to a presentation such as the one I delivered on the morning of the first full day of the "Not Drowning But Waving" conference. The session, "Women in/as Suits," asked panellists to meditate on varieties of administrative work in the academy: How do we negotiate relations of power? Is it possible to make change in a context of neo-liberal surveillance and under a regime of time starvation?

The presentation I gave was fuelled by anger, exhaustion, frustration, shame. I wanted to draw not only on my experience as (at that time) an associate dean of Arts and Social Sciences but also on my experience as vice-president, Equity Issues, and chair of the Steering Committee on Equity Issues for the Canadian Federation for the Humanities and Social Sciences. I wanted to *show* the degree to which our work environment—and even our own systems of accountability—deflect our attention from ongoing inequities

that require urgent redress. The scholarly distance, analytical language, and close reading of the paper that I had proposed seemed inadequate to the urgency of these issues.

It seemed that many delegates were ready for someone to say some things that needed to be said, and to be unapologetic in doing so. It was clear that conference delegates wanted to put these issues on the table and wanted to find proactive, immediate, undistanced ways of talking about them. For that reason, the editors of this volume asked me to try to retain as much of the performative, collage-like element of my presentation as possible in this chapter. What follows includes elements of that presentation interspersed with my own current reflections.

HOW OFTEN DO YOU FORGET to attach the attachment to the message in which you've said "Attached is..."? How often do you get messages that say "Attached is..." but there's no attachment? This happens frequently to me (as both sender and receiver)—so frequently that I think it's a sign of the times, and a sign of what is happening to our relationship to time. But I also believe it is a sign of an erosion of my attachments in that other sense, of what (and who) I feel close to, of what I am committed to, of what I am willing to fight for. I want to talk about this today.[...]

In despair, I wrote to Susan [Brown] early in September to say I just can't do it, I just don't have time to write this paper, and she conferred with her co-organizers who agreed that of all conferences to have to say no to, this one should not be it. With Susan's and co-organizers' words of wisdom and support, and Ann [Wilson] whisking me off to the airport at 5:45 yesterday morning—and with Pat's extraordinary career to celebrate—I'm here.

I'm here without the paper that I had proposed to give (and this is a first for me), but contrary to my usual practice when I'm feeling inadequate, this is not an apology, because I am not inadequate. I'm just swamped (and not all swamps contain enough water for

drowning). I have not abandoned the points I had hoped to make with the proposed paper, namely, that the historical record of government and university policies, reports, and plans is a record of the engineering and exacerbation of disciplinary inequities for the liberal arts, a record that we need to counteract by explicitly being "other than" and "other to" business as usual.

I have shamelessly (well...I'm still working on that) pulled together a collage of images, texts, and observations, and I am trying to convince myself, and model for others, how this change in plans is perfectly fine and necessary: necessary because I ran out of time to write the proposed paper, but necessary also for performing *otherwise. Indeed, I am acting out of, while also acting against, the internalization of an institutional imperative to be "a good subject." That phrase, "a good subject," updates the terminology by which middle-class women have come to govern ourselves and be governed: from the "Dutiful Daughter" who morphed into "Super Woman," who is sought as a "Change Agent," and more recently hailed as a "Leader."*

PEOPLE IN THE ROOM COMMISERATED with the fatigue and the workload reflected in my remarks, registered the irony in a century of duty calling us names, and recognized the language used by head-hunting firms to recruit university administrators. The administration of higher education is subject not only to the language of business but to the neo-liberal platform by which individualism, meritocracy, and accountability are "bundled," and by which governability and governmentality reproduce—with universities' participation—ever more uneven redistribution of wealth. Accountability in this context is to be understood as meeting government's investment in accountability to voters-as-taxpayers, through disinvestment in education (and health care and other social services), *as a public good*; if university administrators cannot show accountability for the spending of these reduced

public investments, government will be empowered to continue to answer the apparent public demand for tax cuts and investment of government funds in other domains, such as the militarization of security and increased subsidies for business.[4]

This redirection of the definition of the public good, this redirection of the definition of "security" to economic and military security (from the more recognizable provisions of "social security" for which Canada has been admired by other countries), and the "bundling" of individualism, meritocracy, and accountability: these are the contexts that gave coherence to my presentation that morning. Features of governmentality at work were clearly visible and audible in the images and analyses in my presentation. I provided an encounter not just with what is done *to* women, to feminism, and to the liberal arts, but also an encounter with how feminist gains and positions of privilege, in universities and in corporate business—steeped as such gains and successes are in romantic notions of agency that are individual, heroic, and competitive—*also* participate in that governmentality.

SO: I'VE BROUGHT WITH ME a miscellany of images and observations, culled from my working environment within the last year and a half or so, including particularly recent bits and pieces from the Careers and Business sections of the Globe and Mail, *because business is my working environment, though, silly me, I thought that in the liberal arts I was somewhere else.[5] Other bits of the miscellany are from reports on post-secondary education and plans for undergraduate curricular reform, a poster advertisement for workshops for senior undergraduates, and so on. These bits and pieces are signs of the times, but also signs about time, its disappearance or foreshortening in academic work environments, the multiplication of ever more "urgent" tasks in a still finite day, and the importance of rapid response time in the formation of good subjects under neo-liberal*

capital. We all have to go faster, with less time for reflection, consultation, communication.[6]

So, without further ado, but with due diligence to the thematic title for this session, Women in/as Suits, let's start with some images of "suits":

In an October 2006 Globe and Mail Report on Business *magazine we find a typical example of the suits of power, in the* CEO's *weekly page of "Congratulations to these recent appointments": stamp-sized portraits of twelve recent appointees to various law firms (counsel and tax partners), corporations, a "properties group," an income fund, a search firm, and a chair of a university's board of governors.[7] The uniformity of power across the portraits is captured not simply in the uniform—11 suits and ties, 1 suit and necklace—but also in the homogeneity of whiteness, in the economic and political clout of the appointments, and in whatever difference one-twelfth in the gender mix can make when little else has changed by way of race and class positioning.*

But, then, there's an explanation, of course. In the 10 October 2006 Report on Business *section of the* Globe and Mail, *we find a column about the scarcity of women in governance roles on boards, in management positions, in chief executive and chief financial positions. The column that begins on page B1 entitled "Female Directors Need Apply" is continued on page B4 with a title in larger font, "'Not Many Women Have Been* CEOs.'" *Accompanying the column on B4 is a photograph of three smiling authors of a report from Patrick O'Callaghan and Associates and Korn/Ferry International (the latter a corporate search firm sometimes hired by universities). They "found Canadian corporate directors are almost unanimous in the belief that boards should become more active about appointing female directors—but also found few boards are actually heeding the advice and hiring female candidates.*

"The 'perplexing' contradiction between activist attitudes and
passive behaviour explains the lack of progress women have made
in boardrooms across the country, says [...] one of the report's
authors."[8]

While the reporter identifies "the lack of progress of women" in
boardrooms (not the lack of progress of boards and their members),
the authors of the report clearly say that in the U.S., companies ask
that the search firm propose female candidates for director positions,
whereas "'Here [in Canada], it's very much something they espouse
and they would like to have, but it's not a prerequisite.'"[9] Another
Korn/Ferry representative "says many boards define the qualifica-
tions for new directors so narrowly that it is likely the number of
women will not increase notably in the near future."[10] Their "study
said many directors believe gender diversity on boards will change
naturally as the pool of women in senior management positions
steadily increases."

Did you hear that? That's two familiar forms of gate-keeping back
to back! Yet the reporter quotes Patrick O'Callaghan saying "'We have
to blow up that myth,'" because of "other research that has shown the
number of women in top management jobs in Canada is also growing
at a glacial pace, so boards can't wait for an explosion of female CEOs
before appointing more women to boards."[11]

But if you're reading this newspaper in a hurry (I usually am), will
you get to the fine print within the column? Are you more apt (I am) to
read the insert in large font, with those bolded items numbered 1 to 5?
This insert provides advice—to women, not to companies addressed
by the report—on "Five ways to break onto a big corporate board."
And the caption for the photograph with this article? Remember, this
photograph accompanies an article reporting on what companies
need to do to appoint more qualified women: the caption identifies
the three male authors of the report as saying "few boards are hiring
female directors."[12] So you could come away from this newspaper

item thinking that the solution to the problem is that women need to develop the skills, get the experience, improve themselves, and apply (indeed, that's what the headline on the first page of this section of the paper said: Female Directors Need Apply).

The photograph that accompanies this story does not show, say, some women directors of boards or CEOs or CFOs, not even the three women named early in the article as examples of "finds" of a search firm for one board that had fallen for the myth that there weren't enough qualified women out there. Instead, the photo with the column shows the report's authors, three white businessmen in white shirts and ties, two of them from a search firm, as if this is a free advertisement for head-hunters and consultants. They stand casually, one with arms folded, the others with hands in pockets, as if grouped for a working portrait of a team. Nobody appears harried or stressed; "it's all good," as was their advice for firms looking to recruit qualified women—but their good advice is buried in the fine print by the layout of the article.

Stranger still, the portrait seems to have been taken through a window that has been decorated with black silhouettes of two women rushing from the right to the left side of the photograph. These one-dimensional figures in dresses and heels appear to be riding through the photograph, or through a corporate office, on broomsticks.

WHAT THE H-LL IS THAT? asked participants in the room, pointing at the presentation screen and leaning forward in their seats to see what could be creating this effect of, yes, witches flying through an otherwise ordinary photograph!

An ad for an online brokerage product occupies a third of the same page (top to bottom), and also features a silhouette, but it is of a man holding an open laptop, one suited arm in the air, as if he has just made a bundle through "Real-time portfolio tracking," "Immediate transaction confirmations," and "Ultra-quick response to markets."[13] He is sitting, as the caption says, "on top of

the world," while the phantom women of boards of directors make their way by broomstick.

AND NOW FOR THE GLOBE *Careers section, same newspaper, almost the same date, we find an article under the headline "Mission Accomplished—By the Book," which tells how "Angela Mondou has brought leadership lessons from the front lines of the military to the front lines of the workplace."[14] Her self-published guide* Hit the Ground Leading! *provides "a military 'by-the-book' approach to mission focus, setting objectives, team building and fast execution." The cartoon that accompanies the article covers almost half of the page— and this is the first page of the Careers section of the paper.*

It's a blonde, pony-tailed woman in military fatigues, flak-jacketed and helmeted with a communication headset, her arm firmly outstretched, gloved hand pointing to a destination toward which three also-helmeted, briefcase-toting, business-attired employees rush in panic, ties and beads of sweat trailing them as they scramble, two men and one woman, to follow her orders. Look at the scale: the three employees are heading to their destination along their commander's outstretched arm. They are the little people, not leaders. The article continues over the page, with a headline that says, "Always Have a Second-in-Command." It features a head shot of Angela Mondou and quotes her in the caption: "'As a leader, you don't get paid to be liked.'"[15]

So what about the little people? Did you know you'll be a better worker if you are in a good mood at work (or at least appear to be), says another Careers section article under the title "Goodbye Cruel World, I'm Going to Work."[16] The reporter refers to a "study that shows that, no matter how you're really feeling, if you smile a lot and fake it at work, your mood (and work performance) will actually get better" [...] If you really believe it's essential to your work to arrive happy, by all means try the lattes, deep breathing, meditation and any other temporarily good-mood-inducing tactics.

"I'd like to suggest, however, that what really puts us in a good mood at work and affects our performance is a lot more obvious: It's called real accomplishment."[17]

The photos that accompany this story are of two young women in a study of contrasts: one is blonde, smiling, dazzling white teeth and crisp white shirt against a dark jacket, communication device attached to one ear; the other wears a less-than crisp white shirt, no jacket, no smile, and no headset: she has dark, lank hair, fingers of both hands pressed to her temples, her face compressed in a grimace of pain. The caption that links the two photos says: "Happy... not-so-happy: The former mood makes us better workers; one way to overcome the latter [...] is a good dose of work."

Interesting dichotomizing, no? The fair and dark ladies of the nineteenth century continue to circulate, along with the advice to just "fake it," and not only will you be productive, but the company or institution for which you work will not needlessly expend resources helping you to deal with your bad mood. Interestingly, in the article itself, the source of this bad mood, which requires faking it to be productive, is not anything in the workplace: it is unresolved issues with a husband and children. Hence the article's headline "Goodbye Cruel World, I'm Going to Work!" Always helpful to those feminists who are trying to make a case for a more holistic view of work–life balance!

THE MISCELLANY OF QUOTATIONS from national, provincial, and university documents on post-secondary education that I shared with participants at the conference only reinforced this sense that "whining" won't do, that in the absence of a different reality "faking it" will do, and that "going forward" has to happen on a timeline that identifies an urgent project today for completion yesterday, and a commitment to being out in front to be sure that *we* determine the directions in which *we* go *(are sent?)* forward. I reproduce here just a few of the texts examined at the conference, to show (as the images did) the repetition and reinforcement of

the message, the "bundling" of individualism, meritocracy, and accountability.

What is at stake is how accountability will be defined, and what will constitute "performance" or "quality." Either we actively work to shape the rules of engagement, or we play with rules designed by others. As it stands, there is no third option.[18]

Ontario is at the cusp of real reform. The higher education system is ready for change and it's going to get better with your attention. Your government knows this, which is why I took on this task in the first place. You understand the importance of higher education to students, to the economy, to Ontario society—and to the nation at large. You also understand that it's important to make change happen now—which is why we agreed to do this over a compressed period of time so that decisions could happen as early as budget 2005. You are right—it's critical to make a difference now.[19]

We need to invest in graduate education immediately. [...] We have a window of time at the moment in which to address this problem—we must take action. [...] Ontario needs to expand significantly the number of skilled workers and apprentices it trains, as well as increase opportunities for Masters and phds. At the same time, universities can strive to do a better job of ensuring that graduate degrees are completed in a timely fashion. Graduate students and their teachers need to take this job seriously.[20]

This is no quick reaction to the latest government pronouncement. But with renewed external attention being paid to quality, and the announcements that funding decisions will be linked to accountable quality measures, developing a clear and comprehensive strategy for enhancing quality becomes all the more important. [...] We cannot afford to let that opportunity slip by.

[...] It has become clear that the outcome of the Rae Report will be more than just increased government funding for the university sector. Attached to that funding will come significantly increased government interest in the performance and accountability of universities. We can choose to engage in this re-imagination effort now, and do so in a proactive manner that helps to shape the still-forming directions being set for the university system. If not, it is highly likely that we will soon have to react to new standards and expectations imposed upon us, having foregone the opportunity to play a leadership role and to influence how those expectations and standards are developed.[21]

OKAY: SO THERE'S A MISCELLANY from reports, plans, and imperatives—and I hope you will have observed therein that the pace of change and the reasons for change bring with them these imperatives to be a "good subject." Who would want to forego the opportunity to exercise leadership, to engage, to take ownership of the process? Institutions have always required good subjects, but there's something different going on, I think, and I'm engaging in something of a reality check with everyone here. Please tell me I'm not imagining this: there is a frightening transparency to this language of agency, embedded in these exhortations to make our own destinies of institutional and "external" demands for "change," on deadlines announced today for yesterday's date. Worse still, the leaders of some universities have folded so far in not speaking back to public funders, that they are taking out ads in national newspapers to thank the provincial government for ever-receding, more narrowly-targeted funding. It seems that critique, construed as ingratitude, does not pay. No wonder some of us feel hurried, harried, silenced; no wonder some of us are forgetting our attachments.

SO WHERE ARE WOMEN, feminism, and the liberal arts in business as usual? Some feminists use the numbers of women in

the academy to call for action, to leverage change from seem-
ingly intractable spaces, and to make institutions accountable
for gender inequities in hiring. Witness, for example, the
"Postsecondary Pyramid," the Equity Audit postcard campaign
(formerly known as "Ivory Tower Feminist Audits") circulated at
Congress 2007, the annual gathering of scholarly associations
under the umbrella of the Canadian Federation for the Humanities
and Social Sciences (CFHSS, or FedCan.ca).[22] The "Postsecondary
Pyramid: Equity Audit 2007" captured in gradations of pink and
blue the critical mass of numbers of women as students at the
bottom of the pyramid, in contrast to the critical mass of men at
top of the administrative and faculty pyramid. When nearly 60 per
cent of undergraduate university students in Canada are women,
women represent less than 20 per cent of faculty at the full profes-
sor rank, and just 13 per cent of university presidents. The numbers
that do measure progress in one area can be "leveraged" to
demand progress in another area, for example in the case of seek-
ing gender equity in the Canada Research Chairs program.[23]

To be sure, while such statistics track the increased partici-
pation rates of women, I think it is sometimes a mistake to argue
for representation by numbers, because both representation and
numbers, and representation by numbers, can become perilous
ground. For example, the number of girls enrolling in university is
in sharp contrast to the dropout rate for boys in high school; such
numbers could easily be used to abuse feminism and women, and
their allies. On this topic I witnessed a senior woman administra-
tor publicly dress down a young woman senator whose feminist
argument questioned the administrator's use of statistics. By citing
the statistics on the dropout rate of boys, and using the statis-
tics as a measure of the urgency of the problem, the administrator
managed to turn the young feminist's critique into self-interest-
edness—and as a result did nothing for boys or for girls, just gave
public fuel to antifeminism. The dropout rate is a serious problem

and deserves and requires a better response, one that does not reduce issues of gendered, racialized, classed, and physical access to post-secondary education to two white women arguing in public, and one that does not forego an analysis of education's relation to past, current, and possible economies.

A major irony here is that the same Senate meeting was very self-congratulatory for its approval of an anti-sweatshop business policy, as if exploitation under global capital only ever happens somewhere else. The policy is important, but in the absence of an integrated analysis of business as usual, we miss opportunities to make differences that would count differently and be differently accountable.

I think we are seeing a convergence of forces that *feminism of a certain kind* (the kind with which the public feels most familiar, the kind that is so easily bashed by REAL women[24]) cannot respond to effectively on its own, principally because it is too often unconscious of the role it plays in *business as usual*—and this is why the cult of speed, the compression of downloaded labour into less and less time, and the competition to succeed without support concerns me. Neo-liberal work/time discourages reflection and analysis and can distract us from differentially urgent work. The September 2006 announcement of government cuts to equity-seeking groups made explicit the consolidation of forces against the values, practices, and people who are active in and allied with justice movements inside and outside the university.

I WANT TO END BY SHOWING YOU what I had hoped to circulate as the Equity Audits postcard for Congress 2008 (wearing my hat as chair of the Equity Issues Steering Committee for FedCan, who advised a re-design of bold statements interspersed with statistical data). I want to show you this because in the end this version of an Equity Audit was never published, out of respect to the compilers of the original Ivory Towers postcard campaign, one of whom

EQUITY AUDITS 2006: SELECTED INDICATORS FOR CANADIAN UNIVERSITIES

1. **Canada Research Chairs** (CUMULATIVE TOTALS, NOVEMBER 2005)

	TIER 1	TIER 2	ALL CHAIRS
% Women	15.2%	26.3%	21.0%

2. **CRC Program data on Chairs held by other equity groups: none.**
 [Trying to make a point about data collection as itself problematic: for the endnote for this item, provide weblinks for the March 2005 WEI and November 2005 CAUT reports on the CRCP]

3. **Percentage (2001) of university teachers by visible minority [*sic*] status (2001): 11.1%**
 [Endnote: Source: CAUT 2006 Almanac Fig. 2.3, p. 11]

4. **Percentage increase (1996–2001) of teachers of visible minority [*sic*] status: 0.8%**
 [Endnote: Source: Statistics Canada, CAUT 2006 Almanac Fig. 2.3, p. 11]

5. **At the current rate of progress, even a 10% increase in teachers of visible minority [*sic*] status (to 21.1% of the professoriate) will not occur until *2051*.**
 [Endnote: estimate calculated from same source as 4]

6. **Percentage (2001) of women university teachers by selected equity group:**
 Of all employed visible minority [*sic*] university teachers 26.9% (of 11.1%)
 [Endnote source: Statistics Canada 2001 Census, special tabulation for CAUT]
 Of all employed ranks of university teachers 31.7%
 [Endnote source: Statistics Canada, CAUT 2006 Almanac Table 2.11, p. 15]

7. **Percentage (2003) of women, PHD enrolments:**

60% Social Sciences	50% Humanities	45% Bus., Mgt., & Admin.
40% Physical & Life Sciences	27% Math/Comp. Sci.	19% Engineering & Arch.

 [Endnote source: CAGS 35th Statistical Report 1994–2003 etc.]

8. **Percentage (2003) of women at highest academic rank: 18.1%**
 [Source: CAUT Education Review 8.1 (March 2006) Table 2, p. 2 online at http://www.caut.ca/en/publications/educationreview/education-review8-1.pdf]

9. **Full-time university teachers by type of appointment and sex (2004–05):**

Tenured:	Women 28%	Men 72%
Tenure Track:	Women 40%	Men 60%
Non-Tenure Track:	Women 45%	Men 55%

 [Endnote source: Statistics Canada, CAUT 2006 Almanac Fig. 2.5, p. 17]

10. **Faculty wage gap (2004): women's (university teacher) salaries as a percent of men's salaries, all academic subjects combined: 87.2%**
 [Endnote source: CAUT 2006 Almanac, Table 2.5, p. 6]

 At the current rate of increases to women's salaries (approximately 6% across all subjects from 1994 to 2004), *women faculty will achieve pay equity with men's (2004) faculty salaries in 2025–26*
 [Endnote source: calculation based on data in CAUT 2006 Almanac, Table 2.5, p. 6]

is here with us, Dr Wendy Robbins, who disagreed with these plans because they contained "speculation," not fact, and because the focus on "women's issues," issues still in need of action, would be diluted. With continued great respect for Wendy and her ongoing feminist work, I show this unpublished draft here because it provides in items 2, 3, 4, 5, 6, and 10 (the others are original to Wendy's draft), another version of "time" and "timing," as in slowness of change for groups other than white women and men.[25]

WE'RE STILL WAITING FOR Statistics Canada to provide better data on a full range of equity groups under the Federal Contractors Program. In the meantime, the first number of the Canadian Association of University Teachers' online Equity Review makes me return to my remarks about numbers and representation, and the uses to which statistics can be put:

> *While we know anecdotally that many equity-seeking groups remain seriously under-represented in Canadian colleges and universities, the lack of consistent and reliable data makes it very difficult to determine the full extent of this problem. This hampers the ability of policy-makers, administrators and academic staff associations to know the exact nature of the problem and to develop the most effective and appropriate tools to ensure equity.*[26]

For a productive contrast in methodology and perspective, see Nielsen, Marschke, Sheff, and Rankin's "Vital Variables." But if you don't have time to read that just now, take a few moments to consider the question Malinda Smith posed to delegates in the conference's final panel: "What's up with whiteness?" Women, feminists, liberal arts professionals: there is still work to be done.

THE PRESENTATION ON WHICH this chapter is based prompted strong reactions from delegates. It was a necessary illustration

of how even in the twenty-first century, with real feminist gains in some quarters, it is still possible for women academics to feel afraid of saying I am tired, I am discouraged, and I am ashamed of not having done the work I had proposed, just getting done what I could at the time. The undertow of fraud, of the "not good enough," continues to ambiguate Stevie Smith's original wonderful, anguishing phrase, "not waving but drowning," and I think it spoke to a lot of people in the room who, from different positions, were feeling similarly beleaguered and were grateful that someone had spoken her fatigue out loud. Following the editors' advice, I have tried to retain some of the performance elements of the original presentation while also incorporating reflection and feedback, some of it from other speakers' references to the presentation at the conference itself.

It is important to remember that there was a highly visual component to this presentation, showing a predominance of white subjects in various states of stress or success at work under neo-liberal capital. Next to this visibility of the racial dominance of whiteness in the images that I showed, the silence of my spoken text on whiteness in the "bundling" of neo-liberal factors bearing down on women, feminism, and the liberal arts erupted into "spoken visibility," as it were, with the introduction of the draft Equity Audit at the presentation's end. In the act of drawing attention to the glacial pace of change for groups other than white women under Canada's Federal Contractors Program, and by projecting real change into some far statistical future, I spoke difference out loud into the room in ways that made delegates' embodiment differentially present. The silent visibility of my own race privilege disclosed unconscious material at work (in both my presentation and in the world of work), even as I worked to show what "women, feminism, and the liberal arts" were up against under neo-liberalism. The problem, seen in retrospect, was the targeting of neo-liberal economics without explicitly naming and

taking responsibility for the role that the whiteness of liberal feminism has played in propping up, in participating in, and measuring progress by an economy that exploits and discriminates against racialized and other under-classes of women (and) workers.

The presentation remains critically useful as an illustration of business as usual, even as at moments it breaks through to critique. But with the passage of time, and prompted by both the experience of the delivery of the paper and the mixed reactions to it, and subsequently by other work, I have come to recognize that this too, this feeling and speaking of being tired of "the work," comes from a differentially privileged position as a white woman and a feminist in the liberal arts in a university setting, and that I should not let the time–work compression of neo-liberal expectations of academic workers distract me from thoughtful critique and appropriate action that is not all about me. Indeed, as M. Jacqui Alexander noted in her prefatory remarks to her plenary address later in the conference, talk of time as a scarce resource in the academy overlooks the existential dilemma of survival of women workers in global factories, from which theorizing also comes, and that academics need to learn and use.

AUTHOR'S NOTE

Full-page digitized archives of the *Globe and Mail* can be accessed through institutional library holdings using ProQuest's electronic database "The *Globe and Mail*: Canada's Heritage from 1844 [to 2007]." To view the images described in this chapter, search this online resource for article title, date, and page number (see notes 8, 14, 15, and 17 for publication information).

NOTES

1. These social services are being provided almost entirely by women employees: they are overwhelmingly the majority of the program counsellors, disability counsellors, and psychological counsellors, and just as overwhelmingly the personnel hired to operate Human Rights and Equity Offices, usually at the margins of the university's work, are racialized; see, for example, Mojab.
2. Andrée Côté, Urgent Call to Action. Email message from NAWL/ANFD to PAR-L distribution list, October 12, 2006, n.pag.

3. NAC Condemns Changes to Status of Women Canada's Mandate. News release by email from National Action Committee to PAR-L distribution list, October 12, 2006, n.pag.

4. Just to be clear: I believe universities should be accountable for monies invested in them, but accountability engages values other than money alone. I believe that taxpayers (among whom are university faculty, staff, administrators, and students) should also be accountable to universities for sustaining, not starving, universities' capacity to deliver quality public goods that exceed the financial bottom line. The promise on which so many young people "bank," that education will improve quality of life, will become increasingly empty if the redistribution of wealth (including education itself) ceases to be a value and valued as a public good.

5. With suitable irony, the conference was held in the Stollery Executive Development Centre, 5th Floor, Business Building. Asha Varadharajan reminded us later in her plenary paper that such binarizing (Arts vs. Business) is resolutely unhelpful because the business I am in is not (only) "out there" but (also) "in here."

6. I addressed this issue in another conference venue; see Pennee, "Pedagogies." For a book-length treatment of the subject, see Menzies.

7. "Congratulations to these recent appointments." Report on Business, *Globe and Mail*, 23, no. 2 (October 2006): n.pag.

8. Janet McFarland, "Female Directors Need Apply," *Globe and Mail*, October 10, 2006, B1, B4.

9. Ibid.

10. Ibid.

11. Ibid.

12. Ibid.

13. Ad in Canadian Business, *Globe and Mail*, October 10, 2006, B4.

14. Wallace Immen, "Mission Accomplished—By the Book," *Globe and Mail*, October 6, 2006, C1.

15. Ibid., C2.

16. Judith Timson, "Goodbye Cruel World, I'm Going to Work," *Globe and Mail*, September 27, 2006, C5.

17. Ibid.

18. "Performance Indicators and the Humanities and Social Sciences." Project report prepared by Donald Fisher, Kjell Rubenson, Kathryn Rockwell, Garnet Gosjean, Janet Atkinson-Grosjean, n.pag. Centre for Policy Alternatives in Higher Education and Training, UBC, September 30, 2000.

19. "Ontario: A Leader in Learning." Report and recommendations. February 2005. n.pag. Prepared by the Honourable Bob Rae, Advisor to the Premier and the Minister of Training, Colleges, and Universities. http://www.edu.gov.on.ca/eng/document/reports/postsec.pdf (accessed February 18, 2010).

20. Ibid., 10.

21. "The White Paper: The Lighting of a Fire: Re-Imagining the Undergraduate Learning Experience." Office of the Provost and Vice-President Academic, University of Guelph. November 14, 2005. n.pag. http://www.uoguelph.ca/vpacademic/whitepaper/ (accessed February 18, 2010).

22. The postcard campaign, "Ivory Tower Feminist Audits: Selected Indicators of the Status of Women," was first created and compiled by Drs Wendy Robbins and Michèle Ollivier, with assistance from CAUT and Statistics Canada, with updates reproduced and circulated in print form each year (and web-archived) by FedCan through (on average) 3,500 delegates' packages, beginning in 2001. In a postcard-sized report, this feminist audit charted rates of change for women in the Canadian academy as measured through such statistics as the numbers of women vs. the number of men in part-time, assistant, associate, and full-professor positions; statistics on the "gendered wage gap"; on the academic "baby gap," etc. In spring 2006, the postcard circulated data for women and a range of other equity groups, under a new title, "Feminist and Equity Audits," as a newly constituted FedCan Women's and Equity Issues steering committee sought to broaden the reach of the former Women's Issues portfolio of FedCan, and as the FedCan Board advised that however ironically intended, the use of the phrase "Ivory Towers" was just too risky in a climate so clearly unsupportive of post-secondary education as a publicly-funded good. See http://www.fedcan.ca/english/issues/issues/audit/ for archived pdf copies of these audits; see also "Narrowing the Gender Gap."

23. See, for example, "Response by the CFHSS to the Fifth-year Evaluation of the CRC Program" and "Alternative Fifth Year Review of the Canada Research Chairs Program."

24. "REAL Women of Canada," n.d., http://www.realwomenca.com/ (accessed February 18, 2010).

25. I include this draft equity audit because at another conference, a year after "Not Drowning But Waving," Aruna Srivastava asked if I had published this draft anywhere. When I said no, she quietly reminded me that to not go public with this draft was to leave work undone. While CFHSS has not published Equity Postcards since the Postsecondary Pyramid (Equity Audit 2007), the work of addressing a fuller spectrum of equity issues, including women's issues, continued with specific programming through the Vice-President, Equity Issues portfolio, in my final term of service on the executive, and in collaboration with Dr Malinda S. Smith, whom I first met at the "Not Drowning But Waving" conference. The Equity campaign has continued more robustly since Malinda was named Vice-President, Equity Issues, CFHSS (in November 2008). See the FedCan.ca website for work on equity issues.

26. "A Partial Picture: The Representation of Equity-seeking Groups in Canada's Universities and Colleges." CAUT [Canadian Association of University Teachers] Equity Review No. 1 November 1, 2007. 4 pp. http://www.caut.ca/uploads/EquityReview1-en(2).pdf (accessed February 18, 2010).

School/work, Home/work

Academic Mothering and the Unfinished Work of Feminism

SUSAN BROWN

MOTHERING IS VEXED. LIKE SEX,[1] mothering is ideologically overcharged because it is one of the areas that is supposed to compensate for the alienation of post-bourgeois life—all the more, perhaps, because it is specifically gendered. It brings to bear all the ideology of "nature" on the female body and, no matter how well versed we might be in social constructionism and anti-essentialist theory, it subjects women to technologies and social practices that "naturalize" the maternal at every turn. Femininity and mothering are conflated, and constructed socially into the institution that Adrienne Rich identified as "motherhood."[2] As a result, addressing mothering within the university feels uncomfortably complicit with promoting a conservative or essentialist version of femininity that gets all too much press and ideological support as it is. When second-wave feminism sought to divorce women's identities from reproductive ability, it made the academy a space more hospitable

than most to women who of choice or necessity are not mothers. The academy is that rare context in which women are not regarded as females *manquées* if they do not have children, a context that at its best valorizes myriad complex subjectivities.[3] We have been less successful thinking through the complexities and needs of women who *are* mothers as well as academics.

Nevertheless, that is what I hope to do here, in a small way: to begin to unpack the intense affect[4] of strain that attaches to mothering in the academy, the "significant tension" that infuses, not only for me, being a mother and an academic feminist of an uncertain generation, one who is heir to the second and treading on the heels of the third.[5] This essay is my attempt to understand why my relatively privileged position, personally and institutionally, feels at times impossible, and why those very feelings have felt opaque and intractable to analysis, suggesting deep contradictions in subjectivity and institutional relations.[6]

I don't really think we can pin it all on the second wave. The first has much to answer for, insofar as women of the bourgeois form of feminism that was organized from the 1850s invested their hopes for women's movement into public life and remunerative labour in a combination of education and entry into the professions, including the expanding education and public service sectors. Early British feminists such as Mona Caird responded to conservative claims, such as Eliza Lynn Linton's assertion that "the raison d'être of a woman is maternity," with a call to help women "modify the treadmill," a call taken up by, among others, U.S. birth-control activist Margaret Sanger.[7] So second-wave feminism, with its equation of reproductive control—tantamount to wholesale rejection of a private, domestic sphere metonymically linked to motherhood—with the freedom to work, is really only playing out the implications of these earlier priorities. The political unconscious of the mainstream women's movement is bourgeois liberal economics. One of its primary legacies, despite challenges by bell

hooks and others to "feminist devaluation of motherhood and overvaluation of work outside the home," is the idea that pleasure, fulfillment, and a sense of identity are to be found in remunerative work.[8] Labour, figured as career or vocation, is heavily sedimented with meaning, progress, and identity formation. Certainly as a young woman I bought strongly into that notion that, despite the language of "choice," the choice was clear, since motherhood did not equal fulfillment, a conclusion reinforced for me personally by my observation of my frustrated-artist mother.

Entering the academy at the time when many institutional battles in Canadian universities—to establish feminist courses within humanities disciplines, create programs such as women's studies, institute equity in hiring policies and practices, and foster the movement of women into administration—were being led by women roughly a generation older than myself, and being situated, moreover, as a feminist at that site where higher education meets employment, it seems to me unsurprising that my relationship to academic labour should be overdetermined in some quite particular ways, and in ways that my later movement into mothering put under intense strain. One was identity: because mothering is so ideologically freighted and bound up with the history of women's movements, this transition might well be difficult for most feminists, but to me it felt like a kind of absolute contradiction to my identity as a professor. Over the long haul, however, the most intense strain has had to do with my difficulty in thinking through and managing my labour as an academic, by which I mean when I do my academic work, where I work, how I work, and how much I work in conjunction with mothering.

It's hard to crystallize my relationship to my job and to my mothering, because they seem constantly to be shifting in themselves and in their relationships to each other. The spectrum is invoked, however, in the contrast between two relatively early moments. The first occurred when I was abruptly called from my

office, once more, to pick up my year-old infant from the daycare, which was suffering from a run of gastrointestinal viruses and had to send home all infants because of ministry guidelines. My resentment at being called away from work to collect an asymptomatic child from the outfit that I would continue to pay for childcare while I also cared for my child at home while stressing about work—all this evaporated swiftly into gratitude for the flexibility of my employment as I saw another mother, in tears, collecting her child, saying "I'm going to lose my job," and I contemplated what it might mean to have my work hours regulated by a punch-clock. And yet—I still sometimes fantasize about a kind of employment that would free me from deciding whether I can read another bedtime story or, no, I really ought to tackle my prep for the next day while my eyes can still focus, or whether a weekend activity with children who are growing up way too fast has to be foregone in order to finish a batch of grading or an overdue article. Or even of a job that didn't feel like it was in competition with my identity as a "mother" but was merely (if annoyingly) there to pay the bills. As for many, I believe, becoming a mother was for me an almost traumatic experience, as the identity founded largely on individualistic and institutionalized public activities as an academic was shoved aside for one that had to be built in negotiation with the socially lauded and mythologized yet drastically disorienting, sleep-deprived, privatized experience of having another creature radically dependent on me.

A second crystallizing moment as an academic mother occurred at home when I informed my five-year-old that I would be away for a couple of nights for a conference, carefully answering questions about why I had to go and the relationships of conferences to my job, to be told emphatically, "The day you quit your job will be the best day of my life!" The denouement was calling home the next day to learn of the cracked head and trip to Emergency resulting from a chair-tipping incident at school. It was a good

conference, but one in which I felt mightily torn, as I always do on parting from my children for sustained periods, given that one of the many joys of children for me resides in the quotidian of daily routine and interaction, the sense that I am "there" for them. Still, paradoxically, I've elected to take up a "split" academic position—a secondment to a university four hours away by plane—that requires me to part from them regularly, because I also find such time a source of real pleasure, intellectually and socially. How interesting that Rich's characterization of the experience of motherhood as ambivalence seems no less true three decades later for someone who has reaped a substantial share of the harvest of second-wave feminist transformations.

There are other points that stand out as emblematic of institutional factors. There was the jaw-dropping moment when a tenure and promotion committee—composed in part of myself (junior and childless), a mid-career feminist mother who vocally denied the right of the university to claim her time for scheduled activities beyond regular business hours but whose 11 p.m. emails testified to the length of her workdays, and an accomplished senior scholar who had worked in a contractual position for much of her academic life while raising children—was invited by the chair to congratulate, in our formal assessment, a highly published male colleague, whose partner was underemployed and doing most of the hands-on childcare, on doing a fine job of balancing work and family. Acknowledging the challenges of work–life balance in this case, when it had not been mentioned in assessing female colleagues, and never in assessing the mothers who were present, seemed laughably perverse. Another moment that has given me an outside perspective on the tolls of academia on feminism took the form of a question put to me years ago by a service-sector friend: "What is it with you academic women?" The implication that so many of us get pulled away from activism by the conditions of our work has reverberated as the little activist engagement I was previously able to

sustain has been pushed entirely aside, along with other pursuits that also fuelled me and sometimes even basic self-care like fitness, since becoming an academic mother.

The vacillations and ambivalences I am exploring here partake of larger patterns and problems related to the position of professional mothers in late-capitalist Western societies. Rich's insights into the basic cultural contradictions of mothering have been further explored in reflections both popular and scholarly, in print and increasingly in the blogosphere, including Sharon Hays's probe into the increasing insistence over the course of the twentieth century on "intensive mothering."[9] This construction of mothering not only adopts the prevailing western view that child-rearing should be done by individual mothers of their own children despite the fact that a majority of mothers work, it also insists that mothers devote "a tremendous amount of time, energy, and money"[10] to constant and selfless nurture of their children in a "fragile and precarious" opposition to capitalist values of rational self-interest that intensified through the 1980s.[11] Whereas in my childhood suburban children were typically turfed out of the house to play independently all over the neighbourhood after school and in the early evenings, in building sites, along streams, and in woods, today such parenting would be considered neglect. We are now expected to walk or drive our children to school where they once would have walked independently, to arrange playdates where they would once have found each other outside, and to "program" them to the extent that almost all their time is structured and we are constantly ferrying them from one activity to the next. The rest is "quality time," at home with us. In what one hopes is an extreme and American example, a friend of mine was reprimanded by a police officer, and told her she would be charged next time, for being inside while her children played in the front yard of their house on a dead-end street. How is such mothering to be reconciled with the fact that in Canada, as of 2004, women constituted

nearly half of the workforce (47 per cent), and 65 per cent of women with children under three years of age and 73 per cent of those with children under 16 worked?[12] Clearly there is a strong backlash element in the continuing stress on specifically maternal (as opposed to parental, social, or governmental) responsibility for children's well-being and development, as well as an attempt to make women responsible for compensating for the impact of larger social ills.[13] At the same time, the ideology of the stay-at-home mom as the mother superior inclines most of us who work, I believe, to strive to prove to ourselves and others that our children are not being shortchanged. This means that women are less likely to resist such pressures if the form of resistance would be construed as actively neglectful (turfing them outside to play) or disadvantageous to the children (underprogramming them), making us complicit, to greater or lesser degrees, with backlash constructions of motherhood.

The division between the personal and the political has remained largely intact in our society and our institutions, with the boundaries merely shifting slightly or being more strenuously policed in relation to, for instance, intimate relationships between colleagues or between instructors and students. As far as mothers who are academics are concerned, a major advance in Canada is that maternity leave has been extended, in part by university benefit plans for tenure-track or tenured employees but in larger part by the state. Employment Insurance provisions cover a year of parental leave, and most universities top up that amount to close to full salary for about thirty-five weeks. Parental leave, permitting the other partner to take a period as primary care provider, is available to many under the Employment Insurance (EI) provision, and some employers, including universities, provide further parental leave benefits. Within most universities, the tenure clock can be stopped for the duration of a parental leave. These measures don't modify the boundary between the domain of work and the personal

terrain of mothering, but they do reserve a space in the former for a mother, if she decides to return to her former job within a certain period, and they go some distance toward compensating for the economic losses involved in taking leave.

Such advances should not be underrated. I recall the dramatic story of how one of my friends was born surreptitiously: his mother, who worked in a science lab at a university (becoming a professor apparently not being an option), hid her pregnancy beneath her lab coat, had the child on the weekend, and returned to work on Monday. In contrast to Canada, many universities in the United States have minimal or no maternity leave, forcing women to return to work within a few weeks of giving birth. At the same time, many mothers in the Canadian academy, especially those outside the professoriate proper, face major struggles. Contractual employees, while possibly eligible for Employment Insurance maternity leave, receive no additional benefits and may jeopardize their seniority and thus access to future courses if they cease to teach for a period. Most receive no accommodation for pregnancy. Graduate students and postdoctoral fellows have few resources on which to draw: their income does not usually count toward EI parental leave eligibility, and there are few institutional resources available for them beyond taking leave without stipends or trying to progress through their programs as if nothing were happening. It remains true that there is no optimal time for a woman on an academic career track to have children, and that many smart, talented, motivated women who do so earlier fall off that track.

At the same time, though, I would have liked to experience maternity leave. My first was officially inaugurated by an argument with an official in the EI office about when I had stopped working before having the baby on the Monday. The previous Sunday afternoon, I replied, when I wrote a reference letter. But this caused a difficulty with something to do with how work weeks or pay periods are calculated, so although we had a brief skirmish over whether

how I was filling in the form was "true," I believe we settled on making it the previous Friday afternoon when I had attended a painful meeting over hiring. This incident stands in for me for the large disconnect between the conditions of labour in the academy and the measures that are supposed to address the arrival of a child in one's life. Although I was grateful for relief from teaching and (most) administrative responsibilities, I don't feel like I really did leave my job. As a mid-career tenured academic, I was deeply involved in a collaborative research project that quickly drew me back in. Although my burdens were certainly lightened by others, I continued to read for research purposes (futile, since mommy brain and fatigue led to almost total amnesia), and generally kept up with email and some administrative activities (such as reference letters and reports for performance assessment) that felt unpostponable or that I elected to retain (such as research project supervision). The experience made me better understand and sympathize with the stance (unpopular with many feminists on campus) of one of my colleagues at Guelph, engineer and later Graduate Studies dean Isobel Heathcote, who had caused a furor by declining to take a (second?) maternity leave. And although some are better than I at drawing boundaries, I suspect the overwhelming majority of academics on maternity leave feel pressure to keep up some degree of research activity or at least try to "keep up with the field."

The flexibility of an academic job has great advantages. Yet the erosion of the home–work barrier in relation to academic work is already so great—considering that weekly work hours for most tenure-track or tenured professors are well in excess of thirty-five hours per week, and that many prefer to do certain kinds of work such as writing at home where we are free from the interruptions common at the office—that the question of how to wrest time away from schoolwork for veritable homework becomes a puzzle. Loving one's work means that, for many of us, home life as well

as office life is often already permeated by work-related activities, and in the wonderful wireless world of constant communication and convergent technologies we are always plugged in, always potentially on call. This has meant for me not only feeling psychically split between the two identities of academic and mother, but practically always, on the domestic front, feeling torn between mothering activities and academic activities, because there is virtually no divide between professional and domestic time and space. The confusion of job satisfaction with total human fulfillment is at least as damning as the myth of total womanly fulfillment in motherhood. It means that professional academic life becomes ambient and voracious. As valued as non-remunerative and leisure pursuits might be personally—even socially, when linked to consumption—their claims suffer when placed in direct competition with professional demands that are infinite. The impact of feminism, combined and aligned with the expanded workweek and erosion of home–work boundaries by a late-capitalist labour ethos and electronic technologies,[14] produces a sense of irreconcilable strain in my situation as an academic and mother, undeniably privileged as that position is in terms of class and job flexibility. One of the biggest adjustments to being a mother in atomistic western culture is the consciousness of being always "on call"; in the case of academic women, this gets layered on top of work that already makes one feel, if not on call, always "on," always having to strive to meet those amorphous, internalized professional expectations.

There's an interesting parallel. Mothering is characterized as non-alienated labour, not covered by classical political economy or counted as part of domestic national products. A major source of strain in the transition to mothering both existentially and daily results from the transition from waged labour, which our society tells us reflects our self-worth, to non-waged labour that our society simultaneously denigrates on these terms and elevates ideologically as a self-less vocation. Likewise, academic life is supposed to

be fulfilling on its own terms, valued as an intellectual calling, a life of the mind, not the waged labour it undeniably is. Remember Virginia Woolf and the scholars strolling the grass at Oxbridge in *A Room of One's Own*? That vision seems laughably far from all of us now, not only because there was no place for a woman on that grass, let alone a breastfeeding woman, but also because one doubts those fellows and scholars were answering emails for a couple of hours every day, typing their own CVs and letters of reference, grant applications and reports, lectures, and publications, shopping for and cooking their own meals, or washing theirs and others' dishes and clothing. Some married ones even had live-in research assistants and co-authors whose names never made it to the title pages of their works.[15] The difficulty of mothering in the academy is a result in large part of the difficulty of working in the academy, and particularly of working without the support systems and unwaged labour that underwrote the model of the heteronormative single-income male professor. We have jobs in which there is no limit to what can be accomplished, increasing workload demands, and work speed-up. When you add to this the demands of children and housework, still on average met more often by mothers than fathers, the situation feels untenable.

So while "flextime" and the technologies that support it help many women by making it possible, for instance, to work from home on children's sick days (provided they do not need to be rocked around the clock, of course), they also make every day, every hour, potential worktime. Doubtless it was in the past possible and, because of social and institutional structures, highly desirable for western women to work at home—historically this prompted the incursion of women into the field of writing when it became remunerative—but before the advent of email we were less vulnerable to a sense of urgency outside of normal work hours. As a Victorianist aware of the structural problems that home–work posed for women in the nineteenth century, I am struck that the pre-eminent

coping strategy of academic mothers is that of sleep deprivation.[16] This is hardly historically innovative, desirable, or equitable. The inadequate perception of mothering as a lifestyle choice or leisure activity leads precisely to such deplorable privatized responses. Mothering is usually a choice for academics, and should be for all. But to conceive of it therefore as the equivalent of a personal interest or hobby is to fail to recognize the extent to which mothering (and though by no means as often as it should be, sometimes fathering) is not simply an all-absorbing and, for many, transformative activity that takes over leisure hours and displaces, at least for a time, most other activities. It is also work: the hugely time-intensive work of attending to the needs of one or more physically and emotionally dependent human beings.

I realize of course the irony of lamenting the erosion of the home–work or private–public divide, since that divide is precisely at the root of the problem of how women and their labour continue to be socially and ideologically constructed, but it is an index of how much feminism still needs to grapple with in figuring out how to reshape culture. I realize, too, the irony, in the wake of Lee Edelman's analysis in *No Future*, of the extent to which the figure of the child is linked to "reproductive futurism" and the maintenance of coherent social relations, including the antifeminist discourses of the anti-choice movement.[17] But these are the very contradictions I think are producing the strange disconnect between the privileges and satisfactions of academic jobs and the intense sense of strain associated with mothering in the academy. As the Public Feelings project emphasizes, critical consciousness may be out of step with affective experience, and new modes of engagement may need to emerge where conventional ones have proven wanting.[18] In this case, although feminist theory has for more than 150 years tried to bridge, dismantle, rethink, and reject how women are positioned by economic theory, female academics are interpellated by

institutional and economic structures in ways that make mothering and academic work feel incommensurable.

The structures of academic institutions and of society mean that academic mothers are faced with a limited number of unacceptable choices:

1. Engage fully in a career—in which escalating workloads are normalized and incompatible with mothering (as opposed to maternity) to the extent that much of the work of the latter must be outsourced to other, less economically privileged women who regularly work beyond regulated daycare hours and policies.

2. Pursue a "balanced" life—by taking time away from the academy. This usually means not working or working a reduced load, often in a contractual capacity, since universities have no workload accommodations for mothering beyond initial maternity leave and subsequent crisis-oriented absences, such as stress leaves. It could also mean "coasting," by doing minimal work from the safety of a tenured position, and incurring resentment from colleagues who are always already inclined to suspect that they have to pull some of the weight of colleagues who are mothers.

3. Try to do both at immense cost.

Other options need to be created. Toward the end of World War II, when it was crucial to attract working mothers to the workforce, some communities established daycares to alleviate the strain that even high wages had been insufficient to counter: they not only cared for children during women's factory shifts, they also prepared evening take-home meals and other services, and one in Baltimore packed lunches for schoolchildren, shuttled children to medical and other appointments, and provided laundry services.[19] This is an indication of the kind of restructuring of the conditions

of labour that becomes possible if a community is truly motivated to take the needs of working mothers into account.

Being a mother within the academy is only one of the most common situations wherein the extent to which the detached, disembodied, individual remains the normative model of the academic becomes apparent. Caring for acutely or chronically ill or aged family members, or struggling with chronic illness or disabilities are others. All such situations must drive home the extent to which women are admitted to the academy insofar as they mimic men of a particular type. The academy has not changed significantly in its operations—except perhaps with regards to workload increase and work pace speed-up as the status of the academy has fallen, perhaps not coincidentally as the proportion of women in it has risen—and women, albeit in increasing numbers, have accommodated these changes as best they could. This is not good enough.

Most Canadian universities have neither child-care nor elder-care benefits, nor accommodations for staff or faculty, nor well-developed provisions for dealing with situations of prolonged personal strain that many face. This prevailing atomistic model of the academic means that individuals reeling under the impact of such situations, and administrators when willing to try to alleviate the strain within current structures, bear the burden of attempting to work under a one-size-fits-all model of workload assignments and career patterns. I suspect virtually every academic suffers under these conditions at some point in a career, but women suffer more, since they still, on average, shoulder a disproportionate share of child care, elder care, and maintenance of family support systems at times of crisis.

Betty Friedan, having been a major force in the second-wave bid for women's employment rights, maternity leave, child care, and abortion, argued towards the end of her life that the dominant paradigm in employment was still, problematically, based

on the normative model of the single-income married man: "jobs, career lines, training and professional advancement are all still based on the model of the employee with a non-working partner who takes care of life's details."[20] Although female access to and rates of participation in employment sectors that were previously closed to them have improved, not a lot about the conditions of labour has been changed by feminism. The point needs to be taken seriously. More than one very talented female graduate student has decided to forego an academic career because of the punishing hours and obsessive work habits they observe in faculty members. As members of a supposedly peer-regulated profession, feminists need to revamp the conditions and meaning of labour. An index of how hard our historical baggage makes this is the fact that the most prominent engagement with mothering in academic feminist theory, the mother-daughter debates, reflected Oedipal patterns. Because both our history and conditions of labour are imbricated with those of society at large, we need to move instead toward considering interventions that seek to rethink the meaning of motherhood. We need to do so in opposition to mainstream culture, and if not in opposition to, then at least in alert tension with the feminisms and appropriations of them that have intensified the contradictions I am outlining here.

Will mothering be seen, historically, as one of the things that separate second-wave and third-wave feminisms? I don't know about demographics, but impressionistically it seems likely. If I belong to a wave, it's that 2.5 wave that Julie Rak and Phil Okeke-Ihejirika explore elsewhere in this volume. As the first woman in my academic unit in ten years to have a child, and someone who looked at the mentors in the generation immediately before me and perceived that many academic feminists had chosen (or felt they could but choose) a career over family and children, I see a different relation to mothering marking a shift in feminisms.[21] More seem to be having children at younger ages. Like

critiques of weddings and debates over bras or lipstick, the struggle over whether or not to have kids seems to have receded for the current generation of junior academics. This is not to say that it isn't hard, for the reasons I've outlined, once children are on the scene, but my impression is that the willingness to choose between children and career is dwindling. The parallels with other kinds of consumption seem hardly incidental. Commodification and the production of subjectivities in dialogue with media and the market—even if it is a knowing engagement with an alternative media and market sectors[22]—seem to me to differentiate current and earlier forms of feminism. I witnessed between my first and second child what happened as capitalism found a market niche in hip mothering, and it seems to me quite possible that this shift may be helping to underwrite a new sense of entitlement to and new possibilities within mothering among younger women.

In the context of the question of "waves" of feminism, I am prompted to ask, can this "new" feminism help to address the persistent contradictions I've posited here as the source of my ambivalence? Perhaps. Here's why: if this "wave" is concerned in many respects with a different relation to commodification, there are indications that this may also be linked to a shift in relation to labour. Articulation of a movement through "leisure" activities seems foreign, indeed retrograde, when assessed according to the terms of the over-work ethic I have described, but that might actually be the point. Among the aspects of mothering I have found most liberatory and transformative is precisely the fact that I can't work all the time: that despite my sense of needing always to work more, I have to take time to focus on other things. Might the embrace of feminine and domestic activities, from knitting to mothering, be a reaction to changing orientations of women to labour? Might it also reflect a perception that being a working woman in contemporary society, including in the academy, still means playing a mimic man, and a playful insistence (how

retrograde or not remains to be seen) that sexual difference must out? Despite many attempts to think beyond the notion of separate spheres, the private–public divide has not been worked out, in large part because the economic systems that structure our world give us no way to straddle it, even as the distinction is blurred everywhere in practice.

Whether "third-wave" feminism is a solution or a symptom, its differences highlight for me a set of significant contradictions—ones that we continue to live through and in—in academic feminism. These contradictions are rooted in the mainstream feminist movement's adherence to the assumptions of classical political economy and its foundational division of the world into private and public spheres, in which reproductive labour belongs exclusively to the private while productive, remunerative—literally, valued—labour is public. If the political has, with this latest version of feminisms, swung back toward the personal, that just might be a good thing, because the personal needs serious attention. In the spirit of the "stealth feminist" and queer Public Feelings project, we need to undertake "a broad-based effort to reimagine political life and collectivity" to renegotiate the persistent boundaries of the personal and the political.[23] Tackling the uneasy lived relations between labour and mothering, within and beyond the academy, is an essential component of this long overdue project. Feminism has its work cut out for it.

NOTES

1. Lenore Tiefer, *Sex is not a Natural Act, and Other Essays*, 2nd ed. (Boulder, CO: Westview Press, 2004).

2. Adrienne Rich, *Of Woman Born: Motherhood as Experience and Institution* (New York: Norton, 1976), xv.

3. Karen Ramsay and Gayle Letherby, "The Experience of Academic Non-Mothers in the Gendered University," *Gender, Work, and Organization* 13, no. 1 (2006): 25–44.

4. On the concept of affect in recent feminist and queer cultural criticism, see Eve Kosofsky Sedgwick, *Touching Feeling: Affect, Pedagogy, Performativity*

(Durham, NC: Duke University Press, 2003), Ann Cvetkovich, *An Archive of Feelings: Trauma, Sexuality, and Lesbian Public Cultures* (Durham, NC: Duke University Press, 2003), and Lauren Berlant, *The Female Complaint: The Unfinished Business of Sentimentality in American Culture* (Durham, NC: Duke University Press, 2008).

5. L. Wolf-Wendel and K. Ward, "Future Prospects for Women Faculty: Negotiating Work and Family," in *Gendered Futures in Higher Education: Critical Perspectives for Change*, ed. B. Ropers-Huilman, 111–34 (Albany: State University of New York Press, 2003).

6. My reflections on my own situation cannot represent those of all mothers working in the academy—of working-class mothers, mothers of colour, student mothers, lesbian mothers, for instance—but I hope it points to some persistent factors that inflect the relationship between mothering and feminism in the academy in ways that might allow us to approach it differently. Nor does my perspective deny the important scholarly work done by many feminists, including those of the now defunct Association for Research on Mothering (ARM) at York University, though it does speak to the challenge of assimilating the insights of such research into lived practices, affects, and institutional relations.

7. Susan Hamilton, ed., *Criminals, Idiots, Women and Minors*, 2nd ed. (Peterborough, ON: Broadview, 2004), 161, 268.

8. bell hooks, *Feminism is for Everybody: Passionate Politics* (Cambridge, MA: South End Press, 2000), 76.

9. Sharon Hays, *The Cultural Contradictions of Motherhood* (New Haven, CT: Yale University Press, 1996).

10. Hays, x, 177.

11. Andrea O'Reilly, introduction to *Mother Outlaws: Theories and Practices of Empowered Mothering*, ed. Andrea O'Reilly (Toronto: Women's Press, 2004), 9.

12. Canada, Statistics Canada, *Women in Canada: A Gender-based Statistical Report* (2006): 103, 108.

13. Hays, xiii.

14. On the changing conditions of labour, including the increasing incursion of work into home life, see Maggie Jackson, *What's Happening to Home? Balancing Work, Life, and Refuge in the Information Age* (Notre Dame, IN: Sorin Books, 2002), and Michael Hardt and Antonio Negri, *Commonwealth* (Cambridge, MA: Harvard University Press, 2009).

15. Joanna Russ, *How to Suppress Women's Writing* (Austin: University of Texas Press, 1983), 51.

16. Sandra Acker and Carmen Armenti, "Sleepless in Academia," *Gender and Education* 16, no. 1 (2004): 3.

17. Lee Edelman, *No Future: Queer Theory and the Death Drive* (Durham, NC: Duke University Press, 2004).

18. Ann Cvetkovich, "Public Feelings," *South Atlantic Quarterly* 106, no. 3 (2007): 461.

19. Mary M. Schweitzer, "World War II and Female Labor Force Participation Rates," The Tasks of Economic History, *The Journal of Economic History* 40, no. 1, (1980): 94.

20. Betty Friedan, "Betty Friedan's New Agenda: Apply Feminist Ideals of Equality, Fairness to Men as well as Women," Press release. December 1, 1998. n.pag. http://www.news.cornell.edu/releases/Dec98/Friedan.interview.PR.html.

21. Anne Innis Dagg and Patricia J. Thompson, *MisEducation: Women and Canadian Universities* (Toronto: OISE Press, 1988).

22. See the essay by Groeneveld in this volume.

23. Cvetkovich, 461.

4

What to Expect When You're Not Expecting

or, What Having a Uterus or Even Just Looking Like You Have One Means for Women in the Academy

CECILY DEVEREUX

IN 1996, A YEAR AFTER I defended my PHD, an article appeared in the *Toronto Star*: "Faculties a Man's World," the headline announced, "University jobs climate chilly for women."[1] The article drew attention to a recently published study by Carleton University professor K. Edward Renner, *The New Agenda for Higher Education* (1995), which suggested that, in the mid-1990s, "women still ma[de] up only 22 per cent of the faculty at Canadian universities and only 10 per cent in the sciences." After "thirty years of affirmative action programs at Canadian universities," the article suggested, the study showed "the lot of women" had "barely improved." While that 22 per cent represented a doubling of the number of women faculty in Canadian universities in 1961, when women comprised 11 per cent of faculty, and was thus commensurate with the simultaneous doubling of women undergraduates in the same period, from 26 to 54 per cent, it was still only 22 per cent, a figure not at

that time representative of the fact that more than half of under-graduates at Canadian universities were women. Indeed, as the study suggested, in 1992 "there were exactly the same proportion of women faculty members per female student as there were in 1961." Moreover, as the study indicated and the article reported, women were also "under-represented in positions of power. While 79 per cent of men [we]re in the top two academic ranks [full and associate professors], 52 per cent of women [we]re in the bottom two ranks [assistant and untenured]. Only half of women," the study observed, had tenure, compared to three-quarters of men at the time.

A decade later, figures compiled by Wendy Robbins and Michèle Ollivier for the "Feminist and Equity Audits 2006" of the Canadian Federation for the Humanities and Social Sciences (CFHSS) show that by 2003 women represented 29.3% of full-time faculty at G10 institutions[2] and 33.3% at non-G10 institutions—or around 30% for both, taking into account the greater number of non-G10 institutions in Canada (over and above the thirteen now included in that group). These figures show an increase from 1990, the comparator date used in the "Feminist and Equity Audits 2006," when full-time women were counted at 19.4% and 21.0% respectively. In 2005, according to the CFHSS Equity Audit 2007, the most recent figures available at this time, women comprised 58.2% of undergraduate students at Canadian universities, an increase that alters slightly the proportion of female students to female professors reported in 1992—approximately 30 to 58.2 instead of 22 to 54. While this change marks an improvement, it is also the case that, according to the CFHSS Equity Audit 2007, most of these women are still clustered in the lower ranks of the professoriate: in 2005, in Canada, women represented 48% of full-time non-tenure track faculty, 41.4% of assistant professors, 34.7% of associate professors, and only 18.8% of full professors. In 2007, women represented 13% of university presidents in Canada. Perhaps most startlingly, in 2006,

women held 27.3% of Tier 2 Canada Research Chairs (CRCs) and only 15.8% of Tier 1 CRCs. Ten years later, in other words, the progress of women in the academy remains by and large sluggish, their overall numbers rising only a few per cent, and their distribution through what Robbins and Ollivier represent as the "Postsecondary Pyramid" demonstrating a continued discrepancy between the bottom, densely populated by women, and the top, where women are as scarce as ever.

The question is this: is the slow increase in the numbers of women holding full-time positions in Canadian universities and their disproportionate occupation of positions in the lower ranks cause now, as it was in 1996, for alarm? The figures do not show a *decrease* in the numbers of women and might well function as an indication of continued and gradual change. Indeed, if the numbers continue to rise as they have over the past decade and at the same rate of increase, we can anticipate that in only twenty years women will occupy around half of all full-time positions at Canadian universities. The prospects for expanding the numbers of women at the top, however, remain less promising, at least for the next couple of decades. While we might assume that eventually all the women currently in the lower tenurable or tenured ranks will be promoted, that still leaves us with the prospect of a future in which the highest rank—full professor—will within a decade or so be closer to the 35 per cent mark that currently represents women at the associate level, and that in that period, or somewhat longer, the women who comprise 40 per cent of the assistant level will likewise rise through the ranks and increase the numbers of women at those higher levels. Moreover, although we can anticipate such an increase, there is no real guarantee that all these women will in fact be promoted or that some of them will occupy upper-level administrative positions. Indeed, there is reason, based on the small numbers of women occupying higher academic ranks at this time, and on the terms of the academy as it ranks and rewards

women right now, to anticipate that the numbers will not necessarily change significantly; there is also reason to believe the upward curve of women in the professoriate is actually more fragile and tenuous than it might appear. That is, when questions of gender preference in hiring and promotion are not nearly as prominent as they were during the heated debates of the 1970s and '80s and even into the '90s, when affirmative action is a term rarely heard and often contested,[3] and when established structures of pay equity along gender lines are in danger of being dismantled at the federal level,[4] the prospects for women at this time may not be so much better that women should imagine a future free of gender bias and a career trajectory in which their gender will not be a factor—or, for that matter, that their gender is not a factor now.

Women represent at this time around 30% of full-time faculty in Canadian universities. According the CFHSS statistics for 2004, the most recent numbers available, women earned 87.2% of male salaries at Canadian universities. In 2007, according to Statistics Canada, women in all work categories earned an average of $29,200 per year compared to an average of $44,400 for men, a ratio that shows women earning 65.7% of average male salaries (Statistics Canada—Average earnings by sex and work patterns). Full-time female faculty at the university, at 87.2%, clearly fare better than their counterparts outside of the university—but better is not equal, and 87.2% is not 100%. If women are earning less than men, as they are, and if they number fewer than men, as they do, and if they are occupying the lower ranks within the university hierarchy, as they are, there *is* a problem that needs to be addressed right now. An argument may be made for persistence and patience in the push for a gender balance in the professoriate, or even for an imbalance in favour of the women who comprise more than half the student population—that is, to have the teaching faculty gender ratios actually match those of the undergraduate population. But there is also an argument to be made for continuing pressure

through affirmative action policies to hire more women in universities, and for directing attention to the ways in which the structure itself may still be inherently resistant to both the equal representation and the promotion of women. This resistance is evident in the academic context in ways that are similar to other sectors that likewise concentrate women in lower-paid work and that are also specific to university work. Robbins and Ollivier make this point with reference to the data presented in the "Feminist Audits 2007": "Recent studies," they suggest, "indicate that it is not merely 'lag time,' but systemic discrimination that keeps women from the upper echelons of the academy and other professions."[5]

The possibility rather than the certainty of a continued increase of the numbers of women and their advancement through the ranks, and the probability of systemic discrimination, now strongly suggest it is important to investigate the ways in which the current structure may or may not be adapting to and supporting the continued increase of women's numbers in all positions, and may or may not be facilitating the promotion of women through the ranks—rather than, as the current numbers might suggest, impeding them. It may, in effect, be necessary in the university, as in other sectors, to work toward the goal of balance, rather than assuming it will happen naturally; that is, to identify the nature of the problem and to fix it. Neither of these undertakings is necessarily easy, in part because the problem is pervasive (as is evident by its effects across all sectors in which women are employed) and is thus difficult to see, and in part because it is ideological: it has to do not only with the university as a location for teaching and research, and as a structure shaped by a long history as an institution run by and for men, but with the cultural practices in relation to which the university operates as an institution. If women are impeded in their careers in the university, or are, at any rate, promoted more slowly and less often than men, and occupy fewer positions in upper-level administration, the problem is both institutional and cultural,

something that makes addressing it in the context of the university not less but even more urgent. It is not simply a matter of women being hired, promoted, and paid less than men in the university, but of how gender—or the perception of gender—determines what women can do anywhere. If the problem is to be undone, it is crucial to see it, understand it, and to find ways to address it, in the university and everywhere else.

The problem as it is specific to the university is evident in the numbers of women compared to men, particularly in the upper ranks. This problem has a long history, and it is easy to attribute the current numbers to slow change or "lag time" rather than to current issues; moreover, it is easy to see in this gender imbalance a problem that is similar to what is experienced by women in other fields of work, such, notably, as business, whose structures the university functionalizes in its own administrative practices. The discrepancy between the numbers of male and female CEOs is well established, and the university is *like* business in its similarly male-dominated upper levels, something that likewise has a long history and has been slow to change. To see the problem as it manifests itself in the academy now, however, and to see it specifically in relation to the university's construction of a hierarchy in the professoriate and in administration in relation to conceptions of academic merit—what determines hiring, salary, and promotion— it is useful to consider the radical gender imbalance in the Canada Research Chairs program, where women hold markedly fewer positions than men: not quite 16 per cent at Tier 1 in 2007 and, according to the CRC's own statistics, 25 per cent overall in 2009, or 446 women compared to 1,350 men in September of this year (2009). These figures are particularly important in any discussion of gender in the university now: the Canada Research Chairs were introduced by the federal government in 2000, and these numbers thus represent decisions made *only* in the past ten years, decisions

that clearly suggest the most important work at the highest levels in Canada is being done 75 per cent of the time by men.

The CRC program was created to support the work of scholars who "aim to achieve research excellence in engineering and the natural sciences, health sciences, humanities, and social sciences."[6] These scholars "improve our depth of knowledge and quality of life, strengthen Canada's international competitiveness, and help train the next generation of highly skilled people through student supervision, teaching, and the coordination of other researchers' work"[7]—basically what academics might always be understood to do, with an understanding of how this work in particular can be part of a program that "stands at the centre of a national strategy to make Canada one of the world's top countries in research and development."[8] Like the academy as a whole, the CRC program indicates its commitment "to ensuring access and opportunities to all qualified individuals, while maintaining standards of excellence": "The goals of equity and excellence," the CRC website indicates, "are not mutually exclusive. Equity ensures that the largest pool of qualified candidates is accessed without affecting the integrity of the selection process."[9] Its policy is not, in other words, an affirmative action policy that gives preference to women and other under-represented groups, but one that is based on "equity"—meaning, we can assume, that women and other groups under-represented in the university might be considered in the "pool of qualified candidates." Gender is not specified as a particular equity concern in the statement.

That women do not meet the "standards of excellence" 75 per cent of the time might suggest that they are rejected during the process of adjudication, or it might suggest that they were not in the "pool" in the first place. What it does suggest more clearly, however, is that when universities are collectively assembling the scholars who will "make Canada one of the world's top countries in research and development," they believe women contribute to that

work only 25 per cent of the time. This figure serves compellingly as an index of what women right now might expect to encounter as they work their way through the ranks of the professoriate, situated as it is in a program that has been developed only during the last decade, and revealing as it does a system of measuring merit that has been stabilized for a current program. In this, the CRC program might be understood to be entrenched not only in older ways of thinking, but to be promoting new ways of thinking, about merit, about the value of research, and about who does it best. To put it bluntly, again, the CRC program suggests that men do better and more important work than women three quarters of the time. Its numbers are a little different from those of the university as a whole, where women are around 30 per cent of full-time faculty, but not much. Its measures of "excellence" with a nod to "equity" (but not to affirmative action) may likewise be shared by the university as a whole, and the logic for both is something like this: when "standards of excellence" are the criteria for the position or the promotion, twice as many men as women will get it, and, at the highest level, four times as many men.

Given the principles of equity (that you consider all applicants without reference to matters of race, gender, religion, sexuality, ethnicity, personal history, politics, or physical ability), this figure should indicate that there is a problem either with women—they *cannot* achieve the standard of excellence more than 25 per cent of the time—or with the standards themselves, as they represent a conception of "excellence" that is based on or intrinsic to or supportive of a system within which men typically, in far greater numbers, rise to the top. The possibility that women simply cannot reach the "standards of excellence" in the university as a whole, as top scholars and as top administrators, can thus be understood in two ways. Either the university impedes women's progress, or men are just smarter than women. This latter conception is not new; nor is it, apparently, disproved or outmoded. It is an argument

scientists and scholars continue to make. In 2006, for example, a study co-written by Douglas Jackson and J. Philippe Rushton compared the performance of males and females on the Scholastic Assessment Test.[10] According to Jeanna Bryner in a *LiveScience* post on 8 September 2006, "Rushton and [Jackson] analyzed the Scholastic Aptitude Test (SAT) scores from 100,000 17- and 18-year-olds." Weighting "each SAT question by an established general intelligence factor called the g-factor, they discovered that males surpassed females by an average of 3.6 IQ points,"[11] a difference that, while, as Rushton and Jackson indicate, "not large,...is real and non-trivial."[12] Rushton explains the difference this way, according to Bryner, citing a study that shows "men have larger brains than women, a 100 gram difference after correcting for body size": "It's a very reasonable hypothesis that you just need more brain tissue dedicated to processing high 'g' information." One hundred grams short of the average male, the average female, in other words, doesn't have a hope of getting past that 3.6 IQ point–barrier, keeping her from the highest levels of thinking.

Rushton suggests that "we really do need more research on it before we can be absolutely certain" that men surpass women in intelligence.[13] It is also the case that there may be variables, as psychologist Bruce Bracken notes, that the study does not take into account.[14] One such variable, it might be argued, has to do with the two structural principles reinforced by this study in its use of both the SAT and the IQ measures as its criteria for intelligence. Phyllis Rosser has addressed the inequity of the SAT objectives and questions in *The SAT Gender Gap: Identifying the Causes*.[15] According to Rosser,

> The SAT is biased because, despite its declared purpose to predict how well students are going to do in their first college year, it underpredicts women's college performance. Girls get better average grades in high school and in college than boys, but they

are receiving lower average scores on the SAT. *Unfairly low test scores become a self-fulfilling prophecy, causing girls to lower their expectations and apply to less competitive schools than their grades would suggest. Minority women are doubly penalized. They score lower than the men in their racial groups, who in turn score lower than white men.*[16]

The test itself, in other words, determines the lower outcome of women by virtue of its own emphasizing of "standards of excellence" that, it can be demonstrated, men achieve more often than women. It may, then, not be the case that the SAT and IQ measures show greater intelligence in men, but that the tests themselves are designed to show greater intelligence in men. This, certainly, is Rosser's claim regarding the SAT, and it is reinforced by Rushton's observation that "females actually get better grades than males"[17] in school.

As far as this 2006 study is concerned, however, the point is not to demonstrate that women are not as smart as men "in everyday activities": "For the vast majority of people in the vast majority of jobs," Rushton tells Bryner, "it really doesn't translate into very much." This is, after all, a study of "general mental ability."[18] Where it does matter, he suggests, is at the higher levels of scholarly performance. "When it comes to Nobel Prize winners," he says, "men could outnumber women 10-to-1."[19] This is a problem. For those in the university, even if not aspiring to the status of Nobel Laureates, exercising high levels of scholarly achievement *is* everyday activity; it represents the day-to-day work in relation to which publication records, teaching assignments and release for research, status, promotion, and rank are always measured. On these terms, the prospect of even slow, continued change and a continued gradual increase in the numbers of women in full-time positions and at the higher levels of teaching, research, and administration in Canadian universities looks grim. No amount of work for change,

no implementation of affirmative action policies, and no insistence on the principles of equity can make any difference for women in a world where they might be argued, explicitly, to be less capable than men of figuring "at the very high end of the distribution,"[20] as in the case in the 2006 study, and implicitly, as in the case of women's concentration at the lower ranks of the professoriate and the fact they represent only one quarter of the top-ranked scholars in Canadian universities.

If, however, it is *not* the case that men are smarter than women, the fact of women's continued under-representation at the higher levels of the professoriate and in matters of hiring, pay, and promotion—the systemic discrimination Robbins and Ollivier identify—needs to be understood in some other way. Why, that is, if they're just as smart, aren't more women in Canada full professors? CRCS? university presidents? Answers to these questions are scarce. Although the gender gap is clearly evident in the numbers of women and men in the academy, explanations that do not attribute women's slow progress to their brain capacity or function are difficult to find. It is not unusual in academia to understand the problem to be situated in the system of mutual male support characterized as the "old boys' network," a notion that men still promote men and thus protect themselves and the system. This is possible; but, even if there is such a set of practices in place, it is crucial to understand the logic underpinning it. What, that is, is at stake for male domination on these terms? Does it just feel good? Does it reveal a secret patriarchal conspiracy? Do men generally think they're smarter than women? Do women generally agree, countering their own promotion in support of the status quo? Where, in effect, is the problem, and what is the ideology being reinforced?

If answers in the university context are few, there aren't many more in other sectors where the problem of women's clustering at the lower levels of rank and remuneration is as evident. One recent

suggestion, however, provides a way of understanding the cultural principles behind the resistance of career structures to the inclusion of women at the highest levels. When, in 2005, Neil French, worldwide creative director for the advertising firm WPP Group plc, was asked a similar question—why there aren't more female creative directors in advertising—his response was direct: "Because they're crap," he said. "Women eventually 'wimp out' and 'go off and suckle something.'"[21] French's position, which led to his temporary resignation from the directorship of the firm, was framed bluntly, as Anne Kingston noted in the *Globe and Mail*; however, as one creative officer in a WPP subsidiary in Toronto put it, it was not inaccurate as an index of "the inner thoughts of legions of men in the senior ranks" of that business and, arguably, many others. French's position, or, more precisely, the condition it indicates, is not only a problem in advertising: "It's apparent" in business more generally, Kingston points out, as well as "in politics and academia."[22] That is, the representation of women politically almost anywhere in the world is relatively small. In the academic context, as we have seen, the situation is similarly uneven along gender lines.

If the question, then, directed to French is basically the same for business and academia, and the conditions for women working in these contexts are basically the same, is the answer the same for both? Is French right, or at least accurate, in his representation of a systemic problem for women? Are *all* women penalized in the academic workplace for the *possibility* that they will have babies, or that some women will? This is a very difficult question to answer. On the one hand is the problem that women with children may experience a different set of difficulties than those that women without children may experience in the academy. On the other is the problem that the categorization of all women with reference to a reproductive function, and the suggestion that this reproductive function underpins the clustering of women at lower levels of pay and rank, clearly do not take into account the fact that

women do not necessarily define themselves with reference to a reproductive function. French's argument suggests, however, that whether women do or do not have children, and whether they do or do not see themselves to be determined by biological destiny, this remains, at least in his view, the principle underpinning the demonstrated resistance of hierarchical structures of labour to women's holding higher positions. Anyone who has a uterus, or even appears to have a uterus, has, in other words, the potential to "wimp out" and fail to meet the obligations of a job represented as inherently not do-able without the kind of commitment it is possible to make only without other obligations. The potential, apparently, is enough to justify the exclusion of all women from higher levels.

Although the argument is in itself profoundly silly, since not all women have children, since women with children do not necessarily perform at lower levels than women without or, for that matter, than men, and since it represents an outrageously oversimplified stroke of a biologically determinist, essentialist, and sexist brush, it is nonetheless worth considering whether it is "true" as an articulation of a principle on which labour structures work. But this, too, is difficult to ascertain, since, while the data regarding pay and rank is the same for all women, the data related to women's negotiation of the academic system is by and large to be found in the representation of personal experience. In addition to the inherent problem of personal experience as quantifiable data for the assessment of a condition across a constituency or category, the experiences of women with and without children will differ. The question, then, is whether the experiences of women with children serve to demonstrate a bias in the system that is comprehensible as a gender bias, and, furthermore, if the ways in which women with children find themselves negotiating systemic resistance bespeak a problem that emerges for all women at the point of moving into the upper levels.

This is an important question to raise and one that needs careful attention and greater study, precisely because it does have

significant implications for all women, in the workplace and out-side it, insofar as women continue to be encouraged to have children—thus the contemporary culture of the celebrity mom, the sexy "yummy mummy," and what Susan J. Douglas and Meredith W. Michaels call the "new momism"[23]—and, as the experience of so many women in the workplace indicates, to be punished for having children and working outside of the home. Workplace gender bias may thus exist as a structural principle of patriarchy, not in an old boys' network per se, but in the system's functioning to ensure that women *do* have children by making the balance of work and chil-dren so extraordinarily difficult and by making it as difficult as possible to achieve the highest levels in rank and pay. It seems per-verse that the system might work in this way, rather than, as would make sense, by making it easier for women to have children while working and by making it possible for women to achieve equity in pay and status with men. But the logic of a system in which, after decades of struggle, debate, and affirmative action and equity policies, women continue to earn less and get promoted less, is perverse, and it needs to be understood and undone one way or another. As French's acerbic comment suggests, and as the increas-ing quantity of experience-based data from women with children in the academy demonstrates, this is one way to approach the prob-lem. Experience represents problematic data, but it is a way to interpret statistical data and, as Joan W. Scott suggests, to under-stand what is otherwise inscrutable or outside the received practice of representation: "it establishes," she points out, "a realm of real-ity outside of discourse"[24] and provides the basis for investigating "that which we want to explain."[25] It is thus a way to understand gender bias in a system that makes it difficult, otherwise, to iden-tify the terms of gender bias.

Women who do have children while working in the univer-sity have drawn repeated attention to the difficulties they have encountered balancing work and childcare, and have suggested in

many cases that the conception of academic work as a more-than-full-time undertaking—researching in your own time, marking at home on weekends, preparing classes at night, scrambling to finish papers between other workplace responsibilities—comes profoundly into conflict with the demands of a family, even with the support of a partner and caregivers. A recent collection, *Mama PHD: Women Write about Motherhood and Academic Life* (2008), presents some three dozen personal accounts of women's experience of the challenges of balancing children and academic work. These challenges, at one level, are not significantly different from those experienced by women with children in any other sector, but, because they represent a problem with regard to the perception of women's functionality in the university, as teachers and researchers and committee members, they are also specifically academic and, arguably, germane to the problem of all women as they are collectively excluded from higher levels of scholarly achievement and administration. What these accounts invariably confirm is a system designed for workers who do not need childcare, who can work late, meet late, give up evenings and weekends, take extended research trips, travel to conferences, and devote what amounts to much more than full-time hours to the achievement of a success that is always measured in relation to production made possible only by doing more than is possible in a regular workday.

What the essays in *Mama PHD* demonstrate is that because women, when they are the primary caregivers of children, cannot undertake production on these terms—they cannot do more than is possible in a regular workday—they come to question the structure in ways they may not have done otherwise, or, that is, when they were "simply" women rather than parents. It is not that they necessarily produce less academic work once they have children, but that they become aware of a discomfort in relation to the system that was not necessarily evident when they did not, when they could take more time than a workday allows, and when they

were not required to divide their time between work and children. As the essays in this volume suggest, and as Mary Ann Mason and Eve Mason Ekman likewise indicate in their 2007 study, *Mothers on the Fast Track*, some women choose to abandon the work. Some women continue to struggle, attempting to cope with the workload and with their own combined demoralization, as they begin to feel they are falling short of what is required, and resentment, as they begin to chafe against the system that determines what is required in ways that do not facilitate a balance between children and work. What is clear is that women are aware that the institution punishes them for having children, because children can be seen to impede their academic work. What is also clear is that this punishment is real—women *are* hired, paid, and promoted less—and that it extends across the category of women, who are all together compelled to remain in the lower ranks. More than the missing 100 grams of brain tissue, the possession of a uterus, or the appearance of having one, whether it is used for reproduction or not, is a problem for women working their way through the academic ranks.

Women's accounts of the experience of pregnancy and childcare in the academic context are important, not only for the specific and disappointing workplace experience they detail with remarkable consistency, but for what they indicate about gender bias in the academy. Although the problem of the institution's gender bias is pervasive, it is, experience suggests, arguably made visible in the context of pregnancy and motherhood, when the terms of gendered representation are radically performed in social and institutional space. That is, while more obvious in the context of pregnancy and motherhood, the condition of being female at work is not fundamentally different from the one that was there all along, just as the body that is bearing the child or tending to it is not a different body from the one that existed prior to motherhood. The maternal body may experience the space through which it moves and the structures it inhabits *as if* it were different; but

the consciousness that is produced by the pregnant body—of difference or of strangeness—is different or strange because it makes it possible to understand that space and structure as it actually is. What is significant at the level of experience (in the now slightly quaint and anachronistic second-wave phrase) of the personal as the political is the function and the movement of the maternal body in the institutional space of the university, paired with the catastrophic collisions that are the effect—or the symptom or performance—at the level of the body of what it means to inhabit an inherently contradictory space. By this I mean those moments when a maternal body erupts through a professionalizing exterior and, by virtue of the discomfort of its sudden appearance, emphatically reveals the extent to which it does not belong.

The experience of pregnancy, as many women's accounts suggest, is compelling as a location for the investigation of the problems determining the lower pay and slower rise of women in academic and other institutions, because the representation of femininity in patriarchy is realized at that moment. This consciousness is not necessarily a matter of heightened perception or privileged experience; it is a matter of recognizing that these difficulties are themselves indexical of the condition of uterine femininity. That is, it is not so much the "experience" of a system that is resistant to reproductive women at the moment of reproduction; it is, rather, the recognition of a system that is always resistant to women because of their potential to reproduce. This consciousness is the recognition of a self that is constituted on these terms, not simply at that moment, but retroactively and for the foreseeable future.

This problem is not, of course, biological but institutional. It is, moreover, not unique to the academy, but is socially and culturally pervasive. It arguably underpins the radical discrepancy between the numbers of women and men in Canadian politics, in business, in law, and, in effect, in any profession that understands its own "standards of excellence" to be met only through doing more work

than is possible when caring for children. The maintenance of a profession and a workplace with such "standards" is an index and a performance of systemic discrimination. Using, that is, the old argument that if women can't do it on men's terms they shouldn't be there at all, professions undertake to maintain the structures that exclude women from the highest levels. But if those structures exclude women, *they* are the problem, and they need to change. In Canadian universities, right now, with women at 30 per cent of the full-time professoriate, 25 per cent of Canada Research Chairs, and 13 per cent of university presidents, we need to make changes. We need to reconsider the value of affirmative action in the workplace, to ensure the continuation of the principles and practices of employment equity, to study and assess the criteria for measuring not only intelligence and brain capacity but the criteria for merit assessment in the university, to look closely at what the experiences of women with children tell us about the academic institution, to look closely at the experiences of what women without children tell us about the academic institution, and, if necessary, to radically restructure it. When no one has to ask if having children is an impediment to an academic career, then the "work–life balance" we are all, with or without children, supposed to be finding (and are increasingly supposed to be responsible for *not* finding), and the balance of male and female in pay, rank, and administration, may be real possibilities.

NOTES

1. Elaine Carey, "Faculties a Man's World" *Toronto Star*, September 22, 1996, A6.
2. The G10 institutions in Canada represent a group formed in 1991 "as an informal biannual meeting of university executive heads." Now actually the G13, the universities that comprise the group are as follows: University of Alberta, University of British Columbia, University of Calgary, Dalhousie University, Université Laval, McGill University, McMaster University, Université de Montréal, University of Ottawa, Queen's University, University of Toronto, University of Waterloo, and University of Western Ontario. All other post-secondary institutions in Canada are non-G10.

3. On the ways that affirmative action has been contested in recent years, see, for instance, Doreen Kimura, "Affirmative Action Policies Are Demeaning to Women in Academia," *Canadian Psychology* 38, no. 4 (1997): 238–43. Kimura argues that "currently, women in Canada are being hired in academic institutions at rates *higher* than would be expected from the number of qualified applicants" (Abstract). For a discussion of the ways in which affirmative action is viewed negatively in the business sector, see the *Vancouver Sun*, September 24, 2008, "What Women Want: Board Seats on Merit, Not Affirmative Action." This article by Fiona Anderson suggests that "company heads believe the way to improve matters [for women] is one seat at a time, and not through a quota system mandating more representation" (Anderson).

4. "Bill C-10—Conservatives' Attack on Pay Equity." 40th Parliament, 2nd Session. Edited *Hansard* 011, February 9, 2009.

5. "Postsecondary Pyramid: Equity Audit 2007," compiled by Wendy Robbins and Michèle Ollivier, PAR-L, with assistance from CAUT and CFHSS. Canadian Federation for the Humanities and Social Sciences.

6. "Canada Research Chairs—About Us." Canada Research Chairs, last modified March 8, 2010, accessed February 26, 2009, http://www.chairs-chaires.gc.ca/about_us-a_notre_sujet/index-eng.aspx.

7. Ibid.

8. Ibid.

9. Ibid.

10. Douglas N. Jackson and J. Philippe Rushton, "Males Have Greater *g*: Sex Differences in General Mental Ability from 100,000 17- to 18-Year-Olds on the Scholastic Assessment Test" *Intelligence* 34, no. 5 (2006): 479–86. *Science Direct*.

11. Jeanna Bryner, "Men Smarter than Women, Scientist Claims," *LiveScience* (September 8, 2006). http://www.livescience.com/health/060908_brainy_men.html, November 27, 2009.

12. Ibid., abstract, n.pag.

13. Ibid.

14. Ibid.

15. Phyllis Rosser, *The SAT Gender Gap: Identifying the Causes* (Washington, DC: Center for Women Policy Studies, 1989).

16. Phyllis Rosser et al., "Gender Bias in Testing: Current Debates for Future Priorities," Ford Foundation (New York, April 1989).

17. Bryner, "Men Smarter."

18. Jackson and Rushton, "Males Have Greater *g*."

19. Bryner, "Men Smarter."

20. Jackson and Rushton, "Males Have Greater *g*."

21. Anne Kingston, "Why Women Can't Get Ahead," Report on Business, *Globe and Mail*, November 21, 2005, 57.

22. Ibid., 58.

23. Susan J. Douglas and Meredith W. Michaels, *The Mommy Myth: The Idealization of Motherhood and How It Has Undermined Women* (New York: Free Press, 2004), 1–27. Douglas and Michaels describe "the new momism" as a "set of ideals, norms, and practices, most frequently and powerfully represented in the media, that seem on the surface to celebrate motherhood, but which in reality promulgate standards of perfection that are beyond your reach" (4–5).

24. Joan W. Scott, "The Evidence of Experience," in *Feminist Approaches to Theory and Methodology: An Interdisciplinary Reader*, ed. Sharlene Hesse-Biber, Christina Gilmartin, and Robin Lydenberg, 79–99 (Oxford: Oxford University Press, 1999), 91.

25. Ibid., 96.

5

Things We Gained in the Fire
Burnout, Feminism,
and Radical Collegiality

HEATHER ZWICKER

I WAS RUNNING ON A TREADMILL, literally and figuratively, when I first suspected that my life was out of hand. Even after ten minutes, I couldn't catch my breath. I wondered if I was developing asthma, or having an allergic reaction to something in the gym. My throat closed, my heart raced, and I struggled to gasp enough air. Panic attack.

A few weeks later I blew a breakfast meeting. There I was, flossing my teeth on a Wednesday night and contemplating what to wear to the meeting, when the cold certainty broke over me that today had been the day and I had missed it.

This made me worry a little. I have a mind like a steel trap. I remember PINS and SINS and birthdays and passwords. While other people talk about seeing their life flash before their eyes at the moment of death, I believe I'll just see a single long string of numbers: every ID I've ever had, phone numbers from several

cities, passwords for banking, for email, for eBay, for work, for play. Forgetting things is just not like me. But friends and family laughed it off: "We all forget things," they said, "and it only gets worse." My best friend was the most helpful. She said, "Nobody likes breakfast meetings! You're not losing your mind. Instead, think of it this way: as you get older, your resistance to unpleasantness increases while your susceptibility to guilt decreases." Her explanation gave me a lot of comfort, though it rather underwhelmed the Canada Customs officer that New Year's when I advanced it as the reason I had forgotten my passport.

I figured I had to do something about my stress levels. I set out to find a good yoga teacher. I joined a Monday night class. Then added a Thursday class. And sometimes Saturdays. Come spring, I took up running, swimming, and cycling. There: stress problem addressed. Only it wasn't. When I lost two friends in the same week that summer, to suicide and leukemia, I skidded off the rails completely.

That's when things got colourful. One day I found myself yelling my fool head off at a total stranger in the river valley. The thought bubble overhead—"hmm, that's not appropriate"—propelled me to my doctor, who medicated me. But my humiliation had not yet bottomed out. Toward the end of August, I was out with a friend when a panic attack caused me to pass out. I toppled right off my barstool. As is supposed to be every girl's dream, I came to in the arms of a firefighter who'd been sitting at the next table. He patted my face, saying, "Sweetie, sweetie, come on sweetie, wake up. What's your name? Are you on any medications?" I tried to focus. "Um, yeah, I'm taking Effexor." "And what are you taking that for?" he asked. I'm concentrating hard on the next line: "General anxiety disorder. Effexor is a combination anti-anxiety/anti-depressant drug, a serotonin norepinephrine reuptake inhibitor." "Don't worry, sweetie, we've all been there. How old are you?" "Forty," I said; "Can you believe that? I'm forty years old, and here I am lying on the floor of Suede Lounge."

When had I become the person about whom a bar full of people says, "Be careful she hasn't swallowed her own tongue!"?

DIAGNOSIS: BURNOUT.

Burnout is a late-twentieth-century phenomenon. It's a combination of exhaustion and depression that manifests itself as an inability to continue working. The term refers literally to what's left of a piece of land after a forest fire has ravaged it. It gains its connotations through Graham Greene's 1961 novel *A Burnt-Out Case.*[1] The novel follows Querry, a renowned Catholic architect from Europe, into the Congo. He takes a river boat as far inland as it goes, disembarking at a leper colony where he finds the anonymity necessary for something resembling peace of mind.[2] The novel's first use of the term "burnt-out case" refers to a leper named Deo Gratias, who has lost all of his fingers and toes to leprosy. (Diseases, the leper colony's supervisor Doctor Colin informs us, "burn themselves out" and leave a physical shell behind.) However, as the novel progresses it becomes evident that the truly burnt-out case is actually Querry, who says, "I've come to the end of desire and the end of a vocation."[3] His burnout is spiritual, intellectual, sexual, and vocational. In Doctor Colin's diagnosis, "[Querry] had been cured of all but his success; but you can't cure success, anymore than I can give my *mutilés* back their fingers and toes."[4] So here's an irony of burnout: it tends to be associated with success, but a success that the burned-out can no longer recognize or appreciate.

In the 1960s and 1970s, burnout was primarily associated with caregivers like nurses and clergy. Its institutional recognition took place within the so-called "caring professions"—interestingly, though underappreciated in the literature on burnout, those that are dominated by women. By the early twenty-first century, burnout researchers recognized that the phenomenon can affect every employment sector, from elementary school teachers to investment bankers, fire fighters to academics. Burnout is not just a matter

of hitting a dead end in any given job, but rather an overwhelming sense of the futility of the career itself. In one of the best pieces written on the subject, Jennifer Senior notes that "in a culture where work can be a religion, burnout is its crisis of faith."[5]

Pre-eminent burnout researcher Christina Maslach identifies three critical dimensions to burnout that she cheerlessly describes as chronic: exhaustion, cynicism, and inefficacy. Significantly, Maslach insists that burnout is a consequence of working conditions rather than the predisposition of any individual worker. She actually uses the term *burnout shop* to describe particularly unhealthy workplaces. Indeed, one of the books she co-authored with her research colleague Michael Leiter is entitled *The Truth About Burnout: How Organizations Cause Personal Stress and What to Do About It*.[6] According to Maslach and Leiter's research, what matters most in cases of burnout is the quality of the workplace, the extent to which it fosters workers as whole people. Far less important than the amount of work on your desk, for instance, is how you're supported in doing it, the extent to which you're permitted to "own" your tasks, the amount and kind of recognition your work receives, or how the institution's mission meshes with values you hold.

Certainly there were significant institutional factors in my breakdown. Key among them were rampant cynicism and significant disrespect from colleagues coupled with inadequate recognition and reward, a mystification of my job requirements, a chronic insufficiency of staff and materials to support the work I was required to do, and poor/dysfunctional leadership. But for the purposes of this essay, I want to listen harder to the echoes of Senior's language: "In a culture where work can be a religion, burnout is its crisis of faith." When did "work" become a creed? Why is it we work so hard, even under dehumanizing circumstances? What is it we hope this work will do for the world?[7]

SURPRISINGLY, PERHAPS, these baggy questions are readily answered by feminists and other progressive scholars. Feminist research and teaching take as their immodest goal dismantling a system of deeply entrenched inequities that take shape along the lines of gender, as gender infuses and is infused by race, ethnicity, sexual orientation, social class, nation, and religion. Feminist work, in short, aims at nothing less than changing the world.

I learned how to be a feminist in the heady days of second-wave triumphalism.[8] Women's literary history was everywhere. I cut my teeth in patriarchal classes on the Great Authors—Chaucer, Shakespeare, Milton—with the lessons learned in The Women's Literary Tradition. In those classes, using the impressively hefty and still brand new *Norton Anthology of Literature by Women*, my fellow undergraduates and I learned how to resuscitate minor authors from their historical neglect. We thrilled to Julian of Norwich, Christine de Pisan, and Hilda von Bingen. We raged against our Elizabethan lit professors' ignorance of Aphra Behn. We discovered Anne Phillips, revisited Jane Austen, and mourned the Victorians' need for pseudonyms. Phyllis Wheatley opened our eyes to the idea of race, and we struggled (not always very successfully) to connect her poetry to the themes taken up by Alice Walker, Audre Lorde, and the Combahee River Collective. We learned to read through our mothers.

Virginia Woolf became the poster child for second-wave feminism—or, perhaps more specifically, the postcard child: my late-undergraduate notebooks are covered with the black-and-white postcards of Woolf, Natalie Barney, Vita Sackville-West, and other modernist women writers, hot collection items in 1988–1989. If there were a single blueprint for success in second-wave feminist terms, it would have to be *A Room of One's Own*. With sufficient independence, Woolf asserts, and ample guts, a woman on her own could survive anything. The watchwords are pluck, pride, and

privacy—defiance and self-reliance, in equal measure. Community in *A Room of One's Own* is vertical, historical, a matter of the solitary woman writer identifying the influences that guide her pen and craft her sentence. Woolf's exhortations are to "be oneself"; "see things in themselves"; and "face the fact, for it is a fact, that there is no arm to cling to, but that we go alone...."[9] This lonely road is how we prepare the world for Shakespeare's sister, and such work is ennobling in and of itself. Hence the famous last line of *Room*, with its emphasis on determination and grit: "I maintain that [Shakespeare's sister] would come if we worked for her, and that so to work, even in poverty and obscurity, is worth while."[10]

There is no question that Woolf took her own advice. We are all familiar with the stories of her exacting demands on herself, her writerly perfectionism. She routinely worked herself into a state of exhaustion, what with her own literary experiments, the management of the Hogarth Press, her mentorship of new writers, and the complexities of her emotional and libidinal investments. My undergraduate self was captivated with her model of sole dedication to the world of letters, and I made Woolf's challenge my own. Unremarked in the 1980s was how seamlessly Woolf's advice meshed with the Protestantism of my own background and the demands of university life. "Hard work," as one of my feminist teachers said, "can be salvation." Grad school provided adequate "poverty and obscurity"; as for salvation—well, salvation, vocation—I became a professor.

What we neglected to discuss in my undergraduate classrooms was why, if this work was so very ennobling, did Virginia Woolf ultimately pack her pockets with stones and wade into the River Ouse? Then again, we didn't need to discuss this: "The Yellow Wallpaper" told us why. Women who were prevented from working, women put on the infamous rest cure, would inevitably go crazy. *The Madwoman in the Attic* was less than a decade old, and we were still absorbing its lessons. Madness, we learned, was either a

patriarchal strategy for managing unruly women or a displacement of legitimate feminist rage. According to *The Women's Encyclopedia of Myths and Secrets*, one of my treasured first feminist purchases, madness existed on a continuum with other illicit forms of knowledge—or "sinister wisdom," as the journal of the same name taught us to say.

FLASH FORWARD TWO DECADES. I'm trying to pick myself up off the floor, literally and figuratively. I review my feminist watchwords: pluck, privacy, and pride. Clearly it's too late for privacy or pride; what about pluck? Second-wave feminists are always up for a fight, and we've fought some doozies: the sex wars, the tenure wars, the race wars, the political correctness wars, and the backlash wars. We defended abortion clinics, we marched to end violence against women, we lobbied for child care. My politics have been sharpened by the lessons of stereotype-busting, glass-ceiling-bashing opposition to patriarchy in all its guises.

However, I wasn't up for a fight. I was too tired to fight. Silas Weir Mitchell be damned, I needed to rest. Unable to teach, unable to read, unable to write, unable to function, I was medicated and sent home from work for three months. Three months extended to six. People would ask me how I spent my days and I wouldn't know how to answer. I slept, a lot. I exercised regularly. I hung out with our cats. Although I didn't watch daytime TV (I've avoided it ever since a friend of mine wore a hole in the seat of her pyjamas during a gruesome bout of depression), I did catch up on prime-time phenoms like *CSI*, *Medium*, and *Ugly Betty*. I watched daylight move across hardwood floors. I'd like to say that I contemplated the meaning of life, but I didn't. I napped.

Eventually I started doing some of the things that bring me pleasure. And after coming out in this essay as a madwoman in the river valley, after admitting that I couldn't read Gramsci without crying, I come now to the truly embarrassing admission.

The things that bring me pleasure are quintessentially "girl things"—things like trying new recipes, reading design magazines, shopping. I became the person in my friendships who made the phone calls that others didn't have time to answer. I bagged a lunch for my partner every morning. I planned tantalizing dinners for a Tuesday night, and I redecorated the bedroom. Domesticity became my bliss.

Now, I am not exactly saying that I wish domesticity were my "work" per se. But I am left wondering what we lost when we declared Mary Beton, Mary Seton, and Mary Carmichael better feminists than Mrs Ramsay, with her gorgeous sense of taste and touch, her empathic sensitivity, and her dinner party stewardship.[11] These are not quite the qualities celebrated by third-wave feminism, though the Facebook generation's in-your-face attitude, gob-smacking optimism, and unapologetic consumerism have often evoked my envy and admiration. Mrs Ramsay, like me, and like most professors, I daresay, is too old for *Bust*, too preoccupied to keep up with Kathleen Hanna's projects after Le Tigre, and too over-committed to various research projects to make zines. And none of these third-wave projects is particularly renowned for its compassion, which might be Mrs Ramsay's essential quality, and the thing I most needed after my breakdown.

IN CERTAIN TWENTY-FIRST century circles, we would say that Mrs Ramsay evinces "emotional intelligence." "EI" is a concept bandied about in leadership training and business school textbooks and, in the academy, at the upper levels of administration that are reviled and mistrusted for their "corporate culture." To be sure, there is much to be skeptical about in corporate culture. But what, exactly, is corporate culture replacing in the academy? Some diatribes against corporatization would have you believe that we moved from a golden age of equitable, collegial governance directly into Satan's assembly line. Feminists, of course—say, the plaintiffs suing the

Government of Canada over the disastrous results of the CRC program[12]—know better. What some alarmists presume to be a golden age might more properly be called the old boys' network. A feminist response to corporatization of the academy (or, to be specific, the influence of corporate culture on academic leadership models, for this is not the same as corporatization per se) demands that we analyze the elements of this new leadership culture with care and open minds.[13]

Open-mindedness is key. In some major respects, I believe, contemporary corporate culture is friendlier to feminists and other professors in the humanities and social sciences than old-fashioned models of vocational workaholism. Or, to tone that down a little, at least twenty-first-century corporate culture has a language for compassion. You would be hard pressed, in 2008, to find any corporate documents that do not refer to work–life balance, to mentoring, or to the responsibility of organizations to cultivate "whole people."[14] Forward-looking corporations beyond the academy are increasingly adapting practices like sabbatical into their benefits packages—without the concomitant, if tacit, requirement that you work *even harder* on leave, producing the proverbial cutting-edge scholarship, than during a regular teaching term.

While corporations are no further ahead than the rest of our society in understanding the relationship between mind, body, and spirit, there is at least an administrative language for understanding these as dynamically related, yet distinct, aspects of people's lives—distinct from each other and distinct from the workplace. Compare that to the moniker "my work" within the humanities, an appropriative phrase that makes academic labour the seat of intellectual, political, and often spiritual self-realization. The "work" it refers to is seldom teaching and never administration: it is research. The poverty of this formulation becomes particularly acute when you consider that it is research, above all, that is adjudicated in annual evaluations. In certain key aspects of our lives

as academics, we progressive scholars are our own worst enemies. In the insistence that every shred of our academic lives is political, that everything from the conviction that individual conference papers have important political implications to de rigueur complaints about the "powers-that-be" (a particularly odious phrase, for reasons I'll discuss below), we have eroded too completely the line between our work and our lives, our vocation and our selves. If we expect that every academic article, every class, should be part of a world-changing program, then what—what number of articles, what degree of change, what pedagogical innovation—would be sufficient? Worse, when we extend such expectations to our colleagues, we become each other's worst enemies, too.

Certainly we find ourselves under pressure from evaluative measures of all kinds, but these are often, in public universities in Canada at least, peer evaluations. To summarily and dismissively call them "instruments of surveillance" is to significantly misunderstand the way in which the institution works. In spite of alarmist cries to the contrary, collegial governance is not dead. While I want to stress that neither second-wave feminists nor other rank-and-file academics with a belief in the progressive possibilities of research and teaching invented our dominant administrative models—committee structures, evaluation procedures, etc.—it is my argument that we have made insufficient use of them. Note that I am not saying we've insufficiently "critiqued" them. I'm of the view that we live with a surfeit of critique, particularly where affairs of the university are concerned. You can't get a glass of wine at a cocktail party without someone bemoaning university branding, or the ascendancy of research over teaching, or a Salaries and Promotions Committee's disastrous decisions.

What's common to all these complaints is a "poor us vs. powerful them" mindset. No doubt the 1990s were hard on the liberal arts, on feminism, on intellectualism, on progressive social activism, and on academics. We can all count up the material losses of

the last two decades—funding cuts, departmental attrition, back-sliding on equity, rising bars in at least two senses (heightened expectations, increased barriers), and so on. So much seemed to go wrong so quickly that it was hard to craft a sentence long enough to incorporate it all. We adapted. We developed "coping strategies." Specifically, we learned to be strategic in our thinking, trenchant in our critique, and suspicious at every turn.

I believe that these very coping skills occluded the loss of something more precious than funding, something we have yet to come to terms with, and something that we can't blame on an ineffable "them": our ability to articulate what we want. We can see the discursive limitations of a proposition immediately, and we're always on the lookout for the next administrative swindle. But when's the last time you heard someone on "our side" articulate a positive proposal? Can you finish the sentence "As a feminist [or as an academic, or as an activist], what I really want is..."? At the risk of sounding self-absorbed, I'm going to suggest that my personal experience might be generalizable: consequent to its great successes, at "the end of desire and the end of a vocation" (Querry), and after years of working in a "burnout shop," perhaps feminism burned out, too.

OKAY, I DIDN'T REALLY suggest such a thing. I learned my second-wave lessons well. Our mothers taught us everything we need to know. Feminism is always simmering, even between the waves. We are always working, even in poverty and obscurity. Think Mary Beaton, Mary Seaton, Mary Carmichael. We are tough-minded, hard-nosed, impregnable: *stony*. We are waving, not drowning. No, feminism can't afford to burn out.

But just before we turn our backs on this possibility completely, let me suggest that feminist burnout might not be an unmitigated disaster. Remember the metaphorical origins of *burnout*. I'd like to suggest that instead of focussing on the things we lost in the

fire, perhaps we might think of what to grow now—what our "fire-weed," to riff on the 1970s feminist journal of the same name, should be. That "we" is crucial. Because, you see, even after a good rest, even after spending time away from the university, I still don't know exactly what I want. I know this much: it's not more work, and it's not the same kind of work. The vocationalism summed up in that peculiarly academic locution "my work" colludes all too readily in turning work—which, yes, we should enjoy, and value, and find meaningful—into a creed. Such collusion actively helps produce burnout, and it leaves those who suffer from it with precious few resources for recovery. So in spite of my conviction that collegial governance is not dead, and that we have many of the tools for recovery at our disposal in the form of extant committee structures, I want to stop short of demanding that we storm the administrative barricades to take on yet more work—at least until such work is rationalized as part of an academic workload.

Instead I want to suggest that we might reconsider *the way* we work, in the hope that doing so will rekindle our ability to articulate what we want. Building on a conversation with Jo-Ann Wallace, I'm calling for "radical collegiality," a form of engagement with each other, with our institutions, and our politics that puts our needs as people first. This is not exactly a call to resist corporatization, even though it arises from a conviction that we relinquish collegial governance at our peril. (As I hope I've argued here, particularly for women and feminists, there may be aspects of corporate culture that are preferable to ivory-tower traditions.) It's certainly not a Pollyanna acquiescence to accommodate the status quo, although I am arguing that we must begin from where we are. Radical collegiality entails a mindful orientation to the ins and outs of everyday academic life. It holds that we have many of the tools for a better life at our disposal, and are simply not using them.

That's a baggy definition, to be sure, so let me suggest a few things that I hope radical collegiality might mean in practice.

I hope it means we say "Enough already!" and mean it. Not "Enough already!—just as soon as I finish this article I'm working on...." I hope it means we act more kindly toward ourselves and more compassionately toward each other. It certainly means opening up the profession to people who aren't exactly like us. Let's stop punishing mothers. While we're at it, how about letting someone get away with using a retro term like "women" in a conference paper? Stop being afraid of tenure. Let go of your sense of "juniority" and its comfortable irresponsibility. Next time you adjudicate a SSHRC grant, champion the imagination instead of the CV. Radical collegiality means less obedience, more boldness. Less suspicion, more honesty. Less talking, more listening. Less apologizing. Less certainty, more possibility. More creativity. Less critique. More Mrs Ramsay *and* more Lily Briscoe, and a better relationship between them.[15]

AUTHOR'S NOTE

I am grateful to Corrinne Harol, Natasha Hurley, Susanne Luhmann, Michael O'Driscoll, Jeanne Perreault, Sharon Rosenberg, Mark Simpson, and Jo-Ann Wallace—exemplars of radical collegiality—for honest and helpful feedback on this essay.

NOTES

1. Graham Greene, *A Burnt-Out Case* (London: Heinemann, 1961).
2. The colonialist metaphor of the Congo as "the heart of darkness" is obviously, if unsurprisingly, at play here.
3. Greene, *A Burnt-Out Case*, 58.
4. Ibid., 253.
5. Jennifer Senior, "Can't Get No Satisfaction," *New York Magazine*, November 27, 2006.
6. Christina Maslach and Michael P. Leiter, *The Truth About Burnout: How Organizations Cause Personal Stress and What to Do About It* (San Francisco: Jossey-Bass, 1997). See also their book *Banishing Burnout: Six Strategies for Improving your Relationship with Work* (San Francisco: Jossey-Bass, 2000). One of the striking things about research on burnout is how little of it there is. Maslach's video *Preventing Burnout in Your Organization* (Stanford Video, 2001 [41 min.]) offers an accessible overview of the issues. Other relevant, if

somewhat dated, resources include Winifred Albizu Melendez and Rafael M. de Guzman, *Burnout: The New Academic Disease* (ASHE-ERIC Higher Education Research Report 1983), Beverly Potter, *Overcoming Job Burnout: How to Renew Enthusiasm for Work* (Berkeley: Ronin Publishing, 1998), Ayala Pines and Elliot Aronson, *Career Burnout: Causes and Cures* (New York: Free Press, 1989), Rebekah Dorman and Jeremy P. Shapiro, *Preventing Burnout in Your Staff and Yourself: A Survival Guide for Human Services Supervisors* (Washington, DC: Child Welfare League, 2004).

7. Thanks to Houston Wood for this evocative question.

8. The description that follows is personal, so the feminist lessons it describes might be local. The terms within which this feminist education took place include western Canada, the mid-1980s, and the humanities, particularly English literature (rather than, say, women's studies). Other essays in this volume offer satisfying complexities to the standard "wave" approach to feminism.

9. Virginia Woolf, *A Room of One's Own* (London: Grafton, 1977), 115, 118.

10. Ibid., 118.

11. Mary Beton, Mary Seton, and Mary Carmichael are the characters Woolf evokes in *A Room of One's Own* as proto-feminists. Mrs Ramsay, of course, is the principal character in *To the Lighthouse*. The scene I am specifically thinking of here is the dinner party.

12. See Louise Forsyth's essay in this volume. To the argument that corporatization and the CRC program are coterminous, I would counter that the careers *rewarded* by a CRC were *made* before corporate culture made significant inroads on the academy. I would also point out that in most cases diversity figures have remained unchanged over the last twenty or so years.

13. This is not the only element of corporate culture: the term *corporatization* does duty for phenomena as varied as university branding (see Len Findlay's essay in this volume), the commercialization of research, the reconstruction of students as consumers, or the emphasis on productivity incentives. I favour the specificity of "the influence of corporate culture on academic leadership models" because I think "corporatization" is too quick and inexact a shorthand, particularly in Canada, where universities are not private entities, and where we still possess a (too often neglected) tradition of collegial governance.

14. Of course, some corporations are better than others. I would also concede that there can be a wide gulf between H.R. documents that pay lip service to "work–life balance" and on-site expectations that contradict those policies. Nonetheless, the language carves out a space for articulating what's important.

15. Thanks, Jeanne Perreault, for reminding me of the limitations of Mrs Ramsay's compassion.

6

On Justice, Exhaustion, Apology, Alienation

ARUNA SRIVASTAVA

One of the habits of privilege is that it spawns superiority, beckoning its owners to don a veil of false protection so that they never see themselves, the devastation they wreak or their accountability to it. Privilege and superiority blunt the loss that issues from enforced alienation and segregations of different kinds.

—M. Jacqui Alexander

ONCE NAIVE ENOUGH TO BELIEVE that I was "just" one of us by virtue of who I was, what I had to offer and what I did, I recognize that this sense is illusory, defined only by the extent to which I (or others) are willing—or willed—into a particular national or institutional imaginary. Once we recognize this, we begin to feel alienated, isolated. We withdraw, we whine. More crucially, we are withdrawn from the social body, quietly pushed out, unconsciously. We are wondered about. What happened to...? We don't

muse about ourselves as the rejecting body. How did we act to reject, even if only by not noticing? Effecting burnout, indeed, but we burn out for vastly different reasons. And, as an institutional being, I find myself really puzzling more and more over our responsibilities to others inside and outside our own small spheres: surely we at least have a responsibility for noticing when people fall away, are treated badly, even tell us they are. For looking, literally, at the faces and bodies surrounding us and how those change or do not. At how much they do not. And at how the body politic acts in myriad ways, direct and nuanced, to reject, incorporate, shift around certain peoples, bodies, perspectives. Surely these are all intimately connected to blogs, no-fly lists, national apologies and movements to reconciliation? That, in effect, is my wary, weary, conclusion to what follows, although where my own political agency engages in these processes of what a colleague has often called invisibilization, I have yet to fully determine.

> At some point on our way to a new consciousness, we will have to leave the opposite bank, the split between the two mortal combatants somehow healed so that we are on both shores at once and, at once, see through serpent and eagle eyes.
> —Gloria Anzaldúa

MOMENTS IN MY ACADEMIC career like the "Not Drowning But Waving" conference have been focal moments, moments for pondering belonging, alienation, the nature of what it means to work, what it means in a real sense to be the person I am. Trauma can be so terribly mundane, and trauma is one thing that our academy, the one we help build and nurture, and which nurtures us, is singularly bad at dealing with because of that private–public divide that we as feminists tried to hammer at for so many years.

Can I talk about the death of me, the slow death of my own body to illnesses that my work so rarely speaks of, but which provides

startling insights—spiritual, intellectual, emotional: the pump that I wear to dribble insulin into an already unnerved body, numb toes, eyes, swelling feet—or the enormous plastic box I carry with me on my travels with everything from vitamins to insulin to infusion sets to the three anticonvulsants I gobble twice a day to control seizures that have never really been controlled since I was twelve? As menopause grinds to a whimpering years-long close, I wonder what new autoimmune inanities my body has in store for me, and, more, how my vision of others has changed as a result: all imperfect body parts and pain about to explode or implode only held together, with extraordinary fragility, by stoicism learned at my mother's knee, by myths of coherence and progress and suc-cess. Learning from example that pain is nothing much to endure, really, and life (as most Calvinists know) is about alienation from the self.

That is where my energy flags, physically, engaging me in form-ing and reforming myself in the academy and other environments in a constant play of chicken with myself and others, with the world I choose to engage in. For all of us as we get older comes a sense of urgency with mortality I expect, but for some of us it comes with haste: doctor after doctor (and indeed my life seems to be made of a web of visits to them) reminding me that I am physically far older, really, than I am, that my body will give out earlier, that disease and death are mine to look forward to, it only being a matter of the march of time. This discourse of self-management (good diabetics are those who ward off the ravages of their own disease) is paired with a parallel discourse of shame and guilt that we espouse in the academy around productivity—only I am to blame for whatever happens to myself, a discourse that runs rampant through pop cul-ture television, especially as it circulates around women's bodies, obesity, illness, and health. Reality shows, indeed. Are these things to write of, to speak of, especially as they are also inflected by race and gender and all the rest of it? Can I do it? I have often asked

myself, especially at moments when brain and body defy each other in imminent immanent seizure and I fully re-recognize the constructedness of that sense that my body wholly exists at all...twitch epileptically away into oblivion and fear.

Thus, the second part of the "can I do it?" question is, really, "will anyone listen, or read, or hear?" Does my body listen to me? I know that my particular form of burnout (sputtering and slow) comes from the acute knowledge that it *is* in fact possible to listen and to hear, to take the time to adjust ourselves—whether in the classroom, or our reading, or in an anti-homophobia workshop or on Facebook or a department meeting, in the collegial relationship, in friendship, in a difficult marital separation, across many divides and similarities, even in full bodily revolt. This I have learned.

I think of the antiracism work many of us did years ago, of the much-mourned identity-politics movements. Perhaps one of the reasons they died the death they did, if they did, was because of their insistence on, well, presence, an argumentative (not actual) authenticity, an insistence that hearing occur, even if it was inconvenient, uncomfortable, didn't go with the flow. And if we (those with privilege) didn't want it to, at least there were themselves/ourselves to regroup with for each other...ourselves to talk amongst to offer supportive, interested, and comprehending contexts for storytelling and understanding: a good deal of this undermined when we bought into the simplistic suspicion that identity politics was somehow more intrinsically flawed than other politics circulating discursively, rhetorically, materially (simplistic, I think, because largely theoretical and anti-praxis, unaware of what political movements were really engaged in, coalition politics: *if your coalition is comfortable, then it is too small).*[1]

Where is the quiet, the respect, the slowness, the collaboration that hearing requires? I am reminded of the show on the parliamentary floor, our national apology to Aboriginal peoples for a process of "schooling," many of the assumptions of which we still

bring to bear in our own educational system. It is virtually impossible to speak of the hard work that either truth or reconciliation might involve, since both processes require of us entirely different registers of listening and hearing than we value in the academy. In fact, what we value (publish, accede to, provide merit for) are often forms of bluster instead—talkings for, about and around—circumlocution buttressed by extraordinary and complex forms of cultural and personal defensiveness, as well as showmanship. We have, instead, shows of civility, rules or order, fear of conflict (not opposed to respect or listening at all) and, to my mind, an abrogation of power. I am myself as heartily complicit in this, if aware—worse so for the awareness, perhaps—and so have now engaged in what years ago were once familiar political strategies within antiracism work, ones that might be seen as career-suicide: refusal to do the work, stepping out altogether. Increasingly, my refusals are not strategic only or performative, but acts of integrity.

My refusals in my "real" work have been rare. But "Not Drowning But Waving," in part, made me think a good deal about where I am. I feel like I am barely treading water, to beat the metaphor a little. Certainly not waving. But I have made certain refusals: skeptical in a real way of the cultural and academic politics of publishing, of citation, of the collegial transmission of text and knowledge—all refusals that have affected my career substantially. Antiracism work demands the collaborative, in-real-time, face-to-face work that I get and try to mentor in the classroom: thus, I prefer the performative, the processual, and have pushed myself in those contexts not to rely, as I would not in class or workshop, on the prepared text, the lecture, the outline, in order to listen as fully as I can to what is going on at the moment. My refusals to accede to familiar pedagogies of course can be hugely destabilizing for students (where is the text, the reading list, the outline, the plan, the essay, the structure, the professor—indeed the class?). As it is, and should be, for me: how can a social justice pedagogy work

(I maintain) with prepared scripts and without constant shifting, an attention to transformation? I apply this pedagogical principle, another refusal, in speaking at conferences, panels, workshops.

Which means that everything breaks loose (or gets written out of existence, literally) come review time, the totting up of articles, the proof of the minutes I spoke, when and where and who refereed what and the huge irony (for me at any rate) of the unwashed or at least grubby hordes clamouring for writerly inclusion (if not readerly ingestion) at certain journalistic gates, while it rarely occurs to the gatekeepers, referees, or those within that searching outside of them might be a really cool idea (we used to call this outreach). The production of what we call research or scholarship has, even in my day, become so much the focus of what it means to have "work" and to be "at work," that it is the only (properly, fully) quantified and engaged-with work, whatever fractions and enumeration systems we devise, and fuels our hierarchies entirely: yet, like many mysterious cabbalistic occupations, it is work more or less invisible to novitiates, especially to undergraduate students, to whom the idea of research and scholarship is strangely alien: an alienation we fully foster to keep them slightly grubby.

I recognize in myself and many others a fundamental error in assumption: that what drew us to the academy was the vocation of teaching (a little tawdry in and of itself). Perhaps this is where my version of burnout most clearly manifests itself, that in our corporate culture there is little support, except rhetorical, for the work and intellectual thought that can and should go into the teaching enterprise. There are many vocational assumptions both about teaching and about scholarship (the love of…) but it is rare that the whole package, as a job, as a career, and in its institutional and varying contexts, is made sense of for us. Instead we are treated to a huge (and I would argue) deliberate, systemic fragmentation, so that we cannot make a picture for ourselves of what we are doing.

But I also read my critical pedagogues and critical race theorists to remind me of what my passions have been, since my flickering candle is most dangerously burning low precisely with respect to teaching, with respect to a sense that in particular institutional contexts the teaching enterprise is vexed at its very best, and is transformative only rarely. For years and years, I have been fuelled by the assumption that teaching worked as an agent of social change (or that learning in certain classroom contexts did), find myself increasingly dispirited by what we perceive to be demands on our time, the attentiveness we cannot devote to the *intellectual* activity of and historical attention to the practice and politics of teaching—and its corollaries, such as curriculum and program design for instance.

This is precisely the cult of exhaustion. And even for those who don't feel the exhaustion, we are exhausted by the exhaustion. Perhaps especially for women, but I am not so sure that it cuts so cleanly, since we comply ourselves with this cult, and institutional cult and culture by not refusing them. There is something, as I have learned and worked out in extensive discussions with my partner, an academic and mathematician, that is deeply gendered (racialized, classed, heterosexist) still about the workplace as place of self-worth and sense of being, but, in academic institutions in their variety, most of us women, women of colour, working class people, queer and trans folk and so on, have nevertheless bought into its structures, particularly its sense of time, progress, and functionality.

I am not sure why, if so many of us hate marking, for instance, we continue to do it in the obsessive and self-punishing ways we do. Or why we do not demand more in the way of the infrastructural and social support we crave. Surely the greatest irony (perhaps especially for humanists) is that we feel such alienation from others: a constant refrain, this lack of community, and a lack made

far more stark by ostensible practices of civility and rhetorics of support undercut by other practices of evaluation, backbiting, and this endless, unnecessary and inefficient whooshing rush.

At the conference, Donna Pennee and many others talked about the need to slow down, in order that we take stock, in order that we get "real" real work done: political, networking, justice work. Since then, I have made an unofficial study of the cult of work, exhaustion and speed, watching it in others, in myself, and in my students, how guilt functions; how various utterances perform to solidify and enact our exhaustion, which is real. I feel exhausted, too, but part of my exhaustion has to do with the inability (not something I can do on my own anyway) to slow processes down. My exhaustion has to do with the evacuation of curiosity: my students' in the world; sometimes, my colleagues' and my own in the whys and wherefores and implications of what it is we do and why: indeed, much as we resent it in students, I suggest we model a sort of apathetic resistance for them, model and mentor in them an ideology of consent rather than curiosity and dissent in its best sense and the very critical thinking that almost all professors say we want our students to learn. Rather, we foster a "get it done at whatever cost" philosophy, and do not permit, structurally, ideological pondering, slowness of thought, questioning, critique, and return.

Although I have no illusions that particular things I do, write, or say will effect political change, I feel an increasing sense of urgency that something must change, and that if these are not the ways to do it we must find others. My urgency, to re-state an earlier claim, is about my body, which can tire all on its own, and which depreciates faster than many people's, my sense that, certainly if I am going to have anything to do with anything, then I had better get a move on. We must stop tiring ourselves (admit what tires us; stop talking like fanatics about "work" as if it were a fetish-object), and we must slow down in order that we can even think about important issues, like who we are inviting into our programs, classrooms, research

groups, campuses, and who we are still leaving out in the cold—
rather than rushing headlong with some backslapping sense of
accomplishment about having done all this *and* the all-
important scholarship, slyly criticizing and disciplining those who
are not so wholesome.

I talked at the conference of alienation—and much of the litera-
ture on racism in the academy discusses not so much the hiring of
women of colour (for example), but their retention and their expe-
rience. Climates can change as an individual moves through her
career. I discussed academic alienation, and it seems to me that
alienation, from self, work, and others, must be a profound aspect
or element in the burnout syndrome, particularly if other aspects
of life have not had a very prominent place throughout our careers.
My own sense of collegial and social isolation I can attribute to
any number of factors, but largely I attribute them to long years of
a racial dynamic, a complex and developing one, and, ironically, to
an increased sense of authority (I recall Christine Overall discuss-
ing at the conference the way that, for women, administrative work
confers personhood and identity—certainly this was true for me).
I am old and experienced now, and engage with my own sense that
I have, in some contexts, important contributions to make that are
often against the grain, in part because the smooth flow, the tiring
flow of business-as-usual disturbs me. This smooth flow is not
a place from which to ground any kind of politics, activism,
or agency.

So, I finish with an anecdote about paralysis. Three years ago
I was hospitalized for some time with a rare complication of diabe-
tes, gastroparesis. Stomach paralysis. The stomach muscle stops
working, doesn't digest food or move it through. As a muscle it can
extend for days until the body finally rebels. Without digestion (my
stomach was pumped) an archaeology of everything I drank and
ate for three days was flushed out of my body, as clearly recogniz-
able as when it went in. From that day on, my stomach has taken

its own sweet time to consider, ponder, ruminate, gurgle (or not) and process its way through its job, taking 5 to 100 times as long as the "average" stomach would. Slows down to the speed it needs. As a metaphor, gastoparesis is a fine disease—and one that I will have with me to the end of my days. So, when my stomach won't go and I have to stop eating, I pay attention not just to the physical but everything else in my life that might be what my mother Gladys called sick-making. Paralysis occurs only when we feel trapped, or when we are exhausted, or when our work, the work we value most in ourselves, is discounted or ignored. I paralyze when I feel this happening. One of the oldest lessons of feminist consciousness-raising and of that politic for me rings true to this day, therefore: the art of refusal, strategizing, knowing when inclusive processes are in fact not, when spiritual processes are spirit-murdering, when emotional and physical processes are not accommodating and cannot be accommodated. And of turning my back and walking away before it turns my stomach. Of urging slowness, wonder and critique, to body and mind, head and hands, aches and pains and numbness, to what stops us in our tracks from writing and speaking. I note that my stomach is rustling up a storm now, demanding to be fed (rare indeed). On that unsavoury note, then, I end.

NOTE

1. Originally attributed to Bernice Johnson Reagon, "If you're in a coalition and you're comfortable, you know it's not a broad enough coalition."

7

Feverish Future

ERIN WUNKER

*Feminism's foundational questions are still impossible; they
still look to the future for answers.*

—Schor, Weed, and Rooney[1]

Symptoms

I SHOULD BEGIN BY ADMITTING that I feel a little queasy.

When I was initially approached by the editors and invited
to submit to this collection I was thrilled. *This is it*, I thought,
*my big break. My first really public chance to write about being a
feminist and an academic.* As soon as I sat down to write that excite-
ment evolved, or should I say it devolved? First, I was over-excited:
ideas raced about willy-nilly and I could scarcely catch one before
another had taken its place. Then, as I chased frantically, while
thread after thread evaded my grasp, I started to feel a little sick.

Anxious. Who am I to write about the state of feminists in the academy? I am only a graduate student, and this had been a conference filled with women I considered intellectual mentors. What could I say that they hadn't said? Then I realized that if I were to write anything remotely insightful I would have to commit myself to paper. Literally. I would have to extract my opinions and beliefs from the protected space of my mind and spread them—bacteria-like—on the page, to be examined and diagnosed by you, my reader. It was then, I'm certain, that the fever set in.

Sitting here before my computer, burning up, I find myself wondering where I caught the fever in the first place: am I exhausted from chasing fleeting thoughts? Or have I somehow been infected by my subjects? Am I a sick feminist-scholar? Or is feminist scholarship sick? I suppose it is possible, too, that I am just sick at heart, knowing that in submitting to this collection I will have to go back to the site of an old wound. A wound whose origin I have not yet determined. A wound that has not yet properly healed.

Patient History

My symptoms began shortly after the fall of 2006. In October of that year I was a presenter at the "Not Drowning But Waving: Women, Feminism, and the Liberal Arts" conference held at the University of Alberta. The conference held two main objectives: "to celebrate the career and achievements of Dr Patricia Clements, the first female Dean of Arts at the University of Alberta," and "to provide the first sustained opportunity to evaluate the achievements of feminism in relation to liberal arts scholarship, teaching, and administration over the last twenty-five years."[2] As a young woman scholar I was thrilled to be a part of this conversation. I hadn't long considered myself a feminist. In fact, in the first year of my doctoral studies (2004) I enrolled in a yearlong feminist theory course not because I had had my consciousness raised, but because I was

certain that feminism had reached its goals. I envisioned the course as a historical survey and was, I am afraid to say, one of those rather smug students who felt safe and secure in my own knowledge. The course—its material, my fellow students, and certainly the professor—irrevocably altered my understanding of gender, sexuality, and power. I had begun the difficult work of decolonizing my mind and was learning to interrogate my social reality on my own terms, which now included my gender. I was beginning to understand that being a young woman scholar was complicated, and I wanted to understand why and how gender and the academy function (or not) in the production of knowledge. When I arrived in Edmonton for the "Not Drowning But Waving" conference, I was firm in my feminist beliefs, principles, and ideals. Or so I thought.

My paper was on the last day of what had thus far been a thought-provoking and affirming conference. I had seen presentations by a wide range of scholars but was admittedly most excited to see presentations by the vanguard women whose work I had read. *There are really important feminist scholars*, I thought, *and I am presenting here with them.* I was on a panel entitled "Waves," and my fellow presenters were two associate professors and another doctoral candidate like myself. The first paper, given jointly by the professors, asked "how can we think of and through the times and places of complexity as we describe without thinking of 'waves,' and how does this strategy change our understanding of feminism's meaning at the present moment in this place?"[3] My paper, called "Future Feminism," came second and proposed that through a re-vision of Catherine MacKinnon's *Toward a Feminist Theory of the State*[4] and Julia Kristeva's "Women's Time,"[5] "perhaps a revised form of consciousness-raising may in fact act as a bridge between academic feminism and feminist political activism."[6] The final paper of the panel suggested that the metaphor of waves was not useful, and proposed instead a "rhizomatic approach to feminist histories that would follow multiple—rather than single and

linear—trajectories."[7] In the spirit of full disclosure, I will admit that until that afternoon I really thought the wave metaphor (and the generational transmissions bound up in it) was ever so slightly passé. We were all feminists, right? Was there really a need to continue rehearsing our evolution? I realize, now, that my naïveté was one of the earliest signs of my illness.

The room was full to capacity. After the presentations a few questions were posed to professors Okeke-Ihejirika and Rak, namely about their individual experiences of becoming feminists, which they discussed in their joint paper. A few more questions were posed to the third panellist about her understanding of third-wave feminism and its constituents. Just as I had resigned myself to feeling I had made no impact whatsoever, a well-respected retired professor emerita asked me why I felt it was relevant to use theory when discussing feminism. I was taken aback. Having cut my graduate teeth on poststructuralist theory I fancied myself proficient in what I assumed to be the sophisticated tools of literary analysis. Which is to say, I had never thought about why I used theory. After I had answered ("theory affords feminist scholars the critical space to imagine and experiment with possibilities of *otherwise*"), another senior professor emerita demanded to know why I would quote Louis Althusser when talking about ideology and interpellation. Was I aware, she challenged, that Althusser killed his wife? I was, but before I could answer her, a third senior professor (and dean of Arts at her university) declared that my paper was utterly irrelevant to her experience and implied I was something of a disgrace to feminist studies. I stopped attempting to answer the questions, not so much out of defiance, but as an attempt to hold myself together. The debates about my relevance as a feminist and a scholar continued for about twenty minutes without my speaking another word. It seemed my deference to theory—especially poststructuralist and male—was endemic to all that ails feminist scholarship right now. Indeed, when one of the professors on my

panel attempted to come to my defence ("haven't we worn out this 'why theory' question?"), she too was shut down completely. Finally, the panel chair declared time and we adjourned—I to a lower floor bathroom to collect myself.

A Room of Her Own, or Quarantine

Shortly after I returned to Calgary two women professors in my department asked me how the conference had been. When I related my story, feeling rather sheepish, they reacted with such deep-seated frustration and anger on my behalf that I was taken aback. My experience, or rather the animosity I provoked in senior feminists, was apparently not an isolated case. Instead of feeling better I became more anxious. If the problem lay in my own scholarship and methodology, that meant there was a possibility to restructure and recuperate my work. However, if mine was not an isolated experience, then the symptoms suggested the sickness was not mine alone. My skin started to crawl. What *was* this germ infecting feminism? And, more importantly, how could we begin to inoculate ourselves against it?

I had no idea where to begin. I withdrew both literally and figuratively. I felt ashamed, as though I had missed some terribly obvious key to feminist scholarship and had performed that ignorance in front of a room of scholars. I became a little paranoid and was less vocal about my conviction that feminism is vital to scholarship and to everyday life. I realize now that I felt terribly alone. I had no peers who identified as feminist scholars, and so I felt I had no one on my level with whom to discuss my ideas. I was oppressed with feelings of responsibility to the future of feminist scholarship, and culpability for the history of feminist scholars before me. And so far, it seemed to me I was failing both.

In the following months I continued to think about my experience at the University of Alberta. Initially I felt I had been the

victim of what Annette Kolodny calls "*intellectual* harassment...
[whose] object is always to foreclose feminist inquiry and, more
generally, to shut down women's access to unfettered intellectual
activity."[8] I'll admit it was a defensive reaction that, for my part,
came about as I slowly emerged from my immediate impression
that I was a disgrace. How could I possibly be a disgrace? In my
paper I was proposing a reinvigoration of older texts; I was suggest-
ing that conversations had been prematurely closed and that issues
of consciousness-raising and Marxist politics still had something
to offer feminists. Surely I was simply misunderstood. Of course,
I wasn't able to sustain this optimistic self-assurance for very long.
It wasn't that I was misunderstood, for many of the audience mem-
bers had come of age as feminists and as women during the first
moments these issues were being discussed. Something else had
happened at that conference. I had struck a nerve. The members of
the audience who responded saw me as the face of a very particular
future for feminist scholarship, and they were worried. Either I was
sick, or my scholarship was, and something had to be done to halt
the spread of this pernicious development.

Hereditary Dis-ease?

I realize now that my impulse to quarantine myself from other fem-
inist scholars was due in very large part my impression that I was
a disappointment. I felt I had revealed my hopes and sense of pos-
sibility in front of my mentors and failed disgracefully. But what
I could not get my head around for some time was my absolute
resistance to defer to their authority. I think, in retrospect, that def-
erence and authority have everything to do with both my reception
and the feminist-academic fever that has overtaken me.

Cultural historian Carolyn Steedman has considered aca-
demic illness at length. She observes that for a brief period of
time, between 1820 and 1850, "a range of occupational hazards

was understood to be attendant on the activity of scholarship."[9] While many of these ailments were linked to the sedentary life of a scholar—lack of exercise, lack of fresh air—one symptom stands apart. Brain fever, a result of "too ardent exercise of the brain," was qualified as an illness specific to literary studies.[10] For the solitary scholar of literature this feverishness manifested as a likely result of loneliness and intellectual exhaustion. As Steedman notes, the constant fears that plague scholars revolve around questions of finitude and completion: will the work ever be done? The fever, unsurprisingly, arises from the realization that no, the work will likely never be completed in one's own lifetime. What a shock, to become aware that one might toil her whole life, never to see her work to its completion.

It seems to me there is a connection between this scholarly fever and the future of feminist scholarship. Feminist scholarship is viscerally connected to practice—indeed, it is one mode of scholarship (there are others, of course) that grew out of activist practices. And while the emergence of women's studies departments and feminist theory courses have secured a space in the institution for scholars committed to this work, it has, as others have noted, cordoned scholarship off from practice.[11] Teaching texts and theories, attempting to convey their revolutionary potential, is markedly different than encountering them in the moment of their arrival. Are these texts a part of a larger zeitgeist? And if so, how can I access, not to mention transmit, their spirit? I wonder if institutionalization hasn't hurt feminist scholarship—or at least feminist scholars—who are no longer activists as much as avatars. Though, if this is indeed the case, what does it mean for me and other feminists who consider the institution as our realm of activism? Perhaps what I mean here is that the work of trailblazing feminists has been integrated into the policies (rather than practices) of the institution. In which case, these revolutionary works have been co-opted by the establishment and are no longer oppositional.

Might my generation of feminists feel an inherent drive to resist established practices and policies? If so, then vanguard feminist scholars must feel a certain urgency: has the work they have committed themselves to made enough of a difference? Who will carry it on? For the paradox of institutionalization is normalization. If feminist scholarship has achieved a relatively secure space in the university, it has done so at the cost of its more seditious aims.

Robyn Wiegman makes a useful point when she asserts that "nowhere is the refusal to grapple with this otherness more overt than in the agonized conversations about feminism's generational transmission, when various prophets of the past demand that emergent generations...produce their feminism in ways that delineate...continuity with their feminist foremothers."[12] Generational transmission, like any hereditary inheritance, does not occur with guarantees—it may skip a generation, it may reveal itself in unexpected ways. However, in terms of feminist scholarship, if there is no inheritance, there can be no future. Further, there can be no inheritance without a discourse between generations. Where might this grappling take place?

Positive Contamination

It's been more than a year since the "Not Drowning But Waving" conference, and I'm just starting to untangle what I experienced there. I think what happened in that room was a sign not of feminist scholarship's terminal illness, but rather of a fever beginning to break. The tensions and frustrations my paper evoked appeared in the moment to be harsh, unwarranted, and geared at shutting down discourse across generations. But with some time and distance, and the invaluable opportunity of thinking through the experience again here, I believe what occurred in that room was not an attempt to quarantine a young feminist scholar. Rather, I think it was an instant of raw, visceral fear. Fear not of my work, but of

the realization that so many of us who cover so many generations and experiences are so rarely in conversation with one another, so that when we do meet, the rhetoric is not unlike that of an uneasy family reunion: who *are* these people I'm apparently related to? And *how* do I tell the young ones, the prodigal ones, the new ones, what I know of our family? How can I keep them from making the same mistakes I did? Because feminist scholars so rarely collaborate across generational (and even genre) lines, how can it come as a surprise that we don't know how to talk to one another?[13]

Feminism is not separate from the forces it works against. Instead, as a politics and practice of opposition, feminism and feminists are contaminated by the very inequalities and power imbalances we are fighting. Which is to say, because faults and fissures exist in the patriarchal social reality we live in, feminism is able to rise up from these structural gaps. And contamination is not something to be feared. Rather, to be contaminated means to be entrenched in all those inequalities and injustices that desperately need righting. One of the most important things I learned at the conference is that feminist scholars need to continue to infect one another, through productive provocation (emphasis on productive), through cross-generational discussion and through the continual experimentation with new ideas and methodologies. Rather than cure feminist scholarship of its metaphorical sickness, our aim should be to infect one another with a renewed sense of investment and urgency. Which, I now know, is exactly what the women in that room did for me. Perhaps my anxious fever has broken, but a reanimated and feverish sense of working for the future has taken me over. I hope there is no cure.

Coda: In Retrospect

I wrote this essay when I was still a graduate student, and while I acknowledge the spirit voiced here, I want to provide another layer

of reflection. Namely, I am happy to say that in the years following this conference I have had more opportunities to collaborate with senior feminist scholars. However, I should note that this collaboration has always been initiated by these scholars and has generally taken the form of mentorship. Don't mistake me here: I am not complaining. Rather, as I consider how my relationship with feminism in the academy has evolved, I realize it is through the support these mentorship relationships provide that I have been able to foster a more nuanced—indeed, more self-reflexively theoretical—understanding of who I am as a feminist scholar. While I still can't profess to understand what happened in that room, I can understand the contexts that led to my inability to speak up more forcefully. Without actively mentoring other women—be they junior scholars or undergraduates—the positive institutionalization of feminism within the academy will not progress. Without actively engaging in conversation with one another, we will become increasingly isolated instead of increasingly collaborative. In the academy collaboration across and among generations is difficult—perhaps more so than outside the institution. In a profession that continues to value the single-authored manuscript, it is hard to find the time and energy to devote to working with others. But if I have gained any insight in the past few years, it is that we must make the time—and find the energy and resources—to change the institution. Perhaps what happened in that room was a symptom of something much larger; perhaps it was a symptom of alienation that my paper on Marxism agitated. For without the cross-contamination of our thinking with discussions and the thoughts of others in the academy, feminist scholars become alienated from the work we do and the community with and for whom we work.

AUTHOR'S NOTE

Thanks to Jeanne Perreault and Susan Bennett, two mentors who have been and continue to be formative in my development as a feminist scholar.

NOTES

1. Naomi Schor, Elizabeth Weed, and Ellen Rooney, eds., special issue "Derrida's Gift," *differences: A Journal of Feminist Cultural Studies* 16, no. 3 (2005): vi.

2. "Not Drowning But Waving: Women, Feminism, and the Liberal Arts Conference." Conference pamphlet online, July 6, 2007. http://www.crcstudio. arts.ualberta.ca/waving/index.php.

3. Phil Okeke-Ihejirika and Julie Rak, "The 2.5 Wave/Falling Between the Waves," paper presented at the Not Drowning But Waving Conference, 2006.

4. Catherine MacKinnon, *Toward a Feminist Theory of the State* (Cambridge, MA: Harvard University Press, 1989).

5. Julia Kristeva, "Women's Time" [1979], in *New French Feminisms: An Anthology*, ed. Elaine Marks and Isabelle de Courtivron.137–41 (New York: Shocken, 1982).

6. Erin Wunker, "Future Feminism," paper presented at the Not Drowning But Waving Conference, 2006.

7. Elizabeth Groeneveld, "The Limitations of Wave and Generational Metaphors in Feminist Histories," paper presented at the Not Drowning But Waving Conference, 2006.

8. Annette Kolodny, *Failing the Future: A Dean Looks at Higher Education in the Twenty-First Century* (Durham, NC: Duke University Press, 1998), 103.

9. Carolyn Steedman, *Dust: The Archive and Cultural History* (New Brunswick, NJ: Rutgers University Press, 2002), 21.

10. Ibid.

11. There are many who discuss this. For varied opinions see Dux, Gubar, Gallop, Martin, Kolodny, and Wiegman.

12. Robyn Wiegman, "On Being in Time with Feminism," *Modern Language Quarterly* 65, no. 1 (2004): 165.

13. I hope you're thinking of many examples of cross-generational collaboration and mentorship. I hope, too, that you understand I've made this sweeping generalization because in my own development as a feminist scholar I can't think of many examples.

8

What I Learned in Deanland,
Or The Adventures of a (Female) Associate Dean

CHRISTINE OVERALL

THIS IS A STORY ABOUT my administrative adventures at a medium-sized, research-oriented university in Ontario. It is based not on formal research but on eight years of experience and observation from the vantage point of a mid-level administrative position. Starting in 1997 I served for three (short) terms as an associate dean in the Faculty of Arts and Science at Queen's University in Kingston. I stepped down at the end of my third term in mid-2005.[1] Despite requests to let my name stand for other positions, both at my home institution and elsewhere, I will not be seeking further administrative posts in academia. Nonetheless, I remain profoundly convinced that it is important for more women to move into university administration.

I use the term *Deanland* in my title because, for me, becoming an administrator was like visiting a foreign culture. I had to slowly learn the language and the customs, the implicit assumptions

and the normal practices. Deanland never became my home; I was always something of a tourist, but I did learn how to be reasonably comfortable there for a time. So this chapter is intended to be something of an armchair tour for those who may never visit Deanland, but even more for those who might want to go there someday.

THE FIRST POINT TO be made about Deanland is that it is not an easy place to visit. Administration is notoriously difficult, especially for academics who aren't trained for it. The process of advancement in academia selects for abilities and accomplishments in teaching and research, not administration. Moreover, the scholarly evaluation process, especially for those of us in the liberal arts, seems designed to choose independent, autonomous, even introverted scholars. But academic *leadership* requires that your thinking and planning encompass a wide range of people and issues, that you work as part of an administrative network, and that you become at least a pseudo-extrovert.[2]

Moreover, as an administrator your time is consumed by the job, and you work very long days, evenings, and weekends. There are a hundred tasks every week: meetings, appointments, letters, reports, newsletters, minutes, plans, and budgets. Every moment at the office may well be scheduled—and scheduled for you by others, not by yourself. Say farewell to choosing your own agenda and deciding for yourself how to structure your day. You can expect your phone and email messages to at least triple in number, and don't think you can get away with not responding. For there are also crises—crises in which the administrative machine goes into overdrive and demands yet another document within a day, and crises of individual members of the university, who live all-too-human lives and therefore experience calamities at unexpected times. There's a palpable sense of urgency generated by many administrative tasks. I often had to remind myself that a university is not a hospital, and most likely no one will bleed to death if I don't

answer this email or that phone call within the next two minutes. At the same time, when I was confronted by a sobbing staff or faculty member, I felt compelled to drop everything and try to assist.

Some days as an academic administrator are hard—days when you have to say no, for budgetary reasons, to perfectly reasonable proposals, days when you cannot help people whom you want to help, days when you feel you have lots of critics and few supporters. When you become an administrator, many faculty members will assume you now belong (in *Star Wars* terminology) to "the dark side."[3] With my appointment as associate dean, I went, virtually overnight, from being considered a progressive, feminist, pro-union faculty member, to being suspected a pro-administration, unpredictable alien. One faculty member confidently told me that administrators all take a course to learn the silly things they say. Administrators, I think, are frequently seen as parents—bad parents. Usually they are bad daddies,[4] but some of us, by virtue of our sex, are bad mommies, and the faculty "children" sometimes resent our authority and power, such as it is, even more because they think mum should always be on their side.

And that brings me to the gendered nature of university administration. Inevitably, as one of few women in administration, I was highly visible, noticeable by virtue of my clothes, my voice, my body, and my movements. Often I felt that I'd been cast in the role of representing all members of my sex. Like some other minority group members, I believed I had to represent women well, because whether other women would have a future in administration might depend partly on how I performed.

Even emotions are gendered. For administrators, some negative feelings—mainly anger and aggression—are acceptable; others, like fear and sadness, definitely are not. Incidentally, here is a case where one wrong step can be fatal for women but not for men. Men are permitted to lose their emotional control on occasion—to become very hostile or angry at a meeting. They are then forgiven,

as having an off moment, or even, in some cases, as having shown their real strength. However, women who "lose it" are more likely to be interpreted as being moody, weak, or subject to hormone fluctuations. At the same time, we are responsible for managing the emotions of other people—comforting the grief-stricken, soothing the angry, assuaging the disappointed, and mitigating the fearful.

I also felt there were real limits on how much one could care about the issues and the people involved in them. I had to learn to lose gracefully, and to accept, in the words of my dean, that academia is "not the place for justice"—or democracy. There was also a real Catch-22 for me as a result of my being strongly associated with equity issues: on the one hand, that's an area I continue to believe is very important and that I must support; on the other hand, my role in equity issues got me labelled as limited, a supposedly one-issue person. One woman even told me, confidently, that I would never advance far as an administrator because I was "too closely associated with equity." Indeed, being, and being known as, a feminist can be a mixed blessing. Some progressive staff and faculty members said to me that if I, a notorious feminist philosopher, was part of the administration, then they had hope for the university's future. At the same time, my feminist reputation meant that those same people were almost certain to be disappointed when, from my not-so-mighty position, I was unable to turn the institution into an academic utopia.

Moreover, ironically, if you are included among the boys for long enough, you may come to think you *are* one of the boys. In academic administration I saw the dangers of being co-opted, of buying into administrative values and ideals of which I'd formerly been highly critical. For me, these included the proliferation of business models, methods, and goals within academia; the focus on measurement; the reliance on grant-getting as a criterion of success; the preoccupation with "accountability," "performance indicators," "quality assurance," and "academic reviews"; the

acceptance of severely limited resources, distributed in ways that are not proportional to academic needs; the competition at every level; the dependence on what donors want, and on the agenda of the fundraising and "development" office; the submission to academic fads—the same fads every other university in North America is adopting[5]—and the upholding of harmful university "traditions." The strong emphasis on teamwork makes resistance difficult. Unless you are very senior indeed, your chances of altering those administrative values and ideals are minimal, and there is a persistent danger that you will come to accept them uncritically.

SO, GIVEN ALL OF THESE various drawbacks, **why go to Deanland at all?** Especially if, like me, you love being a scholar and a teacher? I want to suggest that there *are* good reasons, and in particular I want to suggest that more women should consider taking a time-limited sojourn in Deanland as one component of an academic career. Don't assume that if you become an administrator you may be stuck with it forever. One of the assets of life in academia is that you can return to the professoriate if you wish to. You can be, like me, a recovering administrator.

So why go there? I certainly didn't go into administration for the sake of a "vision," a word about which I've learned to be skeptical. In any case it's probably inappropriate for a person in my position, low in the administrative hierarchy, even to have a "vision." But when the dean asked me to become an associate dean, he offered me one compelling inducement: in his words, "the chance to make a difference." That's what convinced me to take the job, and that's what I still believe is best about being an academic administrator.

An important way of making a difference, though one that's easy to underestimate, is simply by providing information. Ironically, information is something university faculty and staff members often lack. If you don't serve on a lot of committees,

regularly read the campus newspaper, go to information sessions on the Collective Agreement, and attend Senate and Board meetings—and no staff or faculty member can do all of these, all of the time—then there's probably a fair amount about the university you don't know. I was able to make a bit of a difference to some people by giving them the information they sometimes desperately needed. In order to do so, of course, I had to know a fair amount about the institution myself. For me, that was also one of the benefits of being in administration—coming to understand how the university really works. Learning is, after all, one of the most basic reasons why academics become academics in the first place.

I enjoyed coming to understand how the university works—both how it supposedly works, based on its public rules and policies, and how it really works, based on who has the power and influence at each level in the university's hierarchy. I learned about my institution's administrative structures and its academic and institutional policies, its budgets, the provincial and federal governments' roles in post-secondary education, our unions and bargaining, and university planning. I also learned a lot about the various academic departments for which I was responsible—which at one time or another included everything from sociology, psychology, and mathematics and statistics to German studies, drama, and women's studies. In the process, I learned about people, what they care about, whom they fear, how they see their futures, what governs their ambitions, and why the kind of person someone is makes a big difference to how, and how well, she or he does the job.

In addition to providing information, I think I also made a small difference through responding to needs that were just a bit therapeutic in nature. Sometimes I was able to connect individuals with problems to others who could help them. And sometimes I just listened. Everyone wants their academic concerns and ambitions to be recognized. Doing so not only reassured them, it also meant that my recommendations to the dean could take into

account what faculty and staff told me about their challenges and goals.

For me, one special benefit of being an administrator was the opportunity to work in and with a team. Although I am what is sometimes derogatorily called a "lone ranger" in my academic research, as an associate dean I had a built-in support group. If I needed facts, advice, or just the relief of exchanging worries or laughs, there were several other associate deans, as well as the dean, in the offices nearby. I also appreciated working with department heads, who are among the unsung heroes and heroines of the university. They must lead their units in an environment of burgeoning regulations and declining resources, and they are, in my experience, unfailingly dedicated, hardworking, and insightful. As an associate dean I was also reminded that the university depends upon the expertise, experience, and generosity of our staff. They preserve the institutional memory while academic administrators come and go, and they correct the mistakes that an inexperienced associate dean may make.

The final benefit of being in administration is that one gains authority. People kidded me about loving power, but what I really loved was actually being listened to, with respect. Other administrators and faculty members certainly did not always agree with me, but at least they almost never ignored me. As an associate dean I had a minor amount of power just by virtue of my position, not always by virtue of anything I did—although of course what I did or did not do could enhance or detract from my power. The title seemed to give me overnight respect in certain quarters, and a willingness on the part of department heads to listen to me.

No doubt this experience is good for the ego. But what was also fascinating was how often just my being the associate dean seemed to matter to the people in my administrative portfolio. I had symbolic meaning. My presence at an event meant something. Attention and recognition for the work they do mean a lot

to academics, especially within the liberal arts, where the material rewards may not be great. If I attended a book launch or a retirement party, people were appreciative. If I sent them an email message congratulating them on a new publication, they were flattered. If I attended a lecture or an arts event, they were gratified. And if I actually showed that I cared about them and their problems, they were astounded.

GIVEN ALL THESE THINGS that are good about administrative positions, **why don't more women visit Deanland?** Over and over I've seen women with strong leadership and administrative skills advance to the position of department head but never go beyond, whereas men frequently use these positions as stepping stones to the position of dean or higher. I'm no expert on this issue, so I'll just offer some partial hypotheses as to why more women are not advancing further.

In academia generally and in administration particularly it's still more "normal" to be male. Women are sufficiently unusual in the upper reaches of administration that those who make it are subject to what I call the "one woman" phenomenon. That is, just having one woman in a senior administrative position is so noticeable and unusual that people, both male and female, get the feeling that women are everywhere, and that there is no need for more. So, ironically, when one woman breaks through the glass ceiling, it may not become easier for others to do so.

In addition, some of the same rationalizations seem to get used, time and time again, to explain why certain women, who may already have made it to low-level academic management positions, cannot and should not advance further. These rationalizations include the following:

1. The woman in question has not done enough research, so faculty members won't respect her.

2. Or, the woman in question has done too much research; she's too focussed on it and won't give enough attention to the administrative demands of being a dean or vice-president.
3. The woman in question is not a team player (implicitly, she can't be one of the boys).
4. Or, the woman in question is too much of a team player and therefore not sufficiently independent and authoritative.
5. The woman in question doesn't really want a senior position (women aren't very ambitious, you know).
6. Or, the woman in question wants a senior position too much (she's a queen bee who is too egotistical to be a leader).

From this list, which is by no means complete, you can see that ambitious women may be in a no-win position, where both the presence and the absence of a particular characteristic can both be used to bar their advancement. Whatever we do can count against us.

YOU MIGHT FEAR THAT there is no way women can win the administrative race. I want to stress that this is not the case, and despite the problems I have described, women can survive and even thrive in administration. Given the psychological barriers I've discussed, **what does a woman need, and need to know, in order to get to Deanland and to succeed once she's there?** Obviously I do not have all the answers, and some aspects of life as an administrator are a matter of luck—like the current university climate and the kinds of people who work in it—that you cannot control. But here are some ideas that I hope will be helpful to women who may be considering travelling to Deanland.

1. Eighty per cent of the job is understanding people.
2. What works in administration is similar to what works in teaching. That is, if you can teach well, you already know more than you might realize about being a good administrator.

3. Don't let yourself be slotted into an adversarial position, even though some people will try to put you there. If you choose a role firmly and confidently, eventually most people will believe in it. I always defined and presented myself as an advocate, not an adversary, on behalf of the departments, faculty members, staff, and department heads in my portfolio. As a result, most people (though never all) stopped seeing me as an enemy.

4. Remember that people are fallible—students, staff, faculty, and administration. That includes you. Also remember that most of the time people are doing the best they can with what they have. Again, that includes you.

5. When in doubt, listen. Ask faculty members and other administrators what they think. And never underestimate the importance of support staff as a source of wisdom and understanding.

6. Pay attention to gossip. It isn't insignificant. Within a university, it can be an important source of information.

7. Think first; then speak. Do not let yourself be railroaded into making a decision or giving a commitment. When someone asks for something, allow yourself to take some time—even if only an hour—before giving an answer.

8. Prepare for the worst but anticipate the best. You can actually *expect* people into good behaviour. If you approach faculty members with the sincere belief that they are talented people who are eager to be good teachers and researchers, they will often turn out to be that way.

9. Much has been written about the importance of mentors and role models.[6] What I recommend is a *coach*. I found a coach who would talk with me about leadership and explain what had worked for her. She helped me think about my own situation and identify my goals. She encouraged me to take a stand on issues where I could not compromise, and to back down or step aside when the situation was unwinnable.

10. In administration you must have supporters. These are not people who will simply follow you unquestioningly, but rather people who are able to point out clearly both the strengths you bring to the position and the places where you are weak, vulnerable, or unprepared. Be ready to develop allies in the university, both within the faculty and among the administration. Those allies can be male or female. In fact, given the predominance of men in administration, you had better be ready, willing, and able to find male allies. They are there.

11. But resist clubbiness. That's the failing of the academic traditionalists. You must reach out to people and groups who are outside your comfort zone. Help, information, and support can come from unlikely places.

12. Act confident, even if that's not how you feel.[7]

13. Don't be afraid to advance new ideas. It's the need for fresh thinking that makes it essential for members of traditionally under-represented groups to travel to Deanland. Your opinions won't always be listened to, and they certainly won't always be accepted. Put them forward anyway.

BY WAY OF CONCLUSION, I will just make a general comment about getting to and succeeding in Deanland. Traditionally, there's been a debate among feminists about how to survive within male-dominated institutions. Should women accent their distinct feminine characteristics? Or downplay femininity and integrate as much as possible into the masculinist climate? My own view, which I can only mention but not fully explain or defend here, is that neither is correct.[8] I think we need to look beyond gender, toward a goal of expressing our full humanity. Rather than leading like a woman or like a man, I wanted to lead like a human being, to be fully and authentically myself, as much as that was possible, and without being limited by either gender constrictions or institutional shibboleths.

Only if you can do that, I believe, is it possible to visit Deanland and still maintain your confidence, your integrity, your ideals—and your sense of humour.

AUTHOR'S NOTE

I am grateful to Yolande Chan, Queen's University, for her comments on an earlier draft of this paper. I also want to acknowledge the enthusiastic audience at the "Not Drowning But Waving: Women, Feminism, and the Liberal Arts" conference at the University of Alberta, where this paper was first presented on October 13, 2006.

NOTES

1. The main reason was that I felt I'd reached my "best-before" date; that is, I'd risen to the top of my administrative capacities, and I did not want to fall victim to the Peter Principle. In addition, I very much wanted to return to full-time teaching and research. And I wanted to reduce the stress in my life. (I had no illusions that I was irreplaceable. As my family doctor pointedly remarked, "If you get sick today, they'll find someone else to do the job by tomorrow.")

2. *Pseudo-extrovert* is a term I learned, in informal correspondence, from Brian Little, professor of psychology at Carleton University. It refers to introverts who learn how to act like extroverts when the job demands it. But for introverts, unlike for extroverts, there is always a psychic cost attached to engaging in extroverted behaviour.

3. As Gary Olsen, a dean at an American university, remarks in the *Chronicle of Higher Education*, "Chairs, deans, provosts, vice-presidents, and presidents are lumped together in a monolithic cabal—'the administration'—all the members of which are thought to operate with lock-step consistency, presumably to advance some identical (but unspoken) agenda." Gary A. Olson, "What Conspiracy?" *Chronicle of Higher Education* 52, no. 25 (February 24, 2006): C2.

4. Carol Becker, "Trial by Fire: A Tale of Gender and Leadership," *Chronicle of Higher Education* (January 25, 2002): B15.

5. Sociologist and department chair Joel Best remarks, "Over the years, I have been assured that our university—if not all of higher education—was about to be transformed by...assessment, active learning, cooperative learning, distance learning, service learning, problem-based learning, responsibility-based management, zero-based budgeting, broadening the general-education requirements, narrowing the general-education requirements, capstone courses, writing across the curriculum, affirmative action, multicultural education, computer networking, the Internet,...critical thinking, quantitative reasoning, and I don't know what else." Joel Best, "From Fad to Worse," *Chronicle of Higher Education* 52, no. 32, (April 14, 2006): B6.

6. Christine Overall, *A Feminist I: Reflections from Academia* (Peterborough, ON: Broadview Press), 1998.

7. As Dean and Vice-President Carol Becker puts it, "For women to survive in leadership roles, we have to cultivate what I have to think of as a public self: a way of being in the world that allows one to handle the complex issues that come one's way in the public sphere. This involves being able to take the blows and criticisms, to tackle difficult decisions—showing people that such decisions are made with great thoughtfulness, care, and consideration—all the while knowing that people are watching, and that if you reveal too much vulnerability, it will be perceived as weakness. For women, a key lesson is to accept the fact that love from the people for whom one is responsible may not be forthcoming, but that admiration and respect might be." Carol Becker, "Trial by Fire," B16.

8. Christine Overall, "Return to Gender, Address Unknown: Reflections on the Past, Present and Future of the Concept of Gender in Feminist Theory and Practice," in *Marginal Groups and Mainstream American Culture*, ed. Yolanda Estes et al. (Lawrence: University Press of Kansas, 2000), 24–50.

9

Western Feminism,
the Multicultural University,
and Institutional Branding
Lessons for Libertarians Now

L.M. FINDLAY

IN THIS CHAPTER I REFLECT on the current state of Canadian universities as sources of, and safe havens for, emancipatory intellectual work. I first read with, and then against, the grain of that powerful but problematic singularity, "Western feminism," as one of the most valuable forces for change in Canadian academe and Canadian society. I then offer a few observations on coalitions and conflicts that have arisen or are emerging as a result of the "diversification" of the student and faculty "bodies" in a publicly funded system in an officially multicultural country like Canada. I conclude by shifting the scene to notions of the liberal arts, institutional autonomy, and academic freedom—notions that, I will argue, remain extremely important and potentially useful sites of institutional intervention, but only insofar as they are thoroughly, and problematically, *re*feminized.

This set of reflections may also give you a sense of how things look to me, as someone who tries never to think "gender" or "race" without also thinking "class," "class" being for me the most endangered and potentially transformative category of a threesome more often invoked as protective colouration, or integrity on the cheap, than as the prelude to tough but essential investigation, debate, and struggle. Class analysis remains for me the intellectual tool most capable of mobilizing difference in the interests of an uncivil society, uncivil precisely in its refusal of the white bourgeois monopoly on civility deriving from Hegel's formulation of the *bürgerliche Gesellschaft*—a monopoly that expresses the dominant ideology of our time.[1]

Western Feminism

The notion of "western feminism" has problems. Which notion does not? But it also has notable advantages. For instance, "Western feminism" invokes a force that can continue to undermine the first-world's masculinist projects from within. These projects are legion, and many of them of course require first-world military legions for their enforcement, and disciplined Lysistratans and same-sex cohorts to resist them. Ominously resurgent military masculinities have recently produced a whole range of activities that I am inclined to gather under the heading of patriarchy, the rule of the father and the rule of the fatherland, despite my embattled experience using this sweeping term. To illustrate, the eminent Canadian feminist scholar Shirley Neuman once scolded me for using the term *patriarchy*. It lacks rigour, she told me in no uncertain terms. She even forbade her students at the University of Alberta to use it, she said. I could see why, but I thought and think that a mistake, and for a couple of main reasons. First, the idea that social progress keeps pace with progressive scholarship and teaching, and that discursive change by itself creates a common cutting

edge, is an illusion. Social change lags behind or takes the lead, but rarely marches in step with scholarship, because that would promote a synchronicity that our economic and political elites are right to fear and only too eager to discourage. Canada's elites, like their acquisitive and strategically philanthropic kin across much of the first world, prefer a tight temporal fit between "useful" knowledge and wealth generation under the aegis of accountability and efficiency. And so we witness the proliferation of university entities dedicated to the commercialization of research and the branding of the institutions themselves—this combined with the migration of "our" erstwhile students to business schools and professional faculties, and the consequent absorption of "creativity" by marketing in the wider economy and the rebranding of cities as "creative" so as to attract mobile young professionals (according to Richard Florida).

In further defence of the term *patriarchy* as Western feminism's overbearing Other, let me suggest that the replacing of venerable terms by new critical lingo, whether these neologisms are gynocentric or not, is a self-impoverishing refusal of "man-made language" (Dale Spender), a move into the linguistic arcanum that may needlessly dehistoricize, and paradoxically depoliticize, intellectual work that claims for itself exactly the opposite. Please don't get me wrong. Feminist scholarship has as much right as any other intellectual movement to fashion a language appropriate to its project, and it has often exercised that right brilliantly. What would our classrooms, curricula, and publications look like without terms like *gender, secondarity, otherness, alterity, gynesis, gynocritics, androcentrism, anti-essentialism, the master's tools* and the activities they make possible and productive? But feminist scholars are also just as prone as others to righteous self-sequestering and the purchase of distinctiveness at the price of isolation, heeding, when they should be critiquing and resisting, the treacherous pull of purity. Sororities can be as smug as any fraternity; indeed, both

need connections to other forms of community. Gender analysis, without the help of race and class analogues, may prefer interpreting the world to changing it, such is the power of academic institutions to keep the world safe from critical ideas by keeping all of us endlessly busy refining them. So **both/and**, not either/or; both the venerable and the new, the specialized and the common, interacting dialectically across feminist discourse rather than holding demurely pluralist hands, and coupling dialectically, too, with the recognition that discourse, even in the "robust" sense promoted by Gayatri Spivak or in Gramsci's "illustrious vernacular," has its limits.

"Western feminism" works for me, then, not only as an invaluably subversive force internal to the West, but also as an appropriate target, an entity homogenized from the outside, under Eastern eyes both distant and diasporic, in a necessary return of the western gaze, a necessary check to diffusionist assumptions and the replay of empire's civilizing mission in a distinctively feminist register. As part of a wider engendering of justice by first gendering it, the inside/outside binary needs to be worked over as well as refused, lest we ignore the real geopolitical distribution of health and wealth and hope, the actual global flows of poison and prosperity. So, as an expression of strategic solidarity from below, and a reading of inherent vulnerability from away, Western feminism remains meaningful, including the meanings derived from its reification and refusal by those who look westwards anxiously, but too often vainly, for signs of self-awareness, including signs of the sort that admit to and contest the rise of post-secondary, neo-liberal madrassas in that so-called free world that may be more accurately termed the phoney-free-market world. Non-western feminists look for signs of self-awareness, too, but perhaps even less successfully, among the swarms of reactionary opportunists who have found a form of gender equality they like, but only because it operates as a pretext for the current war in Afghanistan, playing up

the Taliban's destruction of schools as the abomination it is, but rarely mentioning, for instance, the closing of schools and universities in the West Bank and Gaza by Israel, still in effect an occupying power and the most spoiled of numerous American proxies. The contradictions we perform, the selective sensitivities we evince, are often most apparent to those who suffer directly or indirectly from their consequences. And many of us have ta'en too little care of this.

The Multicultural University

If the west is arguably the home of feminism, it is also arguably the home of official multiculturalism. And I want to reflect briefly on this second claim that seems to speak well for universities as shapers of progressive social policy and havens for victims of racialized as well as gendered difference. The term *multiculturalism* was invented in 1965 by that most Canadian of instruments, a Royal Commission, and it is an area in which Canada is thought to lead the world, gaining praise as it goes, but also scathing criticism from Britons, among others, for allegedly nourishing states within the state, *imperium in imperio*, in a benighted politics of difference that leads to youth alienation and the London subway bombings. Of course, multiculturalism also plays very unevenly here at home, but the level of debate is far superior to what is generally available elsewhere, so far as I can tell, and humanities scholars are prominent participants in these important exchanges. Mapping Richard Day's wonderfully mischievous notion of "canonical Canadians" onto publicly funded universities in an officially multicultural state reveals some challenging features of the genres of institutional self-representation, starting with dirigisme from the upper reaches of university administration where the dangers of embedded intellectualism are most severe, and where human reason is most brazenly reduced to market rationality and muscularity, academic

values to funding levels. The canon as signifier of authentic inspiration and enduring quality maps onto modes of activity and kinds of faculty and students. Meanwhile, in displacing theology in the name and interests of secular reason, science and technology have inherited a fondness for articles of faith and an intolerance of heresy. But academic science and technology like to think their activities co-exist with, if they do not presuppose, an antisexist, antiracist disciplinary and institutional "climate." Colleagues in the humanities and social sciences have helped shape the multicultural state and are leading exponents of multicultural teaching and research within the Canadian multiversity. They can provide institutional cover and alibis for all. Or can they?

Mission statements across Canada continue to construct our universities on the basis of willed amnesia or highly selective recall; and the closer you get to the supposed top-of-the-league table, or to an important moment like a provincial or institutional centenary, the more predictable certain absences and illusions become. Federal and provincial human rights legislation and university codes of conduct can be presumed, of course, but excellence apparently cannot. And so a term like *diversity*, if it can be found at all in such aggressively public documents as mission statements are, has to do duty for all that should be sought and achieved in the name of social justice. And if the university is really good, or its nominal leaders at least are really ambitious, it will parade itself as an unblushingly hyped meritocracy, ultra-competitive to be sure, and refigure capitalist greed as the insatiable thirst for knowledge, but never unfair or uncaring in its pursuit of "discovery," even though its self-styled visionaries complain in private of "compassion-fatigue." The dirty little secret of excellence jilting equity, like the sequestering of research from education, is quite well kept.

But embarrassingly smug or deluded mission statements are no longer enough, especially when the growing army of institutional developers and logo cops have to find something to do once they

are hired, hired at salaries far in excess of remuneration paid
to those who do so much just-in-time teaching in research-
intensive universities. So, along with websites and photo adver-
tising where the best and the brightest are no longer as obviously
the best off and the whitest, and where a carefully composed mul-
ticultural pastoral offers all the charm of painting by numbers,
senior administrators have channelled substantial resources into
branding. For those of you who thought my reference to neo-liberal
madrassas in the West typically exaggerated and needlessly inflam-
matory, listen up, and listen to this.

What does branding mean? One version of branding involves
taking calves and affirming ownership over them while allowing
them a certain permission to range, mature, fatten up, and then
be finished before slaughter. Branders fear wolves, coyotes, rus-
tlers, celebrity vegans, and the hooves and horns that come with
the rump to be branded. So, obviously, that can't be what university
branding means, even in cattle country...or could it really be that
in some places faculty and students are seen as contiguous herds
whose ability to range must be restricted and made to serve the
interests of the branders? Surely not. The word *campus* may liter-
ally mean a field, and we have colleges of agriculture and veterinary
medicine on many of our campuses, but my musings are clearly
over the top.

So more soberly, let's do the scholarly thing and let university
administrations speak in their own voice rather than through my
acerbic conjectures and glib travesties. Here, I am quoting leaders
at the University of Saskatchewan. "Over the next year, University
Communications will be working with the campus and external
communities to develop a brand for the University." Aha. It appears
we don't have a brand yet, despite all those surveys in *Maclean's*,
and generations of alumni ambassadors and fine faculty. We may
have a reputation, but no brand. Tut, tut. On its very own web-
site, the University of Saskatchewan is thus remade as deficient

or retarded, and desperately in need of some guidance on name recognition. The goal of the branders is therefore "a unique positioning statement which sets us apart from other universities." Aha. Niche marketing, then, which turns us into a commodity while deferring to the power of "the" market, or at least the neoliberal version of economic competition and exchange.

But worse is to come. "Consistency in the way the university represents itself helps raise its profile and builds credibility and contributes to success. Stewardship to the brand promise translates into stakeholder loyalty and understanding from students, alumni, donors, government, and even the Saskatoon and Canadian public." So, we have to give up our right to communicate to a person or persons using language in this way. I could spend all day debunking this. But I'll restrict myself to pointing to the euphemism "Consistency," reinforced as it is by the idea of a single unitary university striving toward some vague "success." The second of the sentences I just quoted speaks of "translation" while screaming for translation itself. Here is that sentence again: "Stewardship to the brand promise translates into stakeholder loyalty and understanding from students, alumni, donors, government, and even the Saskatoon and Canadian public." This sounds to me like Obi-Wan Ben Kenobi on a very bad day, or Tolkien with his brains blown out. "May the force of the Granting Councils be with you...and stewardship to the brand promise!" At the same time, this statement constructs students as gullible; alumni as amnesiacs or dolts who were not imprinted with a sense of the university when they actually attended it; donors and government as more interested in the sizzle than the steak; and the Saskatoon and Canadian publics as condescending afterthoughts to this grand communicative strategy.

In the highly manipulative set of questions and answers that follows this website drivel, we find that the initiative is being driven by the concerns of senior administrators that the university's

image was "being compromised by the use of a wide variety of unrelated messages." "A wide variety of unrelated messages" sounds like a reasonable definition of a good university to me, but this is apparently a problem leading to the following specific complaint: "too many sub-brands are minimizing the effectiveness of the larger University brand, making the whole confusing for our audiences." Gosh, no wonder I haven't been sleeping well. As for all those uppity sub-brands out there—let's call them colleges and departments, schools, disciplines, collaborative groups, and individuals, just for old times' sake—fear not. "One strong brand will make your unit richer, stronger, more relevant, and more recognizable." "Richer"? As a humanist, I'll believe it when I see it. "Stronger"? I guess doing more with less toughens you up. "More relevant"? To whom? I can't see how I could be more relevant. And finally "More recognizable"? I find what I do virtually **unrecogniz**able in the Orwellian prophecy that "one strong brand" will bring my unit all these benefits. So I will become "more recognizable" as what, and to whom? And should I be a happier academic prole because not only is **Big Brander** watching me—**Big Brander** will be speaking and thinking for me too. Radical imams eat your heart out. As with everything else, the West's madrassas are better than yours.

Now you may say that I'm reading this effusion—one that all the world could read on the University of Saskatchewan website—that I'm reading it too closely and critically, like some implacable humanist. Maybe it's not meant to be read carefully, but rather mutely or ecstatically accepted. Maybe the faculty are supposed to act with the same stupidity or passivity as the other audiences named by Big Brander; and if any one of us stands quizzically in the middle of what is called grandiosely "the Brand Development Path," then we will surely be trampled by a passing stag hunt led by a provost, who is very high on game theory and integrated planning.

It is all very sad and ever so revealing, and not only on the campus where I have spent most of my career, at an institution that persists in calling itself the People's University, in a province regularly berated as insufficiently welcoming to business. The vision of officialdom can be relentlessly and expensively promoted while criticism of, and alternatives to, that vision have to find their way into circulation through underground and ancillary routes, including the liberal arts.

In my experience, the multicultural university, like the multicultural state in Richard Day's provocative analysis of it, reproduces diversity as a problem while attempting to enforce a unity and harmony neither achievable nor desirable. In Canada, this has always been a public activity tied to the identification and management of people on the basis of what official documents in 1987 call "ethnocultural lines." This process re-centres "unproblematic selves,"[2] something I was deliberately guilty of in my remarks on Western feminism earlier, and it pre-empts multiculturalism as a radical imaginary by promoting multiculturalism as a liberal-democratic simulacrum of the nation. Now, to be fair, this simulacrum may be infinitely preferable to the micro-vindictiveness of the "new government of Canada," but it is still much too captive to a bourgeois masculinist politics of difference, itself massively subservient to free-market ideology. A class analysis of the current student body under current tuition regimes, and of the current faculty body that teaches these revenue-units *cum* uppity customers, must take its place alongside analysis of gender and "ethno-culture" so that Canadian universities can contribute more to social justice than the reproduction of the rapacious classes and trickle-down opportunities for the rest. I underscore two reasons for such an undertaking. First, this is especially important for women because of the disproportionately negative impacts on them of social and financial barriers to access and success. My university is breathless from its pursuit of high-school high-flyers across Canada and

international students with money, but less invested in recruiting single mothers, for example, to our programs. Second, for most of those who pay the biggest part of the post-secondary tab through their taxes, universities remain strong signifiers of independence, intellectual freedom, and the broad public interest, despite some of their best efforts to barter away much of that for the residual largesse of elite donors. The tradition that runs from John Stuart Mill through Northrop Frye to Pat Clements, Christine Overall, and Donna Pennee, for instance, of defending the university as the best guarantor and exemplar of fundamental freedoms in a democratic society, is still alive across Canada, but perhaps as much as an alibi as an actuality. And that situation carries urgent lessons for us all, lessons that can educate the educators into new activism, encouraging new coalitions across difference, new obligations to replace coercive collegiality in the competitive university with uncivil disobedience in the co-operative one. And this takes me to the final section of my remarks.

Lessons for Libertarians Now

Taking liberties with freedom has a long and often disgraceful history and an immense media and military presence today. Terry Goldie, in his reflections on "Liberation" in the "Retro Keywords" issue of *English Studies in Canada*, points astutely to the way this particular term, absent from the first edition of *Keywords* in 1976, appeared in the 1983 edition, and how "liberation" is seen by Williams as borrowed by "women's lib" from the British Liberation Army of 1944 and then, in a swift and effective anti-colonial appropriation, by the liberation fronts in Algeria and Vietnam. One could use this sequence of property claims and borrowings to make apt points about the male chauvinism of male socialists, then and now, but I leave that to others. I want instead to stress Williams's connection of liberation to individualism and nationalism, two myths

that swallow or disperse class in the interests of more pressing or elevating matters. Individualism appeals, of course, to liberals and libertarians, and therefore carries a double charge of emancipation and re-confinement, both waving and drowning, if you will—at least from a socialist perspective. To be "liberated" into the middle classes, like becoming an American, is not an aspiration all of us share. Nationalism is more tricky for me than individualism, but I can offer a brutal summary of my thinking on this matter by saying I'm not prepared to abandon the project of Canada until it has realized its enormous potential as a truly just society, and perhaps not even then. But Canada can make good on its promise only if it admits to its class system as well as its residual and now resurgent racism and sexism.

Attentive as he is to the ironies and contradictions that unsettle so many signs of social progress, Terry Goldie ends his retro-analysis on a minimalist note: "Perhaps the possibilities of liberation as we have known it in the twentieth century are gone... Liberation might not be a hope but an antique. For some, [Theo] Van Gogh's libertarianism is an alternative. For the rest of us the best response to Fortune's Wheel is perhaps 'muddling through.'"[3] I can't be that pessimistic. Earlier in his piece, Terry notes the following: "Many elements of Western culture pivot around 1968, the first date I can find for 'Women's Liberation,' 'Black Liberation' and 'Gay Liberation.' I had expected the terms to arrive much earlier for women, slightly earlier for African Americans and a bit later for gays and lesbians. It is as if various activists simultaneously needed a new form of 'emancipation.'"[4] For me, in that historical moment the synchronicity of which I spoke earlier was evident, and not only discursively. Liberation may not have carried the day as fully as many would have liked, and it did not take very long for the rich and powerful to bring universities back into line. But occur it did, and it can again, as "Western culture" is experiencing a reactionary roll-back of hard-won gains on the basis, once more,

of manufactured fear for the dusky Other inside and outside the rewhitening homeland. While domination once again creates resistance, I suggest the following three lessons.

First, libertarianism is neither dead nor entirely subject to individual whim. Its eighteenth-century roots in free will were and are intimately connected to *une volonté générale*, a General Will never fully dispersed into individual and national sovereignties. The more all-encompassing the reach of American inevitabilities, the stronger grow the strains of anti-necessitarian thought and action.

Second, "the" women's movement has much to teach and do at this moment, and while it understands itself as a Third Wave, it ought perhaps to keep two cautionary analogues in mind: the great third wave of Greek thalassocracy that so often became the billow of calamity; *trikumia kakon* should now be understood as a figure for climate change, and not only by eco-feminists. And notions of a Third Wave should be read against a chilling essay by Leo Strauss, darling of the Amerophiliac right, entitled "The Three Waves of Modernity." First published in 1975, Strauss's piece tells an apparently all-compassing story through the patrilineal sequence of Machiavelli, Rousseau, and Nietzsche. Strauss concludes his essay thus:

> *I draw a political conclusion from the foregoing remarks. The theory of liberal democracy, as well as of communism, originated in the first and second waves of modernity; the political implication of the third wave proved to be fascism. Yet this undeniable fact does not permit us to return to the earlier forms of modern thought: the critique of modern rationalism or the modern belief in reason by Nietzsche cannot be dismissed or forgotten. This is the deepest reason for the crisis of liberal democracy. The theoretical crisis does not necessarily lead to a practical crisis, for the superiority of liberal democracy to communism, Stalinist or post-Stalinist, is obvious enough. And above all, liberal*

democracy, in contradistinction to communism and fascism,
derives powerful support from a way of thinking which cannot
be called modern at all: the pre-modern thought of our western
tradition.[5]

As critical custodians and disputants of "our western tradition,"
feminists need once again to mobilize against patriarchal conti-
nuities, against the magisterial (or is it the managerial) smear in
phrases like "communism and fascism." Feminists need also to
mobilize against the imperturbable illiberalism of an expression
like "liberal democracy" in the work of so many first-world political
scientists who take their cue from Strauss, and in the uncoupling
of theory from practice in a manufactured "crisis," whose solution
is the self-privileging synchronicity of the status quo and a male,
masturbatory grip on the meanings of the past.

Third and finally, if the liberal arts are not to lapse once again
into timidity and illiberalism, taking themselves ever further away
from the socialist feminism, class analysis, and antiracism that
are for me key pieces of the contemporary puzzle, then they have
to repoliticize their self-representations, their pedagogies, their
scholarship, and community presences. I tell my students we are
learning to read justly, and learning to read for justice, and seek-
ing along the way that blend of audacity and nuance expressed, for
instance, in bell hooks' breathtakingly precise description of the
problem of our times: "white supremacist capitalist patriarchy."
Refeminization in this register is possible and necessary, though
from positions that are themselves, like mine, always already
compromised and the ongoing source of inevitable miscues. But
perhaps you will hear me, here and now, as at least sincere in my
appeal for new and renewed solidarities when I adapt the words
of Charles Baudelaire, a figure of modernism and modernity that
Pat Clements has taught me and others so much about. And so I

address you all, finally, as "Hypocrites, lecteurs, mes semblables, mes soeurs."

NOTES

1. Hegel's exposition of bourgeois civil society can be found in the third part of his *Philosophy of Law* (122–55). The most apposite rejoinder for my purposes remains Marx's *Contribution to a Critique* of this work, in which civil society is rescued from Hegel's subordination of it to an idealized state and reclaimed as the key location for and prelude to revolutionary transformation through class conflict. For the ways in which the differences between Hegel and Marx arrange themselves around recognition and redistribution respectively, and how those arrangements have impacted on literary studies, see Nancy Fraser. In the so-called War on Terror, civil society and democracy are often conflated as twin absences from societies in need of liberation, modernization, and exploitation by first-world capital. However, while dominant forces reduce all talk of class to a racialized middle class in states that are resource-rich but "failing," new class formations and solidarities are emerging in rural, urban, and transnational contexts in the name of co-operation, the prekariat, and the cybertariat, and across a range of disciplines and approaches well captured by Erik Olin Wright.
2. Richard J.F. Day, *Multiculturalism and the History of Canadian Identity* (Toronto: University of Toronto Press, 2000), 5.
3. Terry Goldie, "Liberation," *ESC* 30, no. 4 (2004): 40.
4. Ibid., 38.
5. Leo Strauss, "The Three Waves of Modernity," in *An Introduction to Political Philosophy: Ten Essays*, ed. Hilail Gildin (Detroit: Wayne State University Press, 1989), 99.

10

Desperately Seeking Equity
Systemic Discrimination and the
Canada Research Chairs Program

LOUISE H. FORSYTH

THIS CHAPTER RECOUNTS THE RESISTANCE to the inequitable
impact of the CRC program carried out by eight senior academic
women who gathered incontrovertible evidence of the inequities
produced by the CRC program and who successfully took their
claims to the Canadian Human Rights Commission.[1] The chap-
ter recounts our frustrations at the persistent lack of change in the
program and the apathy and wilful blindness of those who enjoy
power and privilege in Canada's universities and political arenas
despite our demonstration of systemic discrimination.[2] I begin by
providing a brief description of the CRC program and the context
of its creation, offer a personal account of the establishment of
the program and of the human rights complaint against Industry
Canada in 2003, and close by suggesting why these problems
remain still unaddressed.

The CRC Program

The Canadian government introduced the Canada Research Chairs (CRC) program in 2000. This program, which has now created two thousand new research chairs in universities across the country, is one of three federal programs created around the turn of the century with the goal of ensuring that research and development in Canadian universities and research institutes meet the standards of international competition in increasingly globalized economies.[3] The companion programs are the Canada Foundation for Innovation (CFI, 1997) and the Infrastructure Costs Program (ICP, 2002). Federal investment in these programs has been and continues to be massive, counting in many billions of dollars.[4]

At the time these programs were introduced, the cuts made in the 1980s and 1990s by the federal government in transfer payments to the provinces, which then made their own reductions, had left universities starved for operating and capital funds. By 2000 their desperate situation was evident to almost everyone. The new federal policy of supporting research and development led to the creation of the CFI, CRC, and ICP programs that provided much-needed infusion of funding without infringing on areas of provincial jurisdiction in matters of education. The moment was seen to be particularly propitious for government investments in university research that could be partnered with private sector interests. These for-profit interests were eager to have access to university specialists and their laboratories. Little specific information about the CRC program was made available to Canadian university faculty members and their associations. The federal Cabinet, Industry Canada, and the newly established CRC Secretariat took no initiatives to ensure that universities made appointments in accordance with legally binding procedures in collective agreements and equity policies that were already in place on most campuses. This fatal flaw in the design of the program resulted in irregular selection and appointment processes at the universities

receiving CRCs because open advertising of academic positions was not a requirement, and recommendations from collegially elected appointment committees could be circumvented. Instead, involvement in the preparation of strategic plans (which universities were required to prepare as a condition for participation in the CRC program) became the way for some to foreground their special interests in the determination of institutional priorities and thus, in cases we observed and about which we heard, mould the plan to fit pre-selected candidates and areas of research. In the absence of an obligation to ensure an equitable process, universities have not done so. Still, in 2008, many universities are avoiding transparency by allowing academic units to nominate potential CRC candidates without respecting procedures laid out in collective agreements.

The announcement by the federal government of this gigantic new program received considerable news coverage. However, the government provided very little specific instruction regarding procedures for its implementation to members of the university community. While university presidents, vice-presidents (research), and their associations were consulted as the program was being designed and put in place, the impact of its implementation on university structures was not studied, and there was little or no consultation generally with members of the academic community or their local, provincial, and national associations. Word about organization, selection criteria, and timing seemed to spread selectively to those who best fit the program's underlying objectives, with no recognition of the importance of such fundamental principles as collegiality. Senior university administrators trying to keep their financially strapped institutions afloat quickly recognized the advantages offered by such a new funding source. The preparation of strategic plans, the downplaying of most areas of teaching and learning (particularly at the undergraduate level), and an emphasis on research and research funding became the order of the day across the country. Allocation of the large fund available for CRCs

does not reflect institution-wide funding distribution in university budgets, insofar as its sole objective is to provide support for research. The fund is distributed in accordance with the percentages established by the federal government for Canada's three primary federal research funding programs administered by the Natural Sciences and Engineering Research Council, Canadian Institutes of Health Research, and the Social Sciences and Humanities Research Council. This has meant that 80% of the CRC fund is available for support of researchers in natural, applied, and health sciences. The CRC requires matching commitments from the university, and so forces reallocation of funding to CRC areas. The issue is further complicated by the fact that many universities use donations to provide the matching funds, thus orienting fundraising in the direction of the CRCs.

The budgetary skewing that has resulted has left the vital teaching function at Canadian universities, particularly at the undergraduate level, seriously unsupported and even obliged to assume an enhanced burden for administration, while fewer dollars are available for classroom teaching. More than 50% of all students and teachers in Canadian universities are in the social sciences and humanities. The transformation of the university landscape and environment as a result of dominant utilitarian and commercially motivated policies that were already apparent in the 1990s was considerably accelerated by the introduction of the CRC program.

I don't recall that our initial concerns regarding the CRC program were focussed specifically on its potentially inequitable result. Instead, I remember worries about the imperfections of the program's design and lack of transparency. I remember widespread concern about the impact of the CRC program, particularly on scholars and students in the humanities, social sciences, and fine arts. Not only was the CRC program unwelcoming to these scholars, but their teaching and administrative workload could

be seen to increase as privileged CRC holders, excused from most undergraduate teaching and administrative responsibility, withdrew into their well-funded laboratories. As we feared, the research support by these programs has benefited only certain sectors, populations, and conceptions of research in the university community. They have in fact worked to the detriment of other research areas, particularly those that do not lend themselves to partnerships with the private sector or hold the promise of economic benefit and commercialization. The CRC program is producing shifts in internal allocations and in institutional priorities that are radically transforming university culture. The traditional heart of universities represented by the humanities, social sciences, and natural sciences, characterized by curiosity-driven research, is increasingly squeezed by strategic plans that stress applied research.

The impact of this shift is distressingly evident in the deteriorating quality of learning environments in basic academic disciplines. Along with this disturbing transformation of university research and teaching culture away from free enquiry and critical thought, there has been clear evidence of discrimination in the implementation of these programs.[5] They have been working to further advantage those who already enjoy disproportionate access to power and privilege.

Personal accounts of academics mystified by announcements of decisions made without recourse to established collegial procedures circulated widely. Irregular procedures resulted in the appointment of individuals whose qualifications and experience were inferior to others who might have been candidates for CRC positions but who had had no opportunity to participate in the selection process. Since CRC terms of reference made it possible to ignore with impunity principles of academic freedom and collective agreement procedures, a privileged few were arranging appointments before most academics were even aware of the availability of these new positions. An associated factor was that

the CRC program required universities to produce strategic plans that would show a commitment to creating centres of excellence housing collaborative research teams. While such an objective is reasonable, the procedures followed to meet this requirement were seriously flawed in many universities. Considerable anecdotal evidence circulated regarding clandestine influence exercised by those who could shape university priorities and develop certain strategic plans. Without participating in open competition, some individuals used the CRC program to recruit former graduate students and friends from other universities. The evidence of old boys' networks at work in individual appointments and arbitrary shortcuts in the adoption of strategic plans (and resource allocation) produced increasing upset and anger. The flagrant disregard for established practices and policies in procedures for hiring and policy determination reinforced the existing networks of power that the equity battles of the 1980s and 1990s had tried to counter.

Critics quickly recognized the reshaping of the entire university system: James Turk in "Feds Redesigning Universities," Neil Tudiver in "Universities for Sale," and Marjorie Griffin Cohen in "Cronyism Thrives in CRC Hiring Process" exposed the changes. Glenis Joyce in 2005 eloquently described the "capture of the ivory tower by the forces of marketisation and corporatism."[6]

Campuses today are in the grips of corporate logos, partnerships, and language, outsourcing, cost recovery, and technology-driven course delivery. And while performance indicators seem to have slipped into the Integrated Plan without a whisper of debate, it remains to be seen whether the judgement of academic work will be based solely or even primarily on academic considerations. There is also a developing literature on what Smith calls the "progressive disappearance in society of bases from which voices and influence representing other interests and concerns can be effective."[7] This trend strikes at the heart of equity and has deep

ramifications for activism, scholarship, and research related to social justice.[8]

Joyce quotes Linda Eyre in concluding, as I do here, that our institutions of higher learning are reverting in teaching, research, and employment practices to earlier, even more inequitable times, thereby transforming the standards and measures for what constitutes "excellence":

> It is as if the neo-liberal economic discourses and neo-conservative ideologies that work together in the current market-driven climate have given new life to "old" sexist, racist, classist, and heterosexist practices, reinscribing what counts as knowledge, framing teaching and research practices, and legitimating structures of inequality.[9]

Ways of Not Seeing

As the impact of the creation and implementation of the CRC program on the entire Canadian university system became increasingly clear, my personal response was initially disbelief, then rage, and ultimately conviction that something had to be done. It was completely unacceptable to me as a citizen, taxpayer, teacher, and researcher that public funds in the billions of dollars should be invested in such a seriously flawed initiative. Working to make Canadian universities places of entirely equitable practices, values, and ideologies has been a priority for me throughout my career, based on a conviction that equity and real academic freedom should prevail in curriculum, research funding, and the evaluation of research results, in appointments at all levels and in all areas of organizational structures, and in collegial decisions and administrative policies.

University reports on the status of women, following the milestone report of the Royal Commission chaired by Florence Bird on the Status of Women in Canada (1970), the *Multicultural Act* (1988),

and the Royal Commission on Aboriginal Peoples (1996), had provided for the first time the opportunity to know what was going on in our society and its universities. We could see and recognize the patterns of discrimination. There is value in holding proof in our collective hands that systems are not functioning equitably. These reports moved a considerable number of the disadvantaged to take action on their own behalf. Like others, we expected that once the fact of discrimination was known, authorities and institutions would act to produce change. The eight of us observed instead that most decision-makers in the university sector chose, ostrich-like, either not to know or not to take action. The CRC complaint grew out of this tradition of activism that had fuelled activists continuously from the time of those early trailblazing reports.

IN SPRING 2001, WENDY ROBBINS, Judy Stanley, and Rosemary Morgan prepared "Ivory Towers: Feminist Audits" for wide distribution at that year's Congress of the Humanities and Social Sciences.[10] The Audits revealed that in the first year of the CRC program women had been appointed to only 16.5% of the positions available: 11.5% to Tier 1 positions and 27.4% to Tier 2 positions. Many universities appointed no women to a Canada Research Chair. The CRC website showed that by the end of May 2003, when we formally lodged our Human Rights complaint, out of 61 universities receiving CRC positions, 28 had not appointed a single woman. The Audits were extended in 2003 to provide the best available statistics for not only women but also persons of Aboriginal origin, persons with disabilities, and racialized persons. Many of us were becoming increasingly outraged witnesses to the introduction on all Canadian university campuses of a large funding program biased in favour of white, able-bodied males. The CRC program seemed to be turning the clock back to times before we began our collective struggles to make our universities

places of fairness and equity for all members of Canada's population.

The annual Congress of the Canadian Federation for the Humanities and Social Sciences (CFHSS/FCSH) has proven to be a vital forum for discussing equity and making plans for action. The annual distribution at Congress of the Equity Audits with their eloquent statistics has been a wake-up call to thousands of delegates and those with whom they spoke after returning to their own universities. The CRC Secretariat acknowledged the existence of the Audits and never challenged the validity of the data on which they were based. Yet, the first CRC director, René Durocher, seemed unconcerned about this disturbing information, claiming that requirements for "excellence" were the determining factor, and that in any case he could not intervene in the universities' selections.

The Audits and the many rumours circulating on campuses across the country caused the CRC Management Committee to recognize at last that there might be a problem. They commissioned consultants to produce the Bégin-Heick report of 2002. This report found that the program was working as intended and that, if any bias did exist in CRC candidate selection, the fault lay with universities and was beyond the reach of the CRC Secretariat. I recall our shared astonishment that serious researchers could produce significantly flawed findings that allowed, encouraged even, those responsible for the program to not know what was really happening.[11]

What was happening was the establishment of a program out of step with Canadian demographics and Canadian commitment to equitable hiring processes. Of the two thousand Canada Research Chairs, women held in 2008 about 23% of all Chairs: 16% of Tier 1 (for outstanding researchers who are acknowledged by their peers to be world leaders in their field) and 30% of Tier 2 (for exceptional emerging researchers, acknowledged by their peers as

having the potential to lead in their field).[12] A comparison of these percentages with available demographic information reveals the inequities in the program. Women currently comprise about 60% of student bodies in Canadian universities and are about 38% of full-time faculty members. Since 2000, the year the CRC program was created, female students have consistently received more than 40% of all PHDs from Canadian universities. As for the proportion of CRCs awarded to qualified Aboriginal persons, racialized persons,[13] and persons with disabilities, the CRC Secretariat itself has not collected reliable figures. However, given that Aboriginal persons make up about 0.7%, racialized persons about 11.1%, and persons with disabilities about 5% of university faculty, an obvious contrast to the rich diversity of the Canadian population is striking.[14] Canada cannot afford a major funding program that aggravates existing systemic discrimination in post-secondary and research institutions, particularly when it also serves to disadvantage humanities, social sciences, and fine arts—those disciplines in which critical thinking is most encouraged and taught.

The Complaint

By 2003 we eight feminist faculty with our shared concerns regarding the CRC program had joined forces. Powerful bonds of mutual respect and professional friendship have brought us together and kept us working our way through the labyrinth of an extremely complicated structure. We have enjoyed invaluable support, assistance, and insight from the Canadian Association of University Teachers (CAUT) and its senior legal counsel, Rosemary Morgan.

Our challenge to the program is not meant to undermine the rationale for enhanced financial support for research in Canadian universities. Nor is our complaint intended to detract from public recognition of the vital contribution made to the public good by

publicly funded university researchers. However, it is our firm conviction that the best research will always be produced when opportunities to engage in it are available to all qualified persons. In short, the existing program favours white, able-bodied males, ignoring the covenants and agreements by which Canada has legally committed itself to equitable practices and the elimination of discrimination.[15]

Over the past five years, the CRC has commissioned consultants to study the program and to examine the validity of criticisms such as ours. Their reports usually glossed over the criticisms or investigated them only superficially. For example, Hickling, Arthurs, Low found, without data, that "the proportion of women in the eligible population and the proportion of women awarded Chairs closely corresponded."[16] In any case, the "review team concluded that introducing further administrative controls, standards, or policies on the use of Chair funds would be difficult to implement and could hamper the different strategic research opportunities the universities are pursuing."[17] The response of the CRC Steering Committee to a recommendation made for certain, modest changes that would have enhanced the program's equity was, "While the Steering Committee endorsed the spirit of this recommendation, it considered that it would be inappropriate for the Chairs program to take any action in this regard."[18]

By 2005, the Steering Committee acknowledged, in response to the Malatest report, "a level of discomfort" with the current allocation of Chairs. It resolved that universities would be required to prepare plans for addressing equity objectives and held accountable for meeting their gender distribution "targets." Failure to do so would result in "sanctions, such as imposing moratoria on new nominations or removing chair allocations." But, as far as we can find out, no action was taken to follow up on such resolutions. It simply has not happened. Many of the required reports were either

late or never submitted; there are no regulations for setting targets, and no sanctions in sight.

We have heard over and over again the lame excuse that a federal body is not in a position to intervene in the academic affairs of universities. However, the conditions of the program could easily include selection procedures that would ensure compliance with Canada's many legal obligations for equitable programs and policies. We have been asking Industry Canada to impose equity rules on universities seeking federal monies, following the model of the Federal Contractors Program. As we see it, the federal government, through Industry Canada, has set up a service (CRCs) for the delivery of federal money to universities. In so doing, the government has identified outcomes (research excellence) and identified the distribution of the money to certain disciplines. Requiring CRC to adhere to federal rules is not an imposition on provincial power or university autonomy. The Federal Contractors Program has predetermined where and how the money will be spent by universities should they decide to participate in the program.

The Canadian Human Rights Commission attempted to resolve our complaints through mediation, but this effort failed when the CRC program refused to make any substantive changes. Our complaint was then sent to a Human Rights Tribunal in 2005. We settled with Industry Canada the next year in hopes of moving the process forward. The majority of CRC positions had been filled by that time. Yet, since the CRC is meant to be an ongoing program, we were encouraged that our complaints had been found legitimate, and optimistic that the rapid implementation of the settlement would correct at least the more glaring flaws of the CRC program. Our press release issued in November 2006, when the settlement was formalized, outlines the major steps to which the CRC agreed:

The CRC Program has agreed to state publicly that the goals of equity and excellence are not mutually exclusive, and that equity ensures that the largest pool of qualified candidates is accessed. It will collect data and set new, enforceable hiring targets for each of four equity groups: women, Aboriginal peoples, members of visible minorities, and persons with a disability. The Complainants were also successful in their demand for significant changes in recruitment, nomination, and appointment procedures, such as open advertising of positions and involvement of university equity officers.

Justice Delayed, Justice Denied

Alas, as I write this account in April 2008, I must admit that we were unduly optimistic in believing the terms of the settlement would be quickly put in place. In fact, the settlement remains still in the dead letter box, perhaps not yet quite dead but certainly not implemented by the CRC Secretariat. Inequitable procedures continue to characterize the program and to have their extremely unfortunate impact on our campuses. Despite our sustained efforts and the commission's ruling, business goes on unchanged and as usual. The very expensive consultants hired by the CRC Secretariat to collect data and set new enforceable hiring targets have not got the job done. We must, therefore, ask whether those negotiating for Industry Canada at the Canadian Human Rights Commission were participating in good faith. We have protested to the Canadian Human Rights Commission regarding the non-implementation of a legally binding settlement, so far without results. Our only small consolation is news of encouraging initiatives taken at some universities by administrators and faculty members to develop both equity targets and practices consistent with established practices. These initiatives reflect, above all,

leadership at every level that gives salient and sustained priority to equity objectives. Such leadership provides visible support to all initiatives taken in the university celebrating the presence of disadvantaged scholars and students and the legitimacy of the research questions they bring to the pursuit of knowledge. In the case of a few universities, senior administrators have indicated that they would support recommendations from academic units for CRC appointments only if they furthered the institution's equity targets. Members of the academic community themselves have had to work to ensure that patriarchal traditions of academic freedom did not function to the disadvantage of equity in today's academy. Of equal importance to the pursuit of equity in Canadian universities has been the recognition in some quarters of the need for conceptual and structural change. This has entailed the modification of the institution's dominant discourse in such ways that objectives of equity are woven centrally into all planning and policy papers. In addition to these fundamental changes brought about by leaders committed to fairness and genuine academic excellence, there has been in their institutions the requirement that all recommendations for CRC appointments conform fully to collective agreements. The CRC website now includes a statement at the very bottom of its page, "About Us," affirming that "the goals of equity and excellence are not mutually exclusive," a statement required by our settlement, and provides a link to the Canada Human Rights Commission page "About Employment Equity."

Despite compelling evidence of serious inequities produced in Canada's research enterprise by the program, we have so far been thwarted in our attempts to effect change, even though there were moments when victory seemed to be ours. Although the Canadian Human Rights Commission recognition in 2005 that our complaint warranted formal investigation, and although we achieved a formal settlement in 2006, real changes have yet to be implemented as of 2008. And since all two thousand Chairs created by

the program have now been allocated to universities, this case has become a clear example of the fact that *justice delayed is justice denied*. Despite the apparent institutionalization of principles of equity at universities across Canada, the wheels of privilege are still turning, greased by systemic discrimination.

Studied Ignorance and Privileged Innocence

A distorted discursive context has made the CRC's inequitable processes and results seem not just normal but commendable. Ideologically charged values packed into words and terms like *excellence*, *innovation*, *the best persons for the position*, and *the knowledge-based economy* create the impression that objective and unchallengeable standards are upheld. This discourse allows those in charge of the processes whereby these results have been achieved—in departments, research teams, research administration, and program administration—to congratulate themselves on the excellence of the program. Expensive external consultants hired to undertake disinterested analyses of the program, but whose perspectives were complicit with the very discourses of systemic discrimination they were asked to detect, have been part of this process of affirmation. Such reassuring ways of seeing have made it possible for those in charge to avoid reflecting on biased attitudes built into received notions of "excellence" in research, on inappropriate recourse to the notion of "academic freedom," or on the unfair measures being used to determine who is "best." Indeed, such ways of seeing allow those already working in privilege not to know how the systems they enjoy are predicated on serious disadvantage for many others who are excluded and unheard where well-funded research is carried out.

Sheila McIntyre conducted a detailed inquiry into "how privileged individuals persist in not knowing or in 'un-knowing' and 'un-thinking' the realities of systemic inequality," demonstrating

that "this recurring exercise of cultivated ignorance serves to justify inaction on systemic inequality claims at the institutional level" and that "such studied ignorance enables and entrenches the freedom of the systemically privileged to dissociate themselves from, and presume themselves innocent of, the cumulative appropriations and dispossessions that define systemic relations of domination."[19] While her starting point was an egregious example in UBC's political science department, where in 1998 convincing allegations of racism and sexism toward students were aggressively swept under the rug by most department members and senior administrators, her probing analysis is equally apt to understanding the inaction surrounding the CRC program. Systems of normalization, coupled with obfuscatory rhetoric, her analysis suggests, work to discredit criticism and shrug off responsibility for change.

In the 1990s, after more than two decades of status of women reports at most of Canada's universities, and after Hall and Sandler had invented the term "chilly climate" to describe the situation of women in the academy, numerous studies revealed that the prevailing impression of women making rapid gains in the academy was largely an illusion (see Bibliography). In "The Conceptual Politics of Chilly Climate Controversies," Prentice has studied the radical differences in world view between those who view social dynamics from a neo-liberal perspective and those who consider chilly climates to be the products of systemic discrimination.[20] Prentice's analysis joins McIntyre's in helping to make sense of why the attempt to reform the CRC program has met with such frustrating results.

Our human rights challenge came up against a widespread, indeed systemic, phenomenon. At each delay or setback, our group has wondered how decision-makers can so easily ignore the compelling evidence presented to them. We might imagine they wish to evade responsibility for change. We have not yet given up, but

we find that we must concur with Sheila McIntyre, who said, "Reasoned arguments and empirical proofs are pointless in the face of studied ignorance, wilful blindness, and the persistently and oppressively exercised 'right not to know.'"[21] The fallout of prevailing inequities continues to land most squarely on those already disadvantaged. McIntyre has movingly described their situation as "a myriad of subordinating acts, interactions, and understanding that continue to excommunicate Others from full acceptance and citizenship within the academy and from full personhood in the world that the academy reflects and shapes."[22]

The obstacles created by wilful ignorance, bureaucratic delays, deliberate foot-dragging, and buck-passing within universities and between universities and the CRC Secretariat have resulted in the creation of a permanent research funding program that is demonstrably inequitable. In an era where neo-liberal and conservative politics generally are working to discredit the hard-won insights into and policies against systemic discrimination, the CRC program acts to re-entrench privilege and exacerbate inequities. At root seems to be the very persistence of systemic discrimination itself, which is more deeply entrenched in the discourses and power structures of universities than we might have thought. Sadly, one of the primary results of the CRC program seems to be institutionalizing the bizarre assumption that equity and excellence are at odds, despite the recent CRC statement to the contrary. In fact, they are complementary cornerstones of universities' ability to serve the interest of all Canadians by producing independent thinkers and creative research.

Addendum

Just before it dissolved Parliament in 2008, the government created an extension of the CRC program to be administered by the CRC Secretariat. The new program is what my fellow complainants

call an über-program, in that it is aimed at an even higher level of elite research performers, with each award worth more than those of the original program. This new program reveals that the government has paid no attention to our concerns regarding inequities and flawed procedures, and that there has been no widespread communication about the program. Once again, those already in inner circles will have their foot in the door before others even learn about the extended program. The matters addressed in this chapter and recent initiatives at the CRC Secretariat continue to be of urgent concern for women and all those who care about excellence and equity in the academy.

NOTES

1. We are eight senior academic women doing scholarly work in a broad range of disciplines at universities in provinces from coast to coast in Canada: Marjorie Griffin Cohen (Simon Fraser University), Louise H. Forsyth (University of Saskatchewan), Glenis Joyce (University of Saskatchewan), Audrey Kobayashi (Queen's University), Shree Mulay (McGill University), Michèle Ollivier (University of Ottawa), Susan Prentice (University of Manitoba), and Wendy Robbins (University of New Brunswick). Rosemary Morgan, legal counsel, Canadian Association of University Teachers, has been invaluable from the start and throughout the process for her legal expertise, her warm, committed and extremely competent advice to the complainants, and her drafting of documents in appropriately legal language. I am indebted to Rosemary Morgan, to Wendy Robbins, and to the others for their research and insight. Sometimes I go so far as to borrow words and sentences from working documents they prepared. For a detailed description of the history and analysis on which our complaint is based, see Side and Robbins, "Institutionalizing Inequalities in Canadian Universities: The Canada Research Chairs Program."

2. Here is the definition of "systemic discrimination" as understood under the *Canadian Human Rights Act* of 1978:

 Discrimination...means practices or attitudes that have, whether by design or impact, the effect of limiting an individual's or a group's rights to the opportunities generally available because of attributed rather than actual characteristics. It is not a question of whether this discrimination is motivated by an intentional desire to obstruct someone's potential, or whether it is the accidental by-product of innocently motivated practices or systems. If the barrier is affecting certain groups in a disproportionately negative

way, it is a signal that the practices that lead to this adverse impact may be discriminatory.

3. Information on the CRC program, including history, publications, contact and application information, current Chairholders, allocations by funding councils and universities, and some statistics, is available on the website: http://www.chairs-chaires.gc.ca/.

4. These well-funded programs seemed to be encouraging new signs that the federal government had a strong will to invest in research and development for the public good in Canada. Since 1997 the CFI, a program to fund research infrastructure, has sent $3.8 billion to 128 universities and research institutions across Canada, and the CRC has distributed more than $2 billion among 70 participating universities since 2000. Universities participating in the CRC program are also eligible for additional infrastructure support through the Infrastructure Costs Program, with its annual budget of $300 million, which supports laboratory costs but not library acquisitions, even though library resources form the base of infrastructure needs in the humanities and social sciences.

5. The clear evidence of unfair discrimination to which I refer pertains only to the number of Chairs awarded to females. Because the CRC program has not ever collected information on other groups protected by Canadian human rights legislation, there is not clear evidence of discriminatory practices underlying the minimal participation by members of these groups in the program. One could, however, suggest that the very fact that the CRC program has shown no interest so far in gathering good information about such participation is, by itself, evidence of indifference to equity issues and willingness to accept inequitable practices. Widespread anecdotal information suggests that unfair discrimination against these groups prevails throughout the Canadian university system. As of January 2008, no statistics were available from the CRC Secretariat on the number of Chairs awarded to persons of Aboriginal origin, persons with disabilities, or so-called "visible minorities."

6. Glenis Joyce, "Chasing the Gorilla in a Silent Jungle: Integrated Planning and the Disappearance of Equity," *vox.* University of Saskatchewan Faculty Association, April 11, 2005, 1.

7. D.E. Smith, "Despoiling Professional Autonomy: A Women's Perspective," in *Inside Corporate U: Women in the Academy Speak Out*, ed. M. Reimer (Toronto: Sumach Press, 2004), 40.

8. Joyce, "Chasing the Gorilla," 2.

9. Linda Eyer, "Teacher Education or Market Lottery? A Look at Recent Shifts in Knowledge, Curriculum and Pedagogy in a Faculty of Education," in Reimer, *Inside Corporate U*, 80 (see note 7).

10. The Audits project represented a daunting research undertaking, since reliable statistics were not easily available. Statistics Canada data were vital, but not broken down in ways that would have made them easily usable; universities and the CRC Secretariat were not keeping information on the sex

of Chairholders; no one was collecting integrated information on the four groups designated under the *Employment Equity Act* (women, Aboriginal persons, racialized persons, persons with disabilities). Robbins publicly stressed the methodological difficulties she and her colleagues had encountered in the preparation of the audits. Yet they managed to produce such credible material that the facts were clear: the CRC program was working to the serious disadvantage of society's already disadvantaged members. These Audits have been progressively enriched each year to provide information on the four designated groups. See http://www.fedcan.ca/english/issues/issues/ivoryaudit/index.cfm.

11. As an indication of the ongoing foot-dragging that characterizes the attitude at the CRC Secretariat regarding the 2006 settlement, see "CRC Program Slow to Implement Settlement to End Discrimination/Programme des chaires de recherche. Un règlement au point mort." *CAUT Bulletin* 55, no. 3 (April 2008): A2, A7.

12. Data received from CRC Secretariat January 18, 2008.

13. In this chapter I am using "racialized persons" to designate those who are referred to in the *Canadian Human Rights Act* as "Visible Minorities," since I find this term biased and based on unfortunate assumptions. There is, in fact, no more **visible** minority in our society than able-bodied white men. Their images and icons, reflecting their powerful presence in all seats of power, are everywhere controlling the mainstream, its institutions and its cultural norms. It is this dominant minority that has invented the demeaning term of *visible minority* to apply to persons of colour, as though they had only recently come into view and are not numerically significant. The term *racialized* at least acknowledges that dominant discourse has hung a racial tag on persons of colour. I hope that the non-use of the word *minorities* underlines implicitly that all groups of people categorized by prevailing practices are, in fact, minorities, none being in a position to make a legitimate claim to membership in an unproblematic majority.

14. Unofficial information received from the CRC Secretariat, December 2007. While figures for racialized persons appear to show that the gap between university faculty and the overall population is not too wide—11.1% compared to 13%—it is important to note that the diversity of racialized persons in the Canadian population is not at all reflected in an equal distribution across academic disciplines. The majority of racialized persons is Asian in ethnic or national origin and is concentrated in disciplines related to mathematics, sciences, and high technology.

15. Through a multitude of instruments, covenants, and laws, Canada has an overarching commitment for all its citizens to non-discrimination, to *equity* in services and employment. Canada has been since the 1960s a signatory to several United Nations and International Labour Organization conventions, and as a member of the U.N. is committed to implementation of its other instruments, including the U.N. *Declaration of Human Rights* (1948). Section 15 of the *Canadian Charter of Rights and Freedoms* (1982) states that "Every individual is

equal before and under the law and has the right to the equal protection and equal benefits of the law without discrimination and, in particular, without discrimination based on race, national or ethnic origin, colour, religion, sex, age or mental or physical disability." The purpose of the *Employment Equity Act* (1986) was to provide even further protection for the four designated groups (Aboriginal peoples, persons with disability, women, and racialized persons) in employment in federal government and federally-regulated industries. There is, as well, a good deal of federal and provincial legislation, such as the Federal Contractors Program. These all mean that the federal government and all of its departments and agencies have a legally binding obligation not only to respect human rights in all areas under its jurisdiction, but to ensure that these rights are respected in any new legislation. As a service to the public, the CRC program, which entails the control and distribution of federal funding, is subject to Section 5 of the *Canadian Human Rights Act* (1977).

16. Hickling, Arthurs, Low. "Technology Management, Strategy, and Economics." *Third Year Review of the Canada Research Chairs Program, Final Report.* (Ottawa. HAL. Ref 7185.06, 2002).

17. Ibid., vi.

18. Ibid., 3.

19. Sheila McIntyre, "Studied Ignorance and Privileged Innocence: Keeping Equity Academic," *Canadian Journal of Women and the Law* 12, no. 1 (2000): 158–59.

20. Susan Prentice, "The Conceptual Politics of Chilly Climate Controversies," *Gender and Education* 12, no. 2 (2000): 195.

21. McIntyre, "Studied Ignorance," 194.

22. Ibid.

Waving

11

Drowning in Bathtubs
Temptation and Terror

ARITHA VAN HERK

WISHING FERVENTLY TO BELIEVE that "feminism" is no longer a suspect term or praxis, feminist scholars, nevertheless, within the grotto of academia, practice drowning gracefully. While there is easy permission to make puns about the stalactites that drip from the roof and we have no compunction about ducking our heads under the surface of the healing mineral water of ideas, we remain, if we are aware, wary. Even immersed, floating, we have learned to brace ourselves against surprise. Daring to be optimistic is sometimes both task and temptation. We linger in the chambers of the sea, we sea-girls, till human voices wake us, and we drown.[1]

BUT NO. WATER IS A PLEASING substance, liquid and yielding. Bodies can glide and step despite the pressure of the element; having suffered innumerable occasions when heads bumped painfully against the solid resistance of glass ceilings, we find the glass

of liquid infinitely more amenable. This is a boundless world, this grotto greater than enclave or penal colony, the hushed echoing arch of stone above and the sandy floor underfoot. Generations have spoken and written, indefatigable leaders swimming fiercely, double breast-strokes moving them inevitably forward, inspiring others with their wave. Besides, it is impossible to drown in a bathtub. Or is it? Better to believe that feminist scholarship traffics in large warm towels, the scent of lemongrass, and the splash of mutually appreciated pages, murmured approbation. Naked together, bodies less than perfect even under the generous glaze of water, feminist scholars might seem an unprepossessing bunch, credentials or not. But there is yet a shapely imprint to heart and intellect, the submerged coda of inheritance an outwash of all the waves of feminism. These are model swimmers, sturdy and unflagging. Much work has been done. Much work is yet to be done.

As any feminist scholar will confess, it is sometimes tempting to drown, to ease back into buoyant oblivion without bothering to wave to the figures clustered on shore. There will always be those who applaud the performance, who nod knowingly and opine, "Of course, she's drowning. She's out of her depth, poor dear." Such pacific eulogies, quick to announce the passing of yet another troublesome woman. The subtext is simple. "Thank god she drowned. She was so much trouble." The sub-subtext is seldom stated so bluntly. "Her own fault. She shouldn't have ventured out so far. She submerged herself." Not quite "good riddance," but close enough.

I DROWN, OVER AND OVER. I drown and wave as well. But I am in good company. Many have drowned, their immersion deliberate or accidental, tawdry or tempting. Virginia Woolf, dreamily and with a sigh of relief I imagine, in the River Ouse.[2] Ophelia, rushed to conclusion in order to pave the way for Hamlet's indecisive flailing toward closure.[3] Her sweet floating a poetic interlude before the shock and awe of treachery revealed. Maria Montez, in

an un-costumed adventure, seized by surprise, after having a heart attack in her bathtub.[4] Bystanders to the anointed, like Mary Jo Kopechne, trapped in a car in a pond on Chappaquiddick Island.[5] She might have become a contemporary running mate. Even Buffy the Vampire Slayer encountered drowning.[6] Although she lives to breathe and tell the tale.

STILL OTHERS REFUSED TO DROWN, and made their own bargains with closures both cruel and kind. Simone de Beauvoir, at a serious age, calling it quits.[7] Marguerite Duras refusing to give up cigarettes.[8] Or Alice Ernestine Prin, Kiki to the uninitiated, the Queen of Montparnasse, succumbing too early for her antics.[9] Susan Sontag documenting her own metaphors of mortality,[10] and Alice B. Toklas dying penniless after hosting the feasts commemorating Gertrude.[11] Not to mention Colette, who at seventy-two was finally admitted to the Academy Goncourt in 1945, the first, yes, the very first female member of that august assembly. Dying a mere nine years later, but waving goodbye at a State funeral,[12] the first woman to be so honoured.

THIS IS NO THRENODY, no dirge or complaint. Leave that to bagpipes or dipsomaniacs, men in suspenders harrumphing over the tides of feminist influence. I float and submerge, in this riff on drowning, among astonishing foremothers, a tradition richer than plum cake, of infinite variety. They teach well the art of waving, saucy, insouciant, and without remorse or regret. If women face now a muddy period, not quite post-feminist, since feminism is still urgent and we have yet to catch a glimpse of post-patriarchy, we are infinitely happy heirs to the work of those women who measured out our graveyards and Utopias, rebellions and reconstructions. Our intellectual challenges have changed with time and temper, but are always already challenging. We still battle the kind of patronizing quote that Charles Dickens wrote to a shy reader,

"Dear Madame, you make an absurd though common mistake in supposing that any human creature can help you to be an authoress, if you cannot become one in virtue of your own powers."[13] Helpful, was he not? Although he spoke true enough in one sense: if we cannot believe in the virtue of our own powers, we won't make it out of the water. We drown and drown again.

Not the least of our sousing is our resistance to play. My bathtub metaphor then is something of a hoax, like the famous practical joke played by H.L. Mencken, who published a fictitious history of the bathtub, claiming that it had been introduced into the United States no earlier than 1842 and that it was an object of controversy, with folk at that time debating whether it was good or bad for the health.[14] Mencken's tongue-in-cheek parody was believed by solid bearded men who entered his spoof as fact in encyclopedias and history books. It was then cited and referred to unquestioningly. One can forgive him for playing the joke, given his gullible accomplices, and his happy remonstrance where he reveals his wit as doubling of that wit.[15] Histories of household appliances have that effect; all attention turns to the men who treatise over them. But surely feminist scholarship has taught us to observe that in every bathtub, fictitious or otherwise, floats a body, as much misrepresented as the bathtub and its history, at the mercy of those who pay far more attention to the scientific heft of weight and volume than the woman who displaces that volume. Archimedes indeed.

I SHOULD, I CONFESS, know better myself, but submergence in generations and citations is one of the pleasures of working within a female intellectual community. Citations perform their own allure for scholars and bad critics, but they remind me of all that has passed and professed, the work that has been done, the work yet to be done. Here is the nexus of pleasure, this digressive conversation with companions, those who scrimped and saved, composed and created.

And still, I am compelled to observe a woman and her drowning. There are particularly insidious moments, like Mary Wollstonecraft Godwin and Percy Bysshe Shelley marrying when they learn that Shelley's wife had managed to drown herself and to unelope their—that would be Mary and Percy's—elopement.[16] Ah, the drownings and wavings of that literary coupling, what a fine set of monsters were set in motion, since he drowned too— how unoriginal of him![17] But she, Mary Shelley, didn't bother with drowning, didn't have time, did she? Had to keep writing to put bread on the table. Pass the bathtub, she might have whispered to herself at times when the words didn't translate quite as readily as a writing woman might wish. She possessed none of the leisure of Marilyn in the *Seven Year Itch*,[18] grimacing at the plumber trying to fix the bathtub while Munroe occupies it, bubbles and all, although they are certainly meant to conceal the reveal. Which is a dilemma that all feminist writing faces: conceal or reveal? Dissemble or camouflage? Divertimento perhaps, as a path to discovery. All akin to waving, curiosity its premise and promise. Whoever reiterates the old proverb about curiosity killing the cat was wrong; that was a warning designed to keep women away from information, the great Pandora's treasure that can be found in the Orlando project[19] and *The Feminist Companion to Literature in English*.[20]

Such impressive compendia argue for what feminist scholarship has accomplished, the sheer weight and volume of that work a call to not arms but continuance. Continue and continue. What these thinkers have modelled, the argument that they have persistently advanced, is that we are not finished. Both "blind and seeing in the dark,"[21] the mothers and sisters and cousins and aunts who preceded us have made a mark, declaring how much this work matters. Despite the temptation of believing that we can rest on our laurels, there's no time for pious resignation.

SO DROWNING IN BATHTUBS is no mean feat, given the many ways that women writers can close chapters. George Eliot, that escapee from Mary Ann Evans, didn't need to take a bath to catch cold,[22] a concert did just as well, despite the lovely cupid's bow of her mouth, her sensual eyelids. Emily Brontë took ill at Branwell's funeral, and then died three months later of consumption.[23] A hot bath would have cured them both. When it comes to dying, it is time to fight back, re-invent the backstroke, stay afloat despite sabotage or the cold comfort of consumption. Perhaps it was baptism (talk about a miniature bathtub) that made Aphra Behn so skeptical, a spy unwilling to wait for appropriate rewards. She stayed afloat with social comedy, mocking the mockable with a Behnesque—or was that Johnsonesque?—aplomb. We'll never know, but feminist scholars never need to know (such DNA trackings are for men who can never be sure they are the fathers of their children), more than her becoming thus—Aphra Behn, that is—the first Englishwoman to make her living writing, and that despite being the daughter of a lively innkeeper.[24] I attribute Behn's delightful ire to her marrying a Dutch merchant and spying for Holland, not to mention writing *The Dutch Lover*,[25] that decided oxymoron, but a mere side interest of mine, a measure of my hyphenated identity and nothing to do with the inundations considered here. Aphra Behn's laggard pay stubs are prelude to all women's doubts and ratifications. Did she really do the work, did she actually deserve a merit increment? Should she be promoted to full professor? Pay inequity can send us all to tenuous retirements or debtors' prisons; and we need to do our work despite promotions committees or subtle jabs of doubt. The feminist scholar will keep scratching with a pen at the cold surface of a page, like Willa Cather at twenty, writing for the *Nebraska State Journal* for the princess-ly recompense of $1 per column.[26] The feminist scholar is not supposed to compare her financial rewards with others—or even expect them. Perhaps we ought to take a lesson from Dorothy Parker. When *Vanity Fair*

forbade its employees to discuss their pay, Parker and her colleagues, Robert Benchley and Robert Sherwood, wore signs around their necks revealing their salaries.[27] Ahh, subversion.

In such subversion is delicious pleasure, pleasure itself a worthy subject of investigation, like Jane Austen's reminder that "one half of the world cannot understand the pleasures of the other."[28] Austen was pleased by publication, although those famously small pieces of paper that could be slipped under a blotter if a visitor blundered into the room might seem close to denial.[29] How can we still continue "accommodating women's aspirations to existing social structures"[30] and yet break free of endlessly stifling inhibitions? That might be the crux of all feminist scholarship. How little, Jane Austen, has changed! How very less it would have changed without those scraps of paper hidden under the blotter.

IN FACT, THE WORK OF FEMINIST scholarship must take surreptitious pleasure in the unexpected, what others might think inconsequential. This is the true gesture of a woman waving and refusing to drown, like Edith Sitwell, eternally "in disgrace for being a female."[31] Becoming a Dame of the British Empire doesn't quite take the sting out of being parodied by Noel Coward as Hernia Whittlebot.[32] And Marianne Moore could very well have thought up the poetic appellation "Utopian Turtletop," in her bathtub. The evocative name was lost when Ford called the car instead the serviceable Edsel. Ford sent Moore roses, though.[33] What was that about? Hire a poet for an idea. Lovely poetic name, and here's your kill fee: a bouquet of roses? While metaphors will not save imaginative women from the automobile, turtletops, those shells that could, inverted, become miniature bathtubs in which we might drown or swim, or float rose petals of ideas, will prevail.

OR IMAGINE THE VISIONARY Sylvia Beach, opening the doors of Shakespeare and Company, on 17 November 1919, and declaring

the site "meeting place, club house, post office, money exchange, and reading room...."[34] She summarizes a spatial outline for generational motivation, the multiple tasks facing the feminist scholar, one as necessary as the next, the way both post office and reading room are archaic but necessary, like tough and dexterous thinking. Beach's memoir, *Shakespeare and Company*, devotes its last pages to a summary of her activities during the depression and the occupation. She describes how, in 1941, she was informed that the entire goods of the shop were to be confiscated after she refused to sell her last copy of *Finnegan's Wake* to a Nazi officer. But before this could happen, she and her friends removed every item, including the light fixtures. (She was later interned by the Germans, but was released six months later.[35]) This is the capacity of a woman who is both intellectual and practical. She will let neither the light fixtures nor *Finnegan's Wake* fall into unappreciated hands, and thus becomes a formidable blur of feminist, writer, teacher, wizard, saleswoman, model, and mentor.

WE MUST RETURN TO PLEASURE, remind ourselves of that subtext in generational inheritance. Vita Sackville-West declares as much in her reference to gardens: "small pleasures must correct great tragedies."[36] The opposite perhaps to the usual assumption that tragedy must be large and bloody and without the redeeming features of gardens, instead comprised of trenches and stony fields and blood. Those gardens that flourish and nourish are subtle indeed. And while Vita doubtless would have agreed with Willa Cather that "most of the basic material a writer works with is acquired before the age of fifteen,"[37] neither stopped there; both acquired far more in the process of acquiring material. Note that Willa Cather's first published work was a university assignment on Thomas Carlyle, which so impressed her professor that he arranged for it to appear in the *Nebraska State Journal*[38] (such an auspicious debut). That said, it is tempting to remember the fate of

Carlyle's manuscript of the first volume of *The French Revolution*.[39] Remember John Stewart Mill's maid burning it as kindling?[40] The tome could probably have been improved upon, and burning might have done the trick. Ah, these fortunate men, relying on maids and wives. It was Jane Carlyle who had to trudge down to the Income Tax Commissioners and demand a lower assessment of her husband's literary earnings, all in order to forestall an outbreak of his famous temper.[41] As literary critics, we might chuckle to read that "it was very good of God to let Carlyle and Mrs. Carlyle marry one another and so make only two people miserable instead of four,"[42] but the marriage was surely the saving of him.

Nor is the provenance of marriage and its fallout to be ignored, when a feminist companion might be both more useful and more satisfying than any spouse. Intimacy's generational reflections are a source of combined frustration and delight, arousing both attention and revulsion in feminist scholarship and its outcomes. Male scholars have likened writing to marriage, like Churchill with his pontifications on being married to six volumes of history when he says, "Writing a book is an adventure. To begin with it is a toy and an amusement. Then it becomes a mistress, then it becomes a master, then it becomes a tyrant. The last phase is that just as you are about to be reconciled to your servitude, you kill the monster and fling him to the public."[43] Such pugilistic metaphors do not translate. Those books, which begin life for women as adventures and amusements, and then become mistresses before morphing into masters and tyrants, are nevertheless our work, our shyly made gifts. Our inclination is still tenderly receptive to this new-minted permission to scholarship and writing. Self-critical we are, but far better for us to heed Katherine Mansfield, who declared, "I imagine I was always writing. Twaddle it was, too. But better far write twaddle or anything, anything, than nothing at all."[44] The profound yearning expressed here, her desire to write anything rather than nothing at all, is a eulogy for a life of words, words without

interruption or censorship, words as intellectual and creative force. And words that speak beyond the expected or imagined. Imagine Virginia Woolf, reading the words we would wish to write. Imagine Woolf, upon the death of Mansfield, writing in her journal that Mansfield's was "the only writing I have ever been jealous of."[45] To live then, a life of the mind, is the gift that this bathtub of footnotes has bestowed.

SUCH CREATIVE DIGRESSIONS might be better served by sustained silence or determined refusals, like Fran Lebowitz, who, when asked if she ever consulted a thesaurus, answered, "No. I've never been able to figure out how to use one. I must have been absent that day."[46] But digressions enable other meetings, meetings that refuse summaries or fidelities or even character slights. When Walter Scott met Fanny Burney he dismissed her out of hand, as "an elderly lady with no remains of personal beauty but with a gentle manner and a pleasing expression of countenance."[47] Surely this was not the same woman who underwent an unanaesthetized mastectomy.[48] So much for appearances or his powers of observation. The temptations of pronouncement are irresistible, a history impossible to escape.

SHALL FEMINIST SCHOLARS march forward then, like Louisa May Alcott, "Duty's faithful child,"[49] dotting the t's and crossing the i's? Ah, we can hardly continue this tradition straight or make a virtue out of any duty that impels us to read carefully, to think richly, and to sidestep morality, whatever the modelling of Sarah Joseph Hale and "moral homilies," despite the longevity of "Mary Had a Little Lamb."[50] This will be the next and most daunting challenge, to sidestep the fetters that would bind us, limit our spectacular power of thought and imagination. This, above all—to refuse duty, birthing strong-willed writers and critics and thinkers.

GRUMPY CANONICAL GATEKEEPERS would claim that most everything is the fault of wives and girlfriends sending tortured poets like Robert Frost out to stumble around great dismal swamps,[51] thinking dark thoughts in order to go home and write down great thoughts. The model of our generational mentors is not to take responsibility for such vapours, but to write instead our own thoughts, to claim ownership of ideas and to push them forward. And yes, a feminist affliction, like Anna Karenina and Madame Bovary, like Eleanor Read Emerson, might be that we read too much. The mainstream critical world continues to be convinced (albeit covertly now) that we should limit our studies to idle chicklists. But think of the source of such advice. Literary sets and friendships, fraternities who doubtless dream still of following in the footsteps of Sherwood Anderson, turning his back on Elyria, Ohio, in quest of his own seductive grotesque.[52] We spend too much time in pursuit of those motivations and not enough in our own company, we who know the cost of shedding "the fetters of respectability and the burden of security."[53] No, the tantrums of women scholars and writers are quiet ones, despite their being "justifiable acts of rebellion against the tyranny of those in authority,"[54] as Elizabeth Cady Stanton would declare, loudly, and precisely. Resistance expects fierceness, a measure of clear-sighted recognition. Even collaborators will appropriate. Does Zelda Fitzgerald need to remind us that "plagiarism begins at home,"[55] when all F. Scott wants her (and by extension us) to do is "give up the idea of writing anything,"[56] and take to an asylum. When the flames engulfed her, in that sad hospital, she would have longed to drown instead.

THERE ARE CAUTIONARY tales aplenty. For all that feminists have exploded Anne Sexton's dwarf heart[57] we still stumble, the unexploded and dangerous bomb of our dilemmas incipient as time.

Think twice when we are tempted to appropriate our pasts, for as Fran Lebowitz cautions, "having been unpopular in high school is not just cause for book publication."[58] But Fran, let me ask, Why not? A thousand reasons will arise that prevent book publication or writing, or any of the other rewards so manifest in feminist scholarship. There are many causes and many models, and sometimes unpopularity is enough.

AND SO, SUBMERGED but re-surfacing, feminist companions and their companions provide guidebooks, for the work done, the work in progress, and the work that needs to be done. They offer no overt advice, but it is there, between the lines. To prevent drowning, breathe normally and don't panic. Practicalities are best. A bathtub is a small space and difficult to drown in. It is possible to recover from systemic hypoxia; women can perform mouth-to-mouth resuscitation. Learn to swim the backstroke; it is the ironic move, but effective. Swim with company, the company of the multi-vocal women, like those who seed this meditation. Even a quotation can be companionable. And finally, face facts. A bathtub is just a bathtub. The surface many seem glassy, and whether we are administrators or artists, critics or computer aficionados, we know only too well the hardness of a glass ceiling, a glass escalator, the glass floor, the glass cliff, stained-glass seductions.

BUT A GLASS OF WATER is refreshing, both quotidian and sublime. Drowning is unnecessary; writing waves a semaphore that cannot be obliterated.

NOTES

1. We all know this one. Thomas Stearns Eliot, "Love Song of J. Alfred Prufrock" (London: The Egoist, Ltd., 1917).
2. Woolf committed suicide on 28 March 1941, by drowning herself in the River Ouse. See Quentin Bell, *Virginia Woolf: A Biography* (1972; London: Hogarth, 1990), 226.

3. William Shakespeare, *Hamlet, Prince of Denmark*, The Complete Signet Classic Shakespeare, ed. Sylvan Barnet (San Diego: Harcourt Brace Jovanovich, 1972), 4.7.163–194.

4. Maria Montez died on 7 September 1951, after having a heart attack and drowning in her bathtub. "Maria Montez, 31, Dies Suddenly After Reducing Bath in Paris Home," *New York Times*, September 8, 1951, 8.

5. Mary Jo Kopechne drowned on 19 July 1969 in a pond on Chappaquiddick Island in a car driven by Senator Edward Kennedy. "Woman Passenger Killed, Kennedy Escapes in Crash," *New York Times*, July 20, 1969, 1+.

6. "Prophesy Girl," *Buffy the Vampire Slayer*, The WB Television Network, June 2, 1997.

7. De Beauvoir died on 14 April 1986, of a pulmonary edema. Deidre Bair, *Simone de Beauvoir: A Biography* (New York: Summit, 1990), 615.

8. On 3 March 1996, Marguerite Duras died at the age of 81, of throat cancer, in her home in Paris. Alan Riding, "Marguerite Duras, 81, Novelist and Screenwriter," *New York Times*, March 4, 1996, sec. A1.

9. On 23 March 1953, Alice Ernestine Prin died in a Paris hospital at the age of 52. "Alice (Kiki) Prin," *New York Times*, March 24, 1953, 31.

10. On 28 December 2004, Susan Sontag died of leukemia at the age of 71. Margalit Fox, "Susan Sontag, Social Critic with Verve, Dies at 71 [Obituary]," *New York Times*, December 29, 2004, late ed. (east coast), sec. A1.

11. Alice Toklas died on 7 March 1967, at the age of 89. Linda Simon, *The Biography of Alice B. Toklas* (Garden City, NY: Doubleday, 1977), 254.

12. Colette died, in Paris, on 3 August 1954. She received a state funeral, the first given for a woman in the French Republic. Judith Thurman, *Secrets of the Flesh: A Life of Colette* (New York: Knopf, 1999), 498–99.

13. Charles Dickens, "To Unknown Correspondent," December 27, 1866, in *The Letters of Charles Dickens Volume Eleven 1865–1867*, ed. Graham Storey (Oxford: Clarendon, 1999), 289. http://library.nlx.com.ezproxy.lib.ucalgary.ca/ (accessed December 13, 2006).

14. H.L. Mencken, "A Neglected Anniversary," in *The Bathtub Hoax, and other Blasts and Bravos from the Chicago Tribune*, ed. Robert McHugh (1958; New York: Octagon, 1977), 4–10. Originally published in the *New York Evening Mail* on December 28, 1917.

15. Mencken's reaction to the bathtub history hoax can be found in H.L. Mencken, "Melancholy Reflections," in *The Bathtub Hoax, and other Blasts and Bravos from the Chicago Tribune*, ed. Robert McHugh (1958; New York: Octagon, 1977), 10–15. It was originally published in the *Chicago Tribune* on May 23, 1926.

16. James Bieri, *Percy Bysshe Shelley: Youth's Unextinguished Fire, 1792–1816* (Newark: University of Delaware Press, 2004). Percy Shelley and Harriet Westbrook eloped on 25 August 1811 (195). Three years later, on 28 July 1814, Shelley eloped again with Mary Wollstonecraft Godwin (323). On 10 December 1816, Harriet's body was discovered; she had committed suicide by drowning

(18). Shortly thereafter, on 30 December 1816, Mary and Percy were married (26).

17. James Bieri, *Percy Bysshe Shelley: A Biography: Exile of Unfulfilled Reknown, 1816–1822* (Newark: University of Delaware Press, 2005). Percy Shelley drowned on 8 July 1822, when his schooner, the *Don Juan*, sank off the coast of Italy (324).

18. *The Seven Year Itch*. Film, directed by Billy Wilder (1955; Twentieth Century Fox).

19. *The Orlando Project: A History of Women's Writing in the British Isles*. http://www.arts.ualberta.ca/orlando/.

20. Virginia Blain, Patricia Clements, and Isobel Grundy, eds., *The Feminist Companion to Literature in English: Women Writers from the Middle Ages to the Present* (New Haven, CT: Yale University Press, 1990).

21. Phyllis Webb, *Water and Light: Ghazals and Anti Ghazals* (Toronto: Coach House Press, 1984), 59.

22. George Eliot caught cold at St James's Hall, and later died on 22 December 1880. Ina Taylor, *George Eliot: Woman of Contradictions* (London: Weidenfeld and Nicolson, 1989), 222.

23. Emily Brontë died on 19 December 1848. Winifred Gérin, *Emily Brontë: A Biography* (Oxford: Clarendon, 1971), 259.

24. Blain et al., "Behn, Aphra," in *The Feminist Companion*, 77–78.

25. Aphra Behn, *The Dutch Lover. Plays Written by the Late Ingenious Mrs. Behn*, vol. 1, London: 1702, *Eighteenth Century Collections Online*. Gale Group. January 8, 2007. http://galenet.galegroup.com.ezproxy.lib.ucalgary.ca (accessed January 8, 2007).

26. Edith Lewis, *Willa Cather Living: A Personal Record* (New York: Octagon, 1976), 36.

27. Marion Meade, *Dorothy Parker: What Fresh Hell Is This?* (New York: Penguin, 1989), 36.

28. Jane Austen, *Emma* (1816; London: Penguin Classics, 1966), 106.

29. David Nokes, *Jane Austen: A Life* (New York: Farrar, Straus and Giroux, 1997). Nokes describes how Austen required privacy when writing her novels, and attended carefully to the sound of her creaking door to alert her to the appearance of unexpected guests (393).

30. Blain et al., "Austen, Jane," in *The Feminist Companion*, 40.

31. Edith Sitwell, *Taken Care Of: The Autobiography of Edith Sitwell* (New York: Atheneum, 1965), 15.

32. Blain et al., "Sitwell, Edith," in *The Feminist Companion*, 988–89. In 1954, Edith Sitwell became the first poet to be named Dame of the British Empire (989).

33. On 19 October 1955, Moore was asked by Henry Ford to contribute names for a new series of cars, which was to become the Edsel. Charles Molesworth, *Marianne Moore: A Literary Life* (New York: Atheneum, 1990), 389–90.

34. Blain et al., "Beach, Sylvia," in *The Feminist Companion*, 72.

35. Sylvia Beach, *Shakespeare and Company* (1956; New York: Harcourt Brace, 1959), 206–21.

36. Blain et al., "Sackville-West, Vita," in *The Feminist Companion*, 938. Source of the quotation, V. Sackville-West, "The Garden" (1946), in *The Land & The Garden* (London: Webb & Bower, 1989).

37. Willa Cather, "Willa Sibert Cather," in *Willa Cather in Person: Interviews, Speeches, and Letters*, ed. L. Brent Bohlke (Lincoln: University of Nebraska Press, 1986), 20. This interview was originally published on 3 May 1921, in *The Bookman*.

38. Edith Lewis, *Willa Cather Living: A Personal Record* (New York: Octagon, 1976), 31.

39. Thomas Carlyle, *The French Revolution: A History* (1837; London: Chapman and Hall, 1904).

40. Thomas Carlyle, "To James Fraser," March 7, 1835, in *The Collected Letters of Thomas and Jane Welsh Carlyle*, vol. 8, ed. Charles Richard Sanders (Durham, NC: Duke University Press, 1981), 66–70. In this letter, Carlyle describes his anguish when John Stuart Mill's maid mistakes his manuscript copy of the first volume of *The French Revolution* as kindling and burns it.

41. Rosemary Ashton, *Portrait of a Marriage* (London: Chatto & Windus, 2002), 374–75.

42. Samuel Butler, "Dear Miss Savage," November 21 1884, in *Letters Between Samuel Butler and Miss E.M.A. Savage*, ed. Geoffrey Keynes and Brian Hill (London: Jonathan Cape, 1935), 349–50.

43. Winston Churchill, "The Short Words Are the Best," in *Churchill Speaks 1897–1963: Collected Speeches in Peace and War*, ed. Robert Rhodes James (New York: Barnes and Noble, 1980), 921–22. These words are from a speech Churchill gave to accept the *London Times* Literary Award, at Grosvenor House, on 2 November 1949 (921).

44. "Mansfield, Katherine. Journal: 1922 July 4," *Journal of Katherine Mansfield*, ed. John Middleton Murry (London: Constable, 1984), 327.

45. Virginia Woolf, *The Diary of Virginia Woolf*, vol. 2, ed. Anne Olivier Bell and Andrew McNeillie (San Diego: Harvest-Harcourt Brace, 1978), 227.

46. Fran Lebowitz, interview, December 5, 1982, http://www.eskimo.com/~recall/bleed/1205.htm (accessed December 13, 2006).

47. Walter Scott, *The Journal of Sir Walter Scott*, ed. W.E.K. Anderson (Oxford: Clarendon, 1972), 240.

48. Blain et al., "Burney, Frances," in *The Feminist Companion*, 160.

49. Bronson Alcott, "Sonnet 16," in *Sonnets and Canzonets* (Boston: Roberts Brothers, 1882), 73. Bronson Alcott, Louisa May Alcott's father, described her in a sonnet as "Duty's faithful child."

50. Blain et al., "Hale, Sarah Josepha," in *The Feminist Companion*, 474–75.

51. Jeffrey Meyers, *Robert Frost: A Biography* (Boston: Houghton Mifflin, 1996), 32. On 6 November 1894, after being rejected by Elinor White, Frost took a

train and steamer to Norfolk, Virginia, to head into the swamp. After meeting a group of duck hunters, he travelled with them to North Carolina, hopped a train to Washington and Baltimore, and then wired his mother for the money to purchase train fare home. Enough said.

52. Walter B. Rideout, *Sherwood Anderson: A Writer in America* (Madison: University of Wisconsin Press, 2006), 155–64. On 28 November 1912, Anderson had what has been termed a breakdown and left his family and career for Chicago.

53. There is also a reference to this incident in Sylvia Beach's *Shakespeare and Company* (New York: Harcourt Brace, 1956), 30–32: she describes meeting Anderson and how when she first encountered him he was "full of" his decision to walk away from his home and business "shaking off forever the fetters of respectability and the burden of security" (30).

54. Elizabeth Cady Stanton, *Eighty Years and More: Reminiscences 1815–1897* (1898; New York: Schocken, 1971), 12.

55. Zelda Fitzgerald, "Friend Husband's Latest," in *The Collected Writings*, ed. Matthew J. Bruccoli (New York: Scribner; Toronto: Macmillan, 1991), 388. First appeared in the *New York Tribune*, April 2, 1922: "Mrs. F. Scott Fitzgerald Reviews 'The Beautiful and the Damned,' Friend Husband's Latest."

56. Matthew Bruccoli, *Some Sort of Epic Grandeur: The Life of F. Scott Fitzgerald*, 2nd ed. (Columbia: University of South Carolina Press, 2002), 348. This quotation is from the typescript of a discussion between F. Scott Fitzgerald, Zelda Fitzgerald, and Dr Thomas Rennie, Zelda's psychiatrist.

57. Blain et al., "Sexton, Anne," in *The Feminist Companion*, 969.

58. Fran Lebowitz, "Letters," in *Metropolitan Life* (New York: Robbins-Dutton, 1978), 143.

History / Temporality / Generations

Postsecondary Pyramid
Equity Audit 2010

C-13 PRESIDENTS (2010) **84.6%**[*]
FULL PROFESSORS (2008–07) **80.0%**
UNDERGRADS ENROLLED (2006–07) **41.9%**

C-13 PRESIDENTS (2010) **15.4%**[1]
TIER 1 CRC CHAIRHOLDERS (2009) **16.8%**[2]
ALL UNIVERSITY PRESIDENTS (2010) **19.0%**[3]
FULL PROFESSORS (2006–07) **20.0%**[4]
ALL CRC CHAIRHOLDERS (2009) **25.2%**[5]
FULL-TIME FACULTY, C-13 (2007) **31.4%**[6]
FULL-TIME FACULTY, NON C-13 (2007) **35.6%**[7]
ASSOCIATE PROFESSORS (2006–07) **35.8%**[8]
ASSISTANT PROFESSORS (2006–07) **42.9%**[9]
FULL-TIME NON-TENURE TRACK FACULTY (2006–07) **44.6%**[10]
PHD STUDENTS (FTE) ENROLLED (2006–07) **46.4%**[11]
MASTERS STUDENTS (FTE) ENROLLED (2006–07) **54.4%**[12]
UNDERGRADUATE STUDENTS (FTE) ENROLLED (2006–07) **58.1%**[13]

Source: http://www.unb.ca/par-l/Pyramid2010.pdf

Compiled by Wendy Robbins, UNB and Bill Schipper, MUN

NOTES

1. AUCC data, email from Christine Tausig-Ford and Ann Allain to Wendy Robbins, 1 March 2010, identifies only two women presidents at G-13 universities: Dr Indira Samarasekera, University of Alberta, and Dr Heather Munroe-Blum, McGill University.

2. CRC Secretariat, email from Cynthia Paquin to Bill Schipper, 17 February 2010. Information supplied to CRC by current Chairholders. The percentage of women at Tier 2 is 31.4%.

3. AUCC data, 1 March 2010.

4. *CAUT Almanac of Post-Secondary Education in Canada 2009–2010*, Table 2.12, p. 16. The same table shows women as 52.7% of Lecturers. See also *CAUT* Equity Review No. 2 (March 2008), Table 6, p. 5. In 2004, at primarily undergraduate institutions, women were 21.5% of full professors; at comprehensive institutions, 20.1%; at medical-doctoral institutions, 17.2%.

5. CRC Secretariat, email, 17 February 2010. Women hold 25.2% of all CRCs.

6. Figures extrapolated from *CAUT Almanac 2009–2010*, Table 2.13, p. 17. Total number of women is 6,009 out of 19,149. Of all full-time faculty (G-13 and non G-13 combined), 33.5% (13,086) are women out of a total number of 39,063.

7. Figures extrapolated from *CAUT Almanac 2009–2010*, Table 2.13, p. 17. Total number of women is 7,081 of 19,914.

8. *CAUT Almanac 2009–2010*, Table 2.12, p. 16.

9. *CAUT Almanac 2009–2010*, Table 2.12, p. 16.

10. *CAUT Almanac 2009–2010*, Table 2.13, p. 17.

11. *CAUT Almanac 2009–2010*, Table 3.13, pp. 27–32.

12. *CAUT Almanac 2009–2010*, Table 3.13, pp. 27–32.

13. *CAUT Almanac 2009–2010*, Table 3.13, pp. 27–32.

Waves, Tangles, Archaeologies, and Loops
Historicizing the Second Wave of the Women's Movement

TESSA ELIZABETH JORDAN
AND JO-ANN WALLACE

Such a volatile movement as the sixties and early seventies tends to get straightened in the telling, so that as it recedes from active memory, it becomes more and more difficult to see the initial generative tangle. Such straightened history makes it easier now to feel that we are somehow more theoretically or politically sophisticated, that we have righted the mistakes, or at least can see the naïveté and down-right silliness of midcentury feminism. But to try to see the tangle, to resist the desire to straighten all the threads, can operate as a humbling tonic to temper what might otherwise be historical arrogance.[1]

KATHRYN THOMS FLANNERY'S metaphor, which describes periods of volatile cultural change as tangled and generative skeins of yarn that get unravelled or straightened by the passage of time, implies that historical accounts inevitably simplify. This may be due to

the imperatives and constraints of narrative historicism that (as Hayden White has pointed out) are shaped by recognizable tropes and plots. It may also be due to the inevitable loss of information and documents, especially ephemera, that might complicate the record.

However, while Flannery points to the ways in which temporal distance tends to create simplified narratives of past events, it is also—and paradoxically—the case that we can be too close to a set of historical events or debates to see them in their full complexity. As Sheila Rowbotham noted in her very early attempt to outline the history of the women's liberation movement in Britain, "It is almost impossible to write about the very recent past."[2] Continuing struggles over the meaning of events or the identification of key participants are a factor, especially when participants are still alive to contest such histories, as Rowbotham's apology to her readers indicates: "If I have distorted anybody's experience, I apologize in advance."[3] Additionally, as is often the case with progressive social movements like the women's movement, practices of self-critique, including those established by the preceding generation, frequently shape and inform the earliest histories of those movements. The need for subsequent generations of activists and progressive intellectuals to define themselves and their projects differently and anew is a related factor. Feelings inevitably run high. This is not to discount the very real significance of new knowledges and analytical or theoretical paradigms, or of changing socio-cultural conditions. But it does suggest that the representation of relatively recent historical events and situations is complicated by their very recentness. In other words, it is a problem of temporality.

The question or problematic of temporality—a problematic that is implicit in the much debated image of "waves" of feminism—has attracted the attention of feminist critics and theorists over the last

decade, prompting a 2002 special issue of *Tulsa Studies in Women's Literature* on "Feminism and Time" and a 2004 special issue of *MLQ: Modern Language Quarterly* on "Feminism in Time." A 2006 issue of *PMLA* similarly devoted a "Theories and Methodologies" section to the topic of "Feminist Criticism Today." Its dedication "in memory of Nellie Y. McKay" points to one of the factors underlying feminism's current time consciousness: the recent deaths of so many significant second-wave feminists.[4] Other factors include the consolidation of the third (or even fourth) wave of the feminist movement, questions about the status of "theory" (which, as Toril Moi points out, usually means "work done in the poststructuralist tradition" [1735]), and, finally, what we might call the rise of a millennial consciousness influenced by the dawning of a new millennium which was followed so closely by the events of September 11, 2001.

Another key factor that emerges strongly in many of the recent articles on feminism and temporality is a broad anxiety, or a resigned acknowledgement, that feminism and feminist theory are no longer at the cutting edge, either politically or intellectually. Toril Moi makes this point bluntly in her 2006 *PMLA* article, "'I Am Not a Feminist, But...': How Feminism Became the F-Word": "The poststructuralist paradigm is now exhausted....The fundamental assumptions of feminist theory in its various current guises...are still informed by some version of poststructuralism. No wonder, then, that so much feminist work today produces only tediously predictable lines of argument."[5] Jane Elliott challenges this position in her article "The Currency of Feminist Theory," which also appeared in *PMLA* in 2006. Elliott points to "feminism's implication in what might be called the temporalization of knowledge,"[6] the logic of an intellectual economy in which, in an ironic mimicry of late-capitalist consumerism, "the new" is valorized regardless of whether the "old" paradigm or theory retains explanatory force,

and regardless of whether the "old" problems remain unresolved. Elliott asks what it might mean "to risk the genuinely untimely" and to attend to "what our boredom might have to tell us."[7]

Robyn Wiegman's 2004 MLQ meditation on the degree to which feminism is, or can be, understood as a historical phenomenon, a project *in time*, goes further, emphasizing the productive force of feminist discontinuities, instabilities, and disarticulations. She argues against projects of "temporal management" that work to maintain the coherence and stability of "women's political subjectivity and desire as feminists"[8] while at the same time acknowledging "the difficult, at times painful, recognition that feminism, oddly enough, is not identical to our investments in it."[9] Wiegman's emphasis here on affect brings to the surface a theme running throughout many of these essays. Almost any engagement with the question of feminism and the temporal raises very real and often very personal anxieties about what is signified by that word. As Margaret Ferguson implies in her introduction to the MLQ special issue, hope and faith in a different and better future define the deeply felt nature of feminist engagement. They are also, of course, sources of vulnerability.

All of these issues—the valence of theory, the nature of the feminist project, the imbrication of personal and political identities, the necessity and risk of hoping, the inevitable emotional investments in particular historical narratives—are at play in any project of feminist recovery, especially when the events or documents being recovered are relatively recent. This chapter takes as its point of departure two such projects: a graduate seminar on second-wave feminist texts (especially writing by radical feminists), and doctoral research on English Canadian second-wave feminist periodicals. As we discuss below, both projects throw into relief the degree to which questions of "theory" continue to frame the reception and historicization of recent feminist pasts. While we will allude only tangentially to our classroom experience and to the case

of Canadian feminist periodicals, our discussion grows out of these very material engagements. In what follows, we focus on issues related to polemical and theoretical writing to argue for a feminist historicism capable of attending to the generative tangle of feminist engagements in time. Such a historicism, we contend, permits a better understanding of the "all at onceness" of discursive formation during a vital period of political and intellectual foment and change.

IN KEEPING WITH ELLIOTT'S critique of "the production of the new as a signal of intellectual value,"[10] we assert that teaching and researching second-wave feminism require a complementary disruption of the precepts that enable second-wave feminism to be dismissed as passé. In other words, reading for something other than a confirmation of the well-rehearsed critiques of the second wave helps to disrupt "the modern logic that equates the new, the interesting, and the valuable."[11] When the second wave is characterized as unaware of or not concerned with issues of race, class, and sexuality, and primarily interested in single issues and liberal values, such as equal opportunity in the workplace, it is easily dismissed as passé by both students and researchers. However, this characterization fails to acknowledge its connection to critiques of liberal feminism that were developed by radical and socialist feminists *during* the second wave; consequently, while not unfounded, this characterization of the second wave exclusively by its deficiencies offers a limited vision of what was an extremely diverse movement.

In fact, as early as 1968, Shulamith Firestone was arguing against "single issue organizing as opposed to organizing to raise the general consciousness."[12] In her article "The Women's Rights Movement in the U.S.: A New View," Firestone questions histories of first-wave American feminism that characterize this movement solely as a suffrage movement. Instead, Firestone identifies the suffrage movement as only one branch of the larger nineteenth- and

early twentieth-century Women's Rights Movement in the United States. Firestone's article re-evaluates histories that characterize the first wave as a "cop-out" or "reformist" and emphasizes "a strong radical strain which has been purposely ignored and buried." In doing so, she constructs a lineage of radical feminism that her contemporaries can draw on, rather than simply dismissing first-wave feminists as politically naive. While Firestone believes that, ultimately, the "monster of the vote had swallowed everything else" for first-wave feminists, she does not allow this belief to blind her to the more radical strains of early American feminism. Instead, Firestone uses her historical analysis to argue against the single-issue organizing associated with liberal feminism in favour of developing a broader (radical) feminist consciousness capable of combating not only "male chauvinism" but also capitalism and racism among other institutions.

From the moment that Anglo-North American women began to organize separately from men in the mid- to late 1960s, feminism has been criticized for its privileging of a sisterhood that claimed to include all women but largely reflected the world view of white, middle-class, heterosexual women. In keeping with Firestone's critique, and as early as the winter of 1970, The Feminists, a radical feminist group formed in October 1968 by Ti-Grace Atkinson when she left NOW (National Organization for Women, the foremost liberal feminist organization in the United States), organized a Class Workshop to address "the exclusion of most working-class women from the women's liberation movement."[13] In their spring 1970 statement, the women in the Class Workshop declared, "The feminist movement began because we were tired of being led by men. But neither do we want to be led by women."[14] Not only were these feminists critical of patriarchy, they were also aware of inequalities that existed within the women's movement. Lower middle-class and working-class women were not interested in being led by their middle- and upper-class "sisters." The Class Workshop reminds us

that critiques of this wave of feminism have not always come from outside the movement, nor have they been solely retrospective.

Similar debates about the privileging of unity over diversity are also present throughout English Canadian second-wave feminist periodicals. For example, an article published in the December 1970 issue of *Velvet Fist*, the Toronto Women's Caucus liberation newspaper, reports on the first national women's liberation conference in Saskatoon and clearly demonstrates the existence of conflicting positions on sisterhood. This article summarizes a debate between Marlene Dixon, a sociology professor at McGill University, and Bev Gibbs of the Vancouver Women's Alliance. Dixon "initiated this debate by launching an attack on the movement for aiming to unite all women."[15] According to the report, Dixon insisted "Sisterhood is bullshit," because "race and class differences divide women too greatly to build a common movement." In contrast, Gibbs reportedly believed that "while it is true that women are divided in many ways...the movement must struggle to overcome this." This exchange demonstrates that the unity/diversity debate was present from the earliest days of the movement and was not solely the product of later feminists and movement critics.

As Elliott's critique of academic overvaluation of the new suggests, critiques launched *during* the early days of the second wave tend to be overshadowed by subsequent analyses. We remember NOW rather than The Feminists, and "Sisterhood is powerful" rather than "Sisterhood is bullshit," because in both cases the former more easily conform to subsequent critiques of a uniformly liberal, middle-class feminism, while the latter force us to reconsider the dismissal of second-wave feminism as passé. Consequently, early second-wave critiques of insufficient sensitivity by the nascent women's movement to issues of race, class, and sexuality have largely been forgotten.[16]

These early second-wave critiques of the women's movement were present throughout many Canadian feminist periodicals. In

the Spring 1972 inaugural editorial of the Toronto-based radical feminist newspaper *The Other Woman*, one member of the paper's editorial collective notes the importance of race and class for feminist analysis: "We're a small collective so the paper reflects mainly our personal viewpoints and interests which are limited by our class (education, lifestyle) and race."[17] Another member expresses her related concern that "there are great gaps in the newspaper. Articles on women in the work force whether as clerks, secretaries, factory workers or housewives are missing also problems of women trying to get or organizing around jobs. We need more communication with women in minority groups in Canada."[18] Throughout its print run, *The Other Woman* struggled against these limitations, publishing articles on the unique situation of First Nations and Third-World women as well as information on labour law, workplace organizing, and the difficulty of finding affordable housing in Toronto. That said, *The Other Woman*'s attempt to include race- and class-based analysis was often in tension with its commitment to building an autonomous women's movement and to providing a forum for lesbian feminists to explore their unique concerns. An article on "Women's Liberation and Lesbians," for example, concludes that "while everyone is always crying out that we must relate to the perenially [*sic*] absent working women and Third World women, lesbians are the scum of the earth."[19]

These moments in *The Other Woman* illustrate how one periodical both issued and defended itself against early second-wave critiques of the women's movement. Even within a single publication, there appears to be no consensus on how the movement should deal with issues of race, class, and sexuality. One moment an editor is concerned with the absence of class and racial diversity; the next moment the privileging of race and class in feminist analysis is critiqued for excluding sexuality. It is this complex relationship between practices of self-critique and feminist analysis that is forgotten when critiques of liberal, middle-class feminism

dominate our understanding of the mid-twentieth-century movement.

One reason why the complex tangle of early second-wave debate has been flattened out or forgotten, especially among younger feminists, is that the language in which that debate took place is now unfamiliar. It is difficult for students in the twenty-first-century classroom to read the manifestos and critical analyses of early second-wave feminism as anything but theoretically naive. This is due to a number of factors. On the one hand, the genre of the political manifesto, with its list of demands, has largely fallen out of fashion, as have many other forms of polemical writing. It can be challenging for students to imagine articulating a demand, which strikes them as blunt and simplistic, as opposed to fashioning a critique.[20] Sometimes it is a dated colloquialism (for example, a reference to "rap groups"[21]) that prevents students from taking an analysis seriously. The word *liberation* itself—a word whose political urgency has long been eclipsed by subsequent mass media references to "women's libbers"—is now a source of much bemusement. While the relationship between the American civil rights movement and the rise of second-wave feminism has been well-documented, the degree to which the international women's movement of the late 1960s and very early 1970s adopted the rhetoric of numerous nationalist liberation movements of the period, from Algeria to Québec, is largely forgotten.[22]

More often, though, it is the lack of reference to the *recognizably* theoretical that persuades students of the naïveté of early second-wave texts. Robyn Wiegman touches on this issue in her discussion of Sheila Rowbotham's 1972 exploration of "the struggle between the languages of experience and those of theory."[23] As Wiegman observes, "theory" meant something different in the 1970s, especially in the context of British socialism and Marxism, than it means now. Theory, Wiegman says, "has been institutionalized" and, we would add, institutionalized to such a degree that it is

difficult for students to recover or comprehend a political and intellectual universe of theory-in-the-making, of theory as a process as opposed to theory as an institutional product.

However, while second-wave feminist texts are frequently dismissed by researchers and students because of their perceived lack of theoretical sophistication or lack of commitment to feminist difference, a contrary and nostalgic view of this moment in feminist history has also emerged. In "Telling Time in Feminist Theory," her contribution to the 2002 special issue of *Tulsa Studies* on "Feminism and Time," Rita Felski observes that

> We are currently seeing a flood of memoirs, autobiographies, and histories of the women's movement that are soaked in nostalgia. Prominent scholars paint a gloomy picture of a feminism that has lost its sense of direction....They lament the fragmentation of feminism, its movement into the academy, its love affair with theory. They tell stories of a fall from grace as female unity falls prey to the sins of division, deviation, and degeneration.[24]

Felski understands this nostalgia as the result of a certain conception of time. She labels this conception "Time as Regression"[25] and praises it for "allowing us to question the smugness of the now and the sovereignty of the new."[26] However, Felski also acknowledges that there are "real dangers in clinging so fiercely to the truths of the past."[27] Felski's characterization of "time as regression" as a double-edged sword is in keeping with her argument that "four forms of time shape and circumscribe feminist thought"[28] and that "each temporal Gestalt...is indispensable yet incomplete, allowing us to see certain things but not others."[29] Whereas Elliott limits her critique to one conception of time—"the production of the new as a signal of intellectual value"[30]—Felski's identification of multiple forms of time and their relationship to feminist thought enables

her to observe how differing conceptions of feminism are precipitated by multiple conceptions of time.

Felski's acknowledgement that "no one time can do justice to the complexities of feminism"[31] is vitally important for a feminist historicism capable of offering a solution to several problems we have identified in our teaching and research. How can we destabilize the equation of the new and the valuable, especially in the context of an academic climate (frequently, if simplistically, characterized as corporate) committed to the manufacture of the new as a self-evident value? How can we capture the complexity, the tangled skein, of feminist history without losing sight of the ineluctable feminist acknowledgement that history is inevitably and necessarily political? And, finally, what can such a history of mid-twentieth-century feminism tell us, not only about feminism but about the larger intellectual history of that period?

ONE POSSIBLE RESPONSE to these questions is that alternate modes of historicizing require different metaphors—but not a simple swapping out of the "old" for the "new." Rather than completely displacing the generational and wave metaphors, which have been so thoroughly critiqued for their linear logic and yet retain some emotional if not explanatory force, we need to supplement them in ways that permit other pictures to emerge. As George Lakoff and Mark Johnson argue in *Metaphors We Live By*, metaphor has the power "to create reality rather than simply to give us a way of conceptualizing a preexisting reality";[32] it does this by "highlighting some things and hiding others."[33] What other metaphors does the feminist historian, and the historian of feminism, have available to her?

Three metaphors that we have found useful in thinking about teaching and researching mid-twentieth-century feminism are archaeology (Foucault), the "generative tangle" (Flannery, see

above), and the feedback loop (Hayles). These metaphors are not at a new cutting edge of feminist theory. In fact, the three scholars from whom we borrow these metaphors all contribute to and/or rely on some version of the poststructuralist theory that Moi emphatically asserts is "now exhausted."[34] Nonetheless, we find these metaphors valuable because they enable a feminist historicism that problematizes the straightening of history in its telling and challenges the equation of the new with the interesting and valuable without resorting to nostalgia or regression.

Outlining his project in the preface to *The Order of Things: An Archaeology of the Human Sciences*, Michel Foucault explains that his analysis "does not belong to the history of ideas" but "is rather an inquiry whose aim is to rediscover on what basis knowledge and theory became possible."[35] Foucault is not interested in the "growing perfection" of ideas; he is interested in their "conditions of possibility,"[36] an enterprise that he labels archaeology. Out to disrupt the "continuity of time,"[37] Foucault questions the impression of "uninterrupted development" and looks to "the archaeological level" to define "systems of simultaneity."[38] Concerned with relationships within rather than across time, Foucault enables connections to be drawn between seemingly disparate systems within a given moment in time (episteme), rather than establishing continuity within a given system across time.

In keeping with Foucault's commitment to "systems of simultaneity," in *How We Became Posthuman*, N. Katherine Hayles insists that it is "crucial...to recognize interrelations between different kinds of cultural productions."[39] While she is primarily concerned with connections between science and literature, the metaphor she uses to describe this interrelationship can easily be applied to other objects of inquiry. The metaphor of the feedback loop is one of the ways Hayles has unsettled assertions of direct influence throughout her writing. Rather than arguing that science influences literature or vice versa, in her introduction to *Chaos and*

Order: Complex Dynamics in Literature and Science Hayles asserts
that both literature and science "are involved in feedback loops
with the culture. They help to create the context that energizes the
questions they ask; at the same time, they also ask questions ener-
gized by the context."[40] The same can be said of feminism. It exists
in a feedback loop with the culture of which it is a part. This asser-
tion may seem passé in light of its affinities with the supposedly
"exhausted" poststructuralist paradigm, or it may be taken for
granted within cultural studies, which has always recognized this
interrelationship. However, while the logic of the feedback loop
may not be new, it could have significant consequences for a fem-
inist historicism interested in what we earlier referred to as the
"all-at-onceness" of discursive formations.

In other words, like Foucault's archaeology, the feedback loop is
a model that precludes easy cause-and-effect models of historical
analysis. It has the potential to work well as an enabling metaphor
in the classroom, where it can sometimes be difficult to convey the
complexity of a discursive moment without resorting to a logic of
influence. One of the real difficulties in teaching the history of any
alternative or progressive social movement is first isolating and
then explaining, by contextualizing, the inevitable silent assump-
tions that underlie or surround public debate. Such assumptions
frequently lodge themselves in a word or phrase that is ubiquitous
in texts of the period but rarely defined. In the case of mid-
twentieth-century social movements, including feminism,
consciousness is such a word. We have already alluded to con-
sciousness-raising groups of the late 1960s and early 1970s, where
the word *consciousness* derived from notions of false conscious- .
ness then current in both the "old" and "new" left.[41] However,
consciousness also had attached to it reverberations from other cul-
tural sectors, including those of alternative psychiatry (like that
of R.D. Laing), new or revived Western counter-cultural interest in
Buddhism and other "Eastern" religions, and interest in the use of

psychoactive drugs or hallucinogens to produce altered "states of consciousness." Far from being a theoretically impoverished term, as it may appear to twenty-first-century readers, the term is massively over-determined in ways that can only be recovered through a thick or tangled appreciation of the historical moment.

THE KIND OF STRENUOUS attention to this historical moment that the feedback loop and archaeology metaphors require enables a better understanding not only of the development of mid-twentieth-century feminism, but of the development of *theory* as we have come to understand that term. As we have suggested above, second-wave feminist texts are often dismissed because of their perceived lack of theoretical sophistication. However, careful reconstruction of the ways in which mid-century feminist thought developed coterminously—or in a feedback loop—with other progressive discursive formations suggests another narrative, one that a brief examination of feminist uses of the term *consciousness* helps to highlight. Here we will focus on Sheila Rowbotham's use of that term in her 1972 essay, "Problems of Organisation and Strategy."

The essay describes the need for what Rowbotham calls "new areas of political resistance" growing out of, and responsive to, new knowledges generated by the "small" (or, in North American terms, "consciousness-raising") groups so characteristic of early second-wave feminist organizing. These insights or knowledges, which would eventually be captured and somewhat reduced by the catch phrase "the personal is political," were born from the close examination and sharing of personal experience. This practice brought new areas into the realm of the political, areas like family relations, "sexual culture," and "female self-image."[42] Rowbotham stresses the degree to which the small-group method resists top-down theorizing—especially from the male-dominated left—in favour of "an idea of consciousness which is not the transmission of some

already established higher body of knowledge but of learning by discovering yourself in relation to others."[43] This is very different from the educational mandate of traditionally hierarchical revolutionary movements that seek to raise "levels" of political consciousness.[44] Instead, in the feminist small group "you are brought to see yourself as a woman self-consciously"[45] and in relation to other women, and to discover a common condition. As a result, "You are consciousness moving."[46] What is learned in this process is the degree to which the capitalist and patriarchal "onslaught on our consciousness is all-pervasive and profoundly internalised"[47] and so requires forms of resistance that target cultural as well as political formations.

It will be obvious from the brief passages we have quoted that Rowbotham uses the term *consciousness* to evoke a very wide range of intellectual, political, psychological, and psychic processes and states. Today we would certainly recognize one of these as the process that Althusser describes as interpellation through ideological state apparatuses, especially systems of education, a process he outlines in "Ideology and Ideological State Apparatuses." This essay was published in English translation in 1971, one year before Rowbotham wrote her essay on "Problems of Organisation and Strategy." Althusser's earlier work was already well known to British leftists, not least through his publications and interviews in the *New Left Review*. Indeed, Rowbotham appears to consciously borrow from his 1970 interview, "Philosophy as a Political Weapon," in the conclusion to her article when she argues for the making of a ground-up theory of socialist feminism: "The making of such a theory is an essential weapon...."[48] It would be easy here to make the cause-and-effect argument for influence: that an emerging feminist theory was influenced and shaped by the work of poststructuralist philosophers like Althusser. However, this ignores the degree to which significant feminist theoretical documents were circulating alongside those that would become

major contributions to poststructuralism. Juliet Mitchell's landmark essay, "Women: The Longest Revolution," appeared in the *New Left Review* in 1966. In it she concluded, "The whole pyramid of discrimination [against women] rests on a solid extra-economic foundation—education."[49] Again we want to resist a cause-and-effect argument that would suggest that Althusser was influenced by early second-wave feminist work. Instead, we are arguing for a feminist historicism that is attentive to the "all-at-onceness" of periods of volatile intellectual, cultural, and political change: a historicism that can account for small-group or consciousness-raising work as a process of theory-in-the-making, and that locates feminist thought at the *centre* of intellectual formation in such periods, not the periphery of oft-cited theoretical texts such as "Ideology and Ideological State Apparatuses."

However, in advocating a historicism that makes connections within rather than across time, we are not suggesting that development across time is unimportant or uninteresting. Admittedly, the usefulness of disrupting the continuity of time and the logic of development is limited by what Felski refers to as feminism's "orientation to the future."[50] We may not believe that the growing perfection of ideas is inevitable, but we cannot forgo the possibility of change that improves conditions for women. Felski explains, "Feminists often think of themselves as allies of the new, as fervent proponents of radical change"[51] in their commitment to a better future for women. Consequently, feminist historians cannot completely do away with progress, "but we can think of belief in progress as a wager with the future, as a nascent hope, rather than a complacent certainty, that something better is around the corner."[52]

NOTES

1. Kathryn Thoms Flannery, *Feminist Literacies, 1968–1975* (Urbana: University of Illinois Press, 2005), 22.

2. Sheila Rowbotham, "The Beginnings of Women's Liberation in Britain," in *The Body Politic: Writings from the Women's Liberation Movement in Britain, 1969–1972*, ed. Michelene Wandor (London: Stage 1, 1972), 91.

3. Ibid., 91.

4. Audre Lorde, 1934–1992; Grace Fulcher Hartman, 1918–1993; Laura Sabia, 1916–1996; Florence Bird, 1908–1998; Carolyn Heilbrun, 1926–2003; Gloria Anzaldúa, 1942–2004; Andrea Dworkin, 1946–2005; Betty Friedan, 1921–2006; Lillian Robinson, 1941–2006; Doris Anderson, 1921–2007.

5. Toril Moi, "'I Am Not a Feminist, But...': How Feminism Became the F-Word," *PMLA* 121, no. 5 (October 2006): 1735.

6. Jane Elliott, "The Currency of Feminist Theory," *PMLA* 121, no. 5 (October 2006): 1699.

7. Ibid., 1701.

8. Robyn Wiegman, "On Being in Time with Feminism," *MLQ: Modern Language Quarterly* 65, no. 1 (March 2004): 165.

9. Ibid., 171.

10. Elliott, "The Currency of Feminist Theory," 1700.

11. Ibid., 1701.

12. Shulamith Firestone, "The Women's Rights Movement in the U.S.: A New View," originally published in *Notes from the First Year* (New York: The New York Radical Women, 1968), n.pag. Available online at The CWLU Herstory Website Archive. http://www.cwluherstory.com/CWLUArchive/womensrights.html. All other quotations from Firestone are taken from n.pag.

13. "What Can We Do About the Media," qtd. in Alice Echols, *Daring to be BAD: Radical Feminism in America, 1967–1975* (Minneapolis: University of Minnesota Press, 1989), 206.

14. Ibid.

15. Lis Angus, "Saskatoon: Our First National Women's Liberation Conference," *The Velvet Fist* 1, no. 2 (December 1970): 4. All other quotations from Angus are taken from page 4.

16. This is a continuing problem. Elliott argues that "the growing tendency to place the debates of the 1980s and 1990s in the past" has the additional effect of "shelv[ing] the critiques by radical women of color that are also associated with those decades" (1700).

17. "Collective Ramblings," *The Other Woman* 1, no. 1 (May–June 1972): 2.

18. Ibid., 2. The grammatical errors in these editorial comments may be accounted for by the editorial's form: passages of various lengths are written in five distinct handwritings and crammed onto a single page. Because most of the rest of the issue is typeset, this editorial is set apart visually as perhaps more spontaneous and less formal.

19. Ibid., 16.
20. Admittedly, this is not a new problem. In 1972 Sheila Rowbotham observed that "When we do go and try and agitate for something in particular we are still floundering around because we have no commonly accepted end. A revolutionary organization has a shared end, even though there is no simple blueprint for translating the everyday possibility within capitalism into the future possibility of socialism. In women's liberation it is different because we are together in our discontent but not in our notion of what we are striving toward," (Rowbotham, "Problems of Organisation and Strategy," 68–69).
21. See, for example, Freeman's discussion of the rap group, more often referred to as a consciousness-raising group: "Essentially an educational technique, it has spread far beyond its origins and become a major organizational unit of the whole movement...."
22. See Terry Goldie's entry on "Liberation" in the "Retro Keywords" section of *ESC* 30, no. 4 (December 2004): 37–40. Goldie cites Raymond Williams in the 1983 edition of his *Keywords*: "Williams's [reference to] 'women's lib' is probably our most common use of liberation yet he notes the overtly political and national use of the word began with the 'British Liberation Army' of 1944 and, soon after, the liberation fronts of Algeria and Vietnam" (38). Canadians will be familiar with the Front de Libération du Québec (FLQ) and with Charles de Gaulle's famous 1967 exhortation, "Vive le Québec libre!"
23. Wiegman, "On Being in Time with Feminism," 169. The article to which Wiegman refers is Sheila Rowbotham, "Women's Liberation and the New Politics," in *Dreams and Dilemmas* (1969), 5–32.
24. Rita Felski, "Telling Time in Feminist Theory," *Tulsa Studies in Women's Literature* 21, no.1 (Spring 2002): 25.
25. Ibid., 23.
26. Ibid., 25.
27. Ibid.
28. Ibid., 21.
29. Ibid., 27.
30. Elliott, "The Currency of Feminist Theory," 1700.
31. Felski, "Telling Time in Feminist Theory," 27.
32. George Lakoff and Mark Johnson, *Metaphors We Live By* (Chicago: University of Chicago Press, 1980), 144.
33. Ibid., 139.
34. Moi, "'I Am Not a Feminist, But...': How Feminism Became the F-Word," 1735.
35. Michel Foucault, *The Order of Things: An Archaeology of the Human Sciences* (New York: Vintage Books, 1973), xxi.
36. Ibid., xxii.
37. Ibid., xxiii.
38. Ibid., xxii, xxiii.

39. N. Katherine Hayles, "Introduction: Complex Dynamics in Literature and Science," in *Chaos and Order: Complex Dynamics in Literature and Science*, ed. N. Katherine Hayles (Chicago: University of Chicago Press, 1991), 24.

40. Ibid., 7.

41. The first use of the term *consciousness-raising* as a method of feminist sharing, analysis, and theory-making is usually attributed to Kathie Sarachild and Anne Forer (see Brownmiller, *In Our Time*, 21).

42. Sheila Rowbotham, "Problems of Organisation and Strategy," in *Dreams and Dilemmas: Collected Writings* (London: Virago, 1983), 57.

43. Ibid., 58.

44. "With the best of intentions, revolutionary intellectuals can seem like the Salvation Army with a new kind of jargon..." (Rowbotham, "Problems of Organisation and Strategy," 66).

45. Ibid., 68.

46. Ibid.

47. Ibid., 72.

48. Ibid., 75.

49. Juliet Mitchell, "Women: The Longest Revolution," *New Left Review* I, 40 (November–December 1966): 35.

50. Felski, "Telling Time in Feminist Theory," 23.

51. Ibid., 21.

52. Ibid., 23.

A *Vindication* and the Imperative of History
Reviving Wollstonecraft for Future Feminisms

KATHERINE BINHAMMER
AND ANN B. SHTEIR

THE WRITERS OF THIS CHAPTER do not share the same history. With twenty years between us, we came of age at different historical moments in feminism. Yet we share a concern with history, or with the state of historical knowledge within feminism and women's studies departments and programs today. Our concern is fuelled by a mutual passion for Mary Wollstonecraft and for what her 1792 work *A Vindication of the Rights of Woman* can offer for the future of feminist studies. Perhaps because of our generational differences, our interpretations of *A Vindication* are very different (a difference we chart below), but the two perspectives we take on this canonical though largely un- and under-read text lead us to the same place. Below we argue that twenty-first-century feminist students and scholars need more encounters with history in order to re-complicate and de-familiarize our present.

The disappearance of historical knowledge from feminist stud-
ies is a troubling fact of our contemporary moment. In *History
Matters: Patriarchy and the Challenge of Feminism*, Judith Bennett,
a historian of early modern culture and sexualities, documents
the lack in key feminist journals over the last years of articles on
historical topics, particularly covering the period 1500–1800. Her
content analysis of the core journal *Signs: Journal of Women in
Culture and Society* demonstrates this paucity, with no histori-
cal articles published in the entire year of 2004, and only a few in
the years preceding. When historical studies do appear, they focus
on twentieth-century history, a trend women's and gender his-
tory journals reflect as well.[1] *Signs* editor Mary Hawkesworth, in a
visit to the graduate program in women's studies at York University
(where one of us works), acknowledged the problem and spoke elo-
quently about their editorial commitment to correct it. It remains
to be seen whether *Signs* and other field-shaping journals will suc-
ceed in correcting an imbalance within women's studies toward
the social sciences and contemporary topics and toward presentist
approaches to knowledge.

The two of us, who both specialize in eighteenth-century British
cultural history, will not explore here the disciplinary trends and
broader topics that could explain why historical knowledge fig-
ures so little now in feminist studies. Rather, what follows makes
the case for history through describing our own encounters with
Wollstonecraft and argues for what she can contribute to the
women's studies curriculum. We are concerned that historical fem-
inism is increasingly not taught within women's studies or, when
it is, it is relegated to a "greatest hits" course where only small
excerpts from women's texts pre-1800 are sampled for how they fit
into the trajectory of modern feminism. Within this context, the
many faces of Wollstonecraft's *A Vindication* are drowned out by
the predominant one that positions her—either positively or nega-
tively—as a foremother of modern Western liberal feminism. In the

following two sections, each of us provides our own historicization of *A Vindication* to demonstrate why history does, indeed, matter, and how Wollstonecraft tells us so much more than what we think we already know about the birth of the modern feminist subject.[2]

A History of *A Vindication*: Take One (Rusty Shteir)

One of my own favourite passages in *A Vindication of the Rights of Woman* comes in the opening paragraph of Wollstonecraft's expansive polemic about systems of female dependence. Asserting the need for female education, Wollstonecraft draws upon vocabulary from the then-popular culture of botany and horticulture:

> *The conduct and manners of women, in fact, evidently prove that their minds are not in a healthy state; for, like the flowers which are planted in too rich a soil, strength and usefulness are sacrificed to beauty; and the flaunting leaves, after having pleased a fastidious eye, fade, disregarded on the stalk, long before the season when they ought to have arrived at maturity. One cause of this barren blooming I attribute to a false system of education.[3]*

Wollstonecraft's use of metaphors from the vegetable kingdom is more than a calling up of playful language. In part she is responding to writers such as Jean-Jacques Rousseau, who, in his pedagogical novel *Emile* (1762), characterized the mind of the ideal wife-to-be as akin to "well-tilled soil just waiting for the grain."[4] In part the horticultural vocabulary represents Wollstonecraft's critique of how women were cultivated as exotic specimens, cultured like hot-house flowers. Metaphors associating women with flowers reflect her historical moment, when interest in the processes of plant growth was widespread across scientific, literary, and artistic milieu. Wollstonecraft uses these metaphors in *A Vindication*

to critique ideas like Rousseau's and to argue for the power of nurture, culture, and a new kind of education. Mary Wollstonecraft wrote *A Vindication of the Rights of Woman* as a *philosophe*, an activist intellectual of the European Enlightenment, and I claim her as such for current feminisms. My position is that Wollstonecraft's book should be particularly important in the current feminist moment, not so much for the canonical status of *A Vindication*, nor for an iconic representation of Wollstonecraft as an analyst of timeless trans-historical relevance. My argument here is that twenty-first-century feminists in women's studies programs and in the academy more generally need Wollstonecraft for her historicity.

A Vindication is an excellent expression of the cultural and intellectual project of the Enlightenment, those decades of ferment across eighteenth-century Europe when writers used their pens as swords, applying tools of reason to examine the human heart and mind and the natural universe in small and large. A sturdy optimism underlay writings by thinkers who sought social change and valued literacy, sociability, autonomy, and civic engagement. This was the intellectual culture in which Mary Wollstonecraft intervened with the high argument and literary activism of *A Vindication*. It has not been the cutting edge of feminist analysis for the past two decades to parade Wollstonecraft as an exemplary figure of an exemplary Enlightenment. Indeed, elements in *A Vindication* have made her a ready target. The Enlightenment became an icon of Eurocentrism—disembodied, repressive, rationalistic, scientistic, racist, imperialist, incipiently totalitarian, "the monopoly of an Olympiad of male philosophers," as the recent editors of a new collection on *Women, Gender and Enlightenment* note.[5] Feminists from the late 1970s on disputed the legacy of the Enlightenment to modern times and also queried the status of women within the project of Enlightenment. A generation of skeptical scholars found that the story of women and the Enlightenment was one of a glass half empty rather than half

full. There clearly was some room for some women to manoeuvre in Bluestocking salons, and the language of equality was there in principle. Nevertheless, they argued, practices remained exclusionary, and gendered hierarchies of value were reasserted all too often.

In recent years, a new and feminist Enlightenment has emerged, and hence a new historiography of this period is reshaping approaches to this era. Instead of the monolithic term *The Enlightenment*—itself a late-nineteenth-century coinage—there is a new pluralism in Enlightenment studies. Scholars now refer to Enlightenments, and these are articulated by national culture and by often substantially contrasting points of view. The Enlightenment is studied for the debates and tensions that existed among writers of that time, who critiqued one another as much as they critiqued social institutions. The multiplicities in their ideas have a flavour familiar to postmodern analysis.[6] Scholars also now foreground women not as objects of Enlightenment speculations and discourses, but as themselves practitioners of innovatory practices across the media of Enlightenment—as writers, intellectuals, teachers, translators, philosophers, and scientists in conversation, debate, and religious controversies.

In this regard, Mary Wollstonecraft emerges even more clearly as an Enlightenment *philosophe* committed to public action through the word, critiquing her society and its underpinnings, working at a level of abstraction but bringing theory into the world of the lived experience of the women readers who are part of her target audience. *A Vindication* is linked to a particular moment and to local debates; its author aims to intervene in French politics and national education policy at a time when revolutionary France was creating a new constitution. Wollstonecraft is an interactionist, living and writing at the intense crossroads of nature and culture, reason and passion. Her interactionism is there in the volatility of her language, and in her reach for metaphors that will help make points that are persuasive. Monolithic approaches to

the Enlightenment have made it harder than it should be to feel the surging energy of struggle across writings of that time.

Wollstonecraft's polemical text from the 1790s vindicates history for feminism by showing us taproots and by giving us some understanding of the cultural soil within which modern feminisms developed. It is, for example, a probe into earlier debates about sameness and difference and into a gamut of equality discourses that run through seventeenth- and eighteenth-century intellectual histories. It therefore illustrates legacies that we ignore at our peril. *A Vindication* also vindicates reading, writing, and culture for the feminist classroom. Are we ensuring that our students, and the next generations of undergraduate women's studies majors, graduate students in MA and PHD programs, and feminist thinkers across disciplines have breadth in their studies? This question is particularly pertinent to women's studies programs because, in the absence of course distribution requirements, it is all too easy for students to specialize in what they know already rather than sample other methods, languages, and areas of study. Given that the disciplinary history of the field of women's studies in Canada has roots in the social sciences, particularly in sociology programs and political economy networks, the humanities can be easily marginalized in curricular requirements. There is a cautionary tale here that *A Vindication* can address as a sustained piece of political writing and an activist attempt to use the power of the pen.

Mary Wollstonecraft, feminist *philosophe*, stands at a cultural crossroads in *A Vindication*, and I think we need to meet her on her home ground. She represents humanistic approaches to knowledge, and these include history with its multiple currents. Wollstonecraft lived with contradictions, as did others whose lives and works are part of Enlightenment culture. In the introduction to her recent edition of *The Collected Letters of Mary Wollstonecraft*, Janet Todd remarks that she is struck when reading the Wollstonecraft correspondence by how often Wollstonecraft

attaches "PSs" in postscript to her letters; "she never seems quite to have said the last word." Todd writes: "At different times the letters reveal [Wollstonecraft] wanting to reconcile different reconcilables—integrity and sexual longing, the needs and duties of a woman, motherhood and intellectual life, fame and domesticity, reason and passion—but all are marked by a similar strenuousness, a wish to be true to the complexity she felt."[7] This is Wollstonecraft the feminist *philosophe* who waves to me across the centuries, and, recalling us to multiple Enlightenments, invites me back to her and her text, to keep her company in struggles that still are all too familiar.

A History of *A Vindication*: Take Two (Katherine Binhammer)

My own personal history with *A Vindication* is, like Wollstonecraft's own biography, tumultuous; our affair swings madly between love and hate but is always passionate and always present. Coming to the text at different times in my life, in different contexts, and in different historical moments, Wollstonecraft's feminist voice has sung in a cacophony of contradictory tones: at times heroic and inspiring, at others frustrating and disappointing, at still others poignant and tragic. When I first encountered *A Vindication* as a young feminist, I came to the text through Wollstonecraft's revolutionary life and I celebrated her as a feminist hero. Her unconventional path—running away to London to live off her writing, travelling to Paris to witness the Revolution, having a child outside wedlock—matched her radical thinking; she was a bold voice in the dark, bravely fighting for the rights we have now. But when I came to *A Vindication* years later, from the perspective of late 1980s sex theory, I could only read her with crushing disappointment. At the time, Wollstonecraft was firmly positioned within women's studies as the "mother" of modern

liberal feminism and, for the reasons Rusty recounted above, the Enlightenment's legacy of liberal feminism was largely being discredited within feminist theory. Liberal feminism was drowning out her heroic voice. From this historical perspective, she appeared as a sexual puritan and an elitist who was blinded to her own class privilege.[8] My two responses, of attraction and repulsion, heroism and treason, identification and rejection, seem to stage a common teeter-totter act in feminist history, the need both to have and to reject fore-mothers, to recognize the same in history (the same feminist courage, the same battles against misogyny), and to assert difference (*that* feminism is not my own, *that* feminism did not work but this one will). My experience of this teeter-totter, I discovered, was not unique. Himani Bannerji's readings of *A Vindication* followed a trajectory similar to my own, except that her story was set twenty years before mine and halfway across the world.[9] Bannerji first read *A Vindication* as a young woman in Bengal awakening to feminism, and she identified with the stifling conditions of female propriety outlined by Wollstonecraft. When she returns to *A Vindication* after she has immigrated to Canada and developed a Marxist and antiracist consciousness, she reads the dramatic difference between herself and Wollstonecraft, and from this perspective Wollstonecraft's orientalism rises to the surface. What does the recurrence of a similar pattern of identification/dis-identification across different generations of feminists, from different historical perspectives within feminism, suggest both about the rhetorical power of *A Vindication* to ceaselessly affect readers and about the history of feminism within feminist studies? I suggest that the teeter-totter between recognition and disavowal is a condition of feminism and, more crucially, that encounters with historical texts force us to come to terms with this condition in our present. History, in this way, is not, as Joan Scott notes, "a cumulative progress toward an ever-elusive goal"; rather, reading history involves acknowledging "the disparate and discontinuous

actions of women in the past," the paradoxes Scott refers to in the title to her history of feminism in eighteenth-century France, *Only Paradoxes to Offer.*[10]

What would it mean for our understanding of the history of feminism and of history within feminism to accept that our relationship to the past will be one of simultaneous recognition and disavowal? I propose that to do so would help us come to terms with our own condition of living in and beyond our time, of accepting and rejecting the discursive terms of one's present. The paradoxes that living in history demands are visible in an encounter with *A Vindication* and can be loosely mapped onto what critics have repeatedly identified as the frustrating swings between reason and passion in the text. Wollstonecraft argues for women's inclusion in the category of rational liberal citizen, yet her rhetorical flourishes and passionate outbursts demonstrate an equally strong attachment to the power of feeling. Critics have often noted this as a problem, a contradiction, a failure of the text. She adamantly claims in the introduction that, "wishing rather to persuade by the force of my arguments, than dazzle by the elegance of my language," she will "avoid flowery diction."[11] And yet the text is full of figurative language and dazzling rhetorical flourishes, as Rusty has shown. Wollstonecraft repeatedly asserts women's rational capacities and positions herself as a rational philosopher at same time as the text erupts in a style of argument that does not logically progress from tenet to tenet but is pushed forward by anger, passion, melancholy, reverie.[12]

Learning to read Wollstonecraft's sways between reason and feeling, between the head and heart, is about learning to read the contradictions both of history and of the feminist project. Feminists must be inside and outside, working within and yet critical of their present moment. This is a stance that can only lead to paradox, but I see it as an enabling paradox. Wollstonecraft's own fruitful paradox sees her speaking both to her historical moment

(a female in the male-identified category of Enlightenment *philosophe*) and to a trans-historical condition of feminism where the only way forward is to boldly force polemics that are at the same time mired in the blind spots of the present. To risk non-contradiction would be to fall silent.[13]

A Vindication can teach us much about the paradoxes of our radical present. I want to suggest that historicizing *A Vindication* and reading it for its radical otherness, for what strikes us as unknowable, and *not* reading to learn from the mistakes of history, will help us to see otherwise in our radical present. In arguing that we need to historicize *A Vindication*, I only partly mean it in its traditional sense: that is, to historicize what it was possible for Wollstonecraft to say or think given her time; in this case, we can forgive her for her frustrating blind spots because other discourses were unsayable in 1792 (class equality, sexual freedom, a positively eroticized female intellectual). But I also want to suggest another way of historicizing—one that does not explain her so-called contradictions through history but acknowledges her paradoxes as fruitful and accepts what we cannot know and cannot explain. By attending to the radical distance of history, the way *A Vindication* strikes us as unknowable rather than as a familiar text about equality rights, we will see differently in our present. Feminism's truth is that it must always struggle within contradiction, of acting on behalf of women while it simultaneously erases the category. If we can read for the ways *A Vindication* and the past speak to both our desire to be part of a feminist tradition and movement under the banner of "woman" and to use gender analysis to question that very category, our encounters with historical incoherence can help us find a home in the contradictions of our present. Historical difference is as crucial to the development of a complex and reflective feminism as other forms of difference, and to disavow it as an irrelevant past in the name of a more sophisticated present, or to see

it only as a reflection of the same or of how far we have come, is to reject the imperative of attending to difference, of de-familiarizing the present through the past.

When I read *A Vindication* in this way, what comes racing out over the page is the sheer force of Mary Wollstonecraft's voice, and the enormous risks she took laying her mind vulnerable for all to see. Rather than using history to judge what failed or succeeded in the past, we should be creating more and more opportunities for feminists to encounter the unfamiliar past. As feminist academics, we have succeeded at critiquing the production of knowledge within the traditionally patriarchal university, but we have a harder time giving up a progress-based, logically coherent feminism and accepting one that would not demand that we make sense all the time—that would not ask us to be the same all the time but would allow for living on in paradox and in the tensions of lived historical moments. Third-wave feminism has articulated precisely the paradoxes of feminism and has incorporated a postmodern subjectivity that lives in contradiction, but it has also been criticized for the assumed paralysis of political action this leads to. In critiquing any one agenda for feminism, is it left without any agenda? In defining itself as the new wave, has it not often misread the old waves of history? Perhaps getting out of this quagmire is what *A Vindication* models for us. In its bold and naked voice, it shows us that we cannot shy away from risking polemics, from laying ourselves open to attack by taking strong stances even when we know those positions are full of holes and contradictions, or even when we know that our positions will be subject to critique. The way feminism moves forward is with humility *and* righteous anger, passion *and* reason, sameness *and* difference.

Conclusion

Why should feminists in the opening decade of the twenty-first century read a text like *A Vindication of the Rights of Woman*, which is so steeped in vocabularies from the past and marked with issues from before the triumphal resurgence of feminisms in the later twentieth century? The writers of this essay, with experience in the undertows, riptides, and cross-currents of recent academic feminisms, have argued for the strenuous and considered placement of *A Vindication* inside the feminist university classroom. As feminist readers, we can attune ourselves to echoes across time, from Wollstonecraft to us, or we can foreground the differences, the radical othernesses, between her world and ours and between her responses and some of ours. Either way, we believe that feminists will benefit from serious trans-historical encounters with her writing.

It is useful to be reminded of the optimism that buttressed the feminism of Mary Wollstonecraft's Enlightenment project in *A Vindication*, because the various feminisms of the decades from the 1960s into the 1990s also had that sense of possibilities, indeed a utopianism about building new worlds. Nowadays, future paths for feminism seem much more challenging, alliances are more fractured, and commonalities are often harder to find and hold onto. But *A Vindication of the Rights of Woman* is still there as a text to be grappled with—ideally in its entirety rather than in short excerpts for a university course kit. We do not have to agree with everything that Mary Wollstonecraft writes in order to grasp the energy of her feminist engagement and the ferocity of her wish for social transformation. That *A Vindication* has provoked this essay by a feminist in her sixties and a feminist in her forties is one solid indication of its ongoing power.

NOTES

1. Judith Bennett, *History Matters: Patriarchy and the Challenge of Feminism.* (Philadelphia: University of Pennsylvania Press, 2006), 32. The six historical articles that appeared in *Signs* between 2001 and 2002 all focussed on twentieth-century topics. Bennett's statistics on the representation of early modern and ancient history in the three top journals in women's and gender history are: 87 per cent on Modern history (1800 to the present), 11 per cent on Early Modern (1500–1800), and only 2 per cent on Premodern (before 1500), 32.

2. For an excellent and stimulating account of the tumultuous reception history of Wollstonecraft, see Cora Kaplan, "Mary Wollstonecraft's Reception and Legacies," in *The Cambridge Companion to Mary Wollstonecraft*, ed. Claudia L. Johnson (Cambridge: Cambridge University Press, 2002), 246–70.

3. Mary Wollstonecraft, *The Vindications: The Rights of Men, The Rights of Woman*, ed. D.L. Macdonald and Kathleen Scherf (Peterborough, ON: Broadview Press, 1997), 109. Further references to this text will be cited parenthetically.

4. William Boyd, ed. & trans., *The Emile of Jean Jacques Rousseau* (New York: Teachers College Press, 1962), 153.

5. Sarah Knott and Barbara Taylor, eds., *Women, Gender and Enlightenment* (Houndmills, Hamps.: Palgrave Macmillan, 2005), 47.

6. See, for example, the multi-year research project in England on feminism and the Enlightenment that brought historians of feminism together with scholars of the Enlightenment in collaborative study (1998–2001). The resulting massive 750-page publication *Women, Gender and Enlightenment*, published in 2005, revisits broad-brush narratives.

7. Janet Todd, ed., *The Collected Letters of Mary Wollstonecraft* (London: Allen Lane, 2003), x.

8. For examples of the critical torrent unleashed against Wollstonecraft's liberal feminism by the identity politics debates, see Cora Kaplan, "Wild Nights: Pleasure/Sexuality/Feminism," in *Sea Changes* (London: Verso, 1986), 31–56; and Susan Gubar, "Feminist Misogyny: Mary Wollstonecraft and the Paradox of 'It Takes one to Know one,'" *Feminist Studies* 20, no. 3 (Fall 1994): 452–73. Cora Kaplan historicizes her own reading cited here in "Mary Wollstonecraft's Reception and Legacies," 258.

9. Himani Bannerji, "Mary Wollstonecraft, Feminism and Humanism: A Spectrum of Reading," in *Mary Wollstonecraft and 200 Years of Feminisms*, ed. Eileen Janes Yeo (London: Rivers Oram, 1997), 222–42.

10. Joan Scott, *Only Paradoxes to Offer: French Feminists and the Rights of Man* (Cambridge, MA: Harvard University Press, 1996), 1.

11. Wollstonecraft, 112.

12. Many of Wollstonecraft's arguments begin with phrases like "I must silently indulge the reveries these reflections lead to" (271), "my imagination darts forward" (314), or "I have been led into a melancholy train of reflection" (296).

13. Joan Scott reaches similar conclusions in *Only Paradoxes to Offer*, where the titular "paradoxes" refer to the historical quagmire in which eighteenth-century French feminists found themselves: needing to make claims for women's political inclusion on the basis of eliminating sexual difference, yet also needing to make those very claims on behalf of the sexually differentiated category "woman." Scott historicizes eighteenth-century feminism not to explain the paradoxes as blind spots—if only Olympe de Gouges had refused the category "woman" she would not have been guillotined—but to accept the *incoherence* of historical feminism. Cora Kaplan makes a similar observation in her overview of Wollstonecraft's legacy as I do here, arguing that "the analytical impulse itself always has, perhaps must have, a blind spot or two" (Kaplan, "Mary Wollstonecraft's Reception and Legacies," 268).

The Way They Stayed

The United Alumnae Association and Women's Co-Education at Toronto

HEATHER MURRAY

THE STORY OF THE ENTRY OF WOMEN to Canada's nineteenth-century colleges and universities is a variegated one. Some institutions opened their doors early and easily, motivated by rationality, liberal sentiment, religious conviction, or a combination thereof. A little later in the century, a number of administrators were seized with a sense of the inevitable and bowed to its dictates. In some cases, the decision was a dramatic one, with long-running contention finally driven to a close; elsewhere, women gained entry incrementally, permitted to sit a matriculation examination here, allowed to audit a lecture there. But everywhere, the women were at work: writing letters, reasoning with teachers and administrators, excelling in their studies in order to demonstrate ability and intellectual stamina.

By now, the centenaries—and more—of women's admission have been celebrated, and the stories of these pioneering

students, and their proponents, woven into institutional histories. Many of these earliest women are known today for their public achievements—as teachers and writers, social reformers and professionals. But we know little about their university connections after the diplomas were awarded. How, or could, the earliest university women retain intellectual associations in the years before they could aspire to a professorship or even a lectureship? How, or could, they remain involved in university governance? Analyses of academic women have tended to focus on those rare instances where women fought their way to positions as researchers, demonstrators, and instructors. Educational historian Alison Prentice has emphasized that we need to examine the careers of these women who "lived on the margins of men's scholarly world" if we are to fully understand women's history and educational history, and to reflexively understand how we define scholarly work and the scholarly life.[1] Prentice has further focussed on the crucial labour performed by women who are marginal *within* the academy—so-called "support staff" and, in a more recent study, "faculty wives"—and she reminds us of the continuing interdependence of "scholarly" and "service" functions.[2]

This essay suggests another off-centring of the examination: looking at alumnae and the way the earliest generation of university women forged the alumna's role. The University of Toronto—the case to be considered here—had been especially recalcitrant on the issue of admission of women. It was late to succumb in 1884 and had been unevenly accommodating. Women were excluded almost completely from its teaching ranks and could participate only occasionally in its academic or intellectual functions. (Some especially well-placed female collegiate instructors served as matriculation examiners, for example, and women could join the new scholarly and educational organizations where teachers in the secondary and tertiary sectors overlapped.) Women were excluded from university governance, and there had never been a

female member of the Senate, a body in which graduates were well represented. But it was crucial for women to continue to occupy this "last bastion": as the provincial university, Toronto was the epi-centre of educational resources, and its governance and decisions as an institution had far-reaching effects.

There was also a specific, more urgent situation that served to mobilize the early university women. Between 1907 and 1909, the university attempted to solve the perceived "problem" of the influx of young women, particularly into the discipline of modern lan-guages. It did so by considering the development of a separate college for female undergraduates, a move that neatly co-opted dis-courses of the day favouring women-centred education. In rallying against it, alumnae (along with female students) needed to come not only to a theoretical and political consensus, but to develop, also, an organizational infrastructure with which to combat the university's proposal and within which to determine their own views.[3] Tracing the contours of the debate provides a window into the question of "co-education" early in the last century, along with its complexities (not least of these was that the anti-segregationist view was most strongly advanced by women such as Charlotte Ross, Florence Keys, and Mabel Cartwright, who were employed in women-only institutions). Since women's enrolment in the modern languages (which then included English) was specifically at issue, the debate reveals the institutional impact of the perceived "gen-dering" of the discipline. In the broader analysis, however, this is the story of how university graduates not only "stayed"—assuming the "academic after-life" enjoyed by male graduates—but of how they ensured the next generation could, quite literally, stay within the university as it was historically defined.

Sir Daniel Wilson, the president of the University of Toronto, was a man of otherwise liberal principles whose elderly prudery had taken the upper hand. He fretted about separate cloak-room facilities, the hazards of studying the racier passages from

Shakespeare in a mixed classroom, and the spectre of male under-graduates in a state of perpetual excitation. Whether cannily or drawing on conviction, Wilson argued for a separate college for women, which the budget could not permit. Finally, in 1884, an exasperated provincial education ministry—pushed from behind by determined women, their enlightened male supporters, and a successful petition campaign—overrode Wilson's scruples. Once admitted, the few undergraduate women were under the care of a female "superintendent" and subject to rather comic by-laws (they were forbidden, for example, from standing before the university bulletin boards, presumably to prevent bodies from touching in the melee when notices were posted). But classes and examinations were integrated, and undergraduates of the day of course found ways to mingle socially. By 1907 the trickle of women had turned into a gentle tide, with more than four hundred women reading for degrees at University College and the affiliated colleges of Trinity and Victoria (if occasional students were counted, the figure approached five hundred). This impact was greatest in the liberal arts disciplines for which entering students were best prepared, or that they believed would fit them for a career. Women composed half of the students in the modern languages stream within five years of their admission. Thus the perceived "problem" of women was threefold: their numbers overall, their special (including resi-dential) needs, and their status in certain disciplines.

This "problem" came into sharp focus in the autumn of 1907 when the chair of history, George Wrong, asked the university Senate to strike a committee "to enquire into and report upon the feasibility of establishing a separate college for women." The installation of a new president only two months before may have signalled that the time was ripe to attempt bold schemes or signif-icant internal rearrangement (indeed, the initiative may well have come from the top). As Martin Friedland makes clear, Wrong's rationale was a mixture of the retrograde and the modern: he

stated that a university education should in part prepare women for their inevitable homemaking roles, but he also gestured, somewhat contradictorily, to the women's colleges of Oxford and Cambridge. (Wrong's own daughter, Margaret, who had attended University College the year before, was now at Somerville.) Professor Wrong was especially concerned to correct the growing disciplinary imbalance. But while he noted a preponderance of men in political science as well as the influx of women in the modern languages, it is questionable whether he wanted to redress both disparities. Not surprisingly, Wrong was chosen to chair the committee. Also unsurprisingly, the committee members seconded were all men.[4]

There was no immediate public opposition to the proposal for a separate women's college, as far as the records show. Wrong's initiative may have seemed pragmatic and even progressive. In the fall of 1907, one did not need to look to Newnham and Girton, nor to the American "sisters," as another institution lay close to hand. January of 1907 saw the ceremonial opening of the new premises of the Margaret Eaton School of Literature and Expression, a private women's college endowed by the Eaton family, of department store fame.[5] While its director, Emma Scott Raff, at times espoused a Ruskinian idea of women's domestic role, the school was unusual in stressing sports and physical activity for women, and it was designed to provide "professional and practical" training, especially in the areas of health and fitness, social work, outdoor education, and the dramatic and spoken arts. The School operated in a loose affiliation with both Victoria College and with the larger university, despite the fact that it did not grant degrees. Indeed, at its opening, the dean of the Arts faculty, Ramsay Wright, "welcomed the institution as another younger daughter."[6] (George Wrong had helped to design its history curriculum, and he and other sympathetic professors sometimes lectured at the school.) In retrospect, it appears the university may have expressed interest and support because it considered the Margaret Eaton School

(MES) a prototype for a women's college. There is an additional way in which the success of the Margaret Eaton School may have factored into the timing of the university Senate resolution. The Massey family (of farming-implement fortune), which was Methodist like the Eatons and equally public-minded, was already funding courses in the household sciences, although this option had limited appeal to the undergraduates. With the building of the Margaret Eaton School, however, the philanthropic stakes were raised: the university may have sensed, or hoped, that a donor was waiting in the wings. George Wrong's suggestion that household sciences would be emphasized in a women's college may have been designed to catch the Massey ear.

Apart from the interest of this proposal for supporters of same-sex education, whether traditional or more progressive, Wrong's proposal may have offered another, practical appeal. The need for residence space for women was assuming crisis proportions. Only Victoria College had fully accommodated their women students, opening Annesley Hall (with assistance from the Massey family) in 1903. Trinity had acquired several houses near the campus for its female wing, St Hilda's College, but it lacked other facilities. Despite the fact that a Women's Residence Committee had begun lobbying and fundraising work in the early 1890s, University College did not acquire a house until 1905, and this was quickly filled to capacity. Indeed, some University College women resided at Annesley.[7] Women students who could not live with family members billeted in the many boarding houses that lay to the north of the campus, an inconvenient and isolating location that appeared morally precarious to their elders. The striking of the Wrong committee seemed to provide a way to move the issue onto the Senate agenda. In the end, however, it was precisely this conflation of women's educational needs with their residential requirements that the progressive women alumnae and students would work to separate. Responding to the report of the Senate committee would

require a movement—first in their own discussions, and then in the arguments they would advance—from a nineteenth-century "bildungs" conception of higher education to a twentieth-century notion of education, including the liberal arts, as a form of professional or pre-professional training.

However, women who were uneasy with Wrong's proposal lacked a forum in which to express their concerns. In the fall of 1907 there were only two women of professorial rank in the entire university, both in household science (although some female physicians were affiliated with the medical school). In University, Trinity, and Victoria colleges combined, there were fifty-seven lecturers, demonstrators, and classroom assistants, among whom was one female lecturer (Margaret Addison, lecturer in German at Victoria, where she was also the dean of women) and one female fellow in mathematics (*Torontonensis* 1907–07).[8] There were no women in the Senate, and while women had their place in the newly-formed Alumni Association, this body had been designed by the university to assist, primarily, with fundraising and was not involved in governance. The three colleges and the medical faculty each had their own alumnae associations, and a Toronto branch of the University Women's Club had been founded in 1903; these groups operated in the orbit of the university, however, and had no official status. Further, it appears that the Wrong committee did not seek submissions or delegations during its deliberations; certainly the eventual report makes no mention of their receipt. A new point of purchase for the women would be required.

The women graduates and students were not, however, beginning their own discussions from scratch. The question of a women's residence had been contemplated for some time, and from different perspectives. Dr Helen MacMurchy presented the University Women's Club's views in an essay published in 1905, and a later contribution by alumna Florence Keys (BA 1891) may well have been written in response to it. A graduate of the modern

languages program who had left Canada to take up a fellowship at Bryn Mawr, and then a position in the English department at Vassar, Keys had an insider perspective on affairs at Toronto through frank and frequent correspondence with her brother David Keys, a professor of English at University College. A few years hence, Florence Keys would undertake a year-long speaking tour in Europe, promoting the co-education ideal on behalf of the Education Committee of the National Association for the Advancement of Women (the association founded by Frances Willard). But in 1905, Keys's views were substantially well-defined. The newer colleges for women, unlike Vassar, she reported, were separating the residences from the classrooms physically and, it is inferred, philosophically. Thus the effort of the woman teacher is exercised where it should be, in the classroom, and focussed on the development of rational inquiry rather than on social or monitorial functions. Of course women teachers may well have a special role to play as models for their students. However, Keys concludes, "The ideal staff is that where men and women collaborate and the real test of effectiveness remains the classroom."[9] While these were earlier contributions to the debate, it is also clear that discussion continued in the period when the Wrong committee did its work. Addressing the Victoria Women's Residence and Educational Association sometime in the spring of 1908, Maud C. Edgar (BA 1896), an instructor at the girls' school Havergal College, reminded her audience that there were more than two options, and that a system of "co-ordinate" education could overcome the respective social and intellectual disadvantages of the "co-ed" and "separate" schemes. Under the co-ordinate scheme, women would take the majority of their lectures apart from men, but the courses and examinations would be identical.[10] While Edgar's address anticipates the Wrong report in its advocacy of co-ordinate education (though the report would not use that term), it diverged as to the implications: for Edgar, co-ordinate education would

necessitate equal funding, equal representation on all governing bodies, and the immediate creation of female faculty positions. That her address was published in the *University Monthly* may be a testament to her familial connections as much as to the strength of her ideas: she was, after all, the daughter of Sir James Edgar, a parliamentarian who had also been the Speaker of the House of Commons. Further, her brother, Pelham Edgar, was then the head of French (and would later be the head of English) at Victoria College. This well-connected woman may have had an inkling of the committee's leanings and attempted to push the outcome of their conclusions.

When the short report was released after long deliberation in the spring of 1909, a "courtesy" copy was provided to the university women, forwarded most probably to University College's alumnae association. Its reception is graphically illustrated by the underlinings and marginalia on their copy: "?" "why?" "no point" and "what reason to believe this." "Prof. Wrong not our spokesman" is firmly written above the chair's opening remarks. There were strong reasons for their skepticism and their alarm. The report avoided the question of whether household science offerings should be expanded, let alone the suggestion that it should be required, and there was no direct mention of women's homemaking roles. Instead, the report built its case on practical grounds—the "main rationale" was overcrowding—but it also took pains to show that educational aims would be served by the proposal: "The present conditions do not do women justice. The special needs of women's education are not adequately studied; the courses are designed for men and men's careers."[11] One positive academic result of a separate women's college would be the recalibration of disciplinary enrolments, which was the Senate's initial concern, for men would no longer avoid women-dominated subjects, and women would be freed to take on subjects such as Latin and economics, as they did at women's colleges elsewhere. Where the numbers warranted,

there would be separate classes for women; where they did not, women would attend the same classes as men. In all cases, there would be a "common course of instruction," and "examinations and standards should be the same."[12] Duplicate courses would be taught on overload by current faculty for a stipend, although in time women would "naturally be appointed to the teaching staff." With a choice of instructors from anywhere in the university, the women's college would enjoy a more "varied" staff than was possible in the existing colleges, it was argued. The proposed institutional structure was sketched in the report: female students in Arts (that is, the women in Arts of University College, the university's teaching arm) would be "organized" into a separate college with a woman "at its head" and a separate building, although they would continue to have the same access to university libraries and laboratories. The reorganization would affect only the women of University College, but Victoria and Trinity might wish to participate in the future, in which case they would retain their own residences, and thus a "free hand in regard to religious and social conditions."[13] A feminist reader of this précis even today will immediately detect the oscillation between discourses of sameness and of separation, of courses that will be "common" yet differently designed for men's and women's careers. Such a reader would be alert to the lack of specificity regarding resources and would note the muted implication that the "college" would come into being before there were any facilities for it. But there was no time to form an adequate response or to mobilize university women. The report was published in a broadsheet version dated 10 March 1909 and placed before the Senate at its meeting of 16 April, where, by a vote of 28 to 8, it was accepted. Any argumentation and lobbying would need to occur after the fact, and would require the involvement of the women of Victoria and Trinity, for the report had implications for them that were not anticipated at the outset.

On the first of May, a date that nicely signals their intended solidarity, the United Alumnae Association (UAA) held its first meeting at Annesley Hall, hosted by its dean Margaret Addison, with representatives from the constituent alumnae associations. While the formation of the committee would shift slightly over time, each alumnae association was represented by its president and secretary; there were four further representatives from University College, reflecting the greater number of women students there and the immediate repercussions for them of the report; and at their second meeting the medical alumnae, too, would send representatives, in recognition of the general importance of this issue for university women. The immediate task of the UAA was to prepare for their meeting with President Falconer, only two days later. No doubt the speed with which they were granted a meeting was due to his secretary, Annie Patterson (BA 1899), who would soon take an active role by joining the United Alumnae herself.[14] They informed the president that the Senate must have passed the motion under the erroneous "impression" that it was supported by university women; but they wished to make clear that they disassociated themselves from its statements and declared their "disapproval of its contents." Some sense of their strategies is evident in their choice of Charlotte Ross (BA 1892) to be chief representative in these and future meetings. A graduate of the modern languages program at University College who had taken further courses in Germany and at the Sorbonne, Charlotte Ross was an intellectually dynamic woman involved in both the Modern Language Association of Ontario and the Women's Art Association, of which she was a founder. An active member of the University College alumnae association, she had also been a founding member of the University Women's Club in Toronto, a branch established in 1903. Most significant, however, was Ross's professional position: formerly a teacher at a Port Hope high school, Ross

was now the instructor of English and French literature, as well as of rhetoric and composition, at the Margaret Eaton School. As a model of intellectual attainment and as a person well-positioned to understand the merits and demerits of women-only education, Ross must have seemed a credible choice.

After the flurry of preparing for their meeting with the university president, the UAA deepened its diplomatic efforts by sending representatives to the principals or presidents of the three separate colleges, and it strengthened its status as a committee by requesting that the college alumnae associations endorse the UAA to act on their behalf. Several meetings focussed on the "clause by clause" analysis necessary to compose a convincing rebuttal: but when the alumnae reply was forwarded to the Senate, it referred this back to its own committee. Professor Wrong regretted that the press of work at the end of term would prohibit the entire committee from convening until the autumn, but he and Principal Hutton of University College met with the women on 22 May, and his points emerge with clarity from their detailed record. The Senate only wanted what was best for the women; there was no intent to "get past" co-education; and the vagueness regarding resources had been "deliberate." (There was, however, a "lady"— could this be a reference to Lillian Massey?—who said she could raise $500,000.) If the women were not in favour, that would be "an end of it." But the issue could not be discussed "properly" without a wider outlook than that of the alumnae associations. With their representative status challenged, the UAA must also have sensed that the force of their response was blunted, as their reply was sidelined. Denied the opportunity to have their views considered by the Senate as a whole, they sent a ditto-mastered letter to each senator individually, expressing their strengthened views: they dissociated themselves "absolutely from Wrong's conclusions," and their disapproval was "entire." What the letter lacked in analytic finesse,

it gained in force, and it bought them some time to mobilize the women students and add other voices to their own.

To achieve its desired end, the UAA had to forge two important sets of connections. The University Women's Club (UWC), which had a prior interest in the question of a women's residence at Toronto, had struck a sub-committee of its own to consider the Wrong report and had issued its own response. Some accounts of the ladies' college debate have concluded that the UWC initially supported the proposal and then changed its view; but its stance seems somewhat different if one considers the bifurcation between the scholastic and the pastoral functions the university women of the day were attempting to retain. Read in this light, the UWC is agnostic on the question of academic segregation: it waited for a meeting with the committee's chair, but it was strongly in favour of the residence (although it emphasized the residence should be constructed on Christian principles). The position of the club and its chief spokeswoman, Dr Helen MacMurchy, was more conservative than that of the alumnae, but rapprochement was eased, since the two groups had many members in common. The two committees had already met and merged within the University Alumnae Association, with MacMurchy taking the chair. The United Alumnae also swiftly organized a dinner to be given to the graduating students the night before Commencement (which would become, as it turned out, an annual tradition). A representative from each college's alumnae association spoke to the young women about the report and its ramifications. On the printed menu cards for the dinner were the words *"Forsan et haec olim meminisse juvabit."* Surely the woman students would recognize what Aeneas said to his shipwrecked companions: Someday, you may be delighted to remember even this.

The elegant and economical alumnae reply was published in tandem with the report in the *University Monthly* of June 1909.

It counters the evidence about women's education that Wrong's committee proffered: a wide variety of courses is taken in women's colleges—not because they are freed from male domination, but because, unlike Toronto, they are on the elective system. And it is utility, not fear of male "predominance," that underlies women's choice of the modern languages, whether they are outfitting themselves for employment or for "pleasure and profit" in later life. The reply also makes short work of the report's illogic. What could persuade the most eminent faculty to teach on stipend and thus ensure the same high standards? How could the religious-foundation colleges retain a "free hand" in conjunction with a secular one? If women are "handicapped" by the current lack of women instructors, surely the solution is to appoint some? And, in an especially ingenious point, the reply asserts that if the disciplines were rebalanced through the establishment of duplicative courses, and the proportion of women in the general classes eased, then women wishing to take such subjects would be forced into the sorts of male-dominated conditions that the women's college was designed to resolve. But the reply also took the broader view, arguing that the courses leading to an Arts degree are designed "to furnish that liberal education which we hold to be necessary both for women and for men," and that both sexes "should study for professional careers after their Arts course is finished." The reply disavows special educational "needs" for women, or the idea of separate women's "careers." All the women and most of the men oppose the report, they conclude, presumably in reference to the female students. The conclusion of the reply involves a telling locutionary choice: they do not say that all of the women, or even some of the men, support their views, which would have seemed radical to some. As Jennifer Brown has noted, the reply, whose authors were in the main accomplished professional women, may not have been fully representative of the broad range of alumnae,[15] as Wrong seems to have suspected. Indeed, it is arguable how fully this

highly tactical rebuttal represented the feelings of even its own authors.

In the preamble to the report, George Wrong vows that the question of higher education for women is not under discussion, nor is "the question of co-education really under discussion." But these remarks point in two entirely different directions, as the alumnae were quick to sense: Wrong is simultaneously asserting that women's higher education needs no discussion because it is an established fact, and co-education requires none because it isn't. Intellectual segregation by sex, he implies, has already occurred through the gender clustering in the disciplines; and he explicitly remarks the social segregation achieved through the system of parallel men's and women's debating societies, literary societies, and clubs of all sorts. If co-education does not exist, then—so the reasoning would run—the report changes nothing, but clarifies and facilitates the de facto social and institutional structures. It is this that draws the comment that "Prof. Wrong is not our spokesman" and forces the alumnae, and indeed the women students, into a tactically awkward position, where they will need to express their "entire satisfaction" with a system of co-education that is in many respects inegalitarian.

The debate continued into the autumn term, with another pair of pieces in the *University Monthly*. The St Hilda's dean of women, Mabel Cartwright, focussed on the positive, vocational reasons why women were drawn to modern languages study, and George Wrong provided expanded rationales for the report. (The even-handedness of the *Monthly* was surely due to its being an alumni publication.) But when the Senate committee finally met with the alumnae representatives in December, it became clear—whatever the arguments pro and con—that the provincial government considered the existing form of co-education satisfactory and would never sanction the expense necessary to alter it. The debate was drawing to a close, and along with it the focus on women's issues, which,

for good or ill, the attention of the Senate committee had afforded. And insofar as the question of women's education had been rearticulated as a process of scholarly and professional formation, rather than as a "gendered" moral and character development, so too did the impetus for a women's residence wane. Wrong, in many ways, was right. Courses *were* designed for the needs of men; and the campus *was* structured on sex distinction, although it would be sixty years before new forms of feminism enabled a concerted critique of these issues at their core.

Attempts to segregate the women did not end. Provost Macklem of Trinity had announced quite bluntly at their meeting with the Senate committee "that the present colleges would prefer to remain principally colleges for men, without too many women in them." A few months later, in the fall of 1909, the UAA convened an emergency meeting on "half a day's notice" upon learning that Dr Johnson, of classics, had separated his Latin class. It would emerge that George Wrong had also divided the men and women in his history seminar, and that women (presumably because they were confined to the female-only reading room) were not allowed to use the special "historical seminary" collection. And they must have wondered, on learning that six women had stood through an entire mathematics lecture when many men were seated, whether this was a pointed and sexist comment on classroom overcrowding. The UAA itemized the main issues at an executive meeting in 1913. The new high school to be attached to the Faculty of Education, for teacher-training purposes, would be restricted to boys. Residences were still needed, as was a dean of women (to replace the "lady superintendent" still there from Wilson's day), and women lacked athletic facilities and even a dining hall. That work had begun on the magnificent centre for male students, Hart House—although it would not be completed until after the war—only made these deprivations more apparent. They still hoped for women teachers and for a role in governance. In the end, their most measurable

success came with the appointment of two women senators in 1911: Charlotte Ross and Gertrude Lawlor, a collegiate teacher active with the Alumni Association, who would soon be joined by the physician and social reformer Dr August Stowe-Gullen. The Alumnae Association itself remained active until 1923.

Charlotte Ross continued to teach at the Margaret Eaton School and in other non-university settings. In 1910 she began her hugely popular Tuesday Literary Class, devoted to the study of Browning, which would attract some two hundred participants. (And after the war, her Reading Group for the Study of Contemporary Authors exposed Toronto women to the newest and most controversial authors.) Denied the principalship of the MES in favour of a man in 1925, Ross ended her teaching years as head of English at Havergal College. Florence Keys, her undergraduate contemporary, would resign from Vassar to pursue a career as a writer and advocate for women's rights: on her return to Toronto, she was never offered teaching at the university despite her strong family connections, and taught only in the affiliated Workers' Education Association, which suited her political sympathies if not her philological train-ing.[16] Maud Edgar moved to Montreal and in 1909 and became one of the two founders of Miss Edgar's and Miss Cramp's School, which has moulded the daughters of the Anglophone elite ever since. Margaret Addison remained the dean of women at Victoria, where a residence (first for women, now sex-integrated) is named after her; a hall is named after Mabel Cartwright at St Hilda's. The talented Annie Patterson, secretary to two presidents of the univer-sity, would finish her career with a third, serving forty years in total in the President's Office. There is more than a little irony in the fact that it was Margaret Wrong, the historian's daughter, who finally secured residences for the University College women and who served for a time as its de facto dean of women as well as an occa-sional instructor in English and history. While these promoters of female co-education remained in female-oriented institutions

for the course of their own careers, or on the fringes of integrated ones, they ensured that the younger generation at Toronto would remain within alma mater and would not be relegated to the care of another "younger daughter."

NOTES

1. Alison Prentice, "Scholarly Passion: Two Persons Who Caught It," *Historical Studies in Education/Revue d'histoire de l'éducation* 1, no. 1 (1989): 7.

2. Alison Prentice, "Boosting Husbands and Building Community: The Work of Twentieth-Century Faculty Wives," in *Historical Identities: The Professoriate in Canada*, ed. Paul Stortz and E. Lisa Panayotidis (Toronto: University of Toronto Press, 2006), 271.

3. The alumnae's efforts to counter the university proposal are described by Anne Rochon Ford and by Martin Friedland; they are also examined in a short monograph by Jennifer Brown, who contextualizes the episode primarily in relation to the "residence" issue of the time.

4. It is difficult to ascertain the exact membership of the committee, but at the meeting of the United Alumnae Association (UAA), the following individuals were present: Provost Macklem (of Trinity), Vice-Chancellor Moss, Mr Brebner (the registrar), Professor Alexander (the professor of English), Dr Pakenham (soon to be the first dean of Education), Professor Young (presumably the metaphysician of that name), Chancellor Burwash (of Victoria), President Falconer, and, of course, Wrong.

5. On the Margaret Eaton School, see Murray's "Making the Modern" and *Working in English* (Toronto: University of Toronto Press), 46–67.

6. D.R. Keys ["D.R.K."] "τὸ καλοκαγαθὸυ" "The Margaret Eaton School of Literature and Expression," *University Monthly* 7, no. 5 (1907): 125.

7. Jennifer M. Brown, *"A Disposition to Bear the Ills...": Rejection of a Separate College by University of Toronto Women, Canadian Women's History Series*, no. 7. The Women in Canadian History Project, Department of History and Philosophy of Education (Toronto: Ontario Institute for Studies in Education, Toronto, 1977), 6.

8. The number of women instructors had declined from the previous year.

9. Florence V. Keys, "Women's Sphere of Influence as Teacher in Women's Colleges," *Varsity* 25, no. 6 (1905): 86.

10. Maud C. Edgar, "The Higher Education of Women," *University Monthly* 8, no. 7 (1908): 226.

11. *Report of the Committee Appointed to Enquire in Regard to a Possible College for Women*, Broadsheet, University of Toronto Archives and Records Management Services. Reprinted *University Monthly* 9, no. 8 (1909): 287.

12. Ibid., 286.

13. Victoria and Trinity were Methodist- and Anglican-foundation colleges, respectively.

14. Martin L. Friedland, *The University of Toronto: A History* (Toronto: University of Toronto Press, 2002), 232.

15. Brown, *"A Disposition to Bear the Ills...,"* 15.

16. For a biography of Florence Keys and a reconstruction of her post-Vassar career, see Murray, "Double Lives."

"Not a Postfeminism Feminist"
Feminism's Third Wave

ELIZABETH GROENEVELD

IN A 1992 ISSUE OF *MS.* MAGAZINE, Rebecca Walker introduced the term *third wave* into feminist discourse by announcing "I am not a postfeminism feminist. I am the Third Wave."[1] The article, a critical response to the Anita Hill/Clarence Thomas affair, served as a rallying cry for younger women of Walker's generation to become (re)politicized and (re)radicalized in a world where feminism was still, and continues to be, crucial in the struggle for social and economic justice.

Through coining the term *third wave*, Walker gave a name to the broad range of political activities in which young women were engaging across the U.S. Her identification of a third wave also directly challenged the assertions in some mainstream media publications that feminism was "dead" and had been replaced by "postfeminism." In one sense, Walker's comment had a performative function: it produced what it named, insofar as the phrase

contributed to a discursive apparatus that allowed some feminists to imagine the ways in which their actions, occurring across the U.S., might be connected and part of a coherent movement.[2] In viewing as performative Walker's declaration that she is not a postfeminist feminist but, rather, "the Third Wave," we can say that the publication of the statement in a widely circulating feminist periodical gave the statement an illocutionary force that was facilitated by popular print culture. That is, Walker's hailing of a third wave reached a national—and international—audience of feminist readers, and thus helped enable the term to gain a certain currency within feminist discourse.

Following Walker's self-identification as third wave, a "wave," in its own right, of print and virtual media has hit bookshelves and Internet sites respectively on this "new," "sexy," and "savvy" iteration of feminism. These are just a few of the adjectives that have been used to describe the third wave, in texts like Jennifer Baumgardner and Amy Richards' *Manifesta: Young Women, Feminism, and the Future* (2000) and Vivien Labaton and Dawn Lundy Martin's *The Fire This Time: Young Activists and the New Feminism* (2004). These texts support the view of third-wave feminism as a nationally occurring phenomenon within the United States that unites a whole range of activities, performed mainly by young women, under a common banner. Richards asserts in her introduction to *Manifesta*, "It's this unspoken connectedness that I believe is out there. This book is meant to expose our conversations for what they really are—part of a big, visible, passionate movement."[3] Here, Richards links personal and political and private and public in a vision of personal feminisms (articulated through conversations) that are connected to an imagined community of similarly-minded feminists. Labaton and Martin express something similar, when they ask, "Does all the work described in this book exist in discrete pockets across the country (and around the world), or is it part of a burgeoning movement for social change

that has serious potential to alter the economic and political land-scape?"[4] *The Fire This Time*'s authors are slightly more skeptical than Richards, however, in suggesting that the answer to their question remains to be seen.

The arguments put forth in both *Manifesta* and *The Fire This Time*, in favour of viewing practices ranging from the 1999 protests against the World Trade Organization in Seattle to watching *Buffy the Vampire Slayer* on television as part of the same movement, bear out Michael Warner's claim that "a public enables a reflexivity in the circulation of texts among strangers who become, by virtue of their reflexively circulating discourse, a social entity."[5] That is, the visions of feminism articulated by Richards and by Labaton and Martin are part of an attempt to create a discursive and mate-rial entity—a movement—by drawing together a set of seemingly disparate activities performed by different groups of people who may never meet each other. In this sense, these third-wave femi-nist publics resemble Benedict Anderson's conception of the ways that nations are "imagined," insofar as members of even the small-est countries may never know most of their fellow members and yet maintain profoundly affective relations to notions of national iden-tity and comradeship.[6] As Anderson argues, all communities are imagined, and thus "are to be distinguished, not by their falsity/genuineness, but by the style in which they are imagined."[7]

This essay critically interrogates both the ways that third-wave feminisms are imagined and the "wave" metaphor more broadly. It highlights the important role of print and virtual cultures in the processes of defining and shaping our understandings of social and political movements. And, it takes seriously Anderson's claim that the discursive style in which communities are imagined has material consequences. Labaton and Martin's question about the feminist work that might be occurring "in discrete pockets across the country (and around the world)" provides an illustrative example of the importance of discourse.[8] That is, the parentheses

around this final phrase may be read as symptomatic of a larger trend within the popular literature on third-wave feminisms: to bracket, literally and figuratively, the activities of feminists outside of the U.S., which may or may not fit so easily into the "wave" structure as conventionally defined. And, indeed, although both *Manifesta* and *The Fire This Time* attempt at times to gesture toward a larger, international context, these texts are quite firmly focussed on iterations of the third wave within the United States. This way of imagining third-wave feminism clearly has implications for how the movement is understood, and engaged with, both in the U.S. and beyond its borders.

Defining Third-Wave Feminisms

Since Rebecca Walker's article in *Ms.*, the term *third-wave feminism*—its definition, its efficacy in describing the current state of feminism, its existence at all—has been discussed with varying degrees of enthusiasm in a number of recent texts. As Stacy Gillis, Gillian Howie, and Rebecca Munford argue, "many have been eager to claim the term—ownership of or affiliation to the brand—of third wave feminism";[9] just as there are many feminisms, there are many versions of "the third wave." In *Third Wave Agenda* (1997), Leslie Heywood and Jennifer Drake suggest that the third wave is "a movement that contains elements of second wave critique of beauty culture, sexual abuse, and power structures while it also acknowledges and makes use of the pleasure, danger, and defining power of those structures,"[10] a definition that does not link this form of feminism with a particular demographic. For Labaton and Martin, third-wave feminism is "young women and men doing social justice work while using a gender lens,"[11] while for Baumgardner and Richards, third wave feminism

means the core mass of the current women's movement in their late teens through their thirties, roughly speaking—the ones who grew up with Judy Blume books, Free to Be...You and Me, *and* Sesame Street. *Another way of looking at Third Wave is as the "daughters," both real and metaphorical, of the Second Wave, the women who read* Ms. magazine, Our Bodies, Ourselves, *and lobbied for* Roe v. Wade *and the* ERA.[12]

These two descriptions do link the third wave to a generational demographic. However, while the former takes a broad perspective on the range of possible activities that, and people who, could be considered "third wave," the latter articulates the subject position of "third-wave feminist" in terms of a much more specific demographic, which is explicitly gendered as female and to some extent implicitly raced as white and classed as middle class.

Indeed, Baumgardner and Richards' book has been criticized by Rebecca Hurdis for its insufficient discussion of problems facing women of colour. Despite critiques from third-wave feminists of second wavers' lack of attention to matters of race and class, there remains some elision of these issues within some of the popular literature on third-wave feminisms. While other texts like *The Fire This Time* attempt to foreground race and class, it is interesting that Rebecca Walker's own anthology, *To Be Real*, published several years after the *Ms.* article, and Daisy Hernandez and Bushra Rehman's *Colonize This!* do not self-identify as "third wave," although their content might be identified as such through the texts' focus on young women, cultural critique, and the ways in which their feminisms resonate with and diverge from those of the "second wave." Instead, both Walker's and Hernandez and Rehman's texts favour the term *young woman-of-colour feminism.* In fact, *Colonize This!* only uses the term *third wave* in its critiques of feminist texts that perpetuate white solipsism. This

phraseology suggests that, despite the frequent usage of *third wave* as an umbrella term to encapsulate a range of feminisms in the 1990s and 2000s, *third wave* as a term is not viewed as necessarily germane to the experiences of feminist women of colour. This may be due in part to the fact that the framing of feminist history in "waves" primarily highlights the accomplishments that have most benefited white and middle-class women; to wit, Walker argues in her introduction to Labaton and Martin's collection that she is a feminist, not a Feminist [*sic*], defined in this context as the mostly white, mainstream women's movement.[13]

These perspectives on third-wave feminism differently delineate what or who is third wave and, by extension, what or who is *not*. The third wave is not a monolithic, pre-existing concept; rather, it is polysemic and discursively produced. I am not suggesting the third wave is not "real" in terms of its material effects. But the ways in which we imagine third-wave feminism—in terms of its origins; of what, and who, it includes and excludes; and of its implications for feminist movements more broadly—are informed by the discourses that constitute them, and have material consequences with respect to how people engage, or don't engage, with feminist politics.

Limitations of the Wave Metaphor

As most self-identified third-wave texts demonstrate, this latest iteration of feminism is primarily associated with younger women, and the narratives of waves and generations have become synonymous with each other in some accounts of feminist history. For instance, Labaton and Martin argue that third-wave feminists are primarily between ages eighteen and thirty-five, while, according to Heywood and Drake, third-wavers comprise women born between 1963 and 1974.[14] Labaton and Martin's formulation of third-wavers as an age group (which is slightly younger than Heywood and Drake's

configuration) suggests a generational window that feminists may pass into and out of as they grow older, while the latter's positing of birth years as an indicator of a "third-wave feminist" suggests a mobile demographic of women who may retain the term as they age. These age-based views of third-wave feminism beg at least two questions: does being born outside a particular generational window preclude someone from being a third-wave feminist? can one still be a third-wave feminist at thirty-six?

To be fair, these texts do not define the particular kind(s) of feminism they discuss solely in terms of an age group, and neither third-wave subjectivities nor the broader "wave" structure are reducible to age alone. Nonetheless, the generational metaphor and the language of "new" feminism often have the effect of obscuring similarities between so-called second- and third-wave feminists. The age delineations within a number of third-wave texts can foster a sense of misunderstanding, or even animosity, between the two groups represented by the monikers *second wave* and *third wave*. These discursive tendencies are quite unproductive for building political alliances and lines of communication that cross generational divides. Further, as Astrid Henry argues,

> *feminists who came of age in the late 1970s to mid-1980s...*
> *must necessarily go missing from feminism's narrative of its*
> *generational structure. They are subsumed under the category*
> *"second wave"....As they can be understood as neither "mothers"*
> *nor "daughters" within feminism's imagined family structure, such*
> *feminists are frequently absent from recent discourse of feminism's*
> *(seemingly two) generations.*[15]

Indeed, one of the main limitations of the wave metaphor is that it implies very little happened during the "lulls." In examining the temporal gap between the second and third waves, for instance, we can see that this conceptualization of feminist movements

elides several significant developments within feminist theorizing during the 1980s, such as the lesbian sex wars, the consequences of which have been quite formative in the articulation of feminist sexualities in a contemporary context, and the contributions of U.S. Third-World feminists, such as bell hooks, Gloria Anzaldúa, Cherríe Moraga, and Audre Lorde, to critiques of essentialist and Eurocentric feminisms.

It also fails to account for coalition politics, such as feminist mobilization around the AIDS crisis, which gained particular prominence in the 1980s, as well as gay rights, anti-poverty, antiracist, and environmental activism. A variety of legal and constitutional amendments were also proposed and, sometimes, achieved: marital rape became a legally recognized crime in both Canada and the U.S.; Catharine MacKinnon and Andrea Dworkin introduced an ordinance to ban pornography in Minneapolis, a significant legal challenge, regardless of whether or not one agrees with it; and, while the Equal Rights Amendment was defeated in 1982, it was reintroduced in every subsequent session of the U.S. Congress. The 1980s may be predominantly characterized by social and economic conservatism, but this does not mean it was a time during which feminists stopped fighting. Further, as Suzanne Staggenborg and Verta Taylor assert, the use of wave language "obscures the range of activities that might be counted as feminist, including the work of poor and working-class women and women of color worldwide."[16] This kind of work includes the actions of women at the forefront of movements that range from the unionizing efforts of maquiladora workers in Mexico, to the agitation against the Narmada Dam Project in India, to the activism of the Revolutionary Association of the Women of Afghanistan (RAWA). Arguably, the narrative of feminist waves privileges the achievements that have in practice benefited primarily white, middle-class women.

The wave metaphor also simplifies the range of debates within feminism; that is, the first-, second- and third-wave categories

represent each period within feminist history somewhat monolithi-
cally. This tendency is particularly apparent within some third-wave
writings about second-wave feminism. The authors of one fem-
inist website assert, for example, "We are putting a new face on
feminism, taking it beyond the women's movement that our moth-
ers participated in, bringing it back to the lives of *real women* who
juggle jobs, kids, money, and personal freedom in a frenzied world
[original emphasis]."[17] In this assessment, second-wave feminists
are the out-of-touch mothers who have exhausted their potential,
while third-wavers bring through their daughterly rebellion some-
thing new, and hence better, to feminist politics. This discourse
assumes that second-wave feminism is both a coherent whole and
essentially over (as evidenced by the past tense of "participated.")
Moreover, it implies that second-wave feminists ignored the com-
plexities of work, reproduction, and political agency. Clearly, this is
not the case. Many second-wave feminists have advocated, and *con-
tinue* to advocate, for precisely the "real women" described in this
statement, including, frequently, themselves.

Although the wave metaphor allows for a consideration of the
ebbs and flows of social movements, and converging and diverging
currents of feminist thought, in practice the first, second, and third
waves are often invoked as neatly bounded categories in a kind of
linear progress narrative in which each wave supersedes the next.
Progressive social change tends to be a far more complicated and
messy process. As deployed within some of these popular print
and electronic media, the wave metaphor is rendered facile and
reductive.[18] This conceptualization of feminist histories tends to
overlook the ways in which the energies within social movements
often take multiple forms or are engaged elsewhere at different
times and in different spaces. How do we then engage with and
write about feminist histories? And, should we dispense with the
wave metaphor altogether?

Waving Goodbye to a Metaphor?

Since any framework for understanding feminist histories will have limitations, it may not yet be the time to retire the wave metaphor entirely, but rather to redeploy it in a more critical and provisional sense. This means acknowledging both the discursivity and the limitations of the term. Such a redeployment of the wave metaphor might also involve placing more stress on the fluidity implied by the word *wave* in the first place.

The work of Gilles Deleuze and Félix Guattari on the concept of the rhizome also offers some promising possibilities for a related but alternative way to think through feminist histories, in a manner that potentially avoids some of the pitfalls associated with the wave metaphor. Rhizomes, conventionally defined, are underground botanical growths that branch out in nonlinear directions. The mushrooms, for instance, that seem to pop up overnight in people's yards are usually the products of vast underground rhizomatic networks. These networks are always present, but it takes the right conditions (of soil, light, humidity, etc.) to produce a visible outgrowth. Deleuze and Guattari take the rhizome out of botany and into philosophy by suggesting that thinking rhizomatically would be a productive way of imagining how things like histories, power, memory, and knowledge work. They contrast this way of thinking with "arborescent" knowledges; that is, ways of thinking that assume a logical, linear flow from roots/origin to trunk/centre to branches/subunits. Using the notion of the rhizome to think and write about feminist histories offers a conceptualization of feminist "pasts" that does not cut them off from other social movements and has the potential to acknowledge the important work done between the waves. Since rhizomes are polydirectional, this concept would allow feminists to better account for overlap and points of connection between various social and political movements, such as civil rights, queer, anti-globalization,

and pacifist movements. Thinking with this concept would involve a discourse of feminist social change that avoids the modernist language of newness and progress that has permeated much of the popular writing on third-wave feminisms. Within Deleuze and Guattari's formulation, each feminist wave might represent a kind of node or "plateau" that, according to Brian Massumi, "is reached when circumstances combine to bring an activity to a pitch of high intensity."[19] Going back to botany, a plateau is a bit like a mushroom; that is, a very visible part of a much larger set of networks, conditions, and forces, but a thing that might seem to have suddenly issued from the earth. Analogously, phenomena like Riot Grrrl and consciousness-raising groups may seem, retrospectively, to have sprung from the ground overnight, but are actually products of long-standing, though less visible, social ferment.

Thinking about feminist histories rhizomatically would not necessarily involve a complete dismissal of the notion of feminist waves. Indeed, many of the qualities of the rhizome also inhere within the wave metaphor; for example, waves cannot occur unless there are large bodies of water underneath them. In this sense, the metaphors of rhizome and wave can work in ways that complement each other. Thinking about feminist histories rhizomatically helps account for the continuities and complexities of, and interrelations between, social movement histories, in ways that, *in practice*, the wave metaphor frequently does not. However, simply replacing one trope with another would not necessarily keep the metaphor of the rhizome from becoming just as limiting or reductive as the wave metaphor currently seems. What is called for thus involves more careful, critical, and nuanced approaches to writing about feminist histories, regardless of the metaphors we choose. Given the growth of recent literature on feminist waves and the "third wave" particularly, this is an opportune moment for feminists to both re-evaluate the current metaphors and consider alternative ways we might articulate the stories of feminist struggle.

Conclusion: Writing Feminist Histories

In her discussion of writing about feminist movements, Susan Friedman asks, "Whose story of feminism gains currency? What interests does it serve? Whose story is lost, marginalized? Why? The same questions feminists have asked of masculinist history about the erasure and distortion of women's lives must be put to feminist histories."[20] It is crucial that we engage with the questions posed by Friedman, because writing feminist histories is a political act. That is, the wave metaphor not only describes feminist histories, it also shapes and creates them in particular ways. As I have demonstrated, current usage of the wave metaphor tends to flatten out what is in fact a vibrant and complex set of interrelated histories, marked by both alliances and schisms. Particularly within the recent literature on third-wave feminisms, there are tendencies to use the notion of feminist "waves" in a way that elides race and class, "interwave" activity, and coalition politics. The further conflation of wave and generational versions of feminism construct older and younger feminists as two oppositional factions, rather than as diverse groups that might engage with each other in challenging and productive ways.

The popular writing on the third wave demonstrates the ways in which this category, like all the "waves," works to unite discursively a collection of practices that may in some cases be quite disparate. Written narratives of feminism, especially ones that circulate widely, facilitate the development of imagined communities of feminists working together for similar purposes. These texts can foster affective bonds of camaraderie, alliance, hope, and support between readers, who may or may not ever meet each other. Conversely, they can also elicit feelings of exclusion, alienation, and disidentification. Given the ways that some past and current feminist writing reinforces an implicitly white and middle-class bias, it is not surprising that the term *feminist* is used less frequently, or

rejected outright, by young women of colour writing about social inequities. While the force of feminism does not necessarily "die" if people stop using the term, it does mean that the unmarked "core" of the movement will continue to be defined primarily by race and class privilege. In these senses, the limitations of the wave metaphor are thus not merely unfortunate lacunae; rather, they have material implications for how people understand and engage with feminist politics.

NOTES

1. Rebecca Walker, "Becoming Third Wave," *Ms.* 2, no. 4 (January–February 1992): 41.
2. J.L. Austin first coined the term *performative* in relation to speech acts that, in their saying, perform an action (e.g., "I do" in a marriage ceremony). Other critics have since developed the concept of performativity, most notably Judith Butler through her theorizations of gender as performance in *Gender Trouble* and *Bodies That Matter*.
3. Jennifer Baumgardner and Amy Richards, *Manifesta: Young Women, Feminism, and the Future* (New York: Farrar, Straus and Giroux, 2000), xxx.
4. Vivien Labaton and Dawn Lundy Martin, eds., *The Fire This Time: Young Activists and the New Feminism* (New York: Anchor Books, 2004), 279.
5. Michael Warner, *Publics and Counterpublics* (New York: Zone Books, 2002), 11–12.
6. Benedict Anderson, *Imagined Communities: Reflections on the Origin and Spread of Nationalism* (New York: Verso, 1996), 6.
7. Ibid., 6.
8. Labaton and Martin, *The Fire This Time*, 379.
9. Stacy Gillis, Gillian Howie, and Rebecca Munford, eds., *Third Wave Feminism: A Critical Exploration* (London: Palgrave Macmillan, 2004), 12.
10. Leslie Heywood and Jennifer Drake, eds., *Third Wave Agenda: Being Feminist, Doing Feminism* (Minneapolis: University of Minnesota Press, 1997), 3.
11. Labaton and Martin, *The Fire This Time*, xxiii.
12. Baumgardner and Richards, *Manifesta*, 401–02.
13. Walker, in *The Fire This Time*, ed. Labaton and Martin, xiv.
14. Labaton and Martin, *The Fire This Time*, 4.
15. Astrid Henry, *Not My Mother's Sister: Generational Conflict and Third-Wave Feminism* (Bloomington: Indiana University Press, 2004), 4.
16. Suzanne Staggenborg and Verta Taylor, "Whatever Happened to the Women's Movement?" *Mobilization: An International Journal* 10, no. 1 (2005): 38.

17. "The 3rd Wave: Feminism for the New Millennium," September 16, 2006. http://www.3rdwwwave.com (accessed March 2008). This article no longer exists in this form.

18. Some critics might argue that the problems with these mobilizations of the wave metaphor reside in the fact that many of these third-wave publications are written for a popular audience (and therefore present feminist histories in a necessarily simplistic manner). However, there are popular feminist media that do not engage the wave metaphor in this way. For example, *Bitch* magazine, a publication that examines pop culture from a feminist perspective, is both written for a mass, non-academic audience and frequently identified as "third wave." Yet *Bitch* consistently avoids many of the pitfalls associated with the wave metaphor and demonstrates a quite nuanced and critical understanding of the ways feminist histories are (mis)represented within both feminist and non-feminist media.

19. Brian Massumi, "Translator's Foreword: Pleasures of Philosophy," in *A Thousand Plateaus: Capitalism and Schizophrenia*, Gilles Deleuze and Félix Guattari. Trans. and forward by Brian Massumi (Minneapolis: University of Minnesota Press, 1987), xiv.

20. Susan Stanford Friedman, "Making History: Reflections on Feminism, Narrative, and Desire," in *Feminism Beside Itself*, ed. Diane Elam and Robyn Wiegman (New York: Routledge, 1995), 20.

17

Between the Waves
Two Perspectives

PHIL OKEKE-IHEJIRIKA
AND JULIE RAK

OUR JOINTLY AUTHORED CHAPTER interrogates the widespread metaphor that describes feminist history as a series of "waves" or movements that accurately track the development of feminism over time. As the two of us talked about our own experiences with and in feminism, we discovered that the differences between our lives, the very different ways in which we became the feminists we are today, shed important light on the limitations of the wave metaphor. At the same time—and in spite of differences of history, culture, and geography—our experiences as women, feminists, and scholars made our conversation possible, meaningful, and purposeful. We see this conversation as a joint contribution to a larger discussion among colleagues directed toward the building of a more inclusive feminism. Our differences ascertain that we come to this dialogue from different angles. Our vision of a broader and wider-reaching feminism presents us with a specific challenge: how

285

to locate ourselves within a feminist history that does not appear to speak to our experiences. As is obvious from our narratives below, our feminist experiences grew out of and responded to very different local conditions, yet neither of us sees herself reflected in, or aligned with, what we have come to think of as The Waves. We struggle with questions of place, context, meaning, and status: how can we think of and through the times and places of complexity we describe outside of The Waves, and how does this change our understanding of feminism's current meanings?

Phil: Julie and I met as faculty members; we were assistant professors newly hired at the University of Alberta in the late 1990s, and we met at a feminist get-together. In such situations my guard is usually halfway up. As a black, African, female scholar, I feel like I'm often the only different person in the room. So when people come over to say hi, I'm not sure whether they really want to socialize with me or satisfy the usual human curiosity for the exotic. But Julie and I hit it off for a reason: we are both Christians, an identity one is not always sure whether to disclose in a feminist scholarly gathering. We shared our experiences of the contradictions embedded in the trajectory of Christianity, feminism, and womanhood, the various ways this trajectory has constricted our lives, and the challenges of surviving in academia. As we settled into our lives in Edmonton, our relationship took the usual turn. We had very little time to meet and talk outside teaching and research, and our friendship relied on encounters at academic events like symposiums, seminars, and other official get-togethers. We have always shared a sense that our experiences do not quite fit neatly into the historical markers of The Waves. The major difference is that while Julie's experience with Western feminism should find a place in The Waves, I speak for societies outside the West and completely outside the historical experience of feminist "waves." We have each struggled with our sense of misfit for much of our feminist lives,

but the increasing controversy surrounding The Waves has opened a space for us to share our common discomfort. While many of our colleagues and students are trying to create a vision for a third wave, we are still asking whether The Waves can capture our lives, our backgrounds.

Julie: I remember that women's studies gathering very well. I was delighted to meet someone else who shared my understanding that feminism and religious ideas can go together, however strangely. It's rare to find anyone who is willing to say that she is a Christian and a feminist, and a scholar too. I was happy that Phil didn't see *me* as an exotic! Later on, Phil and I participated in a prayer group for Christian academics, but both of us resigned because the environment was sexist. As our lives in Edmonton have developed, Phil and I have still found that we share many connections, but there are important differences too. The preparation of this chapter has been another of the "aha" moments we have had at various gatherings over the years, when we see how our understanding of difference has created some common ground for us.

OUR STORIES, WE HOPE, will raise questions about the manner in which developments in feminism have been conceptualized and the relative spaces they occupy in our memory banks, a scholarly reserve that now embraces various contestations from a plurality of knowledge bases. This plurality increasingly disturbs the historical markers by which we have described the development of feminism, forcing a re-thinking, if not a re-negotiation, of the major rallying points of feminist scholarship and activism. Our interrogations, however, do not ignore the challenges feminism faces within the academy and in the social, political, and economic relations and structures of contemporary society. Stories like ours—we also admit—must go beyond exposing the contradictions and contestations silenced by customary historical markers. More importantly,

they should contribute to the growing discourse on what place yesterday's feminism has in steering today's feminism toward a future that embraces, chases after, that inclusive plurality that appears to have eluded us so far.

For Phil, feminism came as a kind of second-life experience seemingly unrelated to the details of her relationship with family, friends, and the Nigerian society she called home. Coming to Canada as a doctoral student in late 1989, she began to learn about The Waves, the paradigms they gave birth to (liberal, socialist, radical), and the rebirth of those paradigms in feminist explanations of women's oppression in her "developing world." But the paradigms of Western feminism did not appear to relate much to either the historical social relations within which African women's lives evolved or to the contemporary setting characterized by social, economic, and political crises that challenge both men and women. But as she waded further and deeper into feminist scholarship as a woman, a Nigerian, an African, a black and transnational feminist, she found herself interrogating her life, a life seemingly miles away from those of her white female colleagues but in a critical way also very similar.

In Julie's case, The Waves of feminist history do not describe her experiences as a feminist either. Julie became a feminist during the 1980s, which she sees as a "lost decade" in North American feminism. She became a feminist after the heady days of the 1970s and during the time that the Equal Rights Amendment legislation failed in the United States, a time of backlash against feminism in North America that also saw the growth of women's studies in the Canadian academy. Her experiences as an activist taught her much about working women who experienced violence and about the importance of racial issues, but these experiences seemed to fall between The Waves as well: she is too old for the third wave, but never got to catch the second.

In spite of our differences, our relationship finds much common ground. We came to feminism from different angles, but we both stood on feminist pillars to make meaning of our lives and assert who we are as women of particular stripes and shades. Each of us sees in the feminist struggle a cause we experienced as an intimate part of our everyday lives and as a response to the injustices we experienced and that we saw (and see) happening to others. But The Waves did not quite carry us along as we became feminists. We had very serious questions about the origin, scope, flow, and direction of The Waves. Exploring these questions brought us together and made us interested in being part of the increasing recognition within feminist forums of the importance of these questions to articulating a vision for tomorrow. We fall between The Waves of feminist history, but our journey is shared because we share the critique of what history and place can mean within feminism.

In the following two personal narratives, we use our life stories—stories that many feminists who feel similarly sidelined can relate to—to contest the metaphor of waves. We do not set out to provide an already-worked-out alternative that readily reconciles contradictions and exclusions. Rather, we hope our stories offer further insight into how our feminist communities can begin to think about feminist history.

Phil's Story: Feminism Becomes Personal and Real

Feminism came to me as an academic experience in Canada. Nigeria of the 1970s and 1980s, my growing-up years, spoke little of feminism. I, for one, had never heard the term in my entire sojourn in the ivory tower. When I gained a doctoral scholarship to study women's studies in Canada, those who placed this fate on a young woman completing her master's degree in economics must have judged me capable of scoping a new ground because I

had no idea of what I was going to—except for the obvious intuition that it had to do with women. But as I moved through the graduate classes, faculty seminars, and a few conferences in my first year at Dalhousie University, I knew I had found my niche. Feminism had great significance for me for two main reasons. I discovered that experiences I held as personal were actually shared by women across the world, women I thought I had no connections with. And these seemingly personal, un-intellectual, unscholarly experiences had established a presence (however modest) in the academy, creating an incredible mosaic of fellowship.

Beyond the academic challenge of obtaining a doctoral degree, feminism created a critical space for me to interrogate my own life and the range of people and traditions that framed it. Although it had been a complete stranger to me, it spoke volumes about my life, a life lived with the unquestioned acceptance of conditions I saw as fixed and natural: that, as a woman, I must accept the leadership of men within and outside the home; the need for the man to move ahead; the importance and urgency of marriage over and above any other aspirations I might have, including the interruption of my education. I realized very quickly that my coming to Canada in my late twenties was radical; I came to understand why this decision did not go down well with those around me. Feminist scholarship exposed as socially constructed what I saw as natural in the entire relations of gender in which I was enmeshed. I began to ask the very question every feminist had at one point asked: why should it be so?

I fought the society that demanded I should bend to cultures and traditions that favour men and demanded to know where those customs come from. In the globalizing world in which I found myself, I saw in the very life I lived every day the intersection of Western and indigenous patriarchy across a history of colonization and capitalist expansion. My place within African, Nigerian, and Igbo (my ethnic group) identities spoke volumes of struggles

to improve society: of a social organization that afforded women some enviable positions, roles, and statuses; of women's confrontation of patriarchy, both foreign and indigenous, to reclaim lost ground. I found that culture and tradition are not cast in stone but refined and fine-tuned to serve the privileged in society. It was in the midst of these discoveries that I forged the motto that I am now well known for: Shall we serve tradition or shall tradition serve us?

But even as I dug through feminist scholarship while I matured as a teacher and scholar, I have never been able to easily identify with the metaphor of The Waves through which Western feminist scholars described feminist history, scholarship, and experiences. If I think about my age and about when I arrived in Canada, with very little idea of how these historical marks relate to life outside the West, I found myself at the very beginnings of a Third Wave that spoke very little about the experiences of women outside the West. I was very quickly swept into feminist forums that discussed topics (postmodernism, girl power, etc.) that held no attraction for the simple fact that they were often discussions of them about them or about us. The paradigms that Western feminism used to describe and analyze the experiences of schooling and formal employment for African women, my subject of research, were inadequate to unravelling the diversity of Africa and its women, the relations of gender in various societies, and their interconnections with class, race, ethnicities, and so on. Along with many other scholars of similar social background, I have often wondered what gave Western scholarship and its feminist strand the nerve to sandbox this plurality of experiences and identities into the well-trimmed theoretical packages commonly described as WID/WAD/GAD (Women in Development, Women and Development, Gender and Development).[1] In reviewing the existing literature on African women, one cannot avoid the question of who speaks for whom; who constructs the academic train that purports to carry the "others" along.

It seems to me that for Julie the issue of how to locate herself within feminist history is rooted in questions she has about how to align herself with The Waves as an outsider whose (Western but nonetheless "outsider") experience could not find a good fitting, while for me the issue is being an outsider who could not even find a way to relate to the situation. It is therefore not surprising that Julie followed the debate about feminist identity more closely, while I was more interested in the debate about who speaks for whom. I found myself drawn to debates on the political economy of feminist knowledge production. I was excited to see the voices of marginalized feminist scholars gradually break through. African female scholars, in particular, argued that they had something to contribute, not only as subjects and scholars of their own cultures but also as part of the feminist train that articulates and names the direction of future scholarship. In a broader context, the debate about feminist plurality and contested knowledge bases may have lost its heat and steam by the turn of the new century, but it has also drawn scholars of all stripes into a more global discussion and search for a more inclusive vision of feminism.

Speaking as an African feminist, the debate about the political economy of knowledge production, in all its strands, is the major historical marker of my own journey. I find the concept of "the Women's Movement" just as problematic as that of "the World Wars," and just as I might readily ask "Whose wars and whose world?" I am also inclined to ask "Whose movement and which women?" What would the forebears of this movement and its waves make of a historical legacy of African gendered spaces? Indeed, many indigenous African social formations developed elaborate and effective systems of governing society, especially at the grass roots level; systems that in many cases provided social spaces for women as daughters of extended families, heads of clans, older and revered citizens with ample wisdom to be tapped, leaders who governed in female forums usually inaccessible to men, and guardians

who served as mediators between humans and the gods in mat-
ters of religion, health, and social welfare.[2] While generations of
social change and upheaval have destroyed much of this social
arrangement, scholarly investigations remain an intricate part of
unravelling the roots of African women's oppression today. For
example, the colonial experience and its ever-present imperialist
legacies brought Africans into a struggle that intricately links race,
gender, class, and ethnicity; Western feminist scholarship has been
reluctant to interrogate this major element of women's oppression.
Not only do I find the historical spaces and times constructed by
the movement and its waves improperly fitted to wade into the his-
torical pluralities of African cultures, I also lament the fact that
the experiences of a vast majority should remain in the shadows
of a Western feminist scholarship so ill-equipped to shape, frame,
and voice their history and direction. Indeed, the complexities of
African social relations still remain largely understudied, and for
feminism to "map" them within existing theoretical formations
would amount to "framing the unseen."

With the emergence of new streams of scholarship on glo-
balization and transnationalism, I gained another status—as a
transnational feminist, uncertain of what space I am entitled to in
the unfolding Third Wave. I nurse, for good reasons, a suspicion
of inheriting the familiar reservations and strictures that could
still keep me at the margins. As "an inheritance" handed down by
an older regime, the Third Wave may not gain much substance in
transnational forums. An extended brainstorming centred on the
aftermath of a feminist hand-over from an older to a younger gen-
eration is not likely to put any spotlight on the lives of populations
caught between two cultures. Transnational feminists who wrestle
with the analyses of social relations within these emerging com-
munities have just enough scholarly energy to make irregular visits
to Third Wave discourses. So what do we make of the women's
movement, especially in its latest evolution as a Third Wave? This

is the question that drives Julie and me, an inquiry we commonly pursue, despite our different backgrounds and experience.

Julie's story: In Between and Apart, or, The 2.5 Wave

Before I describe my own engagements with The Waves, I'd like to articulate some of the differences between Phil's story and my own, and where I think our stories might intersect. Both of us were educated in the Canadian university system, and we learned about academic feminism from that system. But we learned our "everyday" feminism, which had to do with fighting oppression, outside the academy. Although we have chosen not to talk in detail about this here, both of us are from religious backgrounds that have informed, and continue to inform, our political beliefs as feminists. Our differences from each other are significant, but our shared background and beliefs enable us to have discussions about what gender difference is, and why it is important to articulate the experiences of feminism that we have had so far. One of the major differences between us is the nature of our training: Phil is a social scientist with a specialty in African development, while I was trained as a humanist (with some social science background) with a specialty in autobiographical texts and visual representations. Like Phil, I believe that issues of gender have to be considered alongside other pressing issues, including the problems of poverty, racism, and other forms of injustice. Therefore, although each of us works for justice for women, we also believe that there are times that we have to foreground other issues. Our different approaches to research, and even our different styles of writing, reflect that commitment.

So, what do I think about the idea of The Waves? Here are five quotations from public Internet sites that reveal the allegiance in feminist history to a certain kind of generational narrative. As feminist theorists and historians start to think through what feminist

"waves" mean now that there seem to be three of them, the difficulties between thinking the idea of the "second wave" and thinking the "third wave" are becoming apparent. Perhaps this is the case because the women who were part of "the first wave" had no means of articulating their own sense of who they were, since most of them were dead by the time their combination of political movements began to be conceptualized by the feminists of the second wave. But the attempts to create an idea of the third wave, at least in the populist environment of online Web 2.0 participation, are very much about what the second wave might signify. This version of feminist history is creating interesting problems connected to chronology and belonging, as I attempt to indicate in my subtitles below.

1. **The Thirty-Year Second Wave**
 "Second-wave feminism refers to a period of feminist activity which began during the early 1960s and lasted through the 1980s."[3]
2. **The Third Wave as Backlash**
 "Third-wave feminism is a term identified with several diverse strains of feminist activity and study beginning in the late 1980s. The movement arose as a response both to perceived failures of second-wave feminism and to the popular backlash against the progress of that same second wave."[4]
3. **The Fifteen-Year Second Wave**
 "Third Wave Feminism is a new brand of activism for younger women—typically those from their late teens through their early thirties. They follow in the steps of the Second Wave Feminists who revolutionized feminism in the 1960s and 1970s."[5]
4. **"I am the Third Wave"**
 "Rebecca Walker and the Origins of Third-Wave Feminism: Rebecca Walker, a 23-year-old, bisexual African-American

woman born in Jackson, Mississippi, coined the term *third-wave feminism* in a 1992 essay."[6]

5. **Third-Wave Liberal Feminism?**

"We are the 20- and 30-something women who have always known a world with feminism in it. We are putting a new face on feminism, taking it beyond the women's movement that our mothers participated in, bringing it back to the lives of *real women* who juggle jobs, kids, money, and personal freedom in a frenzied world. Women may have been granted grudging access to the job market, but we still bear much more of the burden than men: it costs more money to be a woman, we have to work harder just to be considered competent, we do all the emotional maintenance work in relationships, and all the old stereo-types that keep us from being respected unless we act like men remain firmly in place."[7]

Just what is going on in these quotations? In the first two, second-wave feminism lasts all the way through the 1980s. In the second, third-wave feminism starts in the 1980s with the work of bell hooks, Gloria Anzaldúa, Audre Lorde, Cherríe Moraga, and others who pointed out that the sisterhood of feminism creates inequal-ities and silences within it about race and sexuality. But until Rebecca Walker said "I am not postfeminist. I am the Third Wave" in 1992, in reference to the problems of racism and sexism that formed part of the Anita Hill/Clarence Thomas sexual harassment case,[8] there wasn't a name for this. The third quotation says that third-wave feminism follows in the footsteps of the 1970s second wave. The fourth references Walker as the origin of the third wave in 1992, which positions the third wave as a fifteen-year-old move-ment. And the last one says that third-wave feminists are in their twenties and thirties, and that they represent continuity with the second wave. That quotation is from 2008, which means that these women were born in the 1970s and even in the 1980s.

I am less interested in the inconsistencies between the quotations than in the chronology. Everyone seems to know what the second wave was and when it began, but no one is really sure when "it" ends, or fails, or turns into something else. This lack of certainty, which centres itself on the mid- to late 1980s, is my point of departure and critique. How well does the idea of social movements as waves—the concept is from Alvin Toffler's book *The Third Wave* (1980)[9]—actually fit feminism? Why is there such an interest in ending second-wave feminism right at the beginning of something else? Is history always generational, and should it be? Astrid Henry's meditation on the problem of wave history in *Not My Mother's Sister* raises some issues about the generational trope in feminism that we should keep in mind. Most notably, Henry points out that the tendency of feminists to imagine wave history in terms of the family, and specifically in terms of mother–daughter relationships, means that what could be "feminisms" becomes reduced to a dialectical relationship and a family struggle that does not take into account the problems of thinking that all feminists "naturally" identify with a generation.[10]

I'm interested in these things because I must define myself as a feminist by dis-identification, as Henry describes this.[11] I'm not a third- or a second-wave feminist. I'm too old for the third and too young (and critical) to be part of the second. I had the possible misfortune of becoming a feminist during the 1980s, which has always struck me as a lost decade with regard to feminist wave history. I became a feminist after the failure of the American Equal Rights Amendment in the 1980s, when the debates in Canada about women of colour and lesbians and the problem of women's sisterhood spilled over into organizing for International Women's Day, the creation of women's studies programs in universities, Take Back the Night marches, and the mourning for the women murdered in the Montreal Massacre in 1989. It was an odd time to become a feminist, and it's still a time that is either not talked

about at all, or its achievements (and failures) are co-opted by the other waves. Here is my story of being in the in-between wavelet, or of not being in a wavelet at all. It's my critique of waves as a concept because I'm asking feminists to remember struggles differently, and to teach them differently too.

It's hard to know exactly when I became a feminist, but it partly happened because when I was an undergraduate university student in 1987 my mother tried to leave my abusive step-father and, when this proved almost impossible to do, she attempted suicide. The psychiatric ward where she stayed was filled with women, almost all of whom had also been abused by their husbands, boyfriends, or fathers. I started to read and think about why this would be, and that got me thinking about other issues to do with the world around me. Why were my professors at school all male, but almost all the students in my classes (except my theory class) female? What exactly was Virginia Woolf (whose critical works weren't in my curriculum) talking about when she said that she couldn't get into her university library? What was I to make of my job at a bookstore that sold the most pornography in the city, and of women who would come and ask me, so where's the porn for us? Later on, part of my master's degree was in women's studies, and that got me thinking some more about these questions. After I got my master's degree, I went back and lived in Hamilton, Ontario, an industrial city with an unusually large social services sector because the psychiatric hospital had released the majority of its patients in response to underfunding, and because the bottom was beginning to fall out of the steel industry.

Hamilton was and is a very hard place for people to live, especially in the downtown area. The buildings are black from pollution. Crime is rampant, as is poverty. The only natural area for working-class people in the city had a highway built through it. When I first lived there, Hamilton hadn't yet become a bedroom community for Toronto and hadn't experienced the economic

boom of the later 1980s. I consider Hamilton, not McMaster University, to be my feminist university, where I learned what racism is, what antiracist work could be, why coalitions with Aboriginal women are absolutely vital, and what academic feminism can't do. That's why I'll always love that town.

In Hamilton, I worked at four low- or no-income part-time jobs: I was a secretary in an academic department at my old university, I taught English as a part-time teaching assistant, I was a workshop facilitator in the first year of the university's women's studies program, and I worked in the women's shelter system on the weekends. I also volunteered for International Women's Day and, for many years, worked with youth at risk in the north end of Hamilton, which is one of the poorest areas of the city. Later, I got a better job and helped to start a program in the continuing education department to help train women to work in shelters, and to design their own programs too.

Through my experiences in the community, I learned the following: (1) always respect difference of any kind, and be willing to be made ridiculous when you do not understand differences; (2) if white middle-class women like me couldn't give up the power and the desire to speak for others, racism would never be confronted; (3) fighting for labour rights and sexual harassment legislation is never time wasted; (4) there is much to be learned from Aboriginal women—in my case, Mohawk women—about how to build healing communities; (5) the goddess movement and sisterhood have absolutely nothing to say about my world. In the women's studies program, I saw well-meaning academic women try very hard to unite activist work and work within the academy, in ways that were very hard to maintain. And I learned to teach about first- and second-wave feminism, without having any idea of what my life and experiences actually meant within those paradigms. I learned about The Waves from books, but I never gave thought, until much later, to the fact that the validation of "experience" that was so

much a part of our feminist pedagogical practice back then actually worked against The Waves paradigm itself.

So, what can the 1980s of Canadian feminism tell us now? For one thing, the 1980s was the time when the painful discussions about race, sexuality, and other forms of difference were initiated, a time when feminism became "feminisms" within coalitions about other things, like daycare, violence against women, or elder abuse. For many, I think this made feminism more complex and remote, because it seemed to fracture the movement. But I didn't experience it that way. To me, second-wave feminists had done so much (just as we all owe radical feminists for the existence of women's shelters), but they did not understand the world of backlash that younger women like me had to experience when some aspects of the second wave became publicly successful. They thought that pornography was just wrong, while I thought what was wrong was that men seemed to make all the money from it. And what could I say to straight women, lesbians, and gay men who didn't see themselves or their desires reflected in that industry? And so the 1980s were the time when North American feminists had to come to terms with the successes of the previous movements, especially when feminists began to get academic jobs, and deal with the messiness of feminism in the wake of antiracist work, queer movements, the anti-porn lobbies, and anti-poverty coalitions. It was a difficult time to learn how to be a feminist, but it was my time, even if The Waves paradigm cannot show it for what it is.

Conclusion: Space and Time

The metaphor of waves seems friendlier to the organization of feminist experience than references to periods or epochs. But they really don't work for either of us. For Phil, The Waves paradigm is a Western feminist model that has little to say about the development of feminism and feminist interventions in African

development. Both the explanations and the historical markers provided by The Waves do not relate very much to either the historical social relations within which African women's lives evolved or to the contemporary setting characterized by social, economic, and political crises that challenge both men and women. Wading deeper into feminist scholarship as a woman, Nigerian, African, black, and transnational feminist has further confirmed Phil's weak attachment to waves as an explanatory or descriptive paradigm for feminist history. In Julie's case, the problem of The Waves paradigm is connected to its insistence on generational temporality, a temporality that creates the empty space of the 1980s, when she became a feminist without the possibility of a politics of belonging.

Ultimately, this is our message: an emphasis on feminism as a family structure, like sisterhood, or even as a structure of belonging that works *like* a family, ends up creating others who stand outside the structure and yet whose presence is demanded by it in temporal and spatial terms. But if we think of feminisms as communities of difference that require humility and a practice of listening in order to work together, we can construct different ways to imagine time and space as feminist concepts. That's why we have chosen to relate our stories in this wave, as two discrete perspectives. We value the differences in our stories, and ask that they be heard that way, just as we have listened to what each other has to say about the difficulties that time and space have posed as we have moved through them. We are not waving, and we are not drowning. We are listening, and that is how we work towards understanding.

NOTES

1. See Ifi Amadiume, *Male Daughters, Female Husbands: Gender and Sex in an African Society* (London: Zed Books, 1987) and Oyeronke Oyewumi, *The Invention of Women: Making an African Sense of Western Gender Discourses* (Minneapolis: University of Minnesota Press, 1997).

2. See N.E. Mba, *Nigerian Women Mobilized: Women's Political Activities in Southern Nigeria, 1900–1965*, Research Series, no. 48 (Institute of African Studies: Berkeley, University of California, 1982); Amadiume, *Male Daughters, Female Husbands*; and P.E. Okeke, *Negotiating Power and Privilege: Igbo Career Women in Contemporary Nigeria* (Athens: Ohio University Press, 2004).

3. "Second-wave feminism." Wikipedia (n.d.). http://en.wikipedia.org/wiki/Second_wave_feminism (accessed September 2010).

4. "Third-wave feminism." Wikipedia (n.d.). http://en.wikipedia.org/wiki/Third_wave_feminism (accessed September 2010).

5. Tom Head, "Third-Wave Feminism." About.com (n.d. [2007]). http://civilliberty.about.com/od/gendersexuality/p/third_wave.htm (accessed March 2008). The 2007 version of the article has been edited and no longer exists in the form reproduced here.

6. Ibid.

7. "The 3rd Wave: Feminism for the New Millennium," September 16, 2006. http://www.3rdwwwave.com/ (accessed March 2008). The 2008 article no longer exists in this form and cannot be reproduced here.

8. Rebecca Walker, "Becoming the Third Wave," in *Public Women, Public Words: A Documentary History of American Feminism*. Vol. III, ed. Dawn Keetley and John Pettigrew (Lanham, MD: Rowman & Littlefield, 2005), 503.

9. Alvin Toffler, *The Third Wave* (New York: Bantam Books, 1980).

10. Astrid Henry, *Not My Mother's Sister: Generational Conflict and Third-Wave Feminism* (Bloomington: Indiana University Press, 2004), 2–7.

11. Ibid., 8.

18

Mentoring

ISOBEL GRUNDY

MENTORING, IN RETROSPECT a prominent feature of my education, was invisible there, something at the time not named or taken note of. At a girls' boarding school and a women's college at Oxford, my teachers were female, and while many of them were antagonists, one or two were seriously admired. The two short-term, part-time academic jobs that I held while finishing my doctoral thesis were at women's colleges. I came to my academic career, in fact, as a late beneficiary of the nineteenth-century feminist movement for women's education. My first "real" university job (at the then Queen Mary College, London University) was in an English department which was extremely proud of having a higher proportion of women to men, and of senior women to the rest, than any other department of the college, just as the university's combined English departments had a healthier gender balance than any other combined department in the collegiate university. It was

impossible not to be conscious of the way that gender inflected every aspect of the work: selecting for university entrance, teaching, marking, assessing, administering, and researching. This list did not seem, at the time, to include either mentoring or professionalization.

Mentoring (which was not in my vocabulary, either as a student or as a junior academic) is an odd word to be important to feminists. Mentor was the tutor appointed by Odysseus to raise his son Telemachus during his own absence at the Trojan War, but in Homer's *Odyssey* Mentor hardly gets a word in before his body is usurped by the patriarchal goddess Athena. In this disguise she uses Mentor's voice to utter a string of clichés urging the son to emulate his father, while suggesting that sons rarely measure up to the previous generation. Neither the deceit practised by the teacher nor the tenor of the advice given would be acceptable to twenty-first-century would-be mentors. The name became a common noun with François de Salignac de la Mothe Fénelon's *Télémaque*, 1699, a work of romantic historical fiction with Mentor the tutor as true protagonist. This work (unacceptable to the ancien regime, the first volume suppressed in France and the rest clandestinely published) ascribes immense power to the tutor (teacher of the future monarch) to change the world through shaping the character of his pupil.

Fénelon's Mentor is expert in the art of government as well as in more academic subjects. His teaching mission is to mould his pupil's character (rendering him heroic and selfless) and to indoctrinate him ideologically (equipping him with a reformist political agenda). Fénelon had already published a highly influential, pioneering work on the education of girls (whom he wanted to prepare for a pedagogical role with their own children once they were wives and mothers). *Télémaque*, a plan of education designed to produce an aristocratic (male) public servant, gained equal renown. It had something for educators of girls, too: its message of selflessness. In

the words of *Orlando: Women's Writing in the British Isles from the Beginnings to the Present*, the "exaggeratedly self-sacrificing heroic ideal" of *Télémaque* "became a point of debate among those interested in the education of girls as well as boys."[1] (*Orlando.* Search on Fénelon, François de Salignac de la Mothe)

Fénelon's work heralded intense debate in several European countries over the question of educating girls. It fed those forces which produced the English Victorian boys' public school, and eventually analogous girls' schools. Nevertheless the historical associations of the word *mentor* constitute to my mind a blueprint of how not to do it. The Mentor of fiction suggests unscrupulous dominance, mind control, the hubris of attempting to shape another person. It suggests a kind of influence historically much more likely to be found and approved in girls' education than in boys': a kind of influence wonderfully rendered in more recent times by Muriel Spark in *The Prime of Miss Jean Brodie*. Mentoring as recommended today is not like this: it is not instruction you have to master, not advice you have to follow, but an enabling exchange of views. Yet Homer, Fénelon, Spark provide useful reminders of how widely models and practices of mentoring have varied even within our own relatively short-lived culture.

The mentors I had myself (who did not use that word) operated in hit-or-miss fashion. Working at a thesis-only doctoral degree, one had a supervisor (I had in fact a series of supervisors) with whom to discuss plans for reading, research, structure, timetable. Each of these took some interest in aspects of my development outside as well as within my thesis work, and probably contributed towards shaping my views on contemporary fiction or classical music or stereo systems or gourmet food, as well as on scholarly choices and methods. But self-conscious, purposeful mentoring, no, professionalization, no.

My supervisors would, I believe, have self-identified as scholars and teachers; being professionals would have come in as an

afterthought, if at all. Each was heavily involved in college or university governance, but each one related to Oxford University more as an outsider than as a loyalist. Mary Lascelles (*Jane Austen and Her Art*) and Rachel Trickett (*The Honest Muse*) were Fellows of women's colleges and therefore familiar with the double bind of being equal yet condescended to, as literally poor relations (lacking the capital endowments of the men's colleges), stakeholders in the present but not in the historical past. And David Foxon (*English Verse, 1701–1750*) had spent most of his working life as an employee of the British Library and came to the university systems as a fascinated outsider. Perhaps their mentoring is with me yet as I regard professionalization as a dubious, even a potentially dehumanizing process. I am, of course, a professional academic and a member of the academic profession. But this seems to me a far more limiting, even more cramping, part of my identity, and of the identities of my colleagues and students, than being scholars, teachers, humanists, feminists, and the many other things we are.

I was unusual in having an academic ex-boss as well as my supervisors. I had worked three years as full-time research assistant to Robert Halsband of Columbia, New York (later of the University of Illinois at Urbana). He taught me far more about doing research than I later learned as a doctoral student, and since he was working on a woman writer, he too was sensitized to issues of gender. As my boss he brought me into contact with a shaping generation of East-Coast American eighteenth-century literary scholars (all male), and from a distance he concerned himself generously with my later development as a junior colleague.

From each of my supervisors I heard a certain amount about committees, office-holding, how things got done, and even some strategies for coping with scrupulously veiled misogynist prejudice. As far as I remember, not one of them paid any attention to my development as a future teacher, but each encouraged me to make plans for my next research project after the thesis, and I

received some specific boosts in the manner of an apprentice to a master practitioner. Mary Lascelles enlisted me to give a talk to the Samuel Johnson Society of London, which after some years became my very first (non-refereed) publication. My first refereed article I owe to the foundational helpfulness of Bob Halsband. He had given me my thesis subject (editing Lady Mary Wortley Montagu's poems) and had introduced me to manuscript owners. Without working for him I should never have been in a position to make the discovery (of unpublished poems by Henry Fielding) which went into that article.

So while I was left to fend for myself on future teaching or administrative work, I had a wealth of mentoring in scholarship, publishing, paper-giving. Bob once rapped me over the knuckles for going over time as a conference speaker; all subsequent care in timing, all on-the-spot jettisoning of excessive paragraphs or pages, I owe to him. That Fielding article was crucially enabled by advice from Martin Battestin, the reigning Fielding expert, and also his wife Ruthe, who was the hands-on research element in the Battestin team: another instance of the apprenticeship system.

On this highly anecdotal evidence, I would say that in those days supervisors did not try to shape their students into future academics or professionals: teaching and administration were both regarded as learned on the job, or self-taught. I believe secretly we felt that bad teaching or bad administration resulted not from lack of training but from moral failings: anyone bright enough to be a scholar could do those other things well provided they were serious about the effort involved. The result was a sink-or-swim attitude on the part of seniors towards their juniors.

In today's more regulated society mentoring is expected in most specialized activities, and expectations often run very high. The British novelist Jill Dawson runs an agency which provides mentoring for aspiring writers. It offers its clients, as a year-long package, personal contact with an "established" writer to the

extent of ten meetings (to be held not at the home of either party but on neutral, public ground), each meeting preceded by up to ten hours' reading by the mentor of the mentee's work. Having taught graduate creative-writing courses, Dawson believes that what new writers want and need is not teaching but mentoring, which she says is something entirely different. As an instance of a successful outcome, she relates how she as mentor diagnosed and described her mentee's problem without any notion of how to put it right; how they debated the problem through several meetings, and how the aspiring writer figured out for herself what to do about it, though a series of subtle adjustments which transformed the whole.[2]

I never had, and I'm sure none of us had during our university education, a mentor who would devote one hundred and ten hours of their time to me and me alone. But diagnosing problems without offering solutions was something they were good at. Most crucially, those scholars of earlier generations live still in my imagination; they are figures in my intellectual landscape. Our relationship is one of interaction, not imitation. The memory of the grisly disorder in Rachel Trickett's office ought to be an awful warning, yet somehow it's an encouragement. This woman functioned as a highly effective scholar, teacher, novelist, and principal of a college, even though any kind of tidying up was clearly beyond her. Mary Lascelles pulled no critical punches: when I published my first book she sent me a long, detailed, analytical evaluation. It was short on the element of celebration or congratulation, but was probably the most helpful review I had as regards enabling me to do better next time. I could never model my own practice on this— I'm too soft—but the memory of it is a valuable preventative against letting softness go too far.

Mentoring was offered not only by instructors but by texts studied. Reading to absorb a didactic message (in the way that *Télémaque* was both read and intended to be read) was neither practised nor advised, but messages within the text (like Athena's

views on intergenerational relations or Miss Jean Brodie's views on politics) were and still are to be closely considered for their ideological as well as their structural and dramatic effect. Literary studies, therefore, incorporate exactly the kind of free-wheeling dialogue with more established voices which I have been putting forward as a description of the mentoring process.

Learning from books (not being told what to think, but hammering out new ideas in response to those other minds) is a lifelong process, and so is learning from human mentors. In my first academic job, English department members talked endlessly to each other over coffee about students, teaching, marking, examining, while discussion of books was rare (though occasionally memorable). Only one colleague, Patricia Thomson, whose own work centred on the poet Thomas Wyatt, made a point of asking me from time to time about my research: what was I doing, what did I plan to do next? Ambition, she suggested, might be harder for a woman than for a man, but was advisable. She devoted to my career perhaps five or ten minutes, once or twice a year, but in retrospect her interest was immensely valuable, keeping alive an intention which might otherwise have been drowned in the stream of immediate teaching demands.

As I have written the above paragraphs, I have tried repeatedly to formulate some statement, some description, some narrative, about acting as a mentor myself. Memory offers a thousand important conversations held with individual students, but none of them feels quite like mentoring. I well remember talking with one of my two earliest doctoral students about the disturbing incidence of trivial error he had encountered in a much-acclaimed recent big-name scholarly book; with one undergraduate about the bearing of her English studies on her fundamentalist Christian belief; with another about the value of her degree course in the light of her father's attempt to end it by intercepting her funding; with graduate students about their switch into the British university system

from continental Europe, or Japan, or from Hungary via Australia, or into the Canadian system from China or the USA, and so on. Talking about the problem of being the first in your family to enter higher education, or the problem of having two academic parents, or the many different problems, each distinct from the others, of encounters with misogyny. Talking with school-leavers making their choice of university and degree course; with first-year undergraduates (either careerist and cynical, or impossibly ambitious and idealistic); with those doing their first teaching while completing their thesis work; with those newly on the job market, and with those still on the job market.

Probably none of these talks lasted as long as an hour; none of them made part of a regularly repeated series. As Jill Dawson recognizes, mentoring in the academic world has to fit its roots into cracks and crevices of the structure. Nowadays the practices of university departments suggest that early initiation, instruction, and supervision (proseminars, first-year teaching committees, mock interviews) are judged requisite for producing a teacher, a conference speaker, a grant applicant, or an office holder. These are training but not mentoring; they do not offer access to confidential, free-ranging conversation with someone of greater experience.

Exchange of views on gender issues is especially needed and especially valuable, yet because the development of "feminist" opinions is often a long, even lifelong, process, this is an area in which a meeting of minds can be difficult. Highly intelligent and otherwise sophisticated students can strike an older person as unbelievably blinkered. The battle-scarred female warrior hearing, "Of course I'm not a feminist, but..." or "I've never been discriminated against as a woman," is likely to forget all about a confidential exchange of views and to imitate Athena as Mentor instead, declaiming against a degenerate younger generation while blatantly attempting to shape the younger generation's responses.

In fact, honest mentoring probably cannot begin until the mentor acknowledges, at least to herself, and thinks through her desire to wield an influence. Some academics produce a "school," a group of disciples with a core of common belief. Perhaps it is the trajectory of my own particular experience which makes me suspicious of such intellectual communities. I would love to believe that individuals, through my mentoring, had come to embrace the label "feminist" or to recognize that they had not after all been immune from antifeminist discrimination: that is, in fact, I would be happy to exert an influence. But not too much. It is surely vital to a student's university experience to be exposed to varieties of approach and pluralities of opinion; debate and disagreement is surely the lifeblood of the intellectual life. Personal change which comes about through such debate, in response to open-ended, non-directive discussion, is something which each mentee must negotiate for herself.

So I am left facing the possibility that the student I have argued with may never be prepared to self-identify as a feminist, and the overwhelming likelihood that colleagues of a younger generation will see their academic mission quite differently from the way I see it. Only with a full recognition of the other person's difference can one pursue the attempt to direct, countering with "what is it that you hate about being identified as a feminist?" or with "Have you ever looked at statistics on rates of pay, by gender, in university jobs?" or, to a male undergraduate asking bemusedly, "are you a feminist?" to ask what he thought a feminist would be like, and what or who gave him those expectations.

In these areas, dialogue with texts studied can prove particularly illuminating. Students may find it easier to engage with a text which has designs on them than with a teacher who has the same: they really do reconsider and reshape their own attitudes in response to attitudes which seem to them frankly alien.

A historical approach to texts and to culture introduces a range of attitudes and assumptions that often produces valuable debate, and creative, formative acts of historical imagination. Learning from difference avoids the pitfalls of self-identification.

Students who groan over the tradition of compulsory female humility—who read the sixteenth-century Anne Locke, heroicize her, and then find her writing "great things by reason of my sex, I may not do"—may learn a great deal about women and success or achievement. When, after tasting the humility of texts like that, they rejoice at Judith Man's defiant appeal in 1640 to "many of my sexe, who have traced me the way," they experience contact with a mentor whose value is in direct proportion to her distance from themselves. (*Orlando*. Results of Tag Search query, no content, within tag <Attitudes (to writing or gender)>)

An undergraduate once produced for me a painting showing another early religious woman writer (it was Mary Rich, Countess of Warwick, 1624–1678) in two guises: wearing formal seventeenth-century costume in a box with black bars, top right, and as a large, central figure in some kind of battle armour whose general effect makes her look like a modern athlete or superwoman, while every item of dress is labelled, according to Rich's own terminology, in biblical terms: "the sword of the spirit," etc. The interpretation of the two figures, said the student painter, is wide open. Perhaps the long skirt and strict enclosure represent the writer's actual, physical life and the warrior portrait an allegory of her spiritual life. Or perhaps that unbearably restricted picture is a modern feminist impression of her, while the warrior stance is the way she saw herself.

That sequence—the class reading the text and discussing it, the student painting the picture, all of us discussing the picture— seems to me to involve mentoring rather than just teaching, and mentoring less by me than by that seventeenth-century writer. Who knows what that varied bunch of individuals carried away from

the experience? The same kind of thing is true of other encounters, sometimes peripheral, with the gender attitudes of writers studied: not only early modern writers but those of today or yesterday. In 1988 the English poet Carol Ann Duffy mentioned that much territory is still forbidden to women poets, and that their best route to acceptance is still writing of recognizably feminine topics. In 2005 another poet, Jo Shapcott, raised the same point, regretting that women so often set their poems "in small, familiar and often domestic worlds," as if the historical struggle for the right to look "to a bigger world of ideas and events" had never taken place. (*Orlando*. Results of Tag Search query, no content, within tag <Attitudes (to writing or gender)>) And yet a third poet, found when she published a book of poems about motherhood, and her love-affair with her baby, that most reviewers disapproved of her subject as "too conservative, or too happy, or, mostly, because it involved me talking about myself."[3]

Young women leaning to feminism, students heading towards the academy, need to formulate opinions on these matters: for others it is enough that such issues get raised and discussed. And while only some students, even at graduate level, will enter the academic profession, it is reasonable to expect that all students at that level will go on to be intellectuals, people who recognize the force with which knowledge and ideas shape the world we live in. For such people their own mind is always in active contact with the world outside: with other minds expressed in voice, print, or electronic form, with events and interpretation of events. They are, therefore, always learning behaviour as well as facts, and in their contact with others they are always exchanging knowledge and ideas.

For intellectuals, that is, mentoring and being mentored is inescapably part of the continuing agenda. In the academic profession and probably many other walks of life as well, the trick as I see it is to eschew the practice of those fictional teachers Athena, or

Mentor, or Miss Jean Brodie. Not shaping the mind but feeding it, exercising it, leading it out—whatever metaphor your model of the mind leads you to adopt—that is a goal which writers, teachers, and feminists might all agree on.

NOTES

1. Susan Brown, Patricia Clements, and Isobel Grundy, eds., *Orlando: Women's Writing in the British Isles from the Beginnings to the Present* (Cambridge: Cambridge University Press Online, 2006). http://orlando.cambridge.org/ (accessed on January 7, 2008).
2. Jill Dawson. "Mentor 'Gold,'" *Mslexia: For Women who Write* 35 (October–December 2007): 16–17.
3. Kate Clanchy, "Men's and Women's Poetry: Is there a Difference?" *Mslexia: For Women who Write* 24 (January–March 2005): 24.

Knitters and Night Cleaners
Feminist Alliances in the Academy

ANN WILSON

FOR ME AND MANY OF MY PEERS—those of us who are part of the late "boomer" generation—feminism is important, both personally and professionally, because it provides frames for understanding relations of power within society and the relation of gender to them. The adage of second-wave feminists that "the personal is political" still resonates as we exercise choices that were not available to women of earlier generations: options around careers and affective relationships, including how "family" is configured and the choice to give birth to children. For those of us who pursue careers in the academy, feminist thought provides a critical praxis that informs our scholarly work. As empowering as feminism is, it brought negotiations, often painfully difficult, in terms of the personal and professional; we also learned we are prone to unawareness, sometimes to the degree of blindness. In this essay, I offer my reflections on my life as an academic who has spent

most of my working life largely in the ranks of the professoriate at the University of Guelph. I want to emphasize that while I was busy addressing notions of difference in my scholarly work, I overlooked difference as it featured in other aspects of my professional life, particularly my work with graduate students and with other women working at the university. Given the institutional location of my feminism, its terms and history, the feminisms of graduate students and university women employees failed to register for me. I use my own experience provisionally, as a case study, because I suspect that my story will resonate with those of others and might open discussion about why feminism has had less of an impact on the academy than those of us who began working twenty or twenty-five or thirty years ago hoped it might.

Feminisms are accepted, at least provisionally, within the Canadian academy: their perspectives are recognized as legitimate approaches to scholarly problems, at least within the humanities and social sciences, and feminisms have been a key factor in the recognition of the need to address systemic inequities. They have been a factor in bringing about a partial thaw in the chilly climate of the academy that historically has been unwelcoming to women, among other marginalized social groups. "Partial" is an important modifier because, as the 2007 postcard of the equity audit by the Canadian Federation for the Humanities and Social Sciences indicates, women are under-represented in upper levels of academic life: only 13 per cent of university presidents in Canada are women; only 15.8 per cent of the Tier I Canada Research Chairs are women; but in 2005, 48 per cent of the full-time, non-tenured teaching faculty were women, and 58.2 per cent of undergraduates were female.[1] Feminists in the academy generate an interest in the conditions of women, but clearly there is a lot more work to be done if women are to enjoy equity, to say nothing of proportional representation within the upper echelons of universities, which is the site of policy formulation of and the exercise of institutional power. It

may be that the conditions under which feminism gained some measure of acceptance within the academy were ones that kept—and perhaps keep—different constituencies of feminists (and their differing perspectives and insights) from recognizing each other, and from forging strategic alliances that could be key to the reformulation of governance, allowing the university to become the site of equitable relations for all its constituencies.

SEVERAL YEARS AGO, I WAS ASKED to sit as the external member of a hiring committee in the School of Fine Art and Music at the University of Guelph. The unit was interviewing candidates whose area was contemporary practice in art in either Canada or the USA. There were a lot of strong applications, particularly from women who had recently graduated and who had, either as a primary or secondary interest, art practices that involved craft, usually textiles or knitting. Reading the dossiers of applicants, I assumed that knitting was something that artists did and that scholars analyzed, probably with bewilderment and bemusement. I figured that the feminists writing about knitting were like me and my friends: they didn't knit, but cooked, secretly watching the Food Channel and thumbing food magazines with their glossy pictures.

Returning from reading the files for the job search, I met a graduate student from my own unit. We started to chat, and in the course of our conversation I mentioned that a fair number of the recently graduated applicants for the position in art history were feminists interested in knitting. I cannot remember the exact terms of my comments but suspect that the tone indicated bemused incredulity with just a hint of condescension. The response from the graduate student was, "I knit." That declaration hit me, not just because I had made a social gaffe, but because the gaffe was predicated on my assumption that I knew her well enough to presume that she might share my bemusement that scholars would devote time to writing about knitting. Then she

added, "All the women in the PHD program knit." I had not merely made an error in judgement; I apparently did not have a clue about what was important to the generation of women who are graduate students...and feminists. At that moment, the generational divide gaped wide.

I have thought about the exchange: Why do most of my women friends who are academics cook rather than knit or embroider? I suspect the pleasures of preparing food after culling gourmet magazines for recipes is not entirely innocent but marks a mild renunciation of our class backgrounds and social formation as women. At least that is true for me. When I attended public school in the late 1960s, girls—all girls—took home economics, where we learned to cook porridge, bake cookies, knit scarves, and embroider pillow cases. When I cook now, I don't cook porridge, but choose to explore a range of cuisines in recipes that require ingredients I don't recall being available in the Ottawa of my childhood, where oatmeal was a staple of the cereal section of grocery stores. I don't recall having heard of radicchio, arugula, and balsamic vinegar forty years ago. The salads of my childhood were made of iceberg lettuce, slathered in either Thousand Islands or French dressing from a bottle. Ads for food featured Bruce Marsh, in salacious tones, offering the myriad of culinary possibilities that the lowly marshmallow offered.

My interest in food, like that of my friends, I suspect, is about the pleasures of taste: taste in terms of flavour, but also marking "taste" in relation to the social position of being a professor, of having a sophisticated palate and the financial means to indulge it. In a mild way, my proclivities towards experimenting with new recipes and foods represents a repudiation of my education in the Ontario public school system of the 1960s and its curricular assumption that girls would grow up to be wives and mothers whose primary responsibilities would be to their families and would involve feeding the kids porridge and putting them to bed

on embroidered pillows. There was, apparently, an assumption that women would have the time to embroider pillows.

Even as a child this curricular agenda struck me as perverse and completely at odds with my own family's life. My mother stayed at home until my sister and I attended school for full days, and my mother then went back to work as a school teacher, resuming the professional life she had before she married. My mother was—and is—a great mom, but I do recall having inklings, even as a pre-schooler, that she felt constrained by being a stay-at-home mother. She didn't learn to drive until I was five and so, like the other women in her situation, her mobility was restricted to the neighbourhood on weekdays. For my mother, and for the other mothers in the neighbourhood, standing at a bus stop with pre-school children in the depths of an Ottawa winter, uncertain of when the bus would come, was not a viable option. The mothers of my youth stayed in the neighbourhood, forging their own strong sense of community. They would gather over coffee at someone's house most mornings, while we kids played. I have no recollection of my mother or the other mothers in the neighbourhood having either the time or inclination to embroider pillow cases. I do recall that there was a low level of frustration with the terms of their lives, and that my mother was a happier person when she returned to work, which precipitated a shift in the dynamics of the family. My mother did most of the cooking; my father did what little baking was done in the household. My mother washed the clothes and my father ironed. When repairs were needed, my parents hired some-one because neither was particularly handy.

Being placed in home economics in grade six, with its strict divide between what boys learned and what girls learned, was at odds with what I knew of family life and the divisions of domestic labour. I knew that things were a lot happier in my family's house-hold when my mother resumed her professional life, and that my father was not emasculated by ironing, which he enjoyed. Both my

parents took care of their children, signalling that rearing chil-
dren was a joint responsibility. I figured that if either my mother or
father had been a bit handier with a hammer, it would have been
useful and so, rather than learn to embroider pillowslips, which
even at ten I viewed as a skill of dubious domestic value, I wanted
to be in the shop class and learn how to hammer. At age ten, I had
a strong sense that the curriculum of the Ontario public schools,
which registered a strict divide in domestic labour, was not well-
suited to me and my sense of who I wanted to be when I grew up.
All of this set me up to eschew knitting and, I suspect, to be blind
to its appeal for other women who are feminists.

After the exchange with the graduate student, in the corridor,
I explored the appeal of knitting, which is an important element
of third-wave feminism because it enables building community
through sharing a common activity, in groups, either in person or
online. From talking to graduate students, knitting seems to be
not only relaxing but rewarding, inasmuch as it results in creat-
ing something tangible—mittens or sweater—that can be shared
with, and enjoyed by, those both inside and outside the academy.
Knitting, for these women, represents a reclamation of a craft in
which women have excelled, allowing the graduate students who
participate in the culture of "stitch 'n bitch" to take the time to
attend to themselves and regroup in an activity that relaxes them.
In ways, it parallels my love of cooking as a release from academic
work: it is difficult, while either cooking or knitting, to grade
papers. I wonder, too, given that academic women of my generation
tend to cook on an occasional basis, often allowing the perceived
demands of work take primacy over time for ourselves, if knitting
among third-wave feminists in the academy carries a bit of refusal
to capitulate to my generation's over-investment in work.

Neither my friends nor I are particularly good at relaxing
and "taking time" for ourselves. We were undergraduates when
few women were professors, when fewer reached the rank of full

professor, and when foundational courses of honours English programs featured mainly, if not only, male authors. When "human" was equated with a male subject of Anglo-Saxon extraction, feminism was only beginning to have an impact in universities. By the time we entered graduate school, theory—including feminism—was starting to make its mark and provided us with frames for understanding all aspects of our lives, including the curricula of our undergraduate educations and how academic work seemingly becomes a man. We were invigorated with the possibility that theory, particularly feminist theory, offered the tools of analysis that we believed would make social change possible. We—or perhaps I—bought into heady possibilities that the (feminist) theory of the late 1970s and 1980s offered.

In retrospect, the zealous embracing of feminism had costs. Caught at a moment of disciplinary shifts based on the currency of poststructuralist theories, many of us felt that if feminism were to be credible, it needed to be theorized rigorously. At the same time as we were trying to ensure that scholarship informed by feminism was recognized as legitimate, we felt the need to work within the institution, serving on every committee to which we were invited, so that the voices of women would be heard. Those habits of work have cost us: many of us are burned out because we don't know how to take time for ourselves. I sometimes think that it is ironic that I and many of my generation are the "girls who just can't say 'no,'" at least professionally. We were invested in making activist scholarship legitimate, and so busily wrote our way to tenure and promotion while serving on innumerable committees because we felt that they needed the voice of a woman. In not saying "no," we failed—and fail—to take time for ourselves. When we did— and do—our attempts might be described as "pathetic," because if we allow ourselves to relax, that time becomes a persistent voice within our heads, never silent, reciting the always very long list of things we should be doing as we garden, or lie on a beach, or take a

hot bath. Rightly, women academics who are in the early stages of their careers or who are graduate students are wary of embracing the over-work that they see modelled by those of us in the academy who are more senior. Knitting is about relaxing, but if one is a proficient knitter (as are many of these women), one can also talk about anything, including feminism and global politics, which is what seems to happen, certainly on the blogs associated with knitting.

As a movement, and as a mode of feminism, "stitch 'n bitch" seems predicated on nostalgic notions that making crafts using simple technologies—two knitting needles—is a mode of resisting the forces of global capital. Stella Minahan and Julie Wolfram Cox refine the terms of nostalgia in their suggestion that the movement is inflected with an "ironic mimicry" because the communities of women knowingly avail themselves of the technologies of twenty-first-century capital, not only by chatting online and blogging, but also by knitting using the reclaimed debris of information technologies—fibre optic cable, for example.[2]

Minahan and Wolfram Cox present a convincing argument for "Stitch 'n Bitch" being a viable mode of feminist resistance, save that they mention, but pay little attention to, the terms of the movement, including the reliance on information technologies to support blogging and the sale of patterns for knitting projects.[3] As they mention, it is a phenomenon of affluent countries, and its participants pursue crafts as a mode of leisure, a point that is substantiated by events such as "Stitch 'n Beach 2008," which was a ten-day cruise of the Caribbean, on a Holland America cruise ship, featuring twenty-four hours of instruction in knitting. I could be snide and make the obvious observation that the radical potential of a movement that includes the option of cruising the Caribbean is a bit dodgy, but the point is this: I am caught in parallel contradictions by a mode of feminism that has room for gourmet cooking. At this point in my life, I am willing to allow a politics that gives a bit of forgiveness around contradictions, blindnesses, and

their ensuing lapses, because each of us is a subject, negotiating our complex locations within the terrain of the powerful ideologies that are hegemony. Besides, offering a bit of leeway to others seems to offer the space in which I and my peers—who are prone to overwork—offer ourselves a bit of forgiveness for an evening spent cooking, entertaining, and enjoying friends.

Perhaps the point is that many feminist knitters offer their work in support of movements of resistance. For example, Minahan and Wolfram Cox cite the project of one women's group, that of knitting blankets for people in Afghanistan, a project waggishly titled "Afghans for Afghan."[4] Knitting as a locus of resistance strikes me as a fraught site of resistance, compromised in terms of political efficacy: Are groups of women who knit afghans and overtly talk politics so different from groups of women in, say, churches who knit afghans for the same cause but who may not be talking about politics in the same ways?

I have tended to be a bit dogmatic about who I recognize as feminist. Now, I wonder: What is the cause of my initial reluctance to see "stitch 'n bitch" as feminist? Why has it taken me much of my adult life to recognize that my own mother is a feminist? I think that some of the reasons for my dogmatism, which I raise because I suspect that it is less a personal limitation than a feature of the feminisms of academic women of my generation, warrant rethinking. We came to feminisms in the late 1970s and early 1980s, when feminist scholarship in the Canadian academy was relatively new, a time when women pursuing lives as scholars were struggling for respect within universities. While feminist scholarship, at least within the humanities and social sciences, gained respect in the latter part of the twentieth century, this is also the period in which universities in Canada were losing funding, signalling that post-secondary education—particularly in the humanities and social sciences—was not particularly valued by society. It seems a tired rehearsal of the old story: as women gain inroads into a profession,

it is devalued by society. It is not surprising that feminist scholars were careful "gatekeepers" of their emerging discipline, attempting to ensure that it was viewed as legitimate even when there was a pronounced decline in the respect for scholarship in the humanities and social sciences. To be accepted as a feminist, you could not merely profess to adhere to feminist principles; you had to demonstrate conversance with theory, and apply it rigorously, so that the fledgling field would have academic credibility.

From the luxury of hindsight, "gate-keeping" has had its costs: "gate-keeping," which seemed (and probably was) necessary if feminist scholarship were to register within the academy, led to a creeping elitism around feminism within universities, at least amongst faculty where one proved one's mettle by familiarity with theory. While most feminists are quick to celebrate "grassroots" feminism—women striving to change their lives through active analysis and initiatives to forge change—the inclination seems to be to view these initiatives as occurring beyond campuses, and so nostalgically preserve notions of universities as "ivory towers" that exist outside the exigencies of the social. I want to offer a moment when I came to realize that the grass is growing on campuses.

In the early 1990s shortly after I had received tenure, and so was a relatively junior academic, I was appointed as the acting director of women's studies at the University of Guelph. Like most who assume an administrative position, I thought that I could renew the program and realize its potential. I thought such a renewal was contingent on establishing a connection between feminist scholarship that informed the academic enterprise of women's studies and the lived lives of women within the university. To realize the objective, I wanted the women's studies program to facilitate conversations among women in the university and thought an informal get-together would be a good starting point. I sent out an invitation to women who were members of faculty and staff to gather in the University Club for wine and conversation.

In retrospect, the invitation seems naive: How could I have not realized the fraught terms of the invitation that asked staff to come to the University Club, which, at Guelph in the early 1990s, was not a glamorous venue but even so was snooty enough to restrict admission to faculty members who had paid dues. It was not a venue that was particularly inviting to junior faculty as a place to socialize; I was not a member. I am not sure why I chose the University Club, save that I was insecure and probably felt that the venue would provide a certain sense of legitimacy to the event and so mark it as an important occasion. The truth was the Faculty Club was an analogue to the terms of the professoriate—not very glamorous; it allowed entry to those who had paid their member-ship dues and once inside, the ambience was genteel stuffiness.

Despite the inhospitable location of the social, a few members of faculty came to it, as did a few administrators, some of whom were not academics. There were a few members of staff—some members of the academic support staff and a group of four or five women who were cleaners. That the cleaners accepted the invita-tion was striking, if for no other reason than that they had to make an effort to attend: an event at 5 p.m. was at odds with the hours of their working lives, which for many began in the wee hours of the morning and ended at noon. In thinking back, I presume that in coming to the social some may have set their alarms and disrupted their sleep. They did not say; I did not think to ask.

The women employed as cleaners came with a reason: they wanted other women from the university, women who professed to be feminists, to hear their accounts of their conditions of work. They wanted us to know that while we were sleeping, they came to work on crews that were, in the main, headed by male foremen. They explained that under the cover of dark, the cleaners worked in a culture that was marked by harassment, at a time when there was no formal policy in the university that offered protection and redress from sexual harassment. The women were subjected to

verbal abuse by many of the male foremen and by the few men on crews; there were instances in which the abuse escalated into sexual assault. Many of the women, some relatively new to Canada and without fluency in English, felt alone and powerless to challenge their circumstances, which involved being deployed to work largely alone or with another person. In the night, without anyone around, the men occasionally became physically violent, unleashing anger against women who were vulnerable because they worked in isolation and because they needed the income. Many of the women who cleaned felt that challenging the abuse was pointless, given there was little or no protection for those who availed themselves of the few modes of recourse, such as a grievance. There was always the danger of escalating the harassment and perhaps even the loss of employment that, for the type of work, was well-paid. The cost of pursuing justice was, potentially, extremely high.

A few of the women who cleaned at night saw the abuse as intolerable. Well before the social, a group of these women cleaners were actively working for a remedy. They had launched action, through their union, against the university. At the time of the social, that action was in progress. They came to the social to test the convictions of women who self-identified as feminists. They did not want our advice. They wanted to know if we were willing to hear them and to address injustice that was immediate, occurring in the early morning hours in our offices and corridors. They may have been urged to attend by their union, but I suspect they were not; rather, they came to make visible the appalling conditions of labour practices that, for most of us, were invisible. These women were activists who had analyzed the situation and initiated a course of action to redress it. They came so that I and others would bear witness, by listening and hearing them. They came as feminists.

Conversance with theory is important if you are a scholar and profess feminism, but is not the only way to be a feminist.

Feminism involves analysis of the condition of women, whether through the lens of the theoretical perspectives that circulate amongst scholars or through perspectives gained by having lived with a degree of awareness about the dynamics of power within society; probably the "or" is misleading, suggesting that feminism is singular and does not have multiple, and perhaps contradictory, facets that may produce blindness. The accounts from my own life, about the graduate students who I discovered were avid knitters, about my childhood, and about the night cleaners who wanted the terms of their lives to be known, are about different modes of feminism. The differing modes of feminism are produced by context and could be expanded to include race and ethnicity, to cite but a few of the categories that scholars employ to recognize difference within the sphere of the social. But what is crucial is that each of the accounts involves women who are feminists. They have analyzed their lives, in some instances without the formal lens of theory, but have engaged in rigorous analysis, abstracted their situations to understand that their personal circumstances are not merely the consequence of personal choice but of social inequities. They have responded to the inequities, on the terms that struck or strike them as viable modes of action within the specificity of each context. Whether academics who identify with the second or third wave of feminism, whether women of my mother's generation, or night cleaners, all are conscious of the inequity embedded in the socially produced terms of being women.

Each of the situations I describe is marked by contraction and blindness; although in each account there was action, there was also some degree of compromise, which I offer as an observation, rather than a criticism. Feminisms, in their myriad of forms, were—and continue to be—contingent on analysis that seeks to provide the tools for social change by addressing what strikes me as one of the most entrenched mechanisms of hegemony: the disparate access to agency and power between men and women. At

the risk of being crudely reductive, without this imbalance, capital-
ism—the motor of global economies—would collapse. It is hardly
surprising given that feminists, like everyone else, are caught
within contradiction.

Rather than lament the contradiction, and read the ensuing
lapses as "failure," perhaps feminists, provisionally, should refuse
to read "contradiction" as equating with "failure." Perhaps a strat-
egy would be to take stock. At this point, I find myself wondering
why feminism has had such a limited impact on the conditions
of academic labour and, more broadly, the working conditions of
all women employed by Canadian universities. The statistics are
a bit grim. I think the answer might lie in extrapolating from the
accounts I offer as examples, which I hope carry some resonance
with readers. The details are from my history, but they are offered
in the hopes that the broad contours resonate with those who read
this essay.

Of one thing I am sure: the twenty-first century is not "post-
feminist" if that term suggests that women have equality. Women
fare a bit better than they did twenty-five years ago; but to my mind
"better" is not good enough. Feminists are up against a formida-
ble force: hegemony. We need to know what we confront and that
the terms of hegemony will result in oversights, misunderstanding.
Our strategies will have flaws, but that is not cause for giving up.
Feminism has not failed, but it has been caught in the inevitable
force of contradictions produced by hegemony that maintains the
status quo, allowing only modest change.

In my undergraduate teaching, many students seem to engage
with feminist analysis as an intellectual exercise—which in ways
it is; but few seem to make the leap from using feminist theory
to read literary texts to using feminist theory to provide a rigor-
ous reading of their own lives and the world in which we live. For
example, spousal violence, 90 per cent of the perpetrators of which
are men who assault women, is the largest category of criminal

conviction for violent offences in Canada.[5] Against the horror of the lives of women that are deformed by poverty and prejudice, which are conditions that make them particularly vulnerable to domestic violence, there is an imperative for academic feminists to assert insistently that the twenty-first century is not post-feminist and to be open to strategic alliances that might effect social change. Theory is important, but it is not an end in itself; it is a tool, but only one tool, of analysis. Analysis needs to lead to action. Perhaps, in the end, my impulse nearly twenty years ago to want to facilitate conversations among women was right in terms of impulse, even if naive and clumsy in its execution. Perhaps we need to recognize that political change never involves a linear teleology of progress, and that political gains in the area of attaining gender and sexual equality are fragile and can be rescinded without vigilance.

Against the difficult challenges facing feminism, oddly I am drawn to the words of Samuel Beckett, not only an author but a resistance fighter in World War II: "No matter. Try again. Fail again. Fail better."[6] That I am drawn to the words of Beckett speaks volumes about my own blindness. The quotation carries a resonate truth around living an engaged life because it seems to me that all each of us can do is try, act, and be brave enough to acknowledge failure, pick up, and try again. Maybe I am drawn to Beckett's words because he was a playwright and my scholarly area is theatre. Whatever: the words are on a poster that hangs in my house. The poster was a gift from my mother, whom I have always loved but have not always recognized as a feminist.

NOTES

1. Wendy Robbins and Michèle Ollivier, "Postsecondary Pyramid: Equity Audit 2007." Canadian Federation for the Humanities and Social Sciences, n.d. [May 2007]. http://www.fedcan.ca/english/pdf/issues/Pyramid_and_Notes2007.pdf (accessed July 4, 2008).

2. Stella Minahan and Julie Wolfram Cox, "Stitch 'n Bitch: Cyberfeminism, a Third Place, and the New Materiality," *Journal of Material Culture* 12, no. 1 (2007): 6.

3. Ibid., 7, 8.

4. Ibid., 7.

5. Statistics Canada, *Measuring Violence Against Women*, Statistical Trends 2006: 54.

6. Samuel Beckett, *Worstward Ho* (London: John Calder, 1983), 7.

Activism

20

Who Benefits?

CHRISTINE BOLD

IN MARCH 1996, SOME FACULTY and students sat down at the
University of Guelph to contemplate working together under the
rubric of cultural memory. Casting around for a focus, someone
in the room said, let's not just critique something. I want our work
to support some kind of resistant cultural production. Someone
else said, what about Marianne's Park? This was a small park
near the university, dedicated to Marianne Goulden, a worker for
Guelph-Wellington Women in Crisis who had been murdered by
her partner, and the site of Take Back the Night and December
6th gatherings. By focussing on the park, could the group perhaps
explore and support the hinge between memory and activism, the
link between remembering the past and changing the future? Ten
years later—after considerable shakedown, shakeups, and much
learning—in March 2006, The Cultural Memory Group published
Remembering Women Murdered by Men, a collaboratively written

book that documents, analyzes, and aims to support approximately sixty memorials to women murdered across Canada. I'll say a bit about the making of this group, tell about one occasion on which I talked about our book—then ask the question in my title.

The Cultural Memory Group

The group of co-authors that coalesced over those ten years differed significantly from the original constellation. The two major developments were that the Cultural Memory Group became committedly feminist, and it came to include both academics with activist sympathies and social justice workers from the community. The co-authors of *Remembering Women Murdered by Men* are Sly Castaldi, executive director of Guelph-Wellington Women in Crisis (known as WIC); Jodie McConnell, a human rights and women's equality advisor in Toronto; Lisa Schincariol, currently a doctoral student in communications and culture at York University; Ric Knowles, professor of theatre studies at the University of Guelph; and me—an English professor at the University of Guelph.

This group brought a mixture of skills, knowledges, resources, and contacts to the project, and we've affected each others' positions and perspectives over the years. Sly, for instance, was originally approached by the academics as a kind of local informant, a WIC employee who had been involved in the creation of Marianne's Park. In exchange for some of the inside story, we offered academic resources to support WIC's public outreach activities in the park. As we began to realize how many isolated feminist memorializers were working across the country, Sly became committed to spreading the word, and she became a fully fledged co-researcher and co-author. Lisa began as the project's graduate research assistant, became the main communications link with memorial groups, stuck with the project after she graduated from Guelph, and also became a co-author. My role hasn't changed

substantially, but my perspective did. At the outset, the academics had carefully delimited our zone of research so as not to exploit the life and death of Marianne Goulden. Repeatedly, we said: it's the park we're researching, not the woman. For the social justice workers, from beginning to end, this project was about women— women murdered and women working to end violence against women. The more closely we worked together, the more exhausted memorializers we met, the more stories of femicide and resistance we heard, the more the women took centre stage. As far-fetched as it may sound, these women—those who survived and those who didn't, the women memorializers and the women murdered—have changed the co-ordinates by which I try to live as a feminist in the academy.

Remembering Women Murdered By Men

The book ranges widely over time and space; it's humbling to discover how long and over how large a territory memorial-makers have been insisting that we remember women murdered. The oldest memorial we discovered dates from 1896 in rural Bear River, Nova Scotia. The murders at l'École Polytechnique on 6 December 1989 produced an outpouring of memorials across the country— from Riverview, New Brunswick, to Vancouver, British Columbia. First Nations women and other activists memorialized the so-called "missing women" of Downtown Eastside Vancouver long before the media circus around those murders began. Memorials to women murdered have been created on university campuses too numerous to list, in parks (Place du 6-décembre-1989, Montreal; Minto Park, Ottawa; Victoria Park, London), in city halls (Moncton, Hamilton), and beside at least one provincial legislature (in Winnipeg, Manitoba). Stylistically, they range from the conventional to the minimalist, from a mural to performances. Some dedications name names, each on its own crafted stone:

Helen Betty Osborne, Wendy Poole, Sharon Mohamed, Barbara Daigneault—the names feel never-ending. Some dedications name groups, sometimes in multiple languages: the Women's Memorial Grove in Winnipeg honours "the lives of Manitoba Women," in English and Cree; the Montreal Mural honours, in Mohawk, English, Inuit, and French, "the more than sixty sex workers, most of them indigenous, who were killed or disappeared in Vancouver." A few dedications—this is the riskiest operation of all—name the fact of murder: Enclave, in Ottawa, for example, is dedicated, in French and English, "À La Mémoire De Toutes Les Femmes Qui Ont Subi Jusqu'à La Mort La Violence Des Hommes." By and large, these memorials were forged in isolation, under public attack, and with minimal resources. Part of our job was to help activate these memorials. In analyzing the politics of their creation, form, and use, we sought to increase their visibility as a countrywide web of feminist activism.

In October 2006, a few months after the launch of *Remembering Women Murdered by Men*, I spoke about our book at "Not Drowning But Waving," the conference at the University of Alberta that was the starting point for this volume. I had very rarely represented the Cultural Memory Group on my own and not at all since the book's publication. I was anxious that I would inadvertently misrepresent the group and that, without the various forms of expertise carried by group members, I would be out of my depth.

At the conference, given its location, I chose to speak about two Alberta memorials that sit particularly powerfully within the landscape of memory and forgetting. Sherene Razack has compellingly analyzed "spatialized justice" in Canada: that is, the ways in which the law works differentially across different social spaces, separating off so-called civilized or respectable space from so-called savage or degenerate space (such as the space of prostitution), in order to bolster white bourgeois hegemony.[1]

Lest We Forget, by Theresa Posyniak, 1993.

Part of the power of *Lest We Forget,* a sculpture by Calgary artist Theresa Posyniak, is that—located as it is in the Law Building on the University of Calgary campus—it speaks back directly to the legal system that Razack critiques. Posyniak has talked about how her design—along with the title of her piece—deliberately recalls conventional war monuments, with their phallic and confident verticality. This column, however, is fragile and incomplete, made of crushed, tattered paper, crumbling and broken off at the top. It speaks of vulnerability to violence in its form and in the names inscribed on its surface: 145 names of girls and women, aged six to eighty-four, murdered in Canada—women murdered on the

street, in their homes, in a university, women who were divided across lines of race and class, brought here together in mourning and protest. One face of the monument intones over and over: "one of the disappeared, one of the disappeared." The artist has written: "Ominously, one side of the sculpture is left partially blank for future entries as the violence against women continues."[2] An accompanying information sheet voices the sculpture's institutional challenge: it "would help to reveal the inadequacies of the legal system and the concomitant responsibilities of lawyers and lawmakers to society."[3] The memorial's symbolic breaching of class lines has also taken material form. One of the women named on the memorial was doing sex work at the time of her murder. Her young son was brought to the memorial on his mother's birthday, to have his picture taken by her name; subsequently, flowers appeared annually at this spot. The dead woman's mother has made the point that this woman would never have felt welcome in this space in her lifetime; there's dignity given to her memory in its recognition here. Yet, as with all countermemorializing, the political impact of the piece is somewhat contained. Its placement keeps it far off the beaten track, and the Law School has protected the sculpture with a case of thick glass—cutting the fragile piece off not only from its audience but from the artist, who no longer has access to that empty space for future inscriptions.

A Vision of Hope by Edmonton artist Michèle Mitchell protests violence against women with a very different aesthetic and from a very different space—in Razack's terms, "degenerate space." A sculpture of three powerful female figures—signifying despair, grief, and hope—sits in Mary Burlie Park, a small green space in the poor end of Edmonton, pressed between Chinatown, the Remand Centre, and the railroad tracks. The Sexual Assault Centre

A Vision of Hope, by Michèle Mitchell, 1999.
Photo by MD Mayes.

A VISION OF HOPE
MICHELE MITCHELL 1999

committee responsible for the sculpture's installation has written: "Ironically or symbolically, the park is in one of the most beaten-down areas of town"; "it's not someplace you'd go to at night..., not if you value your life."[4] Here, protest speaks from the heart of danger and violence, and the language is blunt. The dedicatory plaque lists the names of the fourteen women murdered at l'École Polytechnique, then says,

Killed because they were women
December 6, 1989

In memory of all women abused, raped and killed by men
in Edmonton, Alberta and Canada.

The message is reinforced in fifteen trees ringing the sculpture, fourteen of them dedicated to the Montreal women murdered, and the fifteenth dedicated, in these words, to

All women abused,
raped and killed
in Edmonton,
Alberta and Canada.

How directly the protocols of space affect the politics of language is suggested in the contrast with the dedication on a memorial stone on the University of Alberta campus. This dedication names "students" not women, and "tragic deaths," not murder. What the institutional space can bear, it seems, is respectful mourning, not protest nor systemic analysis.

Of course, for all the power of *A Vision of Hope*, it is contained in different ways than *Lest We Forget*. Positioned as it is geographically, it's easy for any of us living outside that space not to know of the park, not visit the sculpture, not be confronted

with its analysis. I ended my talk by acknowledging that countermemorials—indeed the entire undertaking of "feminist memorial-activism"[5]—always work within limits, pressing against odds of different kinds. Bringing memorials together increases the solidarity of resistance, making more graphic than ever the spaces, structures, and social hierarchies that exacerbate and allow violence against women.

The first question came from a woman in the audience who spoke as a strong feminist. She was concerned that Mitchell's sculpture, imitating as it did (at least in her viewing) the triumphant poses of masculinist, war-like statuary, was setting up a problematic, potentially dangerous model for female survival. Isn't it important, she said, to critique this sort of mimicry? My immediate, unspoken, response was "important to whom? Who benefits from that critique?"

Who benefits?

I had obviously learned something from my collaborators. For years, the social justice workers had been raising the "who benefits?" question. On several occasions, they would bring our analytical proceedings—slow enough at the best of times, determinedly collaborative as we were—to a sudden halt. The group would be trading back-and-forth the ways in which memorials aim to stop violence against women, when Sly or Jodie would say: Just a minute, what do you mean "stop violence against women"? Who benefits from that measure? If we set up memorials as a means of ending violence, they're bound to fail. When is such a measure ever established for any other contribution to the struggle against violence against women? Or, as we hashed over a finely developed critique of the wording or form or position of a memorial—often a critique that had taken weeks for us to develop as a group—someone would say: Whose interests are served by that critique? Who

will benefit from its public expression? Those memorial-makers have already been howled down by a hostile press and the anti-feminist brigade. Isn't our job to offer analysis that just might contribute to systemic resistance, not more ammunition to be used against feminist activists?

"Who benefits?" is almost shorthand for the critical position at which the group finally arrived. By trial-and-error, we forged an approach in which the ethical and the theoretical are one, an approach that respects the hard-won trust between researcher and object of study. In our collective, the social justice workers functioned both as researchers *and* as objects of study. In order to learn the struggles of feminist memory-makers, we had to build trust within the group *and* with our co-researchers' communities *and* with communities beyond any of our experience. Our group is quite diverse—by gender, profession, generation, sexuality—but not by race. The women who are most subject to violence are impoverished women of colour and First Nations women, and we tried to honour such groups without appropriating them. Although we failed to forge full partnership, we built some bridges by employing student researchers who belonged to and had the trust of African-Canadian, South Asian-Canadian, and First Nations communities, and in the book one chapter is dedicated to the voices of First Nations women writing their own memorials. All these interests had to be respected.

In the time since the book was published, some have criticized it for "not going far enough" in its critique of memorials' limitations, especially across lines of race and class. (Others have criticized it for insinuating that all men are violent and for ignoring violence against men—but that is another story.) Indeed, as this field of feminist memorial studies—newly emerging, tentative, barely named—comes into being, it already seems to be structuring itself around an argument about critique.[6] The accumulating publications and papers seem to be opening a fundamental divide.

On the one side stand those of us who believe we've been there; we went "far enough" and then, after a lot of discussion and soul-searching and strategic thinking, we decided to go somewhere else—to a point where we could make a contribution through our version of activist analysis. On the other, as I understand their position, are those who believe that the priority is critique, lest the blindnesses and limitations and exclusions of particular memorials reconstitute the class and race hierarchies that produce violence in the first place. Such exclusions clearly are troubling, but our fear is that training attention on them from an academic position of critique will not produce inclusion but paralysis, will erase such imperfect efforts from the memorial landscape and render the violence invisible once more. Memorializers themselves have confronted and worked to redress their privileging of whiteness or suppression of the fact of murder or lack of systemic analysis.[7] Learning about the massive struggle involved in naming men's violence against women at all in public, we understand memorials' shortcomings as giving us insight into oppressive systems of power, we honour the efforts that memorializers have made, and we ask how our analysis can support the expansion and ongoing reorientation of that effort.

On the Cultural Memory Project, now, we set our sights on learning to see and act from the perspective demanded by Andrea Smith and Incite! Women of Color Against Violence. Addressing organization against and analysis of violence against women, Beth Richie, a member of that collective, asks, "what if we centered our attention on those abused women most marginalized within the category of 'women of color'?"[8] If we apply this question to countermemorializing strategies, focus centres on the women of Downtown Eastside Vancouver. Aboriginal women are disproportionately represented in the population of the neighbourhood commonly known as "Canada's poorest postal code." Here, "women are six times more likely to be killed than in the city

overall—10 to 20 times more likely if they are between the ages of 20 and 45."[9] In 2004, Amnesty International reported that, across Canada, Indigenous women between the ages of twenty-five and forty-four are five times more likely than other women of the same age to die violently.

With the initiation of the Valentine's Day Women's Memorial March in 1991, Aboriginal women seize the "degenerate space" of Downtown Eastside and turn it into a space of respect, honour, dignity, and loving commemoration as they move through the neighbourhood, naming and remembering women murdered at the sites where their bodies have been found. While the language and actions of the march explicitly name the multiple violences of colonization and protest its oppressions, the memorial rituals also insist on the survival of Indigenous beliefs, priorities, and values, imprinting them on the memorial landscape each year. Gradually, the march organizers have moved to extend their memorial processes into plastic form, sustaining their principles of women-led community action and Aboriginal traditions. They are now fundraising for a "Lasting Memorial," for all women who have died violently in the Downtown Eastside, built by people from the community. They envision a monument "to honour these women's lives in a real way (a cob building offering massage therapy, reflexology, shiatsu massage, access to a trauma counsellor) surrounded by a living memorial garden filled with native medicinal healing plants."[10] Those of us who are not Aboriginal can learn a great deal from this memorial work, about what memorializing can do for women who live "in the dangerous intersections of gender and race,"[11] about how "remembering otherwise" can build solidarity across difference,[12] and about how to support that work.

The makeup of our group made it manifest from the outset that we were implicated in the work we were analyzing. Some of us had done—continue to do—the hard work of combating the violence, building the memorials, and trying to build solidarity from

a position that is always imperfect. More generally, it's the case that anyone trying to do activist analysis is deeply immersed in the same complicities, compromises, and limitations that structure memorializers' political work. Another story makes the point; it concerns the title of our book.

When the makers of Marker of Change in Vancouver went public with their planned dedication, they were met with a storm of protest, to the point of death threats. The memorializers were committed to naming who was murdering women. Their dedication read, in part,

> *In memory and grief for all women*
> *murdered by men.*
> *For women of all countries, all classes,*
> *all ages, all colours.*
> *We, their sisters and brothers,*
> *remember, and work for a better world.*

The phrase "murdered by men" was unacceptable to vocal members of the community, the press, and the Parks Board whose permission they needed. Eventually, through the intervention of a female Parks Board employee, they won permission by switching the sentences to prioritize men as part of the solution:

> *We, their sisters and brothers,*
> *remember, and work for a better world.*
> *In memory and grief for all women*
> *murdered by men.*
> *For women of all countries, all classes,*
> *all ages, all colours.*

As soon as we learned of this story, our group knew that the right title for our book—a declaration of solidarity—was *"murdered by*

men": *Feminist Memorials across Canada*. For years, we called it the "murdered by men" book. Just before we sent out proposals to publishers, for reasons I can't now remember, we changed the main title to *"murdered by men," Remembered by Women*. After many rejections and much discouragement, Sumach Press—the best feminist press in the world, I have to say—took the manuscript. They were fabulous in understanding our motives, our processes, our priorities, they worked with us in full feminist consultative and collaborative mode, but...they could not live with the title. What they told us—and we believed them—was that, as a small feminist press without leverage, they simply would be unable to persuade bookstores to take that title.

As we were mulling over this development, a huge supporter of our project, a human rights co-ordinator at another university, invited us to come and speak, then phoned to say—I can't use your title; it will cause an outcry detracting from everything we're trying to achieve. Almost simultaneously a massive headline appeared in the *Globe and Mail* above a Christie Blatchford column, reading "When Women Kill"—wording that apparently provoked no cries of protest. Eventually, after much heart-searching, late nights, and bottles of wine, the group followed the Vancouver women, and switched the wording around: "murdered by men, remembered by women" became "remembering women murdered by men." Ten years on from their battle—which they and we thought they had won—the climate had barely changed. For all the differences between building a monument and writing a book, for all the protections and privileges attached to academic research, entering into activist alliances means that researchers become subject to similar power relations, limitations, and compromises.

"Who benefits?" in the Academy

The "who benefits?" question has become, for me, the single most important measure of effective, engaged, and productive analysis the best touchstone for remembering what's at stake in the institution. In the daily ethical decisions of academic life, it is salutary to keep asking the question. Who benefits when academics practice affirmative action in our curricula but not in our hiring, or indeed when we regularly undervalue each others' achievements at evaluation time? The question can guide our scholarly and theoretical choices too. When Susan Stanford Friedman launched her call for a paradigm shift in feminist theory, to move toward a "new geographics of identity," her African-American colleague, Mary Helen Washington, kept her priorities straight (as Friedman reports) with precisely this question: "who benefits from these changes?"[13]

I practiced materialist scholarship long before I became involved in the Cultural Memory Group. It was exhilarating to move beyond learning about and analyzing the material conditions of historical cultural production to entering into an alliance with and to some extent inhabiting those conditions. It has given me a new appreciation for the degree of compromise inherent in such situated analysis and a new set of priorities.

I'm spending a lot of time now recovering forgotten, once-popular works in order to understand how minoritized groups attempted to participate in the literary marketplace at the moment of its consolidation into international mass culture. It would be easy to read these works dismissively—to make great play of their aesthetic and political shortcomings. But who would benefit from that critique?: the establishment that seized the marketplace in the first place and its contemporary descendants. Read with different questions and with skepticism about hegemonic standards, these works tell vivid stories about cultural systems of power, the politics of formula, and how popular print culture can speak back

to oppression. They demand a new literary vocabulary to name the ruthless changes that marginalized writers wrought on the formulas and genres that mainstream audiences thought we knew.

In short, then, the question "who benefits?" expresses the critical position of activist analysis, and it contains within itself an accountability to interests beyond the individual and the academic. For me, this question has permanently changed the ethical and theoretical co-ordinates not only of activist research but of academic and scholarly enquiry *tout court*.

AUTHOR'S NOTE

Heartfelt thanks to my collaborators in the Cultural Memory Project—Sly Castaldi, Ric Knowles, Belinda Leach, Jodie McConnell, and Lisa Schincariol; to the organizers of the "Not Drowning But Waving" conference in honour of Pat Clements; and to the participants who gave me so much food for thought. The work reported here could not have happened without a SSHRC Strategic Research Grant.

NOTES

1. Sherene Razack, "Race, Space, and Prostitution: The Making of the Bourgeois Subject," *Canadian Journal of Women and the Law* 10, no. 2 (1998): 341.
2. Teresa Posyniak, "The Building of 'Lest We Forget' A Monument Dedicated to Murdered Women," (Ts. University of Calgary Law Library), 2.
3. "Law School to Receive Memorial Sculpture in Tribute to Murdered Women." Fundraising flyer, University of Calgary Law School Library.
4. Miranda Ringma, *Concrete Change, Constructed by Many* (Edmonton: December 6th Planning Committee, 2000).
5. Sharon Rosenberg, "Neither Forgotten nor Fully Remembered: Tracing an Ambivalent Public Memory on the Tenth Anniversary of the Montréal Massacre," in *Killing Women: The Visual Culture of Gender and Violence*, ed. Annette Burfoot and Susan Lord (Waterloo, ON: Wilfrid Laurier University Press, 2006), 43.
6. See, for example, Amber Dean's prefatory remarks to the important special issue of *West Coast Line* co-edited with Anne Stone.
7. How energetically feminist collectives critique their own memorial practices is clear in the extended self-reflection and critique of the Women Won't Forget Collective in Toronto and the ongoing efforts of the Women's Monument Committee in Vancouver to support and forge solidarity with Indigenous women and women of colour in their community.

8. Andrea Smith, *Conquest: Sexual Violence and American Indian Genocide* (Cambridge, MA: South End Press, 2005), 153.

9. Caffyn Kelley, "Creating Memory, Contesting History," *Matriart: A Canadian Feminist Art Journal* 5, no. 3 (1995): 8.

10. "Lasting Memorial Garden, Vancouver Downtown Eastside." Fundraising flyer. Circulated December 2006.

11. Smith, *Conquest*, 1.

12. Roger I. Simon, *The Touch of the Past: Remembrance, Learning, and Ethics* (New York: Palgrave Macmillan, 2005), 9.

13. Susan Stanford Friedman, "'Beyond' Gynocriticism and Gynesis: The Geographics of Identity and the Future of Feminist Criticism," *Tulsa Studies in Women's Literature* 15, no. 1 (Spring 1996): 13, 30.

21

Inheriting What Lives On from Vancouver's Disappeared Women[1]

AMBER DEAN

We inherit not "what really happened" to the dead but what lives on from that happening, what is conjured from it, how past generations and events occupy the force fields of the present, how they claim us, and how they haunt, plague, and inspirit our imaginations and visions for the future.[2]

I'VE SPENT THE LAST SEVERAL YEARS researching the events surrounding the disappearances and violent deaths of women from Vancouver's Downtown Eastside, a neighbourhood where the unjust and uneven effects of urban poverty and neglect are deeply felt. For those who might be unfamiliar with the events that I describe, sixty-five women who lived or worked in Vancouver's Downtown Eastside are currently listed by police as "missing." I have chosen to refer to the women as "disappeared," though, rather than missing (or murdered). Disappearance as it was

351

practiced in Argentina (and many other places in the world), and as it is taken up by social analyst Avery Gordon, refers to a state-sponsored "death and improper burial, and denial by the authorities."[3] Although the abduction, torture, and murder of women from the Downtown Eastside is apparently not a state-*sponsored* system of disappearance, the use of the term *disappeared* to refer to the women from Vancouver's Downtown Eastside is appropriate, I believe, because the disappearances are nonetheless tacitly (and historically not-so-tacitly) state-*supported*. Not only were officials extremely slow to respond with any degree of seriousness or efficiency to the disappearance of women from the area, but the Downtown Eastside itself has long suffered the neglect of local, provincial, and federal governments. I am arguing that state *in*action effectively amounts to a tacit system of support for these disappearances—that state *in*action has fostered many of the conditions that contributed to those disappearances. This implies that responsibility for the disappearance of women from this neighbourhood lies not only with the individual perpetrator(s) but also with the broader social fabric of Canadian society (inextricable, of course, from its state formations). The term *disappeared women* seems to me to more clearly mark the social dimensions of the women's disappearances and murders; its resonance with *los desaparecidos* of Argentina is meant to convey that a broad array of actors and forces are implicated in these events.

According to a joint Vancouver Police and RCMP Missing Women Task Force, the first woman reported missing from Vancouver's Downtown Eastside was disappeared in the late 1970s, although there is good reason to believe that many women were vanished from the neighbourhood before then, too. Still, since at least the late 1970s, more and more women from this community have been designated missing by police, with a sharp increase in the number of women listed as last seen in the late 1990s and very early years of the twenty-first century. A much-belated police

investigation eventually resulted in a lone arrest: a man named Robert William Pickton was charged with murdering twenty-six of those sixty-five women on the Task Force's list of missing women, and with one additional charge for the murder of an as-yet-unidentified woman known only as "Jane Doe" (a charge that was set aside by a judge in March 2006). His trial, which received massive media attention, finally came to an end in July 2010 when all avenues for appeal were exhausted. Pickton was tried and convicted of second-degree murder in six of the women's deaths in 2007, while another trial, for the remaining twenty charges of murder, was at one time slated to begin in early 2008. The Crown opted not to proceed with the remaining twenty charges after Pickton's initial convictions were upheld, however, a decision that has brought much grief and anger to some of the family and friends of the women whose lives those twenty charges represent. These details remind me that this is a story that is changing rapidly—I have re-written this paragraph upwards of ten times since I first wrote this essay, signalling that these are events that bear heavily on the present, the losses and suffering they mark still very much ongoing.

The official details, of course, only tell part of the story. Downtown Eastside residents, sex workers, activists, service providers, and some friends and family members of the disappeared were already well aware of and concerned with the disappearances and violent deaths of women from this community long before any attention was paid to Pickton and his property in Port Coquitlam, a suburb of Vancouver, where he is alleged to have transported and then murdered twenty-six women. In fact, community activists have recently placed the total number of missing women at seventy-two, but even this number encompasses only those who are still unaccounted for and those Pickton is accused of murdering. If we include the "closed cases" of previously accounted for violent deaths (the deaths of women whose murders were

previously solved or who died of drug overdoses), then there are at least 296 women from this community who have been disappeared in the last thirty or so years.[4] The fact that there continues to be so much uncertainty about how many women are missing or dead suggests that there is something the matter with how these disappearances and deaths are framed and understood by many who lack a personal connection to the women involved. As many of the women's family members have remarked over the years, if the disappeared women were university students, suburban soccer moms, or women from one of Vancouver's wealthier neighbourhoods, surely we would have an accurate count of just how many are murdered or missing.

Still, all of this information, important or even essential to the story though it may be, is useful primarily for constructing a narrative of "what really happened" to the women who were disappeared. And if there is one thing I know for sure about these events, it's that knowing "what really happened" does little to help us struggle with the stunning complexity of "what lives on from that happening." This is the thought that kept running through my head in January 2007, as I sat in shocked silence in the overflow courtroom in New Westminster, BC, on the first day of Robert William Pickton's trial for the murders of Sereena Abotsway, Mona Wilson, Andrea Joesbury, Marnie Frey, Brenda Wolfe, and Georgina Papin. I thought I was prepared that day for what I was about to hear, as I was no stranger to the circumstances surrounding the trial. But as I listened to Crown council describe, in the cold, matter-of-fact language of legalese, "what really happened" to those six women, I knew that I was not prepared, not at all. And I wondered how knowing this information could make any difference to the injustices the women experienced, injustices that continue to shape the present.

That experience led me to reconsider both what I thought I "knew" about the disappeared women and how I was trying to

communicate, or write about, that knowledge. Shortly after (or possibly before—it's hard to keep the timeline straight, I find, for good reason, a point I'll return to shortly), I stumbled upon the first of many ghosts. I was able to recognize this spectre as a sign that a *haunting* was taking place thanks to my prior engagement with Gordon's important work in her book *Ghostly Matters*. For Gordon, "haunting describes how that which appears to be not there is often a seething presence, acting on and often meddling with taken-for-granted realities."[5] Gordon is interested in projects that track "that which makes its mark by being there and not there at the same time" and in forces that "cajol[e] us to reconsider... the very distinctions between there and not there, past and present."[6] Following hauntings is a very different way of doing academic research. As Gordon explains, such a practice could "be conceived as entering through a different door, the door of the uncanny, the door of the fragment, the door of the shocking parallel."[7] Hence haunting is in part about a different way of approaching knowledge, a different way of understanding what knowledge *is* and how we might recognize it. I'm going to try to explain the significance of this different approach to knowledge production by telling you about one of these ghost sightings, but first I need to explain a bit more about how I got there.

When I started my research, one of the first things I noticed was a significant shift in mainstream media representations of the women who were disappeared. Early descriptions emphasized that the women were "prostitutes" and "drug-addicts," while recent descriptions tend to focus more on the women's roles as mothers, sisters, and daughters. This shift has come about mainly through the determination of the women's family members, who refused to let the world know their loved ones only through such narrow descriptions of how they lived their lives at the time they were disappeared. But why did we need to know that the women were also mothers, sisters, and daughters in order to care about their fate?

Does this imply that, generally speaking, many of us don't consider people labelled "prostitutes" and "drug-addicts" to be worthy of our concern? What might this shift then tell us about the assumptions that underpin our social world and our everyday interactions with others?

In an effort to counter the many ways that missing women were constituted as "ungrievable" losses after they were disappeared, family members, friends, and activists made significant efforts to "humanize" the women to those who remained oblivious or indifferent to the violence done to them.[8] This strikes me as a politically necessary practice: in order to humanize the women and counter their "ungrievability," they are universalized via their attachment to normative gendered, familial roles. There is also an important claim to kinship being made here: families are working to demonstrate that women who are often stereotyped as completely unattached to conventional notions of family *do* in fact possess these familiar, human attachments. In light of the widespread constitution of the women as ungrievable losses, attempts to recuperate their humanity in these ways are perhaps unavoidable or even a necessary step in generating broader public concern for the women in the present.

Yet I remain concerned that a professed desire to "humanize" also reinforces, even as it attempts to respond to, a presupposition that the subject of this humanization is actually *not*-quite-human, since effort is required to make her seem so. Through this reclaiming of the women as mothers, daughters, and sisters, I worry that other aspects of their lives—their involvement in sex work, their addictions, their othering via racialization and association with the Downtown Eastside—are re-stigmatized by (some) mourners' understandable determination to distance our memories of the women from these facets of their lives. In other words, might this reclaiming strategy risk re-casting these other aspects of the women's lives as the constitutive outside to some narrow notion of

normative humanness? The message behind this strategy seems to imply that we should care about the fate of these women and recognize their grievability now because they were someone's mother, sister, or daughter, which reproduces even as it attempts to challenge the belief that being someone involved in sex work, someone with a drug addiction, or someone from the Downtown Eastside is not enough to warrant such caring or such recognition. I worry, then, that this strategy may unintentionally reproduce a "grievable daughters/ungrievable prostitutes" dichotomy, thereby reproducing predominant notions of normative humanness rather than challenging them.

I was reminded recently that this sort of rhetoric, the sort that implies that women are worthy of concern primarily or exclusively because of their status as normative feminine subjects, is an age-old feminist problem.[9] Attaching the women from the Downtown Eastside to traditional feminine roles in particular strikes me as operating to generate an understanding and acceptance of the women's status as victims, to encourage their thinkability, believability, and grievability as innocent victims, in order to counter the widespread tendency to see sex workers, in particular, as women who "ask for it," or "get what's coming to them." The effort to humanize the women by reclaiming them as mothers, sisters, and daughters is obviously ensnared by the ongoing cultural currency of madonna/whore, "good" girl/"bad" girl dichotomies, long an area of intense concern and scrutiny for feminists (see, in particular, Laurie Bell's classic text). Due to the necessity of counteracting the disappeared women's associations with the whore/"bad" girl half of this dichotomy, mourners understandably found it necessary to recuperate the women by broadly and publicly associating them with the madonna/"good" girl side. While I suspect this remembrance strategy is a necessary one, given the persuasive hold these dichotomies continue to claim on the imaginations of many, I nonetheless think it is important to consider how efforts to

reclaim the women as madonna/"good" girl types reproduces the dichotomy instead of rupturing it.

The mainstream media has also paid little attention to the fact that the women who were disappeared from the Downtown Eastside were disproportionately Indigenous. This fact has caused me to wonder how European colonization and resettlement of the land now known as Canada (and particularly of western Canada) is related to this present-day violence. Of course, it's often said that the past is, well, *past*—that what happened in the past is over, finished, done, relevant to the present only in the form of a history lesson. According to that logic, colonization is a completed project. It is something we might lament, or decry, but it's seldom thought to be ongoing in the present. And yet Vancouver's Downtown Eastside is often talked about today using the language and metaphors of the Frontier; it is repeatedly described as a kind of "Wild West" zone. These descriptions invite us to imagine the Downtown Eastside as a bordered space that is awaiting conquest and resettlement. This happens not only through media representations, but also through plans to "clean up" and "bring order" to the neighbourhood, and through efforts to gentrify it (an effect of the 2010 Olympics). So, I wonder: what is the relationship between these descriptions that invite a new "conquest" of the land and the terrible violence that has been inflicted disproportionately on Indigenous women from this neighbourhood?

Feminist antiracist scholar Sherene H. Razack has thought extensively about what this relationship might involve. She argues that the murder of Pamela George, an Indigenous woman who was involved in street-level sex work in an inner-city neighbourhood in Regina, Saskatchewan (another western Canadian city), is overly determined by how Canada's colonial history constitutes and constrains the identities of George and her white, male murderers and simultaneously legitimizes assumptions about contemporary inner-city spaces as "degenerate." "The city belongs to the

settlers," she insists, "and the sullying of civilized society through the presence of the racial Other in white space gives rise to a careful management of boundaries within urban space."[10] Razack argues that George's murderers saw themselves to be crossing a border into a "degenerate," frontier-like space when they visited "the Stroll" in Regina's inner city on the night of George's murder. "What is being imagined or projected onto specific spaces," she asks, "and...bodies? Further, what is being *enacted* on those spaces and on those bodies? [emphasis in the original]."[11] She suggests that the violence George experienced was "fully colonial—a making of the white, masculine self as dominant through practices of violence directed at a colonized woman."[12] I find Razack's delineation of how colonialist legacies naturalize violence against certain bodies occupying certain spaces (in this instance, the body of an Indigenous woman occupying an inner-city neighbourhood) persuasive. Her argument becomes particularly instructive when considered alongside the repetitive use of frontier mythology to describe inner-city neighbourhoods like Vancouver's Downtown Eastside.[13]

Razack traces how, during European (re)settlement of the lands now known as Canada, Indigenous bodies were largely removed from urban spaces, displaced to reserves on the outskirts of cities or in rural settings. Building on comments by the Native Council of Canada, she notes that this historical rearrangement of space continues to sustain a "perception that being Aboriginal and being urban are mutually exclusive."[14] The return of significant numbers of Indigenous people to urban centres since the 1960s has created considerable anxieties that result in efforts to contain Indigenous urbanites within particular spaces in the city and/or to (re)expel them from urban centres. Razack notes that George's murderers drove her to the outskirts of the city, where they assaulted and murdered her and abandoned her body, and she locates this violent act on a continuum of similar contemporary efforts to violently

expel Indigenous bodies from Canadian cities, such as the alarmingly common police practice of driving Indigenous people out of the city and abandoning them there (see, for example, Reber and Renaud). When examined through Razack's analytical framework, it is perhaps shockingly unsurprising, then, that the bodies of women, women who were disproportionately Indigenous, have turned up on the outskirts of several Canadian cities: Edmonton, Calgary, Winnipeg, Saskatoon, Prince George, and of course on a large rural property in a suburb of Vancouver. These discoveries remind us that the past is far from settled, that it continues in present arrangements of the social, and that colonization is a far-from-finished project, one that must be continuously re-enacted in an effort to secure its permanence.

I suspect that the use of frontier mythology to describe contemporary inner-city neighbourhoods (such as the Downtown Eastside) alerts us to a haunting. The resurfacing of frontier mythology in contemporary efforts to remake inner-city neighbourhoods seems to me to be an indication that these efforts are *haunted* by the city's colonial past, a past with claims on the present that are frequently disavowed and are yet to be reckoned with. Frontier mythology slips into these efforts and makes this colonial past "there and not there at the same time":[15] "there" because the mythology evokes this past, but "not there" because those who rely on the mythology to make their arguments in favour of resettlement often in the same breath disavow the past's significance to the present. Instead, they rely on a taken-for-granted assumption that the past is past, is "settled," so to speak, in order to legitimize their resettlement plans. But the mythology seeps in, unwittingly making the past present while at the same time disavowing its significance, its *claims* on the present.

Hauntings, then, are indicative of a disruption in temporality: when taken seriously they have the potential to bring the past's claims on the present to our attention. In *Politics Out of History*,

Wendy Brown begins her final essay in the collection, on "Futures," with a citation from Walter Benjamin's "Theses on the Philosophy of History," in which he describes a vision of the angel of history. Brown is curious about Benjamin's use of a spectre here. "Deities, angels, specters, and ghosts," she writes, "what are we to make of these creatures rising from the pens of radical thinkers in the twentieth century as they attempt to grasp our relation to the past and future...?"[16] And later she asks, "When we cease to figure history in terms of laws, drives, development, or logic, are ghosts what remain?"[17] Like Brown, I am curious about the possibilities that might arise when ghosts mess around with notions of temporality and history: what might hauntings be able to tell us about the past's claims on the present, the past's ongoing *presence* in the present state of things in Downtown Eastside Vancouver?

What might it mean to recognize and reckon with the ghostly contours of Downtown Eastside spaces, the haunting nature of the frontier mythology frequently evoked to describe this space today? Brown acknowledges that "even when avowed, [a haunting] does not make perfectly clear what its meanings and effects are."[18] The outcome of the haunting, any path it might lead us on toward greater justice for Downtown Eastside residents, is not neatly laid out for us. Anything it might signal is necessarily partial, contestable, situational. So what good is it to recognize hauntings, one might ask, when to do so does not guarantee a different approach or a different outcome? Gordon is similarly cautious about delineating the potential effects of haunting, even though they form the central premise of her book. Analyzing hauntings will not result in "a more tidy world," she insists, but possibly, hopefully, in one "that might be less damaging."[19] Less damage, more justice: despite their lack of specificity, these seem reason enough to take hauntings seriously and follow where they lead. "[The ghost] has designs on us such that we must reckon with it graciously," Gordon elaborates, "attempting to offer it a hospitable memory *out of a concern*

for justice. Out of a concern for justice would be the only reason one would bother [emphasis Gordon's]."[20]

I would suggest that the value of *this* haunting lies in its disruption of a notion of history as something fixed, finished, and past. When we recognize the past in the present, it seems to me that it becomes impossible to claim this past as "settled" in any way. Such a realization draws us into a new way of relating to one another, of knowing ourselves to be related to one another. As Gordon helpfully explains, "following the ghosts is about making a contact that changes you and refashions the social relations in which you are located."[21] If we see "settlement" of the land now known as Vancouver not as something that happened between Europeans and First Nations in the distant past, but as an ongoing process evident in the way our spaces and identities are constituted today, then a different understanding of our relation to each other seems necessary. By tracing Downtown Eastside hauntings, I am interested in provoking reconsiderations of the past's claims on the present and, to borrow again from Brown, in inspiring "strategies for conceiving our relation to past and future that coin responsibility and possibilities for action out of indeterminacy."[22]

What might it mean to inherit "what lives on" from the violent deaths of so many women, then, as Brown suggests in the epigraph to this essay? If one were to read this passage from Brown as suggesting we must try to make some kind of meaning from their loss, one might find this a callous or even obscene suggestion. But I don't think that is what Brown had in mind. Instead, I think she is encouraging us to consider how the injustices and vulnerabilities the women experienced (in life as well as in death) "live on" in the present, and how we are all implicated in this arrangement. What is "conjured" now from those deaths, to go back to Brown again; how do those deaths "claim us," and how might they "haunt, plague, and inspirit our imaginations and visions for the future"?[23]

A walk through the Downtown Eastside today is likely to result in an abundance of ghost-sightings, if one is looking for them (and knows what to look for). There is a ghost on nearly every corner; in fact, on some corners they jostle for room. Sometimes ghosts are a "seething presence," as Gordon describes, but at other times I would argue that they are most noticeable through absence: the absence of their human forms. In fact, as Gordon reminds us, sometimes these two forms co-exist, sometimes "that which appears absent can indeed be a seething presence."[24] Absent presences mark the ghostly spirits that are visited and paid homage to each year during an annual Valentine's Day march in the Downtown Eastside, when marchers pause and perform smudge ceremonies at corners where women were last seen before they were disappeared, vanished, made absent from the spaces where they used to live and work. And ghosts as absent presences have also been captured in recent documentaries about the Downtown Eastside.

Recently I was watching one such documentary when I was suddenly struck by a face I thought I recognized. I puzzled over where I knew this face from, backed up the DVD, and suddenly felt completely stunned and disoriented as I realized why I recognized the woman: she is Sereena Abotsway, and I recognized her from her photograph on the Missing Women's Task Force poster and others I have seen of her on websites and in the news. Sereena Abotsway is one of the women who was disappeared from the Downtown Eastside. Pickton has been convicted of her murder. A year ago I sat in a courtroom and listened to a Crown lawyer describe in horrible detail what happened to Abotsway's body. In life, Abotsway was an activist in the Downtown Eastside. She participated in many protests as well as in the Valentine's Day march, that annual memorial event where she once remembered murdered and missing women and is now one of the women whom marchers remember and

mourn. Now, marchers pause to remember Abotsway in front of the Portland Hotel on Hastings Street, where she was last seen.[25]

It is of course not surprising that a documentary made in this neighbourhood at this time would capture the images of some of the women who have since been disappeared. The footage I was watching was filmed in 2000, and Abotsway was disappeared in 2001. Yet Abotsway's presence in the film, because it is unexpected, is surprising, all the more so because it is a moving image of a woman whom I have only ever seen in still photographs. In the film Abotsway is alive, and in the few seconds in which she appears she pounds a wooden cross into the ground, her hammer hitting the top of the cross four times before the camera pans away to other activists doing the same thing. Here, Abotsway is protesting the social conditions that make herself and others from the Downtown Eastside more vulnerable to unjust, untimely death. Her presence here, still alive then but now, at the moment of my viewing, among the dead whose deaths she was at that moment protesting and mourning, indicates a double haunting: Abotsway, haunted by the deaths of friends and neighbours, possibly also enemies, or lovers, or acquaintances, or strangers, has herself come to haunt, her presence (now made absent from the Downtown Eastside) a warning to pay attention to such hauntings, to how they matter now. Abotsway's haunting presence in this film provokes a sense of urgency about the ways that injustice and vulnerability are unevenly distributed and lived.

When I visited Vancouver recently I sat for a long time across the street from the Portland Hotel, where Abotsway was last seen. Although I have walked, biked, taken the bus, or driven past this spot literally thousands of times in my life, and have at times participated in neighbourhood rallies, forums, festivals, and marches, I have seldom stopped and just sat here, on Hastings Street in the heart of the Downtown Eastside. It is not a particularly comfortable spot for me to sit; everything from my MEC rain jacket to my

designer glasses to the hue of my skin marks me as a likely "outsider" in this neighbourhood, even though this demarcation of "inside" and "outside" is shifting, fluid, more porous than usually represented. But on this day I sat for a while and contemplated Abotsway's absent presence from where she was disappeared. For me, what lives on from her death is a building awareness that everything about who I believe myself to be and how I live my life is indelibly bound up in the injustices that are everywhere evident in this neighbourhood. This does not mean that I can, or want to, collapse the vast differences between myself and Abotsway, or myself and many of the people who today call this neighbourhood home. To do so would be to erase those injustices that left Abotsway so much more vulnerable to the violence she experienced and that found her living with so much more exposure to precarity in her daily life. Still, unravelling the complicated binding of our existence is what I inherit from Abotsway and other women who died similarly. An attention to the haunting presences of Abotsway and others like her engages me in a relation of inheritance through which I can begin to imagine a present (and future) that might be otherwise; one that is attentive and responsive to the ongoing symbolic and material injustices of Vancouver's colonialist present-pasts, in the interests of a (different) future.

This awareness demands an attention not only to how such injustices remain evident, but also to what can and is being done to confront them. For Abotsway also "lives on" through the political activism that is documented by the film in which she appeared, activism that of course carries on today in the Downtown Eastside in forms too many and too varied to give a full account of: anti-poverty activism; anti-Olympics activism by the Anti-Poverty Committee, which involved evicting Olympic and government officials from their offices in the lead-up to the 2010 Olympic Games; activism by Indigenous groups and their allies who forcefully proclaimed "No Olympics on Stolen Native Land"; activism by the

Carnegie Community Action Project and the Save Low Income Housing Coalition that aims to stem the tide of homelessness brought about by gentrification; activism by the Vancouver Area Network of Drug Users and their allies that founded and is striving to keep Insite, the safe injection site; activism by the coalitional forces that maintained the Woodward's squat in 2002 or that plan annual memorials for the disappeared women; activism that is taking aim at the laws that so greatly increase the vulnerability of women doing sex work, and on and on I could go.

Most of this activism is performed by residents of the Downtown Eastside, residents who grow tired, as Abotsway did, of watching their friends and loved ones die or suffer terrible injustices. Taking our cue from such activism, advocating that it lead and structure any form of "change" that's imagined or desired in the Downtown Eastside, would be one way to offer Abotsway "a hospitable memory *out of a concern for justice* [emphasis Gordon's]."[26] If justice is to make itself known in the Downtown Eastside, it will be through contending with the work and claims of those many local activists. This activism, work that Abotsway participated in, "lives on" just as much as the injustices that shaped and constrained Abotsway's life, and, as Brown suggests, it can and should "inspirit our imaginations and visions for the future,"[27] not just for those who live in the Downtown Eastside, but for all of us who inherit "what lives on" from Vancouver's disappeared women.

NOTES

1. Excerpts from this essay have appeared, in different form, in Dean 2009 and 2010.
2. Wendy Brown, *Politics Out of History* (Princeton, NJ: Princeton University Press, 2001), 150.
3. Avery F. Gordon, *Ghostly Matters: Haunting and the Sociological Imagination* (Minneapolis: University of Minnesota Press, 1997), 72.
4. This tally is taken from the list of names provided in the program of the 2006 Vancouver Valentine's Day Memorial March for women from the Downtown Eastside, which lists 224 women's names *in addition* to the 72 women either

presumed murdered by Pickton or still unaccounted for. Several of the names in the list of 224 are recognizable as those of other women from the area who were murdered and whose murders have been solved; some are presumably those of women who died from drug overdoses. While the program itself states only "in loving memory of the following women," a banner carried during the march read, "February 14th commemorates our sisters who have died as a result of violence or substance abuse in the Downtown Eastside and throughout Vancouver." The phrase "and throughout Vancouver" is included, I believe, to signal that many women from the neighbourhood have been killed in *other* areas of the city, such as the women Pickton is accused of killing. Since the same unjust material and discursive conditions that increase women's vulnerability to violence also contribute to substance abuse and drug overdose, I would agree with the organizing committee that the actual number of deaths is significantly higher than official records suggest. The inclusion of women who died because of substance abuse complicates notions of "choice" in a compelling way—it suggests that larger social forces are at work in all of these deaths and that they are, as a result, all worthy of our attention, whether or not the death was, within conventional frameworks, "self-inflicted" or inflicted by another.

5. Gordon, 8.
6. Gordon, 6.
7. Gordon, 6.
8. Social theorist Judith Butler develops the notion of "grievability" in her book *Precarious Life: The Powers of Mourning and Violence*, in which she explores "how certain forms of grief become nationally recognized and amplified, whereas other losses become unthinkable and ungrievable" (xiv).
9. Thanks to Heather Zwicker for reminding me of this point.
10. Sherene H. Razack, "Gendered Racial Violence and Spatialized Justice: The Murder of Pamela George," *Canadian Journal of Law and Society* 15, no. 2 (2000): 97
11. Razack, 96
12. Razack.
13. For a host of examples of such descriptions of the Downtown Eastside see Blomley, particularly 81–92. Linking the language used to describe the Downtown Eastside by developers today to the frontier mythology that transformed Indigenous lands into a supposedly vast, empty territory, Blomley argues that "the Downtown Eastside, for some developers, appears to be *terra nullius*, devoid of people who could have any claim to that space" (90). See also England's critique of the popular NFB documentary *Through a Blue Lens* for its reliance on frontier mythology to frame the encounter between police and local residents that the film documents. I examine these and other examples of the use of frontier mythology to describe the contemporary Downtown Eastside in my dissertation, *Hauntings: Representations of Vancouver's Disappeared Women* (University of Alberta, 2009). For an example of how

frontier mythology is deployed to rationalize gentrification and displacement in an inner-city neighbourhood in Edmonton, Alberta (another city in the Canadian West), see Granzow and Dean.

14. Native Council of Canada, qtd. in Razack "Gendered Racial Violence and Spatialized Justice," 102.
15. Gordon, 6.
16. Brown, 142.
17. Brown, 145.
18. Brown, 153.
19. Gordon, 19.
20. Derrida in Gordon, 64.
21. Derrida in Gordon, 22.
22. Brown, 155.
23. Brown, 150.
24. Gordon, 17.
25. See coverage from the *Vancouver Sun*, available online at http://www.flickr.com/photos/joshuatree/391120772/, including a photograph of Abotsway participating in an earlier Valentine's Day march. Accessed September 26, 2007.
26. Derrida in Gordon, 64.
27. Brown, 150.

On Denunciations and Disavowals
Feminism, Trans Inclusion,
and *Nixon v. Vancouver Rape Relief*

LISE GOTELL

THE STORY OF *Kimberly Nixon v. Vancouver Rape Relief and Women's Shelter* has no happy endings. I begin this chapter by imagining a happier ending:

> 1995. *Kimberly Nixon was a woman born a man, a woman who had undertaken the difficult processes of transitioning and of sex reassignment surgery. She had changed her legal identity from man to woman. She had experienced male violence in the context of an intimate relationship. Having just completed counselling, she was anxious to become involved in feminist antiviolence politics. Nixon felt politicized. She decided to apply to be a volunteer counsellor at Vancouver Rape Relief (VRR), a radical feminist-run rape crisis centre, the oldest centre in Canada. After passing through prescreening, she attended a volunteer-training session. But Nixon was taken aside at the first session and asked*

if she was transsexual and told that she could not become a volunteer because of VRR's women-only policies. At first, she felt deeply offended and hurt. She threatened to go to the media and contemplated launching a human rights complaint. But because she was a strong woman and because she felt deeply committed to feminist activism, she asked the collective to reconsider the question of transwomen's inclusion. For its part, collective members felt profoundly challenged, initially seeing Nixon's request as an attack on women-only organizing against male violence. But collective members had also learned a great deal from the struggles around racism that had erupted within feminist politics in the 1980s. The collective decided to embark on a process of self-education around transphobia, just as they had engaged in antiracist education in the 1980s. Out of this process, the collective decided to open volunteer training to self-identified women who, like Nixon, were committed to radical feminist politics. While there would be few other transwomen who would embrace these politics and apply to become volunteers, the evolution of VRR would later be viewed as a significant transition within radical feminist praxis.

I wish that *Nixon* had had a happy ending. The real story of this dispute involves a twelve-year saga, marked by Nixon's successful human rights complaint (*Kimberly Nixon v. Vancouver Rape Relief and Women's Shelter* [2002]), VRR's successful application to have the tribunal decision overturned on judicial review (*Vancouver Rape Relief Society v. Nixon* [2003]) and Nixon's further appeal, culminating, in 2005, in a British Columbia Court of Appeal ruling (*Vancouver Rape Relief Society v. Nixon* [2005]). This decision is distinguished as being the first Canadian appellate-level ruling on transsexual discrimination. The Court of Appeal found that VRR had discriminated against Nixon, but that it was protected by s. 41 of the British Columbia Human Rights Code exempting non-profit groups that have as their objective the promotion of the interests

of an identifiable group.[1] In February 2007, the Supreme Court of Canada declined to hear Nixon's appeal, closing the legal dispute that has left feminists like me feeling incredibly conflicted (*Kimberly Nixon v. Vancouver Rape Relief Society—and—British Columbia Human Rights Tribunal* [2007]).

Nixon stands at the intersection of the kinds of scholarly concerns that have preoccupied my own work (equality rights jurisprudence/sexual violence/queer theory and law). This conflict has reverberated through my own scholarly and political communities. Even so, until now, I have avoided putting pen to paper to sort out a position on this deeply fraught question: the question of whether VRR (a radical feminist collective with a thirty-five-year record of political activism, rape crisis and shelter work) is entitled to exclude a transwoman from volunteer crisis work and membership in its collective. In this chapter, I take this plunge. I want to explain some of the reasons for my own discomfort, a discomfort that has led me to defend VRR against a veritable tide of feminist and queer denunciation. I engage in the deeply conflictual terrain of *Nixon*—not to mark a position, but instead to contextualize.

As I argue in this chapter, critics of VRR have avoided engaging in a careful interrogation of Nixon's claim. This claim, in fact, bears a striking resemblance to the position of VRR, locating the basis for belonging in women-only space in bodies and experience. Moreover, when filtered through the discourse of law, Nixon's demand for inclusion relies on an un-modified formal equality argument that makes irrelevant questions of power, disadvantage, and context. As I suggest, here, context is crucially important to this conflict in two central ways. First, it matters that Nixon advances her claim for trans inclusion against a feminist organization struggling politically against the continuing realities of male violence against women. Second, it matters that the contemporary political context for feminist antiviolence activism is deeply hostile. I write from a position that is simultaneously sympathetic

to the struggle for trans inclusion and also committed to the continued necessity of feminist antiviolence politics. I want to resist the imperative to take sides and, instead, aim to draw attention to the difficult implications of both positions in this dispute. At the same time, and in response to the overwhelming support for Nixon against VRR, I encourage critical reflection on the implications of Nixon's claim. I am worried that sweeping attacks on the politics and work of a feminist-run rape crisis centre may exacerbate broader cultural and political trends that deny the gendered nature of sexual violence and the importance of feminist antiviolence work.

Vancouver Rape Relief: Experience, Truth, and Women-Only Space

It strikes me that the sharp conflict over Nixon, the demand to take sides, is reminiscent of the pornography debates that gripped Canadian feminism in the 1990s (Cossman et al. 1997). In the late 1990s, some of my own work was located within these debates (Gotell 1996; Cossman et al. 1997). In this work, I was sharply critical of feminist litigation organization Women's Legal Education and Action Fund's (LEAF) anti-pornography, pro-censorship intervention in the *Butler* case. In this case, LEAF argued against a freedom of expression *Charter* challenge to Canadian obscenity law on the basis "prohibiting pornography promotes [women's] equality."[2] Effacing the deep conflicts with Canadian feminism on pornography and censorship, LEAF's position exemplified a form of feminist foundationalism in which the assertion of feminist Truth operated to trump the necessary actualities of feminist politics. Drawing on Wendy Brown (1995, 1991), I argued passionately that the epistemic practice of deriving coherent and singular positions from an assertion of women's experience of subordination was flawed. This practice obscures the constructed character of all

experience, and it operates to silence normative conflicts within feminism. My position on feminist litigation, developed over the 1990s in a series of articles on pornography and on equality rights, has been described as a postmodern challenge to feminist litigation and an antifoundational critique of law (Gotell 1995, 1996, 1997, 2001; Conaghan 2004).

To read *Nixon* against these earlier scholarly commitments suggests a stance that is defiantly pro-Nixon. If LEAF's anti-porn position can be condemned as antidemocratic for its easy equation of experience and feminist Truth, so too must VRR's. VRR adheres to a firmly radical feminist analysis of male violence. While its legal arguments in *Nixon* are preoccupied with demonstrating the necessity of women-only peer counselling for rape victims, it is crucial to recognize the epistemic and political foundation of this defence of women-only space. In VRR's view, women-only organizing facilitates consciousness-raising; it provides both an essential epistemic space for revealing the Truth of women's subordination through male violence and a necessary site for resistance. As long-time VRR collective–member Lee Lakemen testified in the tribunal hearing in this case,

> the sum total of [women's] daily experience is the very meat of consciousness raising…we're trying to create a space in the world where we can speak to each other honestly…I don't think it's a very bizarre notion that the oppressed have to withdraw sometimes to a safe space to think even. And I believe that process has paid off. We've created words, notions, strategies, tactics that have made a difference in this—in this period of history. I believe that we have created a huge political force that is beneficial to women.[3]

In its legal arguments in *Nixon*, VRR consistently emphasized the political and epistemological nature of its claim for women-only space. The critical importance of rape crisis work, VRR

insisted, lies not solely in the therapeutic value of women in crisis being able to speak with other women. "Consciousness-raising," VRR contended, "and the concept of acting on common experience is at the centre of the women's movement, and reflects a different philosophy of knowledge."[4]

As Carol Smart (1989) has argued, consciousness-raising is part of a struggle over meaning. It allows for de-individualization of personal experience and, as such, this method has played a crucial role in making visible the systemic nature of sexual violence. Yet when the knowledge produced through consciousness-raising is elevated to the status of "objective" and pure knowledge, as Smart insists, it becomes a mode of disqualifying those who do not conform.[5] Consciousness-raising, as deployed by radical feminists, rests on the insistence on political spaces free from male influence, enabling "discovery" of the collective nature of women's experience of subordination. Male infiltration of women-only space threatens contamination. Drawing heavily on radical feminist anti-trans texts, such as Janice Raymond's *The Transsexual Empire* (1980), VRR constructed trans inclusion as a form of male infiltration and therefore as an attack on the very foundations of feminist knowledge and organizing. According to Raymond, MTF (male to female) transsexuality is a medically-constructed identity that reinforces a misogynist femininity, literally constituting an invasion and an appropriation of women's bodies. MTFs, according to this logic, carry, and cannot leave behind the experience of living in the world as men.

As VRR argued in its testimony at the human rights tribunal hearing and in its legal arguments, the space of consciousness-raising, peer-counselling, and feminist antirape work must be confined to those who have lived the experience of "growing into womanhood" since birth.[6] While recognizing the social construction of gender, VRR insisted that women-only space must be

exclusively inhabited by women-born-women. Here, a form of Truth located in women's experience operates as a force of exclusion. The claim that the experience of women-born-women constitutes an uncontaminated vantage point for revealing the Truth of women's oppression and a necessary basis for political organizing creates a strict line demarcating inside and outside on the basis of an essentialized and foundational claim.

To be sure, these claims have led to widespread feminist and queer denunciations of VRR. VRR has been labelled transphobic and its spokeswomen vilified. According to Patricia Elliot (2004), VRR's response to Nixon's demand for inclusion is nothing less than "hostile," "based partly on ignorance, partly on fear, and partly on an intractable feminist identity politic."[7] Lori Chambers (2007) characterizes VRR's position as a "retreat into essentialist language and a quasi-biological understanding of sex/gender" that is nothing less than "dangerous to the over-arching goals of feminism."[8] Labelling VRR's position as essentialist, biologist, and by extension exclusionary, allows for Nixon's human rights complaint to be analogized with the struggles of women of colour, immigrant women, and Aboriginal women who, in the 1980s and 1990s, issued a powerful challenge to feminist organizing constituted on the basis of a narrow and universalized representation of women's experience.[9] Nixon's challenge has been embraced by those who advance poststructural and third-wave feminist positions committed to inclusion and the deconstruction of rigid sex and gender categories (Chambers 2007; Elliot 2004; Prasad 2005). According to Ajnesh Prasad, for example, Nixon literally embodies a deconstructive politics. While for VRR Nixon's gendered incoherence is represented as "contamination," for Prasad this same incoherence is, by definition, "revolutionary." As Prasad explains, "by attesting that her gender identity did not reflect her genitalia, Nixon refutes biological determinism and provokes disorder...Accordingly, Nixon

becomes part of the feminist revolution, resisting masculinity and patriarchy, while simultaneously embodying a 'subject of differentiation—of sexual contradictions.'"[10]

Within the narrative constructed through these analyses, Nixon becomes a resistant subject standing defiantly against an identity-bound version of feminism, decidedly unsexy, passé, and inherently exclusionary. In fact, the feminist conflicts engendered by *Nixon* have been presented as exemplifying the division between a doctrinaire second wave and a defiant third wave promoting inclusion and radical gender politics (Chambers 2007; Elliot 2004). What are the implications of this repetitive denunciation of VRR? What is missing from analyses that subject VRR to relentless critical examination, while leaving the implications of Nixon's challenge uninterrogated? .

Interrogating Nixon's Position: Experience and Truth

In his important analysis of transgender identity, feminism, and the law, Graham Mayeda (2005) calls for the development of an ethical feminist stance built upon the cornerstones of responsibility and self-reflection. As he contends, because of our inability to fully assimilate the experience of the other, we are called upon to "[inject] the perspective of the other into social dialogue," a stance that necessarily involves "self-critique."[11] I am taken by Mayeda's argument for the deconstruction of legally-enforced gender binaries and by his elegant critical analysis of how gender-essentialist positions reinforce the erasure of transgendered experiences and subjectivities. At the same time, Mayeda's call for an ethical stance founded on accepting "responsibility for the implications of our actions" is applied unevenly in his analysis of the *Nixon* case. VRR's exclusionary politics and its adherence to the gender binary are sites of detailed critical scrutiny in most commentaries on this

conflict (Chambers 2007; Elliot 2004; Mayeda 2005). Nixon's human rights claim, by contrast, almost completely escapes critical interrogation. To interrogate Nixon, it seems, is to dare to question the "victim." Nixon, the marginalized and excluded trans subject, becomes at once an abstraction and a symbol. Her claim for inclusion in women-only space comes to symbolize a radical gender politics pushing against a rigid, old-style essentialist feminism.

I want to suggest that Nixon's claim cannot bear this weight. Far from expressing an anti-essentialist and deconstructive politics, Nixon's claim appears rooted in many of the same assumptions about identity, truth, and politics as VRR's defence of women-born-women-only space. As feminists such as Katrina Roen (2001) and Cressida Heyes (2003) have argued, we must be wary of the celebration of trans identity as emblematic of the subversive potential of feminist postmodern and queer theory. This form of celebration can misrepresent the lived experience and desires of many trans people who embrace practices of surgery and passing as enabling affirmation of their gender identity within a rigid gender binary. Such misrepresentation slides easily into denunciation of transsexual identification (characterized by the desire to live as a woman or a man) as not radical enough.[12]

While I do not want to reinforce a political hierarchy in which "passing" or transsexual identification is seen as less trendy, less radical, and less politically worthy than the transgendered project of crossing and disrupting the gender divide, it is, at the same time, important to locate Nixon's position. Nixon's claim is based upon the desire to pass, to be seen and treated as a woman. Nixon's testimony was formed around the refrain *I am a woman*. Nixon's claim is *not* that the assertion of the identity "woman" inevitably reproduces the discipline of a gender binary that must be deconstructed, *not* that experience must be disrupted as a basis for feminist politics, *not* that gendered instability must be embraced as both politically and epistemically necessary. Instead, the injury

that Nixon described so powerfully through her human rights complaint is the indignity, harm, and discrimination of not being treated as what she had become, a woman—"I keep telling you that I am a woman, that I have always been a woman, but you don't—people don't hear that" (Transcripts, December 12, 2000, 105). The story that is painfully detailed in Nixon's testimony and cross-examination before the tribunal is the narrative of a trans-sexual woman (Transcripts, December 12–13, 2000). She recounts a life in which, from childhood, she felt deeply uncomfortable with her male body. She describes her difficult struggle to become a woman—a process that involved being diagnosed with gender dysphoria, beginning to live as a woman, obtaining sex reassignment surgery, changing her sex on her birth certificate, living through an abusive relationship with a man, and confronting economic uncertainty as she began to live as a woman (including experiencing gender discrimination when seeking employment as a pilot, a profession she had successfully practiced as a man). The end of this struggle is the accomplishment of being a woman, of being understood, read, and treated as a woman—an accomplishment denied by exclusion from a radical feminist collective. In Nixon's own words, this was a deeply injurious experience of "not being believed," of "having my identity stripped away from me as female," one that for her reiterated experiences of intimate abuse and violence in which she had also felt her "identity being chipped away" (Transcripts, December 11, 2000, 31). She described feeling hurt and angry because the women running the VRR training session "saw her as a man," effectively discounting her efforts to be seen and treated as a woman (Transcripts, December 12, 2000, 98).

Throughout this long struggle, Nixon professed adherence to radical feminist analysis and to the importance of women-only space. At the tribunal hearing, she spoke of the "necessity of women-only space" and insisted that it was something that she "agree[d] with totally" (Transcripts, December 12, 2000, 68). Nixon

emphatically defined herself as "feminist" and agreed with the premise that "women who suffer violence at the hands of men may prefer to get support from women" (Transcripts, December 12, 2000, 69 and 100). She agreed that the exclusion of men from rape crisis counselling was acceptable within a context of pervasive male violence against women (Transcripts, December 12, 2000, 100). Nixon also testified about her active participation in a trans organization that limits involvement to those who identify as transsexual and/or transgendered (Transcripts, December 12, 2000, 82). In effect, the claim that experiences of marginalization constitute legitimate bases for political organizing is affirmed and never questioned in Nixon's testimony and cross-examination.

Nixon's challenge, then, is *not* to the legitimacy of women-only space. Instead, she challenges the basis for inclusion within women-only space. It is clear that she rejects VRR's contention that women-born-women should be the exclusive inhabitants of this space. She insists that the lines around women-only space be redrawn to include "women like her." But the manner in which Nixon defined "women like her" shifts in the course of these legal proceedings. At the tribunal, Nixon's testimony can be read as a plea for transwomen's inclusion within feminist organizing. As she argued, self-identification should be the basis for inclusion— "if someone identifies as being a woman they should be believed" (Transcripts, December 12, 2000, 103). This is how Nixon's challenge has been represented by those who see her claim as an attack on the biologism, essentialism, and rigid exclusions that defined VRR's response. Yet before the BC Supreme Court, Nixon argued that VRR could preserve its character as a women-only organization by requiring those seeking inclusion to present their birth certificates.[13] In effect, because BC law makes changing one's gender contingent on the completion of sex reassignment surgery,[14] Nixon argued that the lines around women-only space could be legitimately drawn to include post-operative MTFs and to exclude those

who have not yet undergone surgery, those who decline surgery, and those who embrace a transgendered identification that resists passing.

I eschew the tendency of feminist anti-trans theorists, who, like Raymond, pathologize the transsexual as the mere object of conservative, medicalized discourses. Yet, the marking of an identity-based boundary around feminist politics resonates within Nixon's claim, just as it defines VRR's. The lines drawn are simply in different places, but both sustain a sharp demarcation between inside and outside based upon bodies and experience.

From the basis of a reified identity, Nixon's claim is for recognition motivated by her experience of exclusion and unintelligibility. But her claim also decontextualizes the production of identity and its disciplinary effects. And when articulated through a liberal discourse of rights, context disappears. The complexities of social power, gender disadvantage, and feminist politics dissolve into a liberal language of de-historicized injury.

The Meaning of Discrimination

The adjudication of Nixon's claim through a human rights regime and the courts raises fundamental questions about the resort to law and the transformation of political conflicts into legal disputes. Critics including Viviane Namaste and Georgia Sitara (2005) contend that, given law's historical hostility to the interests of feminism, VRR's appeal to law is deeply problematic, demonstrating a naive faith in the state. Quite apart from a simplistic dismissal of law as always unified and patriarchal, they ignore how both parties are equally responsible for this protracted legal dispute. Nixon launched her human rights complaint only a day after being refused access to volunteer training and refused to consider an apology and an offer of mediation from VRR. VRR first challenged the jurisdiction of the human rights commission over this

case and then appealed the tribunal decision. Nixon appealed the BC Supreme Court ruling and sought leave to appeal the Court of Appeal decision to the Supreme Court of Canada. Both parties were responsible for the legalization of this conflict.

The framing of this conflict as a question of rights to be settled through law decontextualizes the deep complexities of trans inclusion and feminist politics in a manner that resists a feminist solution (Mathen 2004). In this case, the parties were forced to argue in the terms established by the human rights regime: the right of a transwoman to access a "service" available to other women and the right of an organization promoting the interests of an identifiable group to give preference to members of that group. This limited framing trivializes the concerns at stake in this conflict, including the context of women's organizations seeking to do political work to combat male violence and the alienation experienced by transgender people in a rigorously enforced dichotomous gender system. Moreover, given the adversarial nature of law, resolution of this conflict could ultimately only vindicate one party.[15] Those on the side-lines are likewise compelled to take sides, to declare their allegiance, to stand firmly in the camp of Nixon or VRR, collapsing the possibility of a position somewhere in the middle.

As I have suggested, in this demand to take sides, most have declared their allegiance to Nixon as excluded trans subject and neglected to fully unpack the legal implications of her arguments. Nixon's claim was firmly rooted in a formalistic approach to discrimination.[16] It was a claim of sameness and abstract entitlement to similar treatment, the "I" deserving to be treated as the "we" on the basis of similarity—that is, Nixon is the same as other women, so her exclusion from VRR constitutes differential treatment and prima facie discrimination. The fact of differential treatment, based on a ground specified in the human rights code, becomes the singular mark and evidence for the existence of

"discrimination."[17] By this logic, a complex conflict is reduced to a single moment of differential treatment, personally felt, individually experienced.

Reduced to a "service," the feminist politics of VRR disappear, and political and epistemic justifications for women-only space are erased. And when limitations on membership are treated as by definition discriminatory, a feminist organization engaging women-only politics is required to establish a bona fide justification for membership exclusions that would somehow be intelligible to the courts. In Canadian human rights jurisprudence, the existing standards for bona fide justifications are high, requiring respondents to demonstrate that differential treatment was in "good faith," that it was adopted for a goal that is rationally connected to the function being performed, and that the respondent could not accommodate the complainant without undue hardship.[18] Bona fide standards redirect emphasis away from any political justifications for women-only organizing toward an exclusive focus on gender as a kind of occupational requirement. In this case, VRR was compelled to demonstrate the impossible, that the experience of living as a woman is a necessary qualification for rape crisis work. As counsel for VRR, Christine Boyle (2004) reflected in a published commentary on this case, "Placing a burden of proof on a women's group in a world without socially validated sources of information about women can be seen as an exercise in discrimination itself. This may lead to labeling women's groups as discriminatory and force them to prove some defence, relying on knowledge that may not be acknowledged, such as feminist psychiatric knowledge, and research into the impact of traumatized women of unexpectedly encountering people without the life experience of women."[19]

The thrust of Nixon's legal argument is profoundly individualist, making "groupness" per se discriminatory.[20] And while VRR's exclusion of Nixon has generated feminist/queer castigations and

declarations of support for the values of difference and for the project of trans inclusion, too few have considered the dangerous implications of endorsing a legal claim that transforms organizing around identity and experience into "discrimination." Critics like Elliot and Chambers locate their condemnations of VRR within a critique of identity politics. Yet there is a difference between being critical of the implications of identity politics and the argument that organizing on the basis of identity should be viewed in law as discriminatory. What would it mean to sacrifice the ability to organize as women? Would something vital, something embedded in the very meaning of feminism as a political project, be lost?

For its part, VRR insisted that the human rights tribunal and the courts are required to engage in a substantive analysis of discrimination, one that would take into account its status as an organization struggling against conditions of disadvantage and the widespread problem of male violence. In effect, VRR argued that discrimination must be understood contextually and that the ability of disadvantaged groups to self-define must be part of the context analyzed when assessing whether discrimination had occurred (*Vancouver Rape Relief* [2003]; Boyle 2004). VRR insisted that the test for discrimination in the human rights context should be consistent with the test for discrimination in the constitutional context.[21] As legal critics argue, if accepted, this would have had the effect of making discrimination far more difficult to prove in human rights cases.[22] VRR's insistence that human rights complainants must bear the burden of proving substantive discrimination would require that human rights complainants establish more than differential treatment. In the constitutional context, distinctions, per se, are not "discriminatory," and complainants alleging a violation of equality rights must demonstrate how differential treatment reinforces "stereotyping" and disadvantage.[23] As Nixon's counsel barbara findlay argued, VRR's insistence that human rights complainants bear the burden of proving

substantive discrimination in addition to prima facie differential treatment "would have tipped the scales in human rights cases in favour of respondents," shifting the justificatory burden from respondents to complainants.[24]

VRR's legal argument also rested on the deeply problematic *Law* test for discrimination (*Law v. Canada* [1999]); this test ties the meaning of discrimination to the amorphous concept of "dignity" and has produced disturbing results in recent constitutional cases (Sampson 2005; Gilbert 2003). By endorsing the *Law* test, VRR was effectively requiring Nixon to show how being denied the opportunity to train as a volunteer rose beyond an injury to dignity in the subjective sense.[25] VRR argued that a "reasonable person," sharing the values of the *Canadian Charter of Rights and Freedoms*, would not have experienced this as an injury to dignity because she would share this lack of opportunity with the vast majority of people— "including men, pro-life women, women who do not agree that women are free to love whom they will, women who are not willing to work against racism, and women with other political differences with Rape Relief."[26] This argument denies how Nixon experienced this exclusion as an effacement of her identity as a woman and constructs those who live with experiences of disadvantage and discrimination as "unreasonable."[27]

Feminist legal scholars writing on this case have been universally critical of how VRR appropriated a controversial element of constitutional jurisprudence in an effort to cut off Nixon's claim (Mathen 2004; Chambers 2007). But rather than seeing VRR's legal argument as a misguided endorsement of the *Law* approach on the terrain of human rights law, it is perhaps more accurate to characterize its position as expressing a demand for a flexible approach to discrimination guided by substantive equality. As Boyle explains, VRR was insisting that the test for discrimination must be framed by the purpose of human rights law, which, in turn, must be understood as being the eradication of disadvantage and inequality,

rather than the mere erasure of distinction. In most human rights cases, simply proving exclusion or differential treatment (in employment, housing, or services) would be consistent with a purposive and contextual approach to discrimination. Yet, as Boyle points out, *Nixon* is not a typical human rights complaint: "Human rights tribunals and courts are now being asked to address the question of whether groups which are formed to address particular forms of oppression, and thus are not inclusive of all forms of oppression, are discriminating. An unreflective application of a formal approach designed for simpler issues, or mere lip-service to a contextual approach, is inadequate for the challenge posed by such issues."[28] The embrace of a formalistic analysis in such complex cases could make it very difficult for equality-seeking groups to determine their politics and membership.

Nixon in Context

As we grapple with the complex meanings of *Nixon*, we must acknowledge that we do so in a context in which feminist discourses and movements have been decisively delegitimized. During the 1980s and 1990s, feminists enjoyed some limited success in gaining recognition of violence against women as a social problem and an object of state intervention (Gotell 2007). But the spaces once opened have now closed. In what some analysts have labelled the "anti-antirape backlash," critics including Camille Paglia (1992) and Katie Roife (1994) condemned the feminist antiviolence movement as anti-sex, as having convinced women to reinterpret their experiences of bad sex as rape, and, in the process, producing a "rape hysteria" and a manufactured crisis.[29] These polemical claims were eagerly taken up in a cultural context anxious to put to bed the discomforting contentions of antirape feminists. As Nicola Gavey argues, during the 1990s, the story of "rape hysteria" replaced the story of rape in the media, erasing

sexual violence as a social problem, despite resounding evidence of depressing continuities.[30]

Coinciding with this cultural backlash, feminism appeared to lose its political voice. It would be a simplification to attribute the declining influence of feminism to "backlash." Instead, the erosion of feminism needs to be set in the context of the rise of the neo-liberal state. By the 1990s, Canadian federal and provincial governments had wholeheartedly embraced neo-liberal governance, enacting massive budget cuts in areas that would have the effect of weakening social supports to women. Once entitled to state funding and political access, Canadian feminist organizations were increasingly recast as "special interest groups," antithetical to a public good defined in terms of restraint, privatization, and personal responsibility.[31] For much of the late 1980s and 1990s, governmental actors mounted a steady rhetorical attack on the women's movement, delegitimizing feminist voices and leading to a dismantling of programs designed to enhance women's equality (Brodie 2002). The pace of this violent erasure has recently accelerated with the election of the Harper Conservative government intent on dismantling the last remaining institutional sites for gender-sensitive policy making. In a very short space of time, as Janine Brodie (2002) contends, gender and the equality agenda have been virtually erased from public discourse.[32]

The disappearance of sexual violence as an object of public policy and political discourse can be linked to these broader transformations in state form and citizenship norms (Gotell 2007). Over the past decade, the policy field signified by "violence against women" has been evacuated and replaced with de-gendered and individualized policy frameworks. One crucial institutional mechanism by which this has occurred is the elaboration of victims' services bureaucracies and the ascendant policy discourse of "victims' issues." This discourse erases the gendered character of sexual violence and reconstructs those who experience rape as

undifferentiated victims of crime, requiring generic counselling and assistance.

This discursive framing effectively renders feminist rape crisis and antiviolence work irrelevant. To continue to obtain government support, many rape crisis centres have experienced pressures to turn away from political action and analysis, to redefine themselves as social service agencies (Beres, Gotell, and Crow 2008). This depoliticized characterization of VRR as a victims' support service underlies the BC Court of Appeal decision in *Nixon*. While acknowledging that VRR is an organization formed to "assist persons seen by its members as marginalized and disadvantaged by men," Saunders J.A. accepts the tribunal's characterization of its primary mandate and purpose as the "provi[sion] of services to women victims of male violence."[33] Indeed the Court's finding that the exclusion of Nixon was discriminatory rests on the designation of volunteer training as a "service" "customarily available to the public."[34] To construct VRR as an organization providing "services" to "victims" or "volunteers" is to discount its political work, as well as any political and epistemic rationales for women-only organizing against violence against women.

VRR and a declining number of rape crisis centres that mobilize through the Canadian Association of Sexual Assault Centres (CASAC) have stood against these depoliticizing trends. These rape crisis centres have continued to insist on a feminist practice of support and an activist politics.[35] Rather than succumbing to pressures to redefine as victim services, rape crisis centres like VRR define sexualized violence as a systemic problem deeply rooted in gendered, classed, and racialized inequalities. The Canadian feminist rape crisis centre movement has demanded state action on a number of fronts, including social policy, public education, and, crucially, the provision of a stable funding base for independent, women-controlled, frontline work and activism. In effect, in spite of considerable pressures to leave behind a political analysis

of rape, feminist rape crisis centres such as VRR continue to see their work as inherently activist, defined by a commitment to social change and by the objective of eliminating rape and all forms of violence against women. And while this political project does not require a radical feminist analysis, radical feminism has certainly played a central role in the feminist antirape movement.

In a context that has become even more hostile with the ideologically-driven Tory cuts to Status of Women Canada announced in 2006, we must be cognizant of how feminist and queer critiques of VRR can and do function. I am concerned that denunciations of VRR can be used to discount feminist antiviolence politics and the work of feminist rape crisis centres. The language of these denunciations, especially those situated outside specifically academic analysis, is striking and often hyperbolic. For example, in a guest editorial in the queer newspaper *Xtra*, feminist law professor Brenda Cossman (2004) distances herself from VRR's old-style radical feminism in the strongest possible terms—"For Rape Relief, being a woman is all about oppression....This narrow crazy radical feminist talk creates much conflict within the queer community—and gives feminism such a bad anti-sex rap."[36] Cossman and others who engage in such sweeping dismissals need to be aware of how the subtleties of their political critiques are lost when they move into mainstream cultures. There is but a short jump from Cossman's depiction of radical feminism as narrow and crazy, to mainstream media characterizations of VRR as exemplary of the inherently doctrinaire and dangerous character of feminist antirape work. In a *National Post* column, for example, Donna Laframboise (2001) highlights the political character of VRR as a rationale for de-funding all feminist rape crisis work: "rape crisis centres are steeped in politics. Even though they are funded by politically neutral tax dollars, anyone who has been within a mile of one of these centres knows the women who are supposed to be receiving assistance there are, in fact, being proselytized."[37]

Conclusion

In many ways, VRR, through this conflict about trans inclusion, has come to symbolize the excesses and anachronistic character of feminist politics in the present. As I have argued here, Nixon's claim for trans inclusion itself embeds an exclusionary subtext. Nixon's position is possibly more sexy and slightly more inclusionary than that of VRR; yet it is also highly individualistic and embedded in a formal equality discourse that fails to escape the confines of identity politics. Feminist and queer characterizations of VRR as doctrinaire and exclusionary, as an old and unsexy form of feminism that must necessarily be disavowed, circulate in a political and cultural context in which feminist antirape work has been delegitimized. Returning to Mayeda's call for a feminist ethics built upon responsibility and self-critique, I am struck by how this chorus of denunciation has avoided responsibility for the implications of this disavowal. I write this under the shadow of my past work and with a strong commitment to a democratic feminist praxis marked by debate and contestation. I am aware that my argument in this chapter could be read as a call for a return to a foundational feminist politics characterized by singularity and by the adherence to feminist Truth. But this would be a misreading. Feminism must be embraced as a site of legitimate political differences in which participants hold themselves accountable for the implications of their positions.

Trans inclusion is being actively debated in rape crisis centres across the country and also within national organizations like the Canadian Association of Sexual Assault Centres.[38] This is, perhaps, the only positive outcome of *Nixon*, which as a legal case eluded any positive result. It cost VRR twelve years and more than $100,000 in legal fees. Nixon's best hope was state-enforced entry into a radical feminist collective. It was a conflict that should never have been a case, a question better resolved through debate than through the

appeal to law. In the end, we can be grateful that leave to appeal was not granted, for the very idea of the Supreme Court of Canada determining the membership and politics of feminist organizations is frightening. And if we are to learn anything from *Nixon*, we must accept that the lessons that this conflict teaches are complex and troubling.

NOTES

1. Section 41 of the *British Columbia Human Rights Code* allows a "charitable, philanthropic, educational, fraternal, religious or social organization...that has as a primary purpose the promotion of the interests and welfare of an identifiable group or class of persons...[to grant] preference to the identifiable group or class of persons" (*British Columbia Human Rights Code* 1996).

2. Brenda Cossman, Lise Gotell, and Becki L. Ross, *Bad Attitude/s on Trial: Pornography, Feminism and the* Butler *Decision* (Toronto: University of Toronto Press, 1997), 98.

3. *Kimberly Nixon v. Vancouver Rape Relief Society*, Transcripts of Tribunal Hearing 2000–2001 (December 19, 2000), 16 (hereinafter "Transcripts"). All further references will appear as in-text citations.

4. Vancouver Rape Relief Society, Petition to the British Columbia Supreme Court, no. L021846, Vancouver Registry (2003), para. 25.

5. Carol Smart, *Feminism and the Power of Law* (London: Routledge, 1989), 80.

6. Vancouver Rape Relief Society, (2003).

7. Patricia Elliot, "Who Gets to be a Woman? Feminist Politics and the Question of Trans Inclusion," *Atlantis* 29, no. 1 (2004): 19.

8. Lori Chambers, "Unprincipled Exclusions: Feminist Theory, Transgender Jurisprudence, and Kimberly Nixon," *Canadian Journal of Women and the Law* 19, no. 2 (2007): 327.

9. See Chambers, for example, 308. Essentialist feminist approaches universalized white, middle-class women's experiences, erasing intersections of race and class and treating sex/gender inequality as the primary basis of collective feminist struggles.

10. Ajnesh Prasad, "Reconsidering the Socio-Scientific Enterprise of Sexual Difference: The Case of Kimberly Nixon," *Canadian Woman Studies* 24, no. 2–3 (2005): 83.

11. Graham Mayeda, "Re-Imagining Feminist Theory: Transgender Identity, Feminism and the Law," *Canadian Journal of Women and the Law* 17, no. 2 (2005): 471

12. Katrina Roen, "'Either/Or' and 'Both/Neither': Discursive Tensions in Transgender Politics," *Signs: Journal of Women in Culture and Society* 27, no. 2 (2001): 503–04.

13. Vancouver Rape Relief Society [2003], paras. 43–44.

14. Section 27(1) of *Vital Statistics Act* reads: "If a person in respect of whom trans-sexual surgery has been performed is unmarried on the date the person applies under this section, the director must, on application made to the direc-tor...change the sex designation on the registration...in such a manner that the sex designation is consistent with the intended results of the trans-sexual surgery."

15. Carissima Mathen, "Transgendered Persons and Feminist Strategy," *Canadian Journal of Women and the Law* 16, no. 2 (2004): 319.

16. Mathen, 313; Boyle, 2004.

17. See barbara findlay, counsel for Nixon, for a defence of using a prima facie approach to discrimination in the human rights context; barbara findlay, "Real Women: Kimberley Nixon v. Vancouver Rape Relief," *University of British Columbia Law Review* 36, no. 1 (2003): 68–69; Christine Boyle, "The Anti-discrimination Norm in Human Rights and *Charter* Law: *Nixon v. Vancouver Rape Relief,*" *University of British Columbia Law Review* 37 (2004): 56.

18. British Columbia v. British Columbia Government and Service Employees' Union [1999]; findlay, "Real Women," 70–71.

19. Boyle, "The Anti-discrimination Norm," 75.

20. Boyle, 41.

21. *Vancouver Rape Relief* (2003), paras. 80–106.

22. Mathen, "Transgendered Persons," 297–98; findlay, "Real Women," 68–69.

23. Boyle, "The Anti-discrimination Norm," 36–46.

24. findlay, "Real Women," 69.

25. *Vancouver Rape Relief* (2003), para. 110.

26. *Vancouver Rape Relief* (2003), para. 132.

27. Mathen, "Transgendered Persons," 298; findlay, "Real Women," 69.

28. Boyle, "The Anti-discrimination Norm," 71.

29. Nicola Gavey, *Just Sex? The Cultural Scaffolding of Rape* (New York: Routledge, 2005), 64.

30. Statistics Canada's 1993 Violence Against Women Survey found that 39% of Canadian women reported having experienced sexual assault since the age of 16. Since 1993, no national incidence studies have been undertaken. In 2005, there were 23,000 reported cases of sexual assault reported to the police, sug-gesting that overall incidence remains very high in this least-reported (8%) of violent crimes (Holly Johnson, *Measuring Violence Against Women: Statistical Trends*. Statistics Canada Catalogue no. 85-570-XIE (2006), 24–26; Gavey, *Just Sex?*, 64–72.

31. Janine Brodie, "The Great Undoing: State Formation, Gender Politics, and Social Policy in Canada," in *Western Welfare in Decline: Globalization and Women's Poverty*, ed. Catherine Kingfisher (Philadelphia: University of Pennsylvania Press, 2002), 95–96.

32. Brodie, 91.

33. *Vancouver Rape Relief Society v. Nixon* [2005] BCCA 601, paras. 5 and 3.

34. *Vancouver Rape Relief Society v. Nixon* [2005], para. 32.

35. Melanie Beres, Lise Gotell, and Barbara Crow, "The Perils of Institutionalization in Neoliberal Times: Results of a National Survey of Canadian Sexual Assault and Rape Crisis Centres," *Canadian Journal of Sociology* 34, no. 1 (2009): 135–63.

36. Brenda Cossman, "Really Real Women," *Xtra* (January 22, 2004), http://archives.xtra.ca/Story.aspx?s=15021605 (accessed December 1, 2007).

37. Donna Laframboise, "No Straight Help for Rape Victims," *National Post*, March 1, 2001, http://www.fathers.ca/News/studies/violence/Nostraighthelpforrapevictims.aspx (accessed December 1, 2007).

38. At CASAC's national biennial congress, "Canada's Promises to Keep: The *Charter* and Violence Against Women" in 2005, a full day of the three days was devoted to debate on trans inclusion.

23

Guerrilla Grrrls and Sex Trafficking
Activism, Agency, Feminist Debates, and Feminist Oversights

MARJORIE STONE

LOOKING BACK, ONE CAN READ the formation of Guerrilla Grrrls Against the Gag in different ways. Was it a successful media offensive by Dalhousie University student and faculty feminist activists, initiated by the 27 March 1994 Halifax Media Press Release, "Guerrilla Grrrls Swing from the Freedom of Expression Branch" (issued by GGAG contact "Godzilla Grrrl")? Or was it merely an engaging dalliance with performativity in the public sphere: an exuberant eruption of spring fever by term-weary young scholars and their professors? Either way, could it be interpreted as a local manifestation of the rise of third-wave Western feminism, emphasizing "grrrl power," parodic play, identity politics, and cultural interventions over second-wave preoccupations with employment equity, violence against women, and institutional reform?

I first reconstruct the untold story of GGAG here in order to question the segregation of feminist history into discrete waves, then consider some of the challenges of activism on broader social and political fronts for feminists working in the liberal arts. I focus in particular on the relative neglect of global sex trafficking in feminist cultural and textual studies, attributing it to several causes: individualist paradigms of social change; theoretical frameworks privileging performativity and textuality over the material conditions of women's lives; conflicting models of feminist agency; and the differential trajectories of nation, race, economic circumstances, and religion. Among these factors, debates over agency are especially pivotal as current approaches to sex trafficking play out deep divisions over prostitution and pornography extending back through feminism's second wave to its first. The result has been a highly polarized opposition between trafficking "abolitionists" and their critics. Given such contested terrain, questions about the nature of effective activism are fraught with complications, yet many might argue that the need for it grows more compelling by the day.

An Untold Story: Guerrilla Grrrls Against the Gag (GGAG)

The catalyst for the GGAG offensive was an unprecedented intervention by Dalhousie University's Board of Governors (hereafter BOG) into academic policy. On 15 March 1994, the BOG overturned a Dalhousie Senate decision (approved by a two-thirds majority of close to 100 Senators) to institute a discriminatory harassment policy addressing "abusive personal or group vilification" based on race, sex, ethnic origin, disability, or sexual orientation. The policy was the outcome of two years of planning and pressure by student government, faculty advocacy groups like the DWFO (the Dalhousie Women Faculty Organization), and some administrators. It was a period when the "Culture Wars" on North American campuses

(Keefer) facilitated the framing of such a policy as a "Big Brother" "speech code." When the Halifax *Chronicle-Herald* published an opinion piece I had written critiquing the BOG decision as an undemocratic infringement on academic freedom, the columnist Harry Flemming attacked my article as "Orwellian bafflegab," contrary to my own contention that it was the BOG that was "Big Brother." Flemming also denounced me as a "lady" who was "for burning, metaphorically of course," adding that, if I had tenure, it should be revoked. The exchange provoked several letters on the harassment policy in Halifax papers, where the DWFO and some other faculty members came to my defence.[1]

Since the non-appealable Board decision foreclosed further institutional action, the Guerrilla Grrrls spring op was born, initiated at a kitchen-table meeting in my home. I proposed the model of New York's Guerrilla Girls, with their signature stiletto heels and gorilla masks and their satiric protests against the white male domination of the art world. The students in the group, though, had additional models in mind, suggesting that we replace "Girls" with "Grrrls"—a substitution I would only appreciate in retrospect, as Rebecca Munford, Rachael Fudge, and others documented the emergence of the "Riot Grrrls" movement and the broader "girl power" movement associated with third-wave feminism. Melding Guerrilla Girl with Riot Grrrl tactics, GGAG student members wearing gorilla masks (the stilettos were a less favoured accessory) plastered campus with posters parodying the BOG decision. The acronym BOG provided many openings, given the creativity of media spokesperson Godzilla Grrrl Candida Rifkind and other student activists (including Danielle Fuller and Dana James). Some posters offered bananas in "Grratitude" to senior administrators who had supported the Senate policy, or asked faculty members if they felt "bogged down" by the overruling of Senate by a body in which they had little representation. Other posters satirized the BOG as a defender of freedom of speech by outlining its "Speech

Code" (you needed a pass to get into meetings, passes were very limited, you were only allowed to speak if the BOG Chair recognized you). Masked Guerrilla Grrrls also delivered press releases to local media outlets, stormed a Student Appreciation night, and attended both a Senate meeting and a Board meeting. For an impromptu series of interventions at little cost (under $200 plus a lot of human energy), the GGAG offensive garnered considerable attention, including coverage in the Halifax *Sunday Daily News* as an "action" "carried out with a certain 1960s radical aplomb,"[2] and photo essays about Guerrilla Grrrls in the *Dalhousie News* and the Dalhousie student newspaper *The Gazette*. Did the Guerrilla Grrrls also help to shift opinion toward support for institution of a discriminatory harassment policy? The BOG decision stood (a revised policy was successfully introduced a few years later), and GAGG dissolved as quickly as it had formed. Suddenly we realized it was exam time and buckled down to what Alice Munro might call "real life."

The 1994 GGAG spring op coincides in timing and characteristics with emerging third-wave feminism as historians and cultural critics now define it; yet the closer one looks, the more it points to the intermingling of the third with the second wave. As Gillian Howie and Ashley Tauchert note, "waves are complex phenomena....To perceive a wave at all, we artificially arrest the movement by which it is constituted, and separate out *one of myriad* manifestations of that movement."[3] In their "Introduction" to *Third Wave Agenda*,[4] Leslie Heywood and Jennifer Drake point out that feminism's third wave "contains elements of second wave critique of beauty culture, sexual abuse, and power structures," rightly questioning the facile "opposition between 'victim feminism' (second wave) and 'power feminism' (third wave)" postulated by "postfeminist" popularizing writers such as Naomi Wolf, Christina Hoff Sommers, and Rene Denfield. Third-wave feminism is generally associated with a "new identity politics,"[5] a "politics of agency and

Guess Who Came to the Board of Governors' Meeting? No, this was not a scene from *Planet of the Apes*. These guerrillas showed up at a recent board meeting. See story page 3. (Wallace photo)

From the *Dalhousie News*, April 13, 1994.
photo: Wallace.

empowerment rooted in a collective 'girl' identity,"[6] commitment
to "cultural production as activism," and "playful appropriation of
stereotypes."[7] While all these features characterize the GAGG op,
it also flowed out of 1980s second-wave actions at Dalhousie, led
by feminist philosopher Susan Sherwin and feminist psychologist
Toni Laidlaw, founding members of the DWFO. These included the
introduction of a women's studies program and a sexual harass-
ment policy, a push for more women in senior administration, and
the 1984 "Feminist Visions" Killam Lecture series featuring Sheila
Rowbotham, Mary Daly, and Marge Piercy, which packed the uni-
versity auditorium with close to a thousand each night. DWFO

members also provided, through private donations, the funds to cover the costs of the GAGG action.

In fact, 1994 marked a short-lived period when this type of convergence between second- and third-wave feminists was possible at Dalhousie, because by the later 1990s, with more women faculty in more departments and in senior administration, the DWFO had dissolved, and its role as an activist association could not be simply assumed by the institutionally embedded, under-funded women's studies program. Howie and Tauchert observe that the "demise of feminism as a coherent political force occurred simultaneously with the consolidation of academic feminism."[8] While many might question that feminism has died as a "coherent political force"—Dalhousie still has an active women's centre run by students—the comment does resonate with the DWFO's dissolution. Despite the transformations effected by feminism within the liberal arts academy, we also need to ask, with Pamela Church Gibson, "whether or not we have been neutered, cloistered, walled-up within the academy, unable to affect the lives of women outside the Western higher education system."[9]

Sex Trafficking, Feminist Activism, Feminist Debates, and Questions of Agency

When Siri wakes it is about noon. In the instant of waking she knows exactly who and what she has become....The soreness in her genitals reminds her of the fifteen men she had sex with the night before. Siri is fifteen years old. Sold by her parents a year ago, she finds that her resistance and her desire to escape the brothel are breaking down.[10]

Statistics on sex slavery are as hotly debated as definitions of it, given the clashing agendas of differently positioned feminists and anti-trafficking organizations, the varying regulative and

discursive regimes of nation states (such as the U.S. Trafficking in Persons annual audits), the gradations of coercion (from debt bondage to rape and torture), and the underground nature of trafficking activities. In Thailand, Siri's home, Kevin Bales conservatively reckons that "one in twenty is enslaved" among a half to one "million prostitutes."[11] The International Labour Organization estimates that globally 1.4 to 1.7 million are in "forced commercial sexual exploitation,"[12] although statistics on worldwide trafficking vary wildly, "from 700,000 victims...to 200 million."[13] The profits can be enormous for pimps and traffickers, as well as governments: in 2003, Richard Poulin described trafficking in Thailand as a "500 billion Bahts annual business (equivalent to approximately 124 million U.S. dollars)."[14] For Thai girls like Siri, the working life is short—two to five years, given the violence and disease (especially AIDS) they are subjected to—but, as Bales observes, "girls are so cheap there is little reason to take care of them."[15] In *The Natashas: The New Global Sex Trade*, Victor Malarek describes U.N. peace-keeping troops in Bosnia purchasing sex slaves, sometimes not "a day over twelve" (one solider boasted), for $600 and $800.[16] Often, trafficked women and children are moved from brothel to brothel, as in Florida where the Chain Gang subjected fourteen-year-old Mexican girls to "feverish rates of work, with as many as 130 clients a week"; in "Germany or Poland, women are held in clandestine brothels where the windows are often barred," and here as elsewhere in Europe, exploitation is enhanced by the large proportion of immigrant women in the sex trade: from 50 to 90 per cent in some cities, often trafficked from "Central Europe, the Baltic states, the Balkans and the former Soviet Union."[17] In the United States, trafficking networks have been documented in State Department reports, media stories like Peter Landesman's 2004 *New York Times* article, "The Girls Next Door," and David Schisgall's 2007 documentary, *Very Young Girls*, on teen prostitutes in New York and the activist work of GEMS (Girls Education and

Mentoring Services). Canadian trafficking networks are treated in a 2004 report by the Global Alliance Against Trafficking In Women (Penfold), a study the same year by Ruth Magaly San Martin, the 2005 reports on Canada by the U.S. State Department ("Canada") and the Protection Project at Johns Hopkins University (Protection Project), as well as studies produced by the research arm of Status of Women Canada (McDonald, Moore, and Timoshkina) before its defunding by the Harper government.

In fields such as sociology, political science, migration studies, and philosophy, sex trafficking research is extensive or expanding. Yet sex slavery has not been a focus of attention or activism for feminists in some liberal arts fields, especially textual and cultural studies, despite the third wave "global" turn toward human rights and social justice issues.[18] It is also largely absent from anthologies between 1997 and 2007 that testify to the continuing vitality of feminism and the activism it generates inside and outside the academy. Among these, the editors of *The Fire This Time* state that "we must battle sex trafficking as well as the global economic policies that have made sex trafficking a thriving industry."[19] *BITCHfest* is more typical, however, in mentioning "human trafficking" only in passing among issues that "young feminists of all genders have been protesting."[20] However, the subject is not a focus in the volume, and the final section on activism is restricted to "Activism in Pop Culture." Sex trafficking is unmentioned even in the excellent academic anthology *Third Wave Feminism*, despite essays on global feminism and human rights.[21]

What might explain this oversight among both academic feminists and contemporary "Guerrilla Grrrls"? Out of a legion of complex factors, I single out four. First, sex slavery does not easily fit within current dominant paradigms of feminist activism, especially given the co-optation of the radical Riot Grrrl movement into a more commercialized "girl power" privileging individual sexual agency and regarding sexual oppression as an outmoded concept

associated with "victim feminism." Like Rachel Fudge, Munford points out that the Riot Grrrls packed political punch, activist politics, and community-building in their mix of "feminist consciousness and punk aesthetics."[22] The movement definitely had transformative effects in some areas: for example, Feona Attwood charts the linguistic changes influenced by Riot Grrrl reclamation of terms such as *slut*. In these respects, the Riot Grrrls are unlike later mainstream figures of "girl power" such as the "Spice Girls," or the women in Ariel Levy's study of "Raunch Culture" who find a dubious agency and a simulacrum of masculine freedom in performing sexual acts (for free) for video cameras and the male gaze in *Girls Gone Wild* commercial operations. Whether subversive or co-opted, however, both grrrl and more mainstream girl power movements emphasize female agency, power, pleasure, and choice. Influenced by these individualist paradigms, a third-wave activist treating sex workers' rights, like Mary Christmas in *We Don't Need Another Wave*, restricts her focus to her own elective work as stripper: "When I became active in the sex workers' rights movement, the pro-choice slogan 'My body, my business' took on a new significance. My body became my business in the sense that its sex appeal paid my rent, and I was surprised to find that I didn't have a problem with that. I didn't feel like I was selling my soul or damaging my psyche."[23] Christmas's essay is entitled, "No Goddesses, No Slaves," and the reality for many trafficked women and children, that their bodies are *not* their own business, does not enter her frame of reference. In her terms, there are "No Slaves." Nor does she consider the psychic or physical damage a girl like Siri is subjected to in the form of "lethargy, aggression, self-loathing, suicide attempts, confusion, self-abuse, depression, full-blown psychoses, and hallucinations."[24]

Second, sex slavery may not figure prominently in some liberal arts disciplines because a "deradicalization of feminist theory" has occurred with the rise of poststructuralist theories foregrounding

pleasure, desire, linguistic play, performativity, shifting subject positions, and a politics of diversity:[25] theories that resonate with the tactics of the Riot Grrrl movement, as Munford notes.[26] In *Ludic Feminism*, Teresa Ebert critiques the ways in which these postmodern theories trump the material realities of class, capitalism, and power, while Stacy Gillis demonstrates how they extend into the utopic "technological determinism" of cyberfeminism, with its assumption that "the sexed embodiments materialized by gender are suspended."[27] Certainly this is not the case for trafficked women and children, for whom cyber auctions merely provide a means of accessing and violating their physical bodies, as the 2007 film *Trade* dramatizes. Typically, however, those employing postmodern "ludic" feminist theories are more interested in exploring the subversive gender performances of a postmodern "pin-up grrrl" like Annie Sprinkle[28] than in addressing the coerced performances of women subjected to sex slavery like Marika, a young Ukrainian woman trafficked to Israel described by Malarek in *The Natashas*. Marika comments about the men who use her: "We were their sexual fantasy. These fools would walk into the parlor and with a stupid grin on their face call out 'Natasha!' like we were some kind of Russian doll. And we were expected to smile and rush to them."[29] Marika also observes that they were raped, beaten, even murdered if they refused. Such performances of not only a sexual fantasy, but also a deracinated and gendered national identity read like perverse parodies of the liberating performativity, pleasure, and agency privileged by feminists in cultures of the West or global "North." For Denise deCaires Narain, asking "What Happened to Global Sisterhood?" the elisions of poststructuralist theory are writ large within Western academic feminism: "Diversity and difference, in this context, coupled with the focus on pleasure, play and the ironic manipulation of performative gender codes, may result (has already resulted?) in a retreat into individualism and a political ethos in which 'anything goes.'"[30]

As Narain's comments suggest, a third reason for the relative lack of attention to sex slavery arises from differing positionalities of race, ethnicity, nation, and religion (and I would underscore, economic circumstances) more than from differing phases of feminism. For Narain, as for Mridula Nath Chakraborty, "the very idea of a phase/stage/wave-based consciousness is an ideological construct of the Eurocentric subject," an attempt to universalize from a hegemonic "white or Western feminism."[31] Even the Riot Grrrls was largely a "white, middle-class movement"[32] that, in Gayle Wald's words, re-appropriated girl power by effacing "critical questions of national, cultural, and racial appropriation...under the sign of gender transgressiveness."[33] It is no accident, as I have elsewhere argued,[34] that public and political attention to sex trafficking in Canada has been aroused by Malarek's *The Natashas*. Even though Malarek's exposé deals with the global trafficking of women and girls of differing races and origins, it emphasizes white trafficked women from countries of the former Soviet bloc like Ukraine (Malarek is himself Ukrainian-Canadian). This focus reflects the rapid expansion of trafficking networks in countries such as Romania, Moldova, and Ukraine, together with the Canadian sex industry demand for East European women.[35] It also indicates how Canadian public concern has been mobilized through nationalist sympathies, inflected by ideologies of race and ethnicity. We encounter these ideologies in a more transparent form in the resurgence of the historical term *white slave trade* as a synonym for trafficking and/or sex slavery[36] despite the League of Nations introduction of the more accurate and inclusive term *trafficking in women and children* in 1921. As Audrey Macklin observes, in Canada "white slavery narratives" mean that "trafficking villains remain ethnicized" as "brokers and agents of Asian and East European origin," while "Canadian-born bar owners who profit from the women retain the status of businessmen, albeit sleazy ones." Similarly, there is "a racialized, ethnicized intragender

hierarchy wherein migrant East European, Latin American and Asian women are differentially exoticized."[37] Given such power imbalances, addressing sex trafficking entails negotiating the pitfalls of ethnocentrism and appropriation of voice, while recognizing that, as Sarah Ahmed points out, there is a paralyzing "cultural relativism" in assuming that "the best way to avoid speaking for others is to avoid speaking at all."[38]

Nevertheless, it is not the problem of speaking for others that has created the widest fissure between differently positioned feminists in relation to sex trafficking. It is the fault line between those who hold "abolitionist views about pornography, prostitution, trafficking, and sex slavery," like Donna Hughes, as Phyllis Chesler defends her in *The Death of Feminism*, and those denounced as "accommodationist" by Hughes herself in a 2003 *National Review* article.[39] While this contentious divide is more widely recognized and debated among social scientists than those in the liberal arts, it points to the fourth, and most complex, reason for relative inaction on sex trafficking among many academic feminists. The "accommodationists" are more neutrally termed "functionalists" by Paola Monzini in her comprehensive and balanced *Sex Traffic: Prostitution, Crime and Exploitation*.[40] On the one hand, feminists like Hughes and Janice Raymond, associated with CATW, the Coalition Against Trafficking in Women (http://www. catwinternational.org), emphasize the victimization of women and children by international trafficking rings and the sex industry, promote "rescue" operations for sex slaves, and argue that trafficking includes "all forms of recruitment and transportation for prostitution, regardless of consent."[41] On the other hand, organizations such as GAATW, the Global Alliance Against Trafficking in Women (http://www.gaatw.org), and NWSP, the Network of Sex Workers Projects (http://www.nswp.org), advocate for safer labour conditions in the sex industries and critique the "victim" terminology and rescue narratives of the abolitionists, arguing that these

cast sex trade "workers" as passive victims, obscure the agency of "migrants who sell sex,"[42] and reflect "a culturally imperialistic discourse on prostitution."[43] Not surprisingly, abolitionist statistics stress the scale of sex trafficking globally. Those who critique them see such statistics as inflated by "moral panic" (Agustin, Desyllas, Doezema), comparing it to the similar "panic" aroused by Josephine Butler's first-wave feminist campaign against "white slavery" in the 1880s as this has been constructed by historian Judith Walkowitz. (They tend not to note more recent critiques of Walkowitz by historians such as Paula Bartley). The Abolitionists, for their part, present themselves as working directly in the tradition of Butler and of William Wilberforce.[44]

While American abolitionist feminists have been successful agents of legislative change, contributing both to the U.N. Trafficking Protocol adopted in Palermo in 2000, and the U.S. *Trafficking Victims Protection Act* (2000), they have worked through alliances with conservative government partners (such as the Bush administration), the media, and organized religion, much as Catherine MacKinnon and Andrea Dworkin turned to partnerships with the Christian Right and "moral majority" to fight pornography in the 1980s. MacKinnon herself, along with Gloria Steinem, has supported abolitionist anti-trafficking initiatives, while CATW activists have also worked with the National Association of Evangelicals and conservatives such as Republican Congresswoman Linda Smith.[45] This evangelical-feminist coalition is seen as an "unholy alliance," in Anna-Louise Crago's words,[46] by feminists aligned with the GAATW and NWSP position. Alliances parallel to the U.S. evangelical-feminist coalition are also emerging in Canada.[47] Critics of the U.S. abolitionists have particularly denounced the 2003 policy change celebrated by Hughes: that is, the control that U.S. Trafficking In Persons legislation has exerted on global NGO funding through an explicit veto prohibiting USAID support for "organizations advocating prostitution as an

employment choice or which advocates or supports the legalization of prostitution" and for projects perceived as supporting "trafficking of women and girls, legalization of drugs, injecting drug use, and abortion."[48] December 2007, brought another victory for U.S. abolitionists with the passing of the *William Wilberforce Trafficking Victims Protection Reauthorization Act*, and the creation of two levels of criminal activity: sex trafficking "without force, fraud, and coercion," and "aggravated sex trafficking," involving these elements.[49] While the effects of the Wilberforce Act remain to be seen, *Taking the Pledge*, a film produced by the NWSP, available on the Trafficking Policy Research Project website, is one among many sources that denounces the effects of the USAID "anti-prostitution" policy in several developing countries, documenting the closing of drop-in centres for street prostitutes, and the termination of safe-sex programs.[50]

While a majority of academic feminists have sided with the anti-abolitionist position, as the work of Laura Agustin on migration and Lenore Kuo on prostitution illustrates, this approach is problematic because it reduces debate and because the functionalist position is itself open to critique, as Rebecca Whisnant points out in her review of the GAATW anthology, *Trafficking and Prostitution Reconsidered*.[51] Abolitionist studies like the CATW 2001 report on "Sex Trafficking of Women in the United States," co-written by Hughes and Janice Raymond, also highlight the violence against women and children in the sex industries that too often disappears from view in studies focussed on sex workers' agency. As Angela Miles notes in her conversation with Raymond in *Canadian Woman Studies*, "One doesn't very often hear the basic premises of the 'feminist abolitionist' analysis...and what you call the 'pro-sex work analysis' debated....Instead, the pro-sex work position tends to be presented as a new, more up-to-date and nuanced analysis that has simply moved beyond the old fashioned...feminist critique of prostitution as exploitative of women."[52]

In response to such views, Raymond contends that academics romanticize trafficking as voluntary migration for sex work; emphasize the transgressiveness of prostitution over the gender inequality it embodies; advocate for narrow definitions of trafficking that restrict effective regulation of traffickers; and gloss over the victimization sex "work" entails when "the average age of prostitution worldwide is 13 or 14."[53] In her words, "there's a global and powerful sex industry confounding" opposing feminist positions on sex trafficking and prostitution: "the sex industry promotes the view that those who oppose it are conservative, puritanical, moralistic prudes who are anti-sex when, in reality, opponents are anti-sex industry. There's a whole industry out there whose job is to confuse feminist arguments against the prostitution industry with right-wing ideology and practice."[54] While this is a crucial point to keep in mind, the situation is also more complex than Raymond acknowledges, given that abolitionists such as Hughes have explicitly aligned themselves on occasion with more conservative forces associated with the Bush administration.

Faced with such strongly contested, ideologically complicated, and politically fraught positions and legislative policies, what actions should a contemporary academic feminist and/or "guerrilla grrrl" take in response to sex trafficking? At the very least, one should be aware that the social responsibilities of feminism extend beyond academic debates and the individual agency of "grrrls" or advocates of "girl power." While there are no simple recipes for action, one *can* look for common ground between the abolitionist and functionalist approaches, and choose to initiate or to support actions on this basis. For instance, an area in which the two sides share many concerns is the punitive effect of immigration and refugee laws on trafficking victims, who are too often "rescued" in police raids only to be deported and re-trafficked.[55] Changing such laws has been a focus for feminists fighting for policy change in the U.S. and Canada, as well as European countries. One can also

take guidance from feminists like Macklin in Canada and Monzini in Italy who set doctrinal differences over anti-trafficking aside as much as possible, focussing on the intractable complexities of trafficking and specific policy options that might better protect the trafficked.

NOTES

1. In their critique of Flemming's *ad feminam* attack, Toni Laidlaw, Susan Sherwin, and Jane Arscott noted that he had earlier defended, as "only 'mildly wayward,'" a former Nova Scotia premier "who allegedly 'drove his tongue down the throat' of a shocked seventeen-year-old Legislature page." Toni Laidlaw, Susan Sherwin, and Jane Arscott, Letter to the Editor, Halifax *Daily News*, April 5, 1995, 17.

2. Peter McLaughlin, "Politically Correct Fight Back: Masked 'Guerrilla Grrrls' Won't Let Dal Harrassment Policy Die," and "'Guerrilla Grrrls' Want Policy Revived," Halifax *Sunday Daily News*, March 27, 1994, 1 and 3.

3. Gillian Howie and Ashley Tauchert, "Feminist Dissonance: The Logic of Late Feminism," in *Third Wave Feminism: A Critical Exploration*, ed. Stacy Gillis, Gillian Howie, and Rebecca Munford (New York: Palgrave Macmillan, 2004), 37.

4. Leslie Heywood and Jennifer Drake, eds., *Third Wave Agenda: Being Feminist, Doing Feminism* (Minneapolis: University of Minnesota Press, 1997), 2–3.

5. Maggie Humm, *Modern Feminisms: Political, Literary, Cultural* (New York: Columbia University Press, 1992) 266.

6. Rebecca Munford, "'Wake Up and Smell the Lipgloss': Gender, Generation and the (A)Politics of Girl Power," in *Third Wave Feminism: A Critical Exploration*, ed. Stacy Gillis, Gillian Howie, and Rebecca Munford (New York: Palgrave Macmillan, 2004), 146.

7. Leslie Heywood and Jennifer Drake, "'It's All About the Benjamins': Economic Determinants of Third Wave Feminism in the United States," in *Third Wave Feminism: A Critical Exploration*, ed. Stacy Gillis, Gillian Howie, and Rebecca Munford (New York: Palgrave Macmillan, 2004), 20, 16. The rise of third-wave feminism is associated with the early 1990s, although Gayle Kimball notes the term *third wave* was used as early as 1981, to refer to "cultural feminism" (vii). The first use of "third wave" in an anthology title (Heywood and Drake, 1997, 1) was M. Jacqui Alexander's *The Third Wave: Feminist Perspectives on Racism* (cited in a 1994 *Genders* article but not actually published by Kitchen Table: Women of Color Press until 1998).

8. Howie and Tauchert, 42

9. Pamela Church Gibson, "Introduction: Popular Culture." *Third Wave Feminism: A Critical Exploration*, ed. Stacy Gillis, Gillian Howie, Rebecca Munford (New York: Palgrave Macmillan, 2004), 41.

10. Kevin Bales, "Because She Looks like a Child," in *Global Woman: Nannies, Maids, and Sex Workers in the New Economy*, ed. Barbara Ehrenreich and Arlie Russell Hochschild (New York: Henry Holt & Co., 2002), 27.

11. Ibid., 214.

12. Patrick Belser, "Forced Labor and Human Trafficking: Estimating the Profits," foreword by Roger Plant, Working Paper for the ILO (March 2005), 2.

13. Nina Shapiro, "The New Abolitionists," *Seattle Weekly*, August 25, 2004, 8.

14. Richard Poulin, "Globalization and the Sex Trade," *Canadian Woman Studies* 22, no. 3–4 (2003): 39.

15. Bales, 220.

16. Victor Malarek, *The Natashas: The New Global Sex Trade* (Toronto: Penguin, 2003), 175.

17. Paola Monzini, *Sex Traffic: Prostitution, Crime and Exploitation*. Trans. Patrick Camiller (London: Zed Books, 2005), 47, 35.

18. Heywood and Drake, 18.

19. Vivien Labaton and Dawn Lundy Martin, eds., *The Fire This Time: Young Activists and the New Feminism* (New York: Random House, 2004), xxvi.

20. Lisa Jervis and Andi Zeisler. *BITCHfest: Ten Years of Cultural Criticism from the Pages of Bitch Magazine* (New York: Farrar, Straus and Giroux, 2006), 109.

21. Other anthologies with little or no mention of trafficking are *Third Wave Agenda* (Heywood and Drake), *Manifesta* (Baumgardner and Richards), *Women's Culture in a New Era* (Kimball), and *We Don't Need Another Wave* (Berger).

22. Munford, 144.

23. Mary Christmas, "No Goddesses, No Slaves: The Sex Workers' Rights Movement Through a Pro-Choice Lens," in *We Don't Need Another Wave: Dispatches from the Next Generation of Feminists*, ed. Melody Berger (Emeryville, CA: Seal Press, 2006), 234.

24. Bales, 221.

25. Howie and Tauchert, 42–43.

26. Munford, 145.

27. Stacey Gillis, "Neither Cyborg Nor Goddess: The (Im)Possibilities of Cyberfeminism," in *Third Wave Feminism: A Critical Exploration*. ed. Stacy Gillis, Gillian Howie, and Rebecca Munford (New York: Palgrave Macmillan, 2004), 190, 193.

28. Maria Elena Buszek, *Pin-up Grrrls: Feminism, Sexuality, Popular Culture* (Durham, NC: Duke University Press, 2006), 313–14.

29. Malarek, xvi.

30. Denise deCaires Narain, "What Happened to Global Sisterhood? Writing and Reading 'the' Postcolonial Woman," in *Third Wave Feminism: A Critical Exploration*, ed. Stacy Gillis, Gillian Howie, and Rebecca Munford (New York: Palgrave Macmillan, 2004), 242.

31. Mridula Nath Chakraborty, "Wa(i)ving it All Away: Producing Subject and Knowledge in Feminisms of Colour," in *Third Wave Feminism: A Critical*

Exploration, ed. Stacy Gillis, Gillian Howie, and Rebecca Munford (New York: Palgrave Macmillan, 2004), 205–06.

32. Munford, 147.

33. Cited in Munford, 147.

34. Marjorie Stone, "Twenty-first Century Global Sex Trafficking: Migration, Capitalism, Class, and Challenges for Feminism Now." Readers' Forum: Feminism. *ESC* 31, no. 2–3 (2005): 31–38.

35. See the studies by Patricia Elliot, Macklin, and Poulin listed in the Bibliography.

36. See, for example, the website of an American anti-slavery society (http://www.anti-slaverysociety.addr.com/trafficw.htm, accessed March 18, 2008) which employs "white slave trade" interchangeably with "trafficking in women," even though many of the cases of slavery it presents are those of children and women from countries such as Thailand. Malarek, it should be noted, scrupulously avoids the conflation of these terms.

37. Audrey Macklin, "Dancing Across Borders: 'Exotic Dancers,' Trafficking, and Canadian Immigration Policy," *International Migration Review* 37, no. 2 (2003), 479, 482.

38. Cited in Narain, 244.

39. Phyllis Chesler, *The Death of Feminism: What's Next in the Struggle for Women's Freedom* (New York: Palgrave Macmillan, 2005), 62.

40. Monzini, 54.

41. Mini Singh, "Debate on Trafficking and Sex-Slavery," The Feminist Sexual Ethics Project, (Brandeis University): 1.

42. Laura Agustin, "The Disappearing of a Migration Category: Migrants Who Sell Sex," *Journal of Ethnic and Migration Studies* 32, no. 1 (2006): 29.

43. Moshoula Capous Desyllas, "A Critique of the Global Trafficking Discourses and U.S. Policy," 2.

44. See, for example, Donna M. Hughes, "Wilberforce Can Free Again: Protecting Trafficking Victims," *National Review*, March 12, 2008.

45. Nina Shapiro, "The New Abolitionists," 4.

46. Anna-Louise Crago, "Unholy Alliance," *AlterNet* (posted May 21, 2003), 1.

47. Conservative MP Joy Smith has led the abolitionist charge on the sex-trafficking issue, building bridges with the Salvation Army (as Butler did in the nineteenth century), with women's groups, and with ethnic groups such as the Ukrainian Canadians aroused by Malarek's *The Natashas*. In March 2006, a report entitled "Falling Short of the Mark: An International Study on the Treatment of Human Trafficking Victims" was issued by the Future Group, a Calgary-based self-described "non-partisan" NGO with close ties to the Harper government (see Future Group). In a May 16, 2006 editorial/opinion piece in the *Calgary Sun*, Future Group Executive Director Shuvaloy Majumdar rhetorically aligned himself with more right-wing abolitionists associated with the Bush administration: "The worldwide abolitionist movement against sex

slavery has had a major victory, and Canadian leadership is once again proving to be decisive, bold and clear," he observed; Majumdar also linked traffickers to foreign dictators and terrorists, and "standing with trafficking victims" to defending freedom in Afghanistan, "choking off the Tamil Tigers and ending aid to Hamas." The complexity of the ideological positions associated with sex trafficking in Canada is reflected, however, in the multi-party support for the Report of the Standing Committee on Status of Women, "Turning Outrage into Action to Address Trafficking for the Purpose of Sexual Exploitation," tabled on February 27, 2007 (see "Turning"). Taking a strong anti-prostitution stance, the report seems to fall squarely on the abolitionist side of the debate on trafficking (with the exception of the dissenting Minority report by the Bloc Québécois committee members).

48. Cited by Anna-Louise Crago, 1.
49. See Hughes, "Wilberforce Can Free Again," 1–2.
50. See *Taking the Pledge* in the Bibliography.
51. Whisnant argues that the anthology contributors rely on unexamined "central contentions" (210); apply "bugaboo terms" like "state power" and "moral panic" (211); reframe "victimization" within simplistic notions of agency (211–12); and uncritically argue that legalizing prostitution effectively counters trafficking (212–13).
52. Angela Miles, "Prostitution, Trafficking and the Global Sex Industry: A Conversation with Janice Raymond," *Canadian Woman Studies* 22, no. 3–4 (2003), 27.
53. Hughes in Miles, 26.
54. Hughes in Miles, 29.
55. On the re-trafficking and human rights issues associated with deporting trafficked women, see Hughes (2005), 41–47; San Martin, 81; Monzini, 148–50; and Macklin, 482–85.

Contributors

Katherine Binhammer is a Professor of English at the University of Alberta working in the areas of eighteenth-century British literature and feminist studies and is author of *The Seduction Narrative in Britain* (Cambridge, 2009). Inspired by a graduate course she took with Rusty Shteir at York University, she abandoned a project on contemporary women writers to immerse herself in the pleasures of reading historically.

Christine Bold is Professor of English, University of Guelph. Her publications include *Selling the Wild West* (1987), *The WPA Guides* (1999), *Writers, Plumbers, and Anarchists* (2006), *U.S. Popular Print Culture, 1860–1920* (forthcoming), and, as co-author, the award-winning *Remembering Women Murdered by Men: Memorials across Canada* (2006) by the Cultural Memory Group.

Susan Brown is Professor of English at the University of Guelph and Visiting Professor at the University of Alberta. She works on Victorian literature, women's writing, and digital humanities; these inform *Orlando: Women's Writing in the British Isles from the Beginnings to the Present* (co-edited; Cambridge, 2006), an innovative literary historical textbase. She leads development of the Canadian Writing Research Collaboratory.

Patricia Clements, FRSC, Professor of English and former Dean of Arts at the University of Alberta, is Founding Director of The Orlando Project and co-editor, with Susan Brown and Isobel Grundy, of *Orlando: Women's Writing in the British Isles from the Beginnings to the Present* (Cambridge, 2006), which received the Outstanding Achievement Award of the Society for Digital Humanities. Clements has also received the Queen's Jubilee Medal and an Honorary DLITT from Brock University.

Amber Dean is a postdoctoral fellow in the Department of English and Cultural Studies at McMaster University. Forthcoming essays can be found in the edited collection *Reconciling Canada*, and, with Sharon Rosenberg and Kara Granzow, in the journal *Memory Studies*. In 2007, Dean co-edited, with Anne Stone, a special issue of *West Coast Line* on representations of murdered and missing women.

413

Cecily Devereux is a member of the Department of English and Film Studies at the University of Alberta, teaching in the areas of women's writing, English-Canadian literature, chick lit, and feminism. She is currently studying the construction of raced femininity in erotic dance performance in nineteenth-century North America.

L.M. Findlay is Professor of English and Director of the Humanities Research Unit at the University of Saskatchewan. A Fellow of the Royal Society of Canada, his interests include literary theory and the Indigenous humanities. Among his recent publications is a new edition of *The Communist Manifesto* for Broadview Press and such essays as "Can the Institution Speak? The University as Testimony in Canada Today" (*Humanities Review*) and (with Lynne Bell) "Orientalism & Ephemera: Two States or One?" (*West Coast Line*).

Louise H. Forsyth is Professor Emerita (University of Saskatchewan). She was Chair of French (University of Western Ontario), Dean of Graduate Studies and Research (University of Saskatchewan), and President of the Canadian Federation for the Humanities and Social Sciences. She has numerous analytical and theoretical publications in Québec poetry and theatre, feminist criticism, and literary translation. She is one of eight persons who appealed the terms and implementation of the Canada Research Chairs program to the Canadian Human Rights Commission.

Lise Gotell is a full Professor of Women's Studies at the University of Alberta. She has published on diverse areas in Canadian feminist legal studies, including equality litigation, pornography, and sexual orientation jurisprudence. Her recent work explores developments in sexual assault law in the context of neo-liberalism and contemporary forms of feminist antirape activism.

Elizabeth Groeneveld (PHD University of Guelph) teaches courses in English literature, women's studies, and media studies at the University of Guelph. Her work focusses on the relationship between periodical cultures and feminist social movements. She has published work on the reclamation of domesticity within *BUST* magazine and the relationship between feminism and fashion.

Isobel Grundy, FRSC, Professor Emerita (University of Alberta), has published on Samuel Johnson, Lady Mary Wortley Montagu, and women's writing. With Susan Brown and Patricia Clements she created and still regularly updates the digital *Orlando: Women's Writing in the British Isles from the Beginnings to the Present* (Cambridge, 2006).

Tessa Elizabeth Jordan (BA Victoria, MA Alberta) is a PHD candidate in the Department of English and Film Studies at the University of Alberta. Her dissertation examines the Edmonton-based 1970s feminist magazine *Branching Out* and stems from her research interests in Canadian literature, women's writing, regionalism, and print culture.

Heather Murray (English, University of Toronto) is the immediate past-president of the Association of Canadian College and University Teachers of English. She is the

author of *Working in English: History, Institution, Resources* (1996), and *Come, Bright Improvement! The Literary Societies of Nineteenth-Century Toronto* (2002), as well as numerous articles on readership, English studies, and Canadian cultural history.

Phil Okeke-Ihejirika is a full Professor in the Women's Studies Program, University of Alberta, Edmonton, Canada. Her research and teaching focus on gender and development in Africa as well as international migration from the south. Dr Okeke-Ihejirika is also actively involved in building linkages with scholars, academic institutions, and local organizations with the aim of empowering African women.

Christine Overall is a Professor of Philosophy and holds a University Research Chair at Queen's University, Kingston. Her main areas of research are feminist philosophy, bioethics, and philosophy of religion. Her ninth book, on the ethics of choosing to have children, will be published by MIT Press in 2011.

Donna Palmateer Pennee is Dean of the Faculty of Arts and Humanities at the University of Western Ontario, a professor of English, and an affiliate member of the Department of Women's Studies and Feminist Research. An award-winning teacher, she has published on various twentieth-century English-Canadian novelists, on government and university policy and funding for research, and on Canada's cultural and foreign policies under globalization.

Jeanne Perreault is Professor and Associate Head (Graduate Program), Department of English, University of Calgary. Recent co-edited publications include *Tracing the Autobiographical; Photographs, History, and Meaning*; and *Feminism and Indigenous Women*. She is undertaking a major research project on the life writing and photography of American women photojournalists of World War II with Marlene Kadar (York University).

Julie Rak is a Professor in the Department of English and Film Studies at the University of Alberta, and is the author and editor of books about autobiography and popular culture. She is finishing a book about the memoir boom and conducting research about gender in mountaineering film and writing.

Ann B. Shteir, Professor of Women's Studies and Humanities at York University, is a former director of York's Graduate Women's Studies Program. Her publications include *Cultivating Women, Cultivating Science: Flora's Daughters and Botany in England, 1760 to 1860* (1996) and the co-edited *Figuring It Out: Science, Gender, and Visual Culture* (2006).

Aruna Srivastava works in the Department of English at the University of Calgary. Her interests for many years have revolved around feminist and critical pedagogies, critical race theory, as well as postcolonial, indigenous, and disability studies. She has committed herself over the years to antiracism work in the community and the academy, and to the ways in which antiracism education is both successful and unsuccessful as practice and philosophy in academic institutions.

Marjorie Stone is McCulloch Chair in English and Professor of Gender Studies at Dalhousie University. Most recently, she co-edited three of five volumes in *The*

Works of Elizabeth Barrett Browning (2010). She has published on a range of writers (principally Victorian) and on literary collaboration, cultural citizenship, and transatlantic abolitionism, among other subjects.

Aritha van Herk is the author of five feminist novels (*Judith, The Tent Peg, No Fixed Address, Places Far From Ellesmere*, and *Restlessness*), as well as two critical collections, *A Frozen Tongue* and *In Visible Ink*. Her irreverent history of Alberta, *Mavericks: An Incorrigible History of Alberta*, frames the new permanent exhibition on Alberta history at the Glenbow Museum and Archives; her latest book, *Audacious and Adamant: The Story of Maverick Alberta*, accompanies the exhibit. She is a Fellow of the Royal Society of Canada, and she teaches creative writing and Canadian literature at the University of Calgary.

Jo-Ann Wallace is a Professor in English and Film Studies at the University of Alberta. She has published extensively in the areas of women's literary modernism and feminist literary and cultural history.

Ann Wilson has taught theatre studies at the University of Guelph since 1988. Her research addresses the representation of gender and sexuality in twentieth-century drama written in English.

Erin Wunker is an Assistant Professor in the Department of English at Dalhousie University. Her research and teaching are in the fields of Canadian literature and critical theory. She has published articles on feminist theory and contemporary Canadian women's poetics, and she is currently working on two projects. One is a socio-historical survey of public dialogues about poetry in Canada. The second project is engaged in poethics and explores the relation between the poet and the critic.

Heather Zwicker is Associate Professor of English and Vice-Dean of Arts at the University of Alberta. She is editor of *Edmonton on Location* (NeWest, 2005) and co-founder of the feminist academic blog *Hook & Eye* (www.hookandeye.ca). Her research focusses on feminist cultural studies, particularly Canadian urbanism, public intellects, and contemporary university governance and administration.

Bibliography

"Academic units with more than 4 vacancies." Office of Human Rights, University of Alberta, Edmonton, n.d. University of Alberta Archives, Patricia Clements Fonds.

"Academic Women's Association: 1975-." n.d. http://www.ualberta.ca/ARCHIVES/ guide/7ORGAN/153.htm (accessed July 29, 2010).

Acker, Sandra, and Carmen Armenti. "Sleepless in Academia." *Gender and Education* 16, no.1 (2004): 3–24.

Ad Hoc Association of Concerned Faculty Members. Correspondence addressed to Dr Paul Davenport, April 3, 1991. University of Alberta Archives, Patricia Clements Fonds.

Advisory Committee on Women's Studies. Report: *1987 Progress Review. Task Force on the Status of Academic Women*. University of Alberta, Edmonton, 1987.

Agustin, Laura. "The Disappearing of a Migration Category: Migrants who Sell Sex." *Journal of Ethnic and Migration Studies*, 32, no. 1 (2006): 29–47.

Aikenhead, Sherri. "New Dean Lives for Learning." *Edmonton Journal*, February 5, 1989, B3.

———. "U of A Women still Seek Equity." *Edmonton Journal*, February 5, 1989, B3.

Alcott, Bronson. "Sonnet 16," in *Sonnets and Canzonets*, 73. Boston: Roberts Brothers, 1882.

Alexander, M. Jacqui. "Teaching for Justice." Plenary 4: Feminism and Social Justice. Paper presented at Not Drowning But Waving.

Alexander, M. Jacqui, and Lisa Albrecht, eds. *The Third Wave: Feminist Perspectives on Racism*. New York: Kitchen Table: Women of Color Press, 1998.

"Alice (Kiki) Prin," *New York Times*, March 24, 1953, 31.

Alternative Fifth Year Review of the Canada Research Chairs Program. CAUT [Canadian Association of University Teachers]. November 2005. http:// www.caut.ca/uploads/2005_crc_review.pdf (accessed February 18, 2010).

Althusser, Louis. "Contradiction and Overdetermination." *New Left Review* I, 41 (January–February 1967): 15–35.

———. "Freud and Lacan." *New Left Review* I, 55 (May–June 1969): 49–65.

———. "Ideology and Ideological State Apparatuses." *Lenin and Philosophy and Other Essays*. Translated by Ben Brewster. London: NLB, 1971.

———. "Philosophy as a Revolutionary Weapon" [interview]. *New Left Review* I, 64 (November–December 1970): 3–11.

Amadiume, Ifi. *Male Daughters, Female Husbands: Gender and Sex in an African Society*. London: Zed Books, 1987.

Amnesty International. *Stolen Sisters: A Human Rights Response to Discrimination and Violence against Indigenous Women in Canada*. 2004. www.amnesty.ca/stolensisters (accessed March 5, 2005).

Anderson, Benedict. *Imagined Communities: Reflections on the Origin and Spread of Nationalism*. New York: Verso, 1996.

Anderson, Fiona. "What Women Want: Board Seats on Merit, Not Affirmative Action." *Vancouver Sun*, September 24, 2008. http://www.vancouversun.com (accessed November 26, 2009).

Angus, Lis. "Saskatoon: Our First National Women's Liberation Conference." *The Velvet Fist* 1, no. 2 (December 1970): 4–5.

Ashton, Rosemary. *Portrait of a Marriage*. London: Chatto & Windus, 2002.

Association of Universities and Colleges of Canada. *Trends in Higher Education* (2002).

Attwood, Feona. "Sluts and Riot Grrrls: Female Identity and Sexual Agency." *Journal of Gender Studies* 16, no. 3 (2007): 233–47.

Austen, Jane. *Emma*. 1816. London: Penguin Classics, 1966.

Austin, J.L. *How to Do Things with Words*. Edited by J.O. Urmson and Marina Sbisà. Oxford: Clarendon Press, 1975.

"Average Earnings by Sex and Work Pattern." Statistics Canada. Government of Canada. http://www40.statcan.ca/l01/cst01/labor01a-eng.htm (accessed November 26, 2009).

Bair, Deidre. *Simone de Beauvoir: A Biography*. New York: Summit, 1990.

Bales, Kevin. "Because She Looks like a Child." In *Global Woman: Nannies, Maids, and Sex Workers in the New Economy*, edited by Barbara Ehrenreich and Arlie Russell Hochschild, 207–29. New York: Henry Holt & Co., 2002.

Bannerji, Himani. "Mary Wollstonecraft, Feminism and Humanism: A Spectrum of Reading." In *Mary Wollstonecraft and 200 Years of Feminisms*, edited by Eileen Janes Yeo, 222–42. London: Rivers Oram, 1997.

Bartley, Paula. *Prostitution: Prevention and Reform in England, 1860–1914*. London and New York: Routledge, 2000.

Baumgardner, Jennifer, and Amy Richards. *Manifesta: Young Women, Feminism, and the Future*. New York: Farrar, Straus and Giroux, 2000.

Beach, Sylvia. *Shakespeare and Company*. 1956; New York: Harcourt Brace, 1959.

Becker, Carol. "Trial by Fire: A Tale of Gender and Leadership." *Chronicle of Higher Education* 48, no. 20 (January 25, 2002): B15–17.

Beckett, Samuel. *Worstward Ho*. London: John Calder, 1983.

Bégin-Heick, Nicole, and Associates. *Gender-Based Analysis of the Canada Research Chairs Program: Report Prepared for the Canada Research Chairs Secretariat*, 2002. http://www.chairs.gc.ca (accessed 2003).

Behn, Aphra. *The Dutch Lover. Plays Written by the Late Ingenious Mrs. Behn*, vol. 1. London: 1702, *Eighteenth Century Collections Online*. Gale Group. January 8, 2007. http://galenet.galegroup.com.ezproxy.lib.ucalgary.ca (accessed January 8, 2007).

Bell, Laurie, ed., and the Ontario Public Interest Research Group. Toronto Chapter. *Good Girls/Bad Girls: Sex Trade Workers and Feminists Face to Face*. Toronto: Women's Press, 1987.

Bell, Quentin. *Virginia Woolf: A Biography*. London: Hogarth, 1990.

Belser, Patrick. "Forced Labor and Human Trafficking: Estimating the Profits." Foreword by Roger Plant. Working Paper for the International Labour Organization, March 2005. http://digitalcommons.ilr.cornell.edu/cgi/viewcontent.cgi?article=1016&context=forcedlabor (accessed December 1, 2008).

Bennett, Judith. *History Matters: Patriarchy and the Challenge of Feminism*. Philadelphia: University of Pennsylvania Press, 2006.

Beres, Melanie, Lise Gotell, and Barbara Crow. "The Perils of Institutionalization in Neoliberal Times: Results of a National Survey of Canadian Sexual Assault and Rape Crisis Centres." *Canadian Journal of Sociology* 34, no. 1 (2009): 135–63.

Berger, Melody. *We Don't Need Another Wave: Dispatches from the Next Generation of Feminists*. Emeryville, CA: Seal Press, 2006.

Best, Joel. "From Fad to Worse." *Chronicle of Higher Education* 52, no. 32 (April 14, 2006): B6–7.

Bieri, James. *Percy Bysshe Shelley: Youth's Unextinguished Fire, 1792–1816*. Newark: University of Delaware Press, 2004.

———. *Percy Bysshe Shelley: A Biography; Exile of Unfulfilled Reknown, 1816–1822*. Newark: University of Delaware Press, 2005.

"Bill C-10—Conservatives' Attack on Pay Equity." 40th Parliament, 2nd Session. Edited *Hansard* 011. February 9, 2009. http://judywasylycialeis.ndp.ca/page/344 (accessed February 9, 2009).

Blain, Virginia, Patricia Clements, and Isobel Grundy, eds. *The Feminist Companion to Literature in English: Women Writers from the Middle Ages to the Present*. London: Batsford Academic; New Haven, CT: Yale University Press, 1990.

———, eds. "Austen, Jane," in *The Feminist Companion*, 40.

———, eds. "Beach, Sylvia," in *The Feminist Companion*, 72.

———, eds. "Behn, Aphra," in *The Feminist Companion*, 77–78.

———, eds. "Burney, Frances," in *The Feminist Companion*, 160.

———, eds. "Hale, Sarah Josepha," in *The Feminist Companion*, 474–75.

———, eds. "Sackville-West, Vita," in *The Feminist Companion*, 938.

———, eds. "Sexton, Anne," in *The Feminist Companion*, 969.

———, eds. "Sitwell, Edith," in *The Feminist Companion*, 988–89.

Blatchford, Christie. "When Women Kill." *Globe and Mail*, December 11, 2004, A29.

Blomley, Nicholas. *Unsettling the City: Urban Land and the Politics of Property.* London: Routledge, 2004.

Boyd, William, ed. and trans. *The Emile of Jean Jacques Rousseau.* New York: Teachers College Press, 1962.

Boyle, Christine. "The Anti-discrimination Norm in Human Rights and *Charter* Law: *Nixon v. Vancouver Rape Relief.*" *University of British Columbia Law Review* 37 (2004): 31–72.

British Columbia Human Rights Code, R.S.B.C. (1996), c.479.

British Columbia v. British Columbia Government and Service Employees' Union [1999] S.C.R. 3.

Brodie, Janine. "The Great Undoing: State Formation, Gender Politics, and Social Policy in Canada." In *Western Welfare in Decline: Globalization and Women's Poverty,* edited by Catherine Kingfisher, 90–110. Philadelphia: University of Pennsylvania Press, 2002.

Brown, M. Jennifer. *"A Disposition to Bear the Ills...": Rejection of a Separate College by University of Toronto Women. Canadian Women's History Series,* no 7. The Women in Canadian History Project, Department of History and Philosophy of Education. Toronto: Ontario Institute for Studies in Education, 1977.

Brown, Susan, Patricia Clements, and Isobel Grundy, eds. *Orlando: Women's Writing in the British Isles from the Beginnings to the Present.* Cambridge: Cambridge University Press Online, 2006. http://orlando.cambridge.org/ (accessed January 7, 2008).

Brown, Wendy. "Feminist Hesitations, Postmodern Exposures." *differences* 5 (1991): 63.

———. *States of Injury.* Princeton, NJ: Princeton University Press, 1995. 63–84.

———. *Politics Out of History.* Princeton, NJ: Princeton University Press, 2001.

Bruccoli, Matthew. *Some Sort of Epic Grandeur: The Life of F. Scott Fitzgerald,* 2nd ed. Columbia: University of South Carolina Press, 2002.

Bryner, Jeanna. "Men Smarter than Women, Scientist Claims." *LiveScience.* September 8, 2006. http://www.livescience.com/health/060908_brainy_men.html (accessed November 27, 2009).

Buszek, Maria Elena. *Pin-up Grrrls: Feminism, Sexuality, Popular Culture.* Durham, NC: Duke University Press, 2006.

Butler, Josephine. *Child Prostitution and the Age of Consent.* Vol. 4 of *Josephine Butler and The Prostitution Campaigns: Diseases of the Body Politic,* edited by June Jordon and Ingrid Sharp. London and New York: Routledge, Taylor & Francis Group, 2003.

Butler, Judith. *Bodies that Matter: On the Discursive Limits of "Sex."* New York: Routledge, 1993.

———. *Gender Trouble: Feminism and the Subversion of Identity.* 1990. New York: Routledge, 1999.

————. *Precarious Life: The Powers of Mourning and Violence*. London: New York: Verso, 2004.

Butler, Samuel. "Dear Miss Savage," November 21, 1884, in *Letters Between Samuel Butler and Miss E.M.A. Savage*, edited by Geoffrey Keynes and Brian Hill, 349–50. London: Jonathan Cape, 1935.

Byfield, Ted. "What's Academic Excellence when the Sacred is at Stake?" *Alberta Report*, April 10, 1989, 44.

Byfield, Virginia. "Fembos in Academe." *Alberta Report*, January 7, 1991, 24.

"Canada Research Chairs—About Us." Canada Research Chairs. Government of Canada. February 26, 2009. http://www.chairs-chaires.gc.ca/about_us-a_notre_sujet/index-eng.aspx (accessed February 26, 2009).

Canada Research Chairs Secretariat. *Response to the Fifth-year Evaluation of the Canada Research Chairs Program*, 2005.

Canadian Federation for the Humanities and Social Sciences. "Women Are Being Left Behind in the Canada Research Chairs Program," 2001.

Caplan, Paula. *Lifting a Ton of Feathers: A Woman's Guide to Surviving in the Academic World*. Toronto: Council of Ontario Universities, 1993.

Carey, Elaine. "Faculties a Man's World." *Toronto Star*, September 22, 1996, A6.

Carlyle, Thomas. *The French Revolution: A History*. 1837. London: Chapman and Hall, 1904.

————. "To James Fraser," March 7, 1835, in *The Collected Letters of Thomas and Jane Welsh Carlyle*, vol. 8, edited by Charles Richard Sanders, 66–70. Durham, NC: Duke University Press, 1981.

Carmichael, Don, et al. "Employment Equity Critical for U of A." *Edmonton Journal*, September 3, 1991, A11.

Cather, Willa. "Willa Sibert Cather," in *Willa Cather in Person: Interviews, Speeches, and Letters*, edited by L. Brent Bohlke, 20. Lincoln: University of Nebraska Press, 1986.

Cartwright, M. "A College for Women." *University Monthly* 10, no. 1 (1909): 1–4.

Chakraborty, Mridula Nath. "Wa(i)ving it All Away: Producing Subject and Knowledge in Feminisms of Colour." In *Third Wave Feminism: A Critical Exploration*, edited by Stacy Gillis, Gillian Howie, and Rebecca Munford, 205–15. New York: Palgrave Macmillan, 2004.

Chambers, Lori. "Unprincipled Exclusions: Feminist Theory, Transgender Jurisprudence, and Kimberly Nixon." *Canadian Journal of Women and the Law* 19, no. 2 (2007): 305–34.

Champion, Chris. "Political Correctness in Political Science." *Alberta Report*, July 8, 1996, 33.

Chesler, Phyllis. *The Death of Feminism: What's Next in the Struggle for Women's Freedom*. New York: Palgrave Macmillan, 2005.

Christensen, Ferrel, et al. Correspondence, June 17, 1991. University of Alberta Archives, Patricia Clements Fonds.

Christmas, Mary. "No Goddesses, No Slaves: The Sex Workers' Rights Movement through a Pro-Choice Lens." In *We Don't Need Another Wave: Dispatches from the Next Generation of Feminists*, edited by Melody Berger, 226–38. Emeryville, CA: Seal Press, 2006.

Churchill, Winston. "The Short Words Are the Best." In *Churchill Speaks, 1897–1963: Collected Speeches in Peace and War*, edited by Robert Rhodes James, 921–22. New York: Barnes and Noble, 1980.

Clanchy, Kate. "Men's and Women's Poetry: Is there a Difference?" *Mslexia: For Women who Write* 24 (January–March 2005): 24.

Clements, Patricia. *Baudelaire and the English Tradition*. Princeton, NJ: Princeton University Press, 1985.

"Collective Ramblings." *The Other Woman* 1, no. 1 (May/June 1972): 2.

Conaghan, Joanne. "Review: *Women's Legal Strategies in Canada.*" *Feminist Legal Studies* 12 (2004): 119–24.

"Congratulations to these recent appointments." Report on Business, *Globe and Mail* 23, no. 2 (October 2006): n.pag.

Cossman, Brenda. "Really Real Women." *Xtra*, January 22, 2004. http://archives. xtra.ca/Story.aspx?s=15021605 (accessed December 1, 2007).

Cossman, Brenda, Shannon Bell, Lise Gotell, and Becki L. Ross. *Bad Attitude/s on Trial: Pornography, Feminism and the Butler Decision*. Toronto: University of Toronto Press, 1997.

Côté, Andreé. Urgent Call to Action. Email message from NAWL/ANFD (National Association of Women and the Law) to PAR-L (Policy Action Research List/Liste politique action recherche) distribution list October 12, 2006, 10:50:55 -0300.

Crago, Anna-Louise. "Unholy Alliance." *Rabble*. AlterNet, posted May 21, 2003. http://www.alternet.org/rights/15947 (accessed March 20, 2008).

"CRC Program Slow to Implement Settlement to End Discrimination/ Programme des chaires de recherche. Un règlement au point mort." *CAUT Bulletin* 55, no. 3 (April 2008): A2, A7.

Cultural Memory Group. *Remembering Women Murdered by Men: Memorials across Canada*. Toronto: Sumach Press, 2006.

Cvetkovich, Ann. "Public Feelings." *South Atlantic Quarterly* 106, no. 3 (2007): 459–68.

Dagg, Anne Innis, and Patricia J. Thompson. *MisEducation: Women and Canadian Universities*. Toronto: OISE Press, 1988.

Davenport, Paul. "Contentious Issues a Test of University's Ability to Define its Values." *Folio*, University of Alberta, Edmonton, December 7, 1989. President's statement to *General Faculties Council*, November 27, 1989.

———. Correspondence to Graham S. Lowe and Dr Sandra Niessen, President of the Academic Women's Association, February 6, 1992. University of Alberta Archives, Patricia Clements Fonds.

————. Correspondence to Patricia Clements, Dean, "Faculty of Arts Task Force Report," April 10, 1992. University of Alberta Archives, Patricia Clements Fonds.

Dawson, Jill. "Mentor 'Gold.'" *Mslexia: For Women who Write* 35 (October–December 2007): 16–17.

Day, Richard J.F. *Multiculturalism and the History of Canadian Identity*. Toronto: University of Toronto Press, 2000.

Dean, Amber. *Hauntings: Representations of Vancouver's Disappeared Women*. Unpublished Dissertation, University of Alberta, 2009.

————. "Space, Temporality, History: Encountering Hauntings in Vancouver's Downtown Eastside." In *The West and Beyond: New Perspectives on an Imagined Region*, edited by Sarah Carter, Alvin Finkel, and Peter Fortna, 113–32. Athabasca, AB: Athabasca University Press, 2010.

Dean, Amber, and Anne Stone, eds. *Representations of Murdered and Missing Women*. Spec. Issue. *West Coast Line 53* 41, no. 1 (Spring 2007).

"Defending the Ivory Tower: The U of A Whacks Mining to Protect Arts." Editorial, *Alberta Report*, March 4, 1991, 34–35.

Delane, Mary. Untitled report prepared for Dr Patricia Clements, Dean of Arts, University of Alberta, June 1999. University of Alberta Archives, Patricia Clements Fonds.

Deleuze, Gilles, and Félix Guattari. *A Thousand Plateaus: Capitalism and Schizophrenia*. Translation and foreword by Brian Massumi. Minneapolis: University of Minnesota Press, 1987.

Desyllas, Moshoula Capous. "A Critique of the Global Trafficking Discourse and U.S. Policy." Unpublished Paper.

Devereux, Cecily, and Jo Devereux. "Feminism: What Are We Supposed to Do Now?" *ESC* 31, no. 2–3 (June–September 2005): 9–11.

Dickens, Charles. "To Unknown Correspondent," December 27, 1866, in *The Letters of Charles Dickens Volume Eleven, 1865–1867*, edited by Graham Storey, 289. Oxford: Clarendon, 1999. http://library.nlx.com.ezproxy.lib.ucalgary.ca/ (accessed December 13, 2006).

Doezema, Jo. "Loose Women or Lost Women? The Re-Emergence of the Myth of White Slavery in Contemporary Discourses of Trafficking in Women." *Gender Issues* 18, no. 1 (Winter, 2000): 23–50.

Douglas, Susan J., and Meredith W. Michaels. *The Mommy Myth: The Idealization of Motherhood and How it has Undermined Women*. New York: Free Press, 2004.

Drakich, J., K.R. Grant, and P. Stewart, eds. "The Academy in the 21st Century." *Canadian Review of Sociology and Anthropology* 39, no. 3 (2002): 249–61.

Drakich, Janice, and Penni Stewart. "Forty Years Later, How Are University Women Doing?" *Academic Matters* (February 2007): 6–9.

Dux, Monica. "Loud, Proud, and, Yes, Feminist." *The Age*, June 2, 2007. http://www.theage.com.au/news/books/loud-proud-and-yes-feminist/2007/05/31/1180205420788.html?page=fullpage (accessed October 13, 2007).

Ebert, Teresa L. *Ludic Feminism and After: Postmodernism, Desire, and Labor in Late Capitalism.* Ann Arbor: University of Michigan Press, 1999.

Echols, Alice. *Daring to be BAD: Radical Feminism in America, 1967–1975.* Minneapolis: University of Minnesota Press, 1989.

Edelman, Lee. *No Future: Queer Theory and the Death Drive.* Durham, NC: Duke University Press, 2004.

Edgar, Maud C. "The Higher Education of Women." *University Monthly* 8, no. 7 (1908): 225–30.

Ehrenreich, Barbara. *Fear of Falling: The Inner Life of the Middle Class.* New York: Perennial Library, 1990.

Eliot, T.S. "Love Song of J. Alfred Prufrock." London: The Egoist, 1917.

Elliott, Jane. "The Currency of Feminist Theory." *PMLA* 121, no. 5 (October 2006): 1697–1703.

Elliott, Mark. "Christian Responses to Trafficking in Women from Eastern Europe." Paper presented at the Lilly Fellows Program National Research Conference, Christianity and Human Rights, Samford University, Birmingham, Alabama. November 13, 2004. http://www4.samford.edu/lillyhumanrights/papers/Elliott_Christian.pdf (accessed August 29, 2010).

Elliott, Olive. "Preferential Hiring." Four articles. *Edmonton Journal*, June 1989, n.pag.

Elliot, Patricia. "Who Gets to be a Woman? Feminist Politics and the Question of Trans-Inclusion." *Atlantis* 29, no. 1 (2004): 13–20.

England, Jennifer. "Disciplining Subjectivity and Space: Representation, Film and its Material Effects." *Antipode* 36, no. 2 (2004): 295–321.

Evans, Elrena, and Caroline Grant, eds. *Mama PHD: Women Write about Motherhood and Academic Life.* New Brunswick, NJ: Rutgers University Press, 2008.

Eyre, L. "Teacher Education or Market Lottery? A Look at Recent Shifts in Knowledge, Curriculum and Pedagogy in a Faculty of Education," in Reimer, *Inside Corporate U*, 67–86.

"Faculty Ask Human Rights Agency for CRC Program Inquiry." *CAUT Bulletin* 4 (April 2003): n.pag.

Felski, Rita. "Telling Time in Feminist Theory." *Tulsa Studies in Women's Literature* 21, no. 1 (Spring 2002): 21–28.

"Feminist and Equity Audits 2006." Compiled by Wendy Robbins and Michèle Ollivier. Canadian Federation for the Humanities and Social Sciences. http://www.fedcan.ca/images/File/PDF/Policy%20Work/FEA%20Audit%20postcard%202006.pdf (accessed December 4, 2009).

"Feminist Audits." *PAR-L*. http://www.unb.ca/par-l/research5.htm (accessed December 4, 2009).

Ferguson, Margaret. "Feminism in Time." *MLQ: Modern Language Quarterly* 65, no. 1 (March 2004): 7–27.

findlay, barbara. "Real Women: Kimberley Nixon v. Vancouver Rape Relief." *University of British Columbia Law Review* 36, no. 1 (2003): 57–76.

Firestone, Shulamith. "The Women's Rights Movement in the U.S.: A New View." Originally published in *Notes from the First Year*. New York: The New York Radical Women, 1968. Available online at The CWLU Herstory Website Archive. http://www.cwluherstory.com/the-womens-rights-movement-in-the-us-a-new-view.htm (accessed October 3, 2010).

Fitzgerald, Zelda. "Friend Husband's Latest." In *The Collected Writings*, edited by Matthew J. Bruccoli, 388. New York: Scribner; Toronto: Macmillan, 1991.

Flannery, Kathryn Thoms. *Feminist Literacies, 1968–1975*. Urbana: University of Illinois Press, 2005.

Flemming, Harry. "Stone's Plea Orwellian Bafflegab." Halifax *Daily News*, March 30, 1994.

Florida, Richard. *Cities and the Creative Class*. New York: Routledge, 2005.

Ford, Anne Rochon. *A Path Not Strewn with Roses: One Hundred Years of Women at the University of Toronto 1884–1984*. Toronto: Governing Council, University of Toronto, 1985.

Foucault, Michel. *The Order of Things: An Archaeology of the Human Sciences*. New York: Vintage Books, 1973.

Fox, Margalit. "Susan Sontag, Social Critic with Verve, Dies at 71 [Obituary]," *New York Times*, December 29, 2004, late ed. (east coast), A1.

Freeman, Jo. "The Women's Liberation Movement: Its Origin, Structures and Ideas." Pittsburgh: Know, Inc., c. 1971. Available online at Documents From the Women's Liberation Movement, An On-line Archival Collection, Special Collections Library, Duke University http://scriptorium.lib.duke.edu/wlm/womlib (accessed October 3, 2010).

Friedan, Betty. "Betty Friedan's New Agenda: Apply Feminist Ideals of Equality, Fairness to Men as well as Women." Press release. December 1, 1998. http://www.news.cornell.edu/releases/Dec98/Friedan.interview.PR.html (accessed October 3, 2010).

Friedland, Martin L. *The University of Toronto: A History*. Toronto: University of Toronto Press, 2002.

Friedman, Susan Stanford. "Making History: Reflections on Feminism, Narrative, and Desire." In *Feminism Beside Itself*, edited by Diane Elam and Robyn Wiegman, 11–53. New York: Routledge, 1995.

———. "'Beyond' Gynocriticism and Gynesis: The Geographics of Identity and the Future of Feminist Criticism." *Tulsa Studies in Women's Literature* 15, no. 1 (Spring 1996): 13–40.

Fudge, Rachel. "Girl, Unreconstructed: Why Girl Power is Bad for Feminism."
 In BITCHfest: Ten Years of Cultural Criticism from the Pages of Bitch
 Magazine, edited by Lisa Jervis and Andi Zeisler, 155–61. New York:
 Farrar, Straus and Giroux, 2006.

The Future Group. "Falling Short of the Mark: An International Study on the
 Treatment of Human Trafficking Victims." March 2006. "Resources."
 http://www.thefuturegroup.org/ (accessed October 3, 2006).

Gavey, Nicola. Just Sex? The Cultural Scaffolding of Rape. New York: Routledge, 2005.

Gérin, Winifred. Emily Brontë: A Biography. Oxford: Clarendon, 1971.

"Germain Greer vs. Larry Zolf." Midweek. Canadian Broadcasting Corporation,
 October 28, 1971; 5 min., 29 sec. From CBC Digital Archives. March 20,
 2008. http://archives.cbc.ca/health/reproductive_issues/clips/12448/
 (accessed September 21, 2010).

Gibson, Pamela Church. "Introduction: Popular Culture," in Gillis, Howie, and
 Munford, Third Wave Feminism, 137–41.

Gilbert, Daphne. "Time to Regroup: Rethinking Section 15 of the Charter." McGill
 Law Journal 48 (2003): 627–47.

Gillis, Stacey. "Neither Cyborg Nor Goddess: The (Im)Possibilities of
 Cyberfeminism," in Gillis, Howie, and Munford, Third Wave Feminism,
 185–96.

Gillis, Stacy, Gillian Howie, and Rebecca Munford, eds. Third Wave Feminism: A
 Critical Exploration. London: Palgrave Macmillan, 2004.

Goldin, Megan. "Sex Slavery Thriving in Holy Land." September 7, 2003, Reuters.
 http://www.scribd.com/doc/27031087/Isral-Sex-Slavery-Thriving
 (accessed December 1, 2008).

Goldie, Terry. "Liberation." ESC 30, no. 4 (2004): 37–40.

Gotell, Lise. "Litigating Feminist 'Truth': An Antifoundational Critique." Social and
 Legal Studies: An International Journal 4, no. 1 (1995): 99–131.

———. "Policing Desire: Obscenity Law, Pornography Policy and Feminism." In
 Women and Canadian Public Policy, edited by Janine Brodie, 279–317.
 Toronto: Harcourt Brace, 1996.

———. "Towards a Democratic Practice of Feminist Litigation?: LEAF's Changing
 Approach to Charter Equality." In Women's Legal Strategies in Canada,
 edited by Radha Jhappan, 135–74. Toronto: University of Toronto Press,
 2002.

———. "The Discursive Disappearance of Sexualized Violence: Feminist Law
 Reform, Judicial Resistance, and Neo-liberal Sexual Citizenship." In
 Reaction and Resistance: Feminism, Law, and Social Change, edited
 by Dorothy E. Chunn, Susan B. Boyd, and Hester Lessard, 127–63.
 Vancouver: UBC Press, 2007.

Gordon, Avery F. Ghostly Matters: Haunting and the Sociological Imagination.
 Minneapolis: University of Minnesota Press, 1997.

Granzow, Kara, and Amber Dean. "Revanchism in the Canadian West: Gentrification and Resettlement in a Prairie City." *Topia: Canadian Journal of Cultural Studies* 18 (2007): 89–106.

Greene, Graham. *A Burnt-Out Case.* London: Heinemann, 1961.

Griffin Cohen, Marjorie. "Cronyism Thrives in CRC Hiring Process." *CAUT Bulletin* 50, no. 5 (May 2003): n.pag.

Groeneveld, Elizabeth. "The Limitations of Wave and Generational Metaphors in Feminist Histories." Paper presented at Not Drowning But Waving.

"Group of Thirteen (Canadian Universities)." *Wikipedia.* http://en.wikipedia.org/wiki/Group_of_Thirteen_(Canadian_universities) (accessed December 4, 2009).

Gruhn, Ruth. "Feminizing a Faculty: An Agenda for Arts." *Academic Concerns,* March 17, 1992, 1.2.1. University of Alberta Archives, Patricia Clements Fonds.

Gubar, Susan. "Feminist Misogyny: Mary Wollstonecraft and the Paradox of 'It Takes one to Know one.'" *Feminist Studies* 20, no. 3 (Fall 1994): 452–73.

———. *Condition Critical: Feminism at the Turn of the Century.* New York: Columbia University Press, 2000.

Gunning, Harry E. "President's Convocation Address." *Folio,* University of Alberta, Edmonton, November 25, 1976.

Hamilton, Susan, ed. *Criminals, Idiots, Women and Minors,* 2nd ed. Peterborough, ON: Broadview Press, 2004.

Hall, R., and B. Sandler. *The Classroom Climate: A Chilly One for Women.* Washington, DC: Project on the Status and Education of Women, Association of American Colleges, 1982.

Hamilton, Janice. "Women's Progress Not Enough, Says Academic Group." (AUCC). *University Affairs,* November 31, 2000.

Hannah, Elena, Linda Paul, and Swani Vethamany-Globus, eds. *Women in the Canadian Academic Tundra: Challenging the Chill.* Montreal/Kingston: McGill-Queen's University Press, 2002.

Hardt, Michael, and Antonio Negri. *Commonwealth.* Cambridge, MA: Harvard University Press, 2009.

Harris, Misty. "Defining the New Feminism." *Edmonton Journal,* August 8, 2008, B11.

Hayles, N. Katherine. "Introduction: Complex Dynamics in Literature and Science." In *Chaos and Order: Complex Dynamics in Literature and Science,* edited by N. Katherine Hayles. Chicago: University of Chicago Press, 1991.

———. *How We became Posthuman: Virtual Bodies in Cybernetics, Literature, and Informatics.* Chicago: University of Chicago Press, 1999.

Hays, Sharon. *The Cultural Contradictions of Motherhood.* New Haven, CT: Yale University Press, 1996.

Head, Tom. "Third-Wave Feminism." About.com (n.d. [2007]). http://civilliberty.about.com/od/gendersexuality/p/third_wave.htm (accessed March 2008).

Hegel, G.W.F. *Philosophy of Right [or Law]*. 1821. Translated by T.M. Knox. Oxford: Clarendon Press, 1962.

Henry, Astrid. *Not My Mother's Sister: Generational Conflict and Third-Wave Feminism*. Bloomington: Indiana University Press, 2004.

Hernandez, Daisy, and Bushra Rehman, eds. *Colonize This! Young Women of Color on Today's Feminism*. New York: Seal Press, 2002.

Heyes, Cressida. "Feminist Solidarity after Queer Theory: The Case of Transgender." *Signs: Journal of Women in Culture and Society* 28, no. 4 (2003): 1093–1120.

Heywood, Leslie, and Jennifer Drake. "'It's All About the Benjamins': Economic Determinants of Third Wave Feminism in the United States," in Gillis, Howie, and Munford, *Third Wave Feminism*, 13–23.

Heywood, Leslie, and Jennifer Drake, eds. *Third Wave Agenda: Being Feminist, Doing Feminism*. Minneapolis: University of Minnesota Press, 1997.

Hickling, Arthurs, Low. "Technology Management, Strategy, and Economics." *Third Year Review of the Canada Research Chairs Program, Final Report*. Ottawa. HAL. Ref 7185.06, 2002.

"History of Employment Equity." Human Resources and Skills Development Canada. Government of Canada. http://www.rhdcc-hrsdc.gc.ca/eng/lp/lo/lswe/we/information/history.shtml (accessed December 4, 2009).

hooks, bell. *Feminism is for Everybody: Passionate Politics*. Cambridge, MA: South End Press, 2000.

Hornosty, J.M. "Corporate Challenges to Academic Freedom and Gender Equity," in Reimer, *Inside Corporate U*, 43–66.

Howie, Gillian, and Ashley Tauchert. "Feminist Dissonance: The Logic of Late Feminism," in Gillis, Howie, and Munford, *Third Wave Feminism*, 37–48.

Hughes, Donna M. "Accommodation or Abolition? Solutions to the Problem of Sexual Trafficking and Slavery." *National Review*, May 1, 2003. http://www.nationalreview.com/articles/206761/accommodation-or-abolition/donna-m-hughes (accessed September 15, 2010).

———. "The Demand for Victims of Sex Trafficking." Research Report, June 2005. http://www.uri.edu/artsci/wms/hughes/pubtrfrep.htm (accessed March 15, 2008).

———. "Wilberforce Can Free Again: Protecting Trafficking Victims." *National Review*, March 12, 2008. http://www.nationalreview.com/articles/223881/wilberforce-can-free-again/donna-m-hughes (accessed November 28, 2008).

Hughes, Donna M., and Janice G. Raymond. With project coordinator Carol Gomez. "Sex Trafficking of Women in the United States: International and Domestic Trends." March 2001. http://action.web.ca/home/catw/attach/sex_traff_us.pdf (accessed November 28, 2008).

Human Resources and Skills Development. The Federal Contractors Program, 1986. http://www.rhdcc-hrsdc.gc.ca/eng/labour/equality/fcp/index.shtml.

Humm, Maggie. *Modern Feminisms: Political, Literary, Cultural.* New York: Columbia University Press, 1992.

Hurdis, Rebecca. "Heartbroken." Hernandez and Rehman, *Colonize This!*, 279–92.

"If Academe is a 'Dream World,' Here's How to Wake it Up." Editorial, *Alberta Report*, March 4, 1991, 4.

Immen, Wallace. "Mission Accomplished—By the Book." *Globe and Mail*, October 6, 2006, C1, C2.

Incite! Women of Color Against Violence. *Color of Violence: The INCITE! Anthology.* Cambridge, MA: South End Press, 2006.

"Ivory Towers: Feminist and Equity Audits 2005." Compiled by Wendy Robbins, Michèle Ollivier, John Hollingsworth, and Rosemary Morgan. Canadian Federation for the Humanities and Social Sciences. http://www.fedcan. ca/ftpFiles/documents/indicators2005eng.pdf (accessed December 4, 2009).

Jackson, Douglas N., and J. Philippe Rushton. "Males Have Greater *g*: Sex Differences in General Mental Ability from 100,000 17- to 18-Year-Olds on the Scholastic Assessment Test." *Intelligence* 34, no. 5 (2006): 479–86. *Science Direct.* http://www.science.direct.com (accessed November 27, 2009).

Jackson, Maggie. *What's Happening to Home? Balancing Work, Life, and Refuge in the Information Age.* Notre Dame, IN: Sorin Books, 2002.

Jervis, Lisa, and Andi Zeisler. *BITCHfest: Ten Years of Cultural Criticism from the Pages of* Bitch *Magazine.* New York: Farrar, Straus and Giroux, 2006.

Johnson, Holly. *Measuring Violence against Women: Statistical Trends.* Statistics Canada Catalogue no. 85-570-XIE (2006).

Joyce, Glenis. "Chasing the Gorilla in a Silent Jungle: Integrated Planning and the Disappearance of Equity." *VOX.* Saskatoon: University of Saskatchewan Faculty Association. (April 1–6, 2005).

Kaplan, Cora. "Wild Nights: Pleasure/Sexuality/Feminism." In *Sea Changes*, 31–56. London: Verso, 1986.

———. "Mary Wollstonecraft's Reception and Legacies," In *The Cambridge Companion to Mary Wollstonecraft*, edited by Claudia L. Johnson, 246–70. Cambridge: Cambridge University Press, 2002.

Keefer, Michael. *Lunar Perspectives: Field Notes from the Culture Wars.* Conrad, ON: Anansi, 1996.

Kelley, Caffyn. "Creating Memory, Contesting History." *Matriart: A Canadian Feminist Art Journal* 5, no. 3 (1995): 6–11.

Kempadoo, Kamala, with Jyoit Sanghera and Bandana Pattanaik, eds. *Trafficking and Prostitution Reconsidered: New Perspectives on Migration, Sex Work, and Human Rights.* Boulder, CO: Paradigm Publishers, 2005.

Keys, D.R. ["D.R.K."] "τὸ καλοκαχαθὸυ" "The Margaret Eaton School of Literature and Expression." *University Monthly* 7, no. 5 (1907): 124–26.

Keys, Florence V. "Women's Sphere of Influence as Teacher in Women's Colleges."
 Varsity 25, 6 (1905): 86–88.

Kimball, Gayle, ed. *Women's Culture in a New Era: A Feminist Revolution?* Lanham,
 MD: Scarecrow Press, 2005.

Kieren, Dianne, Aruna D'Souza, Anne McLellan, Peter Smy, and Jim Vargo. Report
 of the President's Commission for Equality and Respect on Campus.
 University of Alberta, Edmonton, July 1990.

*Kimberly Nixon v. Vancouver Rape Relief Society—and—British Columbia Human
 Rights Tribunal.* 2007 CanLII 2772 (S.C.C.).

Kimberly Nixon v. Vancouver Rape Relief Society [2001] British Columbia Human
 Rights Tribunal 1.

Kimberly Nixon v. Vancouver Rape Relief Society. Transcripts of Tribunal Hearing,
 December 11–15 and 18–22, 2000; January 8, 15–19 and 31, 2001; and
 February 20–23, 2001.

Kimura, Doreen. "Affirmative Action Policies Are Demeaning to Women in
 Academia." *Canadian Psychology* 38, no. 4 (1997): 238–43. HighBeam
 Research. Web (accessed November 26, 2009).

Kingston, Anne. "Why Women Can't Get Ahead." Report on Business, *Globe and
 Mail*, December 2005, 56–71.

Knott, Sarah, and Barbara Taylor, eds. *Women, Gender and Enlightenment.*
 Houndmills, Hamps.: Palgrave Macmillan, 2005.

Kolodny, Annette. *Failing the Future: A Dean Looks at Higher Education in the
 Twenty-First Century.* Durham, NC: Duke University Press, 1998.

Kristeva, Julia. "Women's Time." In *New French Feminisms: An Anthology*, edited
 by Elaine Marks and Isabelle de Courtivron, 137–41. 1979. New York:
 Shocken, 1982.

Kuo, Lenore. *Prostitution Policy: Revolutionizing Practice through a Gendered
 Perspective.* New York: New York University Press, 2002.

Labaton, Vivien, and Dawn Martin, eds. *The Fire This Time: Young Activists and the
 New Feminism.* New York: Anchor Books, 2004.

Laframboise, Donna. "No Straight Help for Rape Victims." *National Post*,
 March 1, 2001. http://www.fathers.ca/News/STUDIES/VIOLENCE/
 Nostraighthelpforrapevictims.aspx (accessed December 1, 2007).

Laidlaw, Toni, Susan Sherwin, and Jane Arscott. Letter to the Editor, Halifax *Daily
 News*, April 5, 1995, 17.

Lakoff, George, and Mark Johnson. *Metaphors We Live By.* Chicago: University of
 Chicago Press, 1980.

Landesman, Peter. "The Girls Next Door (How Sex Trafficking Works)." *New York
 Times*, January 25, 2004.

"Lasting Memorial Garden, Vancouver Downtown Eastside." Fundraising flyer.
 Circulated December 2006.

Lauber, Jean K. "Women's Studies—A Report on a Trial Course." Correspondence; attachment to a letter to Mrs M.M. Midgley, Secretary, General Faculties Council, April 28, 1976. University of Alberta Archives, Patricia Clements Fonds.

Law v. Canada [1999] 1 S.C.R. 497.

"Law School to Receive Memorial Sculpture in Tribute to Murdered Women." Fundraising flyer, University of Calgary Law School Library.

Lebowitz, Fran. "Letters." In *Metropolitan Life*, 143. New York: Robbins-Dutton, 1978.

———. Interview, December 5, 1982, http://www.eskimo.com/~recall/bleed/1205.htm (accessed December 13, 2006).

Levy, Ariel. *Female Chauvinist Pigs: Women and the Rise of Raunch Culture*. New York: Free Press, 2005.

Lewis, Edith. *Willa Cather Living: A Personal Record*. New York: Octagon, 1976.

Lowe, Graham. Correspondence to Dr Paul Davenport, January 16, 1992. "Summary of our January 7th meeting on equity." University of Alberta Archives, Patricia Clements Fonds.

Lowe, Graham, et al. "Developing and Implementing Department Employment Equity Plans in the Faculty of Arts." Report and Recommendations of the Dean's Advisory Task Force on Employment Equity. Revised March 16, 1992. University of Alberta Archives, Patricia Clements Fonds.

MacDirmid, Robert. "Women Receiving Less than 1 in 6 Canada Research Chairs." *York University Faculty Association News*, n.d.

MacKinnon, Catherine. *Toward a Feminist Theory of the State*. Cambridge, MA: Harvard University Press, 1989.

Macklin, Audrey. "Dancing Across Borders: 'Exotic Dancers,' Trafficking, and Canadian Immigration Policy." *International Migration Review* 37, no. 2 (2003): 464–500.

Macleod, Rod. *All True Things: A History of the University of Alberta, 1908–2008*. Edmonton: University of Alberta Press, 2008.

MacMurchy, Helen. "The University Women's Club and Residences for Women." *University Monthly* 5 (1905): 138–43.

"Major Organizations Dealing with the Status of Women." *CAUT Bulletin*, September 1975, 24.1.26.

Majumdar, Suvaloy. "Editorial/Opinion—Canada Offers Ray of Hope." *Calgary Sun*, May 16, 2005.

Malarek, Victor. *The Natashas: The New Global Sex Trade*. Toronto: Penguin, 2003.

Malatest, R.A., and Associates. *Fifth-Year Evaluation of the Canada Research Chairs Program: Final Evaluation Report*. Prepared for the Canada Research Chairs Evaluation Steering Committee. Victoria, BC: Malatest and Associates, 2004.

Mansfield, Katherine. "Journal: 1922 July 4." In *Journal of Katherine Mansfield*, edited by John Middleton Murry, 327. London: Constable, 1984.

Marchak, P. *Racism, Sexism, and the University: The Political Science Affair at the University of British Columbia.* Vancouver: UBC Press, 1996.

"Maria Montez, 31, Dies Suddenly After Reducing Bath in Paris Home," *New York Times*, September 8, 1951, 8.

Martin, Biddy, and Chandra Talpade Mohanty. "Feminist Politics: What's Home Got to Do with It?" In *Feminist Studies/Critical Studies*, edited by Teresa de Lauretis, 191–212. Bloomington: Indiana University Press, 1986.

Marx, Karl. *Contribution to the Critique of Hegel's "Philosophy of Law."* Translated by Annette Jolin and Joseph O'Malley. Cambridge: Cambridge University Press, 1970.

Maslach, Christina, and Michael P. Leiter. *The Truth About Burnout: How Organizations Cause Personal Stress and What to Do About It.* San Francisco: Jossey-Bass, 1997.

Maslek, Carolyn. "Bills C-16 and C-72: Steps Forward in the Struggle to End Discrimination." *CAUT Bulletin*, September 1975, 24.1.5.

Mason, Mary Ann, and Eve Mason Ekman, eds. *Mothers on the Fast Track: How a New Generation Can Balance Family and Careers.* New York: Oxford University Press, 2007.

Massumi, Brian. "Translator's Foreword: Pleasures of Philosophy." Deleuze and Guattari, *A Thousand Plateaus*, ix–xv.

Mathen, Carissima. "Transgendered Persons and Feminist Strategy." *Canadian Journal of Women and the Law* 16, no. 2 (2004): 291–316.

Mayeda, Graham. "Re-Imagining Feminist Theory: Transgender Identity, Feminism and the Law." *Canadian Journal of Women and the Law* 17, no. 2 (2005): 423–72.

Mba, N.E. *Nigerian Women Mobilized: Women's Political Activities in Southern Nigeria, 1900–1965.* Research Series, no. 48. Institute of African Studies. Berkeley: University of California, 1982.

McDonald, Lynn, Brooke Moore, and Natalya Timoshkina. *Migrant Sex Workers from Eastern Europe and the Former Soviet Union: The Canadian Case.* Ottawa: Status of Women Canada, 2000.

McDonald, W.J., and P. Davenport. Correspondence to Deans' Council, Employment Equity, March 4, 1992. University of Alberta Archives, Patricia Clements Fonds.

McFarland, Janet. "Female Directors Need Apply." *Globe and Mail*, October 10, 2006, B1, B4.

McIntyre, Sheila. "Studied Ignorance and Privileged Innocence: Keeping Equity Academic." *Canadian Journal of Women and the Law* 12, no. 1 (2000): 147–96.

McLaughlin, Peter. "Politically Correct Fight Back: Masked 'Guerrilla Grrrls' Won't Let Dal Harrassment Policy Die," and "'Guerrilla Grrrls' Want Policy Revived." Halifax *Sunday Daily News*, March 27, 1994, 1 and 3.

McMaster, R.D. "The Department of English, 1908-82." *Folio*, University of Alberta, Edmonton, September 30, 1982, 11.

Meade, Marion. *Dorothy Parker: What Fresh Hell Is This?* New York: Penguin, 1989.

Mencken, H.L. "A Neglected Anniversary," in *The Bathtub Hoax, and other Blasts and Bravos from the Chicago Tribune*, edited by Robert McHugh, 4-10. 1958. New York: Octagon, 1977.

————. "Melancholy Reflections," in *The Bathtub Hoax, and other Blasts and Bravos from the Chicago Tribune*, edited by Robert McHugh, 10-15. 1958. New York: Octagon, 1977.

Menzies, Heather. *No Time: Stress and the Crisis of Modern Life*. Vancouver: Douglas & McIntyre, 2005.

Meyers, Jeffrey. *Robert Frost: A Biography*. Boston: Houghton Mifflin, 1996.

Miles, Angela. "Prostitution, Trafficking and the Global Sex Industry: A Conversation with Janice Raymond." *Canadian Woman Studies* 22, no. 3-4 (2003): 26-37.

Minahan, Stella, and Julie Wolfram Cox. "Stitch 'n Bitch: Cyberfeminism, a Third Place and the New Materiality." *Journal of Material Culture* 12, no. 1 (2007): 5-21.

Mitchell, Juliet. "Women: The Longest Revolution." *New Left Review* I, 40 (November-December 1966): 11-37.

"Modern Abolitionists at the U.S. State Department." http://www.america.gov/st/hr-english/2008/January/20080117162306ajesroMo.7160913.html (accessed December 1, 2008).

Moi, Toril. "'I Am Not a Feminist, But...': How Feminism Became the F-Word." *PMLA* 121, no. 5 (October 2006): 1735-41.

Mojab, Shahrzad. "Equity Coordinator: Change Agent in an Unyielding Power Structure," in Hannah, Paul, and Vethamany-Globus, *Women in the Canadian Academic Tundra*, 162-67.

Molesworth, Charles. *Marianne Moore: A Literary Life*. New York: Atheneum, 1990.

Monzini, Paola. *Sex Traffic: Prostitution, Crime and Exploitation*. Translated by Patrick Camiller. London: Zed Books, 2005.

Munford, Rebecca. "'Wake Up and Smell the Lipgloss': Gender, Generation and the (A)politics of Girl Power," in Gillis, Howie, and Munford, *Third Wave Feminism*, 142-53.

Murray, Heather. *Working in English: History, Institution, Resources*. Toronto: University of Toronto Press, 1996.

————. "Making the Modern: Twenty-Five Years of the Margaret Eaton School of Literature and Expression." *Essays in Theatre/Études Théâtreales* 10, no. 1 (1999): 39-57.

————. "Doubled Lives: Florence Valentine Keys, David Reid Keys, and the Work of English." *University of Toronto Quarterly* 76, no. 4 (2007): 1007-39.

NAC Condemns Changes to Status of Women Canada's Mandate. News release by email from National Action Committee to PAR-L (Policy Action Research List/Liste politique action recherche) distribution list October 12, 2006, 10:48:24-0300.

Namaste, Vivianne, with Georgia Sitara. "Inclusive Pedagogy in the Women's Studies Classroom: Teaching the Kimberly Nixon Case." In *Sex Change, Social Change: Reflections on Identity, Institutions, and Imperialism*, 60–81. Toronto: Women's Press, 2005.

Narain, Denise deCaires. "What Happened to Global Sisterhood? Writing and Reading 'the' Postcolonial Woman," in Gillis, Howie, and Munford, *Third Wave Feminism*, 240–51.

"Narrowing the Gender Gap: Women Academics in Canadian Universities." CAUT [Canadian Association of University Teachers] Equity Review No. 1 March 2, 2008. 5 pp. http://www.caut.ca/uploads/EquityReview2-en.pdf (accessed February 18, 2010).

Neuman, Shirley. "Systemic Discrimination and the Canada Research Chairs: Diagnosis and Treatment." *Advances in Clinical and Experimental Medicine* 26, no. 1 (2003): 35–37.

Nielsen, Joyce McCarl, Robyn Marschke, Elisabeth Sheff, and Patricia Rankin. "Vital Variables and Gender Equity in Academe: Confessions from a Feminism Empiricist Project." *Signs: Journal of Women in Culture and Society* 31, no. 1 (2005): 1–28.

Nokes, David. *Jane Austen: A Life*. New York: Farrar, Straus and Giroux, 1997.

Not Drowning But Waving: Women, Feminism, and the Liberal Arts Conference, University of Alberta, Edmonton, AB, October 12–14, 2006.

"Not Drowning But Waving: Women, Feminism, and the Liberal Arts Conference." Conference pamphlet online, July 6, 2007. http://www.crcstudio.arts. ualberta.ca/waving/index.php.

Okeke, P.E. *Negotiating Power and Privilege: Igbo Career Women in Contemporary Nigeria*. Athens: Ohio University Press, 2004.

Okeke-Ihejirika, Phil, and Julie Rak. "The 2.5 Wave/Falling Between the Waves." Paper presented at Not Drowning But Waving.

Olson, Gary A. "What Conspiracy?" *Chronicle of Higher Education*, 52, no. 25 (February 24, 2006): C2–3.

"Ontario: A Leader in Learning." Report and Recommendations. February 2005. Prepared by the Honourable Bob Rae, Advisor to the Premier and the Minister of Training, Colleges, and Universities. http://www.edu.gov. on.ca/eng/document/reports/postsec.pdf (accessed February 18, 2010).

O'Reilly, Andrea. Introduction. In *Mother Outlaws: Theories and Practices of Empowered Mothering*, edited by Andrea O'Reilly, 1–28. Toronto: Women's Press, 2004.

Overall, Christine. *A Feminist I: Reflections from Academia*. Peterborough, ON: Broadview Press, 1998.

―――. "Return to Gender, Address Unknown: Reflections on the Past, Present and Future of the Concept of Gender in Feminist Theory and Practice." In *Marginal Groups and Mainstream American Culture*, edited by Yolanda Estes, Arnold Lorenzo Farr, Patricia Smith, and Clelia Smyth, 24–50. Lawrence: University Press of Kansas, 2000.

Oyewumi, Oyeronke. *The Invention of Women: Making an African Sense of Western Gender Discourses*. Minneapolis: University of Minnesota Press, 1997.

Paglia, Camille. *Sex, Art and American Culture*. New York: Vintage Books, 1993.

Panzeri, Allen. "University Urged to be at 'Forefront of Change' in Hiring." *Edmonton Journal*, June 8, 1991, n.pag.

―――. "Education and the White Male Bias." *Edmonton Journal*, June 30, 1991, E1

"A Partial Picture: The Representation of Equity-seeking Groups in Canada's Universities and Colleges." CAUT [Canadian Association of University Teachers] Equity Review No. 1 November 1, 2007. 4 pp. http://www.caut. ca/uploads/EquityReview1-en(2).pdf (accessed February 18, 2010).

Penfold, Amy. "Trafficking in Persons in North America." n.d. http://gaatw. org/working_papers/N%20America/United%20States%20Report.pdf (accessed September 15, 2010).

Pennee, Donna Palmateer. Response by the Canadian Federation for the Humanities and Social Sciences to the 2004 *Fifth-Year Evaluation of the Canada Research Chairs Program*, 2005.

―――. "Pedagogies that Challenge the Cult of Speed in Undergraduate Learning and Teaching." Paper presented at the 19th Annual Teaching Support Services conference, University of Guelph, Guelph, ON, May 16, 2006. http://www.tss.uoguelph.ca/tli/tlio6/tlio6resources/ DPPenneeCultofspeed.pdf (accessed February 18, 2010).

"Performance Indicators and the Humanities and Social Sciences." Project report prepared by Donald Fisher, Kjell Rubenson, Kathryn Rockwell, Garnet Gosjean, Janet Atkinson-Grosjean. Centre for Policy Alternatives in Higher Education and Training, UBC, September 30, 2000. http://fedcan. ca/content/en/364/performance-indicators-and-the-humanities-and-social-sciences.html (accessed February 18, 2010).

Perreault, Jeanne. "Imagining Sisterhood, Again." *Prose Studies* 26, no.1–2 (April–August 2003): 299–317.

Polster, Claire. "A Break from the Past: Impacts and Implications of the Canada Foundation for Innovation and the Canada Research Chairs Initiative." *Canadian Review of Sociology and Anthropology* 39, no. 3 (2002): 275–300.

"Postsecondary Pyramid: Equity Audit 2007." Compiled by Wendy Robbins and Michèle Ollivier, PAR-L, with assistance from CAUT and CFHSS. Canadian Federation for the Humanities and Social Sciences. http://www.unb.ca/ par-l/research5.htm (accessed November 26, 2009).

Posyniak, Teresa. "The Building of 'Lest We Forget' A Monument Dedicated to Murdered Women." Transcript. University of Calgary Law Library.

Poulin, Richard. "Globalization and the Sex Trade: Trafficking and the Commodification of Women and Children." *Canadian Woman Studies* 22, no. 3–4 (2003): 38–47.

Powrie, T.L. Correspondence to Academic Staff in Economics, September 25, 1989. University of Alberta Archives, Patricia Clements Fonds.

———. (Department of Economics). Correspondence to W.J. McDonald, Vice-President (Academic), October 7, 1991. University of Alberta Archives, Patricia Clements Fonds.

Prasad, Ajnesh. "Reconsidering the Socio-Scientific Enterprise of Sexual Difference: The Case of Kimberly Nixon." *Canadian Woman Studies* 24, no. 2–3 (2005): 80–84.

Prentice, Alison. "Scholarly Passion: Two Persons Who Caught It." *Historical Studies in Education/ Revue d'histoire de l'éducation* 1, no.1 (1989): 7–27.

———. "Boosting Husbands and Building Community: The Work of Twentieth-Century Faculty Wives." In *Historical Identities: The Professoriate in Canada*, edited by Paul Stortz and E. Lisa Panayotidis, 271–99. Toronto: University of Toronto Press, 2006.

Prentice, Susan. "The Conceptual Politics of Chilly Climate Controversies." *Gender and Education* 12, no. 2 (2000): 195–207.

"Prophesy Girl," *Buffy the Vampire Slayer*, TV, written and directed by Joss Whedon, The WB Television Network, June 2, 1997.

Protection Project. "Canada." n.d. http://www.protectionproject.org/report/allreports.htm (accessed July 29, 2005).

Ramsay, Karen, and Gayle Letherby. "The Experience of Academic Non-Mothers in the Gendered University." *Gender, Work, and Organization* 13, no. 1 (2006): 25–44.

Raymond, Janice G. *The Transsexual Empire: The Making of the She-Male*. London: Women's Press, 1980.

Razack, Sherene H. "Race, Space, and Prostitution: The Making of the Bourgeois Subject." *Canadian Journal of Women and the Law* 10, no. 2 (1998): 338–76.

———. "Gendered Racial Violence and Spatialized Justice: The Murder of Pamela George." *Canadian Journal of Law and Society* 15, no. 2 (2000): 91–130.

"REAL Women of Canada." n.d. http://www.realwomenca.com/ (accessed February 18, 2010).

Reber, Susanne, and Rob Renaud. *Starlight Tour: The Last, Lonely Night of Neil Stonechild*. Toronto: Random House Canada, 2003.

Reimer, M., ed. *Inside Corporate U: Women in the Academy Speak Out*. Toronto: Sumach Press, 2004.

Renner, K. Edward. *The New Agenda for Higher Education: Choices Universities Can Make to Ensure a Brighter Future*. Calgary: Detselig Enterprises, 1995.

"Reply of the Alumnae." *University Monthly* 9, no. 8 (1909): 289–91.

Report of the Committee Appointed to Enquire in Regard to a Possible College for Women. Broadsheet, University of Toronto Archives and Records Management Services. Reprinted *University Monthly* 9, no. 8 (1909): 286–89.

Report of the President's Commission for Equality and Respect on Campus. Recommendation 2.1.5, 26. University of Alberta Archives, Patricia Clements Fonds.

Report of the Royal Commission on the Status of Women in Canada. Ottawa: Information Canada, 1970.

Response by the Canadian Federation for the Humanities and Social Sciences to the 2004 *Fifth-Year Evaluation of the Canada Research Chairs Program*, by R.A. Malatest and Associates Ltd. Prepared by Donna Palmateer Pennee. March 2005. http://www.fedcan.ca/english/pdf/issues/ResponsetoMalatest-E.pdf (accessed September 8, 2010).

Rich, Adrienne. *Of Woman Born: Motherhood as Experience and Institution*. New York: Norton, 1976.

Richer, S., and L. Weir. *Beyond Political Correctness: Toward the Inclusive University*. Toronto: University of Toronto Press, 1995.

Rideout, Walter B. *Sherwood Anderson: A Writer in America*. Madison: University of Wisconsin Press, 2006.

Riding Alan. "Marguerite Duras, 81, Novelist and Screenwriter," *New York Times*, March 4, 1996, A1.

Ringma, Miranda. *Concrete Change, Constructed by Many*. Edmonton: December 6th Planning Committee, 2000.

Robbins, Wendy, and Michèle Ollivier. "Postsecondary Pyramid: Equity Audit 2007." Canadian Federation for the Humanities and Social Sciences, n.d. [May 2007]. http://www.fedcan.ca/english/pdf/issues/Pyramid_and_Notes2007.pdf (accessed July 4, 2008).

Roen, Katrina. "'Either/Or' and 'Both/Neither': Discursive Tensions in Transgender Politics." *Signs: Journal of Women in Culture and Society* 27, no. 2 (2001): 501–22.

Roiphe, Katie. *The Morning After: Sex, Fear, and Feminism*. Boston: Little Brown, 1993.

Rosenberg, Sharon. "Neither Forgotten nor Fully Remembered: Tracing an Ambivalent Public Memory on the Tenth Anniversary of the Montréal Massacre." *Feminist Theory* 4, no. 2 (2003): 5–27. Rep. *Killing Women: The Visual Culture of Gender and Violence*, edited by Annette Burfoot and Susan Lord, 21–45. Waterloo, ON: Wilfrid Laurier University Press, 2006.

Rosser, Phyllis. *The SAT Gender Gap: Identifying the Causes*. Washington, DC: Center for Women Policy Studies, 1989.

Rosser, Phyllis, et al. "Gender Bias in Testing: Current Debates for Future Priorities." A Public Policy Dialogue. Proceedings of the Ford Foundation Women's Program Forum. New York, April 1989.

Rowbotham, Sheila. "The Beginnings of Women's Liberation in Britain." In *The Body Politic: Writings from the Women's Liberation Movement in Britain, 1969–1972*, edited by Michelene Wandor, 91–102. London: Stage 1, 1972.

———. "Problems of Organisation and Strategy." In *Dreams and Dilemmas: Collected Writings*, 56–75. London: Virago, 1983.

Russ, Joanna. *How to Suppress Women's Writing*. Austin: University of Texas Press, 1983.

Samarasekera, Indira. "Centenary Address: Daring, Discovering, Delivering," University of Alberta, January 28, 2008. In Macleod, *All True Things*, 15.

Sampson, Fiona. "LEAF and the *Law* Test for Discrimination: An Analysis of the Injury of *Law* and How to Repair It." *Women's Legal Education and Action Fund* (November, 2005). http://www.leaf.ca/legal-pdfs/Law%20Report%20Final.pdf (accessed December 1, 2007).

San Martin, Ruth Magaly. "Undocumented Migrant Women Sex-workers in Toronto." In *Calculated Kindness: Global Restructuring, Immigration, and Settlement in Canada*, edited by Rose Baaba Folson, 71–83. Halifax, NS: Fernwood Publishing, 2004.

Schoeck, Ellen. *I Was There: A Century of Alumni Stories About the University of Alberta, 1906–2006*. Edmonton: University of Alberta Press, 2006.

Schor, Naomi, Elizabeth Weed, and Ellen Rooney, eds. Special issue "Derrida's Gift," *differences: A Journal of Feminist Cultural Studies* 16, no. 3 (2005): vi.

Schweitzer, Mary M. "World War II and Female Labor Force Participation Rates." *The Journal of Economic History* 40, no. 1, The Tasks of Economic History (1980): 89–95.

"Second-wave feminism." Wikipedia (n.d.). http://en.wikipedia.org/wiki/Second_wave_feminism, (accessed September 2010).

Senate Task Force Report on the Status of Women. Report on Academic Women. The University of Alberta Senate, March 1975, 12.

Scott, Joan Wallach. *Only Paradoxes to Offer: French Feminists and the Rights of Man*. Cambridge, MA: Harvard University Press, 1996.

———. "The Evidence of Experience." In *Feminist Approaches to Theory and Methodology: An Interdisciplinary Reader*, edited by Sharlene Hesse-Biber, Christina Gilmartin, and Robin Lydenberg, 79–99. Oxford: Oxford University Press, 1999.

Scott, Walter. *The Journal of Sir Walter Scott*, edited by W.E.K. Anderson. Oxford: Clarendon, 1972.

Senior, Jennifer. "Can't Get No Satisfaction." *New York Magazine*, November 27, 2006.

Shakespeare, William. *Hamlet, Prince of Denmark*, The Complete Signet Classic Shakespeare, edited by Sylvan Barnet. San Diego: Harcourt Brace Jovanovich, 1972.

Shapiro, Nina. "The New Abolitionists." *Seattle Weekly*, August 25, 2004.
 http://www.seattleweekly.com/2004-08-25/news/the-new-abolitionists
 (accessed December 1, 2008).

Side, Katherine, and Wendy Robbins. "Institutionalizing Inequalities in Canadian
 Universities: The Canada Research Chairs Program." *National Women's
 Studies Association Journal* 19, no. 3 (2007): 163–81.

Simon, Linda. *The Biography of Alice B. Toklas*. Garden City, NY: Doubleday, 1977.

Simon, Roger I. *The Touch of the Past: Remembrance, Learning, and Ethics*. New
 York: Palgrave Macmillan, 2005.

Singh, Mini. "Debate on Trafficking and Sex-Slavery." The Feminist Sexual Ethics
 Project. Brandeis University. http://www.brandeis.edu/projects/fse/
 Pages/traffickingdebate.html (accessed December 1, 2008).

Sitwell, Edith. *Taken Care Of: The Autobiography of Edith Sitwell*. New York:
 Atheneum, 1965.

Smart, Carol. *Feminism and the Power of Law*. London: Routledge, 1989.

Smith, Andrea. *Conquest: Sexual Violence and American Indian Genocide*.
 Cambridge, MA: South End Press, 2005.

Smith, D.E. "Texts and Repression: Hazards for Feminists in the Academy." *Writing
 the Social: Critique, Theory, and Investigations*. Edited by D.E. Smith.
 Toronto: University of Toronto Press, 1999.

———. "Despoiling Professional Autonomy: a Women's Perspective," in Reimer,
 Inside Corporate U, 31–42.

Smith, Malinda S. "Artful Dodging and the Conceits of Diversity Talk, Part I: The
 Pursuit of Equity and Diversity in the Faculty of Arts." Prepared for Arts
 in the 21st Century—Social Science Panel, 15 November 2007. University
 of Alberta, Edmonton.

———. "What's Up with Whiteness?" Presentation of University of Alberta
 Employment Equity Data. Closing Roundtable: Five Women Look Ahead.
 Paper presented at Not Drowning But Waving.

Smith, Stevie. "Not Waving but Drowing." In *The Norton Anthology of Literature by
 Women*, edited by Sandra M. Gilbert and Susan Gubar, 1684. New York:
 Norton, 1985.

Spender, Dale. *Man Made Language*. London: Routledge and Kegan Paul, 1980.

Staggenborg, Suzanne, and Verta Taylor. "Whatever Happened to the Women's
 Movement?" *Mobilization: An International Journal* 10, no. 1 (2005):
 37–52.

Stalker, Jacqueline, and Susan Prentice, eds. *The Illusion of Inclusion: Women in
 Post-Secondary Education*. Halifax, NS: Fernwood Publishing, 1998.

Stanton, Elizabeth Cady. *Eighty Years and More: Reminiscences, 1815–1897*. 1898.
 New York: Schocken, 1971.

Statistics Canada. *Measuring Violence Against Women: Statistical Trends 2006*. Last
 modified October 17, 2006. http://www.statcan.gc.ca/pub/85-570-x/85-
 570-x2006001-eng.htm (accessed July 4, 2008).

————. *Women in Canada: A Gender-based Statistical Report*, 2006.

Steedman, Carolyn. *Dust: The Archive and Cultural History*. New Brunswick, NJ: Rutgers University Press, 2002.

"Steering Committee" to "Members of 'Merit Only' Group." Memo, September 18, 1989, and meeting agenda for 28 September, 1989. University of Alberta Archives, Patricia Clements Fonds.

Stitch 'n Beach 2008. http://www.stitchnbeach.com/ (accessed July 4, 2008).

Stone, Marjorie. "Discriminatory Harassment Policy: Dal Board's Decision Infringes on Academic Freedom." *Chronicle-Herald*, March 28, 1994, C2.

————. "Twenty-first Century Global Sex Trafficking: Migration, Capitalism, Class, and Challenges for Feminism Now." "Readers' Forum: Feminism." *ESC* 31, no. 2–3 (2005): 31–38.

Strauss, Leo. "The Three Waves of Modernity." *An Introduction to Political Philosophy: Ten Essays*, edited by Hilail Gildin, 81–99. Detroit: Wayne State University Press, 1989.

Taking the Pledge. Film. Produced by the Network of Sex Work Projects. http://www.nswp.org. See http://www.bayswan.org/traffick/trafficking.html (accessed September 15, 2010).

Taylor, Ina. *George Eliot: Woman of Contradictions*. London: Weidenfeld and Nicolson, 1989.

"The 3rd Wave: Feminism for the New Millennium." September 16, 2006. http://www.3rdwwwave.com (accessed March 2008).

The Orlando Project: A History of Women's Writing in the British Isles. Cambridge: Cambridge University Press, 2006. http://www.arts.ualberta.ca/orlando/.

The Seven Year Itch. Film. Directed by Billy Wilder. Twentieth Century Fox, 1955.

"Third-wave feminism." Wikipedia (n.d.). http://en.wikipedia.org/wiki/Third_wave_feminism (accessed September 2010).

Thurman, Judith. *Secrets of the Flesh: A Life of Colette*. New York: Knopf, 1999.

Tiefer, Lenore. *Sex is not a Natural Act, and Other Essays*, 2nd ed. Boulder, CO: Westview Press, 2004.

Timson, Judith. "Goodbye Cruel World, I'm Going to Work." *Globe and Mail*, September 27, 2006. C5.

Todd, Janet, ed. *The Collected Letters of Mary Wollstonecraft*. London: Allen Lane, 2003.

Toffler, Alvin. *The Third Wave*. New York: Bantam Books, 1980.

"Trade." Directed by Marcho Kreuzpaintner. 2007.

Tudiver, N. *Universities for Sale: Resisting Corporate Control over Canadian Higher Education*. Toronto: James Lorimer & Company Limited, 1999.

Turk, James. "Feds Redesigning Universities." *CAUT Bulletin* 47, no. 9 (2000): n.pag.

————. *Alternative Fifth Year Review of Canada Research Chairs Program*. Ottawa: Canadian Association of University Teachers. November 2005.

"Turning Outrage into Action to Address Trafficking for the Purpose of Sexual Exploitation." Report of the Standing Committee on the Status of Women. February 2007.

University in Jeopardy. A One-Day Conference, March 12, 1993, Royal York Hotel, Toronto. Poster and Program. University of Alberta Archives, Patricia Clements Fonds.

Vancouver Rape Relief Society v. Nixon [2003] BCSC 1936.

Vancouver Rape Relief Society v. Nixon [2005] BCCA 601.

Vancouver Rape Relief Society, Petition to the British Columbia Supreme Court, NO. L021846, Vancouver Registry, August 12, 2003.

Varadharajan, Asha. "Thinking the Universal Singular: Femininity in the Next World Order." Plenary 5: Which Way? Paper presented at Not Drowning But Waving.

Verberg, Peter. "Deconstructing the Arts Faculty: Doctrinaire Feminism Tightens its Grasp on the U of A's Biggest Department." *Alberta Report*, September 30, 1996, 32–37.

Very Young Girls. Film. Directed by David Schisgall, with Nina Alvarez and Priya Swaminathan. 2008.

Vital Statistics Act, R.S.B.C. 1996, c.469.

Walker, Rebecca. "Becoming Third Wave." *Ms.* 2, no. 4 (January–February 1992): 39–41. Reprinted as "Becoming the Third Wave" in *Public Women, Public Words: A Documentary History of American Feminism*. Vol. III, edited by Dawn Keetley and John Pettigrew, 501–03. Lanham, MD: Rowman & Littlefield, 2005.

———, ed. *To Be Real: Telling the Truth and Changing the Face of Feminism*. New York: Anchor Books, 1995.

Wallace, Jo-Ann. "'Fit and Qualified': The Equity Debate at the University of Alberta." In *Beyond Political Correctness: Toward the Inclusive University*, edited by Stephen Richer and Lorna Weir, 136–61. Toronto: University of Toronto Press, 1995.

Warner, Michael. *Publics and Counterpublics*. New York: Zone Books, 2002.

Webb, Phyllis. *Water and Light: Ghazals and Anti Ghazals*. Toronto: Coach House Press, 1984.

"The White Paper: The Lighting of a Fire: Re-Imagining the Undergraduate Learning Experience." Office of the Provost and Vice-President Academic, University of Guelph. November 14, 2005. http://www.uoguelph.ca/vpacademic/whitepaper/ (accessed February 18, 2010).

Wiegman, Robyn. "On Being in Time with Feminism." *MLQ: Modern Language Quarterly* 65, no. 1 (March 2004): 161–76.

Whisnant, Rebecca. Review of *Trafficking and Prostitution Reconsidered: New Perspectives on Migration, Sex Work, and Human Rights*, edited Kamala Kempadoo with Jyoti Sanghera and Bandana Pattanaik. *Hypatia* 22, no. 3 (2007): 209–15.

Wolf-Wendel, L., and K. Ward. "Future Prospects for Women Faculty: Negotiating Work and Family." In *Gendered Futures in Higher Education: Critical Perspectives for Change*, edited by B. Ropers-Huilman, 111–34. Albany: State University of New York Press, 2003.

Woodbridge, Linda. Correspondence, sent to Chairman and Council of the English Department, University of Alberta, n.d. (sent for the Council meeting of November 20, 1975.) University of Alberta Archives, Patricia Clements Fonds.

———. Correspondence, sent to Dianne Kieren, Chair, President's Commission for Equality and Respect on Campus, March 27, 1990. University of Alberta Archives, Patricia Clements Fonds.

Wollstonecraft, Mary. *The Vindications: The Rights of Men, The Rights of Woman*, edited by D.L. Macdonald and Kathleen Scherf. Peterborough, ON: Broadview Press, 1997.

"Woman Passenger Killed, Kennedy Escapes in Crash," *New York Times*, July 20, 1969, 1+.

"Women's Liberation and Lesbians." *The Other Woman* 1, no. 1 (May–June 1972): 16–17.

Woolf, Virginia. *A Room of One's Own*. London: Grafton, 1977.

———. *The Diary of Virginia Woolf*, vol. 2, edited by Anne Olivier Bell and Andrew McNeillie. San Diego: Harvest-Harcourt Brace, 1978.

Wright, Erik Olin, ed. *Approaches to Class Analysis*. Cambridge: Cambridge University Press, 2005.

Wrong, George. "A College for Women." *University Monthly* 10, no. 1 (1909): 4–7.

Wunker, Erin. "Future Feminism." Paper presented at Not Drowning But Waving.

Wylie, A. ed. *Breaking Anonymity: The Chilly Climate for Women Faculty*. Waterloo, ON: Wilfrid Laurier University Press, 1995.

Index

Page numbers in *italics* refer to
photographs.

Binhammer, Katherine
career of, 243, 413
on reviving Wollstonecraft, xiv,
243–50
Bitch (magazine), 284*n*18
BITCHfest, 400
Blatchford, Christie, 346
Blomley, Nicholas, 367*n*13
Bold, Christine
career of, 39*n*25, 333–36, 347, 413
on feminist memorial studies and
"who benefits?" question,
xii–xiii, 333–49
Bosnia, sex trafficking in, 399
Boyle, Christine, 382, 384–85
Bracken, Bruce, 95
branding of the university, 120*n*13,
162–66
See also corporatization of the
academy
British Columbia, University of. *See*
University of British Columbia
British Columbia Human Rights
Commission
transsexual discrimination case,
370–71 (*See also* Vancouver Rape
Relief Society)
British Columbia Supreme Court,
transsexual discrimination
case, 379, 381, 387
Brodie, Janine, 33, 42*n*62, 386
Brontë, Emily, 202
Brown, Jennifer, 264, 268*n*3
Brown, Susan
career of, 48, 70–71, 74–75, 81, 413
early life, 69, 72
on motherhood in the academy, xiv,
67–85
on women, feminism, and the
liberal arts, vii–xxi
Brown, Wendy, 361–62, 366, 372
Bryner, Jeanna, 95–97
Buffy the Vampire Slayer (television),
199, 273

Burney, Fanny, 206
burnout/exhaustion in the academy,
xii, 107–20
alienation and, 127–29, 140
compassion and, 114–15, 119, 122
definition of burnout, 109–10
domesticity and, 114
future directions, 117–19, 128–30
history of burnout/illness, 109–10,
112–13, 136–37
meaning of work and, 128–30
personal experiences of, 107–09,
113–14, 124, 128–30
radical collegiality and, 118–19
refusal as prevention, 125–30,
320–22
research on, 109–10, 119*n*6
symptoms and treatment, 107–09,
113–14
unhealthy workplaces and, 109–10,
116–19, 126–30, 136–37
See also illness in the academy
Burnt-Out Case, A (Greene), 109
business
affirmative action by, 105*n*3
CRC private partnerships with,
174 (*See also* Canada Research
Chairs)
emotional intelligence and, 114
female reproductivity as issue,
98–99, 103–04
media representations of race,
class, and gender, 51–53, 62
as model for corporatization of
academy, 92, 114–15, 146–47
(*See also* corporatization of the
academy)
neo-liberalism and the academy
(*See* neo-liberalism and the
academy)
work–life balance and, 115, 120*n*15
(*See also* work–life balance)
Butler, Josephine, 405
Butler, Judith, 283*n*2, 367*n*8

Schisgall, David, 399
Schoeck, Ellen, 38n2
scholarships and gender restrictions,
10
Scholastic Aptitude Test, gender
differences, 95–96
Schor, Naomi, 131
Scott, Joan W., 100, 244–45, 250n13
Scott, Walter, 206
Second Sex, The (de Beauvoir), 8
second-wave feminism
class inequities and, 223–25, 275
coalition politics and, 278, 280–82,
299–300
consciousness-raising groups and,
230–31
cooking and, 317–20, 322–23
cross-generational communication
and, 277, 279, 317–18
diversity within, 221–25
feminist periodicals and, 223–24
generational demographic, 275–78
generational narrative, 294–97, 301
historicizing of, 218–26, 230–31
"interwave" activity, 81–82, 277–78,
282, 288–89, 297–98
literary histories, 16–17, 111–13, 201
motherhood and employment,
67–69, 71
motherhood and the academy,
80–83
over-investment in work, 320–23
overview of, 113, 274, 295–96, 315,
393, 396
as passé, 221, 223, 225
"personal is political," 103, 230–31,
315
political manifestos and, 225
pornography and, 278, 298, 300
poststructuralist theory and, 321,
324 (*See also* poststructuralism
and feminism)
progress narrative in, 279
racial inequities and, 223–25, 275

self-critiques within, 221–25
sexuality and, 223–25, 278
temporality critiques of, xiii–xiv,
218–20, 294–98
theory and, 225–26, 230
transsexual issues and, 375–76 (*See
also* transsexuality)
women's studies and, 397 (*See also*
women's studies programs)
See also waves of feminism
Selman, Jan, 42n62
Senior, Jennifer, 110
sessional academics. *See* professors,
non-tenured, and female
contract instructors
Sexton, Anne, 207
sex trade/prostitution
agency of sex workers, 401, 406–07
anti-sex *vs.* anti-sex industry, 407
colonialism, frontier mythology,
and Aboriginal women, 358–62,
367n13
debates on, 394
Eastside Vancouver media
representations, 355–56
"humanizing" strategies, 356–58
memorials to murdered women,
338 (*See also* memorials to
murdered women)
organizations for safer conditions,
404–06
violence against Aboriginal women,
358–60
See also Vancouver, Downtown
Eastside, disappeared women
Sex Traffic (Monzini), 404
sex trafficking/sex slavery, 398–408
agency of sex workers, 406–07
anti-abolitionist initiatives, 406–07
anti-sex *vs.* anti-sex industry, 407
anti-trafficking coalitions, 405–06,
410n47
damage to young girls, 398–99,
401–02, 407

as white, middle-class female
movement, 62–63, 222–23, 276,
278, 282–83, 286–89, 299, 403
See also first-wave feminism;
second-wave feminism;
third-wave feminism
We Don't Need Another Wave
(Christmas), 401
Weed, Elizabeth, 131
"What Happened to Global
Sisterhood?" (Narain), 402–03
"What Women Want" (Anderson),
105n3
"When We Dead Awaken" (Rich), xx
"When Women Kill" (Blatchford), 346
Whisnant, Rebecca, 406, 411n51
Whitaker, Muriel, 39n11
White, Alison, 9–10
White, Hayden, 218
White, Terry, 17
white slave trade, as term, 403, 410n36
See also sex trafficking/sex slavery
WIC. *See* Guelph-Wellington Women
in Crisis
Wiegman, Robin, 138, 220, 225
"Wife of Bath's Prologue" (Chaucer),
38n1
Wilkie, Dale, 39n11, 39n25
Williams, Dolly, 47
Williams, Raymond, 167–68, 234n22
Wilson, Ann
career of, 48, 315–17, 324, 416
on feminist alliances and knitting,
315–30
Wilson, Catherine, 42n62
Wilson, Mona, 354
Wilson, Sir Daniel, 253–54
Wolf, Naomi, 396
Wolfe, Brenda, 354
Wolfram Cox, Julie, 322–23
Wollstonecraft, Mary, 201, 209n16,
240–44, 246–47
See also *Vindication of the Rights of
Woman, A*

Women, Gender and Enlightenment
(Knott and Taylor), 240, 249n6
*Women's Encyclopedia of Myths and
Secrets, The*, 113
Women's Legal Education and Action
Fund, 372–73
Women's Memorial Grove, Winnipeg,
336
Women's Monument Committee,
Vancouver, 348n7
"Women's Rights Movement in the
U.S." (Firestone), 221–22
women's studies programs
at Dalhousie, 397–98
at U of A, 13, 16–17, 33–34, 39n25
at U of Guelph, 324–26
development studies and, 291
emphasis on social sciences, 238,
242
Enlightenment studies in, 238,
240–44, 247–48
future directions, xiii, 247–48
need for historicity and breadth,
237–38, 242, 247–48
social activism and, 299–300
"Women's Time" (Kristeva), 133
"Women: The Longest Revolution"
(Mitchell), 232
Women Won't Forget Collective, 348n7
Woodbridge, Linda
career of, 15–17, 39n11, 39n24,
39n25, 40n34
as chair of Dept. of English, U of A,
during backlash, 20–21, 23–26,
40n31, 40n34
Woodrow Wilson Foundation, 10
Woolf, Virginia
To the Lighthouse (Mrs. Ramsay),
114, 120n11
personal life, 112, 198, 206, 208n2,
298
A Room of One's Own, 4, 11, 77,
111–12

work (labour, career, vocation)
 art of refusal of, 125–30, 320–22
 burnout and unhealthy workplaces,
 109–13, 116–19, 126–30 (*See
 also* burnout/exhaustion in the
 academy)
 domesticity and workload, 82 (*See
 also* domesticity)
 information technologies and,
 76–77
 meaning of work, 68–69, 76–77,
 110–12, 122, 128–30
 meaning of work for female
 administrators, 129, 147–50,
 152, 155n7
 model of single-income married
 man for, 71, 77, 80–82
 parents in the academy (*See*
 fatherhood in the academy;
 motherhood in the academy)
 radical collegiality and, 118–19 (*See
 also* collegiality in the academy)
 recognition of, 149–50
work–life balance
 business workplaces and, 115,
 120n15
 information technologies and,
 76–77
 motherhood in the academy
 and, 69–71, 100–02 (*See also*
 motherhood in the academy)
 private–public divide and, 75–78,
 116–17, 122 (*See also* private–
 public divide)
Wright, Ramsay, 255
Wrong, George, 254–59, 262–66
Wrong, Margaret, 267
Wunker, Erin
 on being a young academic, xiii,
 131–41
 career of, 131–33, 416

Xtra (newspaper), 388

Yedlin, Tova, 39n24
"Yellow Wallpaper, The" (Gilman), 112

Zolf, Larry, 39n10
Zwicker, Heather
 on burnout and radical collegiality,
 xii, 107–20
 career of, 111–12, 416
 on women, feminism, and the
 liberal arts, vii–xxi

Other Books from The University of Alberta Press

One Step Over the Line
*Toward a History of Women
in the North American Wests*
Elizabeth Jameson, Editor
Sheila McManus, Editor

480 pages | B&W photographs, notes, bibliography, index
Co-published with AU Press at Athabasca University
978-0-88864-501-2 | $34.95 (S) paper
Western American History/Women's History/
Borderlands Studies

Retooling the Humanities
*The Culture of Research
in Canadian Universities*
Daniel Coleman, Editor
Smaro Kamboureli, Editor

336 pages | Notes, bibliography, index
978-0-88864-541-8 | $49.95 (S) paper
University Administration/Economics/Humanities

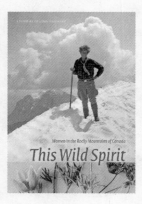

This Wild Spirit
*Women in the Rocky Mountains
of Canada*
Colleen Skidmore, Editor

508 pages | B&W photographs, colour section,
bibliography, index
Mountain Cairns: A series on the history and culture
of the Canadian Rockies
978-0-88864-466-4 | $34.95 (T) paper
Women's Studies/Canadian History